A long time ago
in a cutting room
far, far away. . . .

A long time ago in a cutting room far, far away. . . .

My Fifty Years Editing Hollywood Hits —*Star Wars*, *Carrie*, *Ferris Bueller's Day Off*, *Mission: Impossible*, and More

PAUL HIRSCH

CHICAGO
REVIEW
PRESS

An A Cappella Book

Published by Chicago Review Press Incorporated
814 North Franklin Street
Chicago, Illinois 60610
ISBN 978-1-64160-255-6

Library of Congress Cataloging-in-Publication Data

Names: Hirsch, Paul, 1945– author.
Title: A long time ago in a cutting room far, far away : my fifty years
 editing Hollywood hits; Star Wars, Carrie, Ferris Bueller's day off,
 Mission: impossible, and more / Paul Hirsch.
Description: Chicago, Illinois : Chicago Review Press Incorporated, [2020]
 | Includes index.
Identifiers: LCCN 2019014536 (print) | LCCN 2019022238 (ebook) | ISBN
 9781641602556 (cloth)
Subjects: LCSH: Hirsch, Paul, 1945– author. | Motion picture
 editors—United States—Biography. | Motion pictures—Editing.
Classification: LCC TR849.H57 A3 2020 (print) | LCC TR849.H57 (ebook) |
 DDC 778.593/092 [B]—dc23
LC record available at https://lccn.loc.gov/2019014536
LC ebook record available at https://lccn.loc.gov/2019022238

Unless otherwise indicated, all images are from the author's collection

Typesetting: Nord Compo

Printed in the United States of America
5 4 3 2

To Jane

Contents

Introduction

IN 1975 I EDITED A FILM directed by Brian De Palma called *Obsession*. It was an independent production, and upon its completion no studio in Hollywood would agree to release it because of an edgy plot development. After some thought, I suggested changing one shot in the film, from a wide establishing shot of a mansion to a close-up of our star. With this one substitution, Columbia Pictures agreed to distribute the film. That is what editing can do.

I have been working in the film business for fifty years. I have participated in big successes and big failures. At one point, I had worked on both the biggest hit of all time and the biggest flop, but I'd have to say, all in all, I have led a charmed life. This book is intended to share with you my experiences in the business, as well as some of my opinions and the insights I gleaned from the many extraordinary figures I have met and worked with.

Think of the world's biggest movie stars, the most powerful producers, the most talented writers, directors, and cinematographers hired by one of Hollywood's historic studios to create a movie into which they will pour hundreds of millions of dollars to market and distribute around the world. Sometimes over a thousand people are employed on a single movie. The production crew spends weeks and months carefully prepping the shoot, building sets, designing costumes, and scouting locations. Then they spend more weeks and months shooting, often in bitter cold or broiling heat; in the rain or snow; at night, hours on end, with too little sleep, eating

in tents, often twelve or more hours a day. Actors will show up hours before shooting just to be properly made up or coiffed. All this investment of time, money, creativity, and physical effort combines to provide the editor with his or her raw materials. That's me, the editor. It's the best job on a movie.

Editing is a bit of a misnomer. Just as the pocket computers we all carry are called *phones*, even though making phone calls is just a fraction of what we use them for, editing film is just one facet of the job. We editors spend a great deal of time building up the first cut. It's as if we are given a big box containing all the parts needed to put together a gizmo of some kind, except there is a lot of other junk in the box as well. We sift through all the footage shot each day looking for and extracting the useful parts of each angle or setup. We then cut these together into longer and longer sequences, or scenes. Sometimes these useful parts are analogous to sentences; other times they are like phrases or individual words, or even syllables, strung together to form meanings greater than their constituent parts. The shots derive their meaning from their context. Context is everything. You can take the most affecting moment of a four-hankie movie and cut it into the middle of a broad comedy, and it will seem absurd. We must choose with care how to frame the best moments. Looking through dailies (the raw footage shot on a particular day) is hunting for jewels, and once they're found, we have to mount them to maximum effect. What precedes a shot is critical, and the art of editing is, in part, how to make each shot achieve its full potential in the sequence.

Building the first cut is not just cutting out the "bad stuff" but, more important, putting together a collage out of bits of action and sound. Which bits the editor chooses and how they're arranged makes his or her work unique. Not until all the scenes have been shot and each one has been built into a rough version of itself can the editing phase of post-production really begin. This process, cutting the final version that the audience will see, is the most interesting and crucial step in the editing of a film. And because it is a process that is shared with the director, it varies as much as people differ one from the other.

Showing a first cut to a director can be an anxious moment, especially if it is the first time you are working together. Agreeing to work for a new director is a bit of a blind date. You can meet and talk, and learn

from other editors' previous experience, but the moment of truth comes when you start collaborating to turn the rough cut into the finished film. Screening the first cut is difficult for the director too. Will all the ideas and hard work pay off? I learned on my first picture that no matter how well edited the individual sequences are, it doesn't mean that the picture will work. But even so, it is an extremely important moment, because as director Herbert Ross used to say, "You only get one chance to see a picture for the first time."

The editor and director are mutually vulnerable. The editor is the director's first audience, and any mistakes made in shooting are there on the screen for us to see. As for us editors, the director is really our only true audience. Only he or she is privy to all the choices we have made, unfiltered through anyone else's sensibility. Consequently, the creative bond between director and editor can be extremely intimate. Ideally, each one provides emotional support to the other.

Every picture is handmade, and consequently the editor's sense of authorship of a film can be intense. But the culture of filmmaking forbids anyone to see the editor's work until after the director has seen it and made changes, so editors are sometimes thought of as mere assistants to the director. Today, however, advances in technology have somewhat eroded this tradition of secrecy. The complexity of making special effects films requires early assemblies to be more widely shared than they used to be, and new technology has made it easier to do this.

I am often asked how much discretion I have in performing my work. The truth is, I am hired to make the myriad choices that go into cutting each scene. It is very much like an actor, who may do ten takes of a scene, making a different choice each time. Only one of them is endorsed by the director and used in the film. The others are rejected. I make dozens, or even hundreds of choices a day—subject, of course, to review by the director. But that doesn't mean that all the choices are revised. I take great pleasure in the moments in my films that are just the way I cut them the first time. The directors looked at them and decided they couldn't be improved, like the Fonz from 1970s TV's *Happy Days* checking himself in the mirror, comb in hand, then stopping and putting the comb away because he looks perfect already.

Editing is the only aspect of filmmaking without deep roots in some earlier art form. Writing and acting come from theater. Production design has its antecedents in the theater too, as do costume, hair, and makeup. Photography has painting as its ancestor, but telling a story through a succession of images and sounds is native to the art of motion picture making. There is a relation to hieroglyphics as well as to picture books, but these are to the dynamic of film editing as the oxcart is to the space shuttle.

The illusion that we call cinema relies on human perception and a pair of biological and psychological phenomena. One is the phi phenomenon, an optical illusion first defined in 1912 by Max Wertheimer, one of the founders of Gestalt psychology. When an object is shown in one place and then in a second place, the viewer assumes it has moved there. Film consists only of still pictures, but when they are shown at twenty-four frames per second, the displacement of the objects in the images creates the perception of motion. This is combined with a second phenomenon, persistence of vision. When the image before our eyes is suddenly changed, the earlier image remains briefly on the retina. Close your eyes. For a fraction of a second, you will see a ghost of what you had just been looking at. On these two phenomena, physical and psychological, is built a multibillion-dollar industry.

Accompanying this illusion of movement through the rapid succession of still images is another illusion, on which editing is based: that actions spliced in sequence will appear to have occurred in the same order and time it takes to view the sequence. Suppose we have a particular sequence—CU (close-up): Handsome Movie Hunk stares lovingly; CU: Beautiful Film Goddess returns his gaze; two shot (both actors are in frame): they kiss. The audience is unaware that the kiss may have been filmed first, before the CU of the Hunk, after which the crew broke for lunch and came back to shoot the CU of the Goddess last, a process that may have taken any number of hours, depending on how many takes of each angle the director asked for and how complicated the relighting of the various shots was. We suspend our disbelief and accept that the actual sequence of events was as we see them on screen. It is this reconstruction of time that gives film its magic and makes my work fascinating.

Occasionally, I will see a movie crew on location. A crowd gathers. They watch and watch but see very little, unless the crew is blowing up a

building or performing some big stunt. But the crowd stays, because they want to get close to the magic. Well, the real magic isn't there. It takes place when the editor combines two pieces of film and makes it seem as if one led directly to the other. Or when a whole succession of images in montage creates an impression the way a poem does.

In an effort to communicate what it is all about, editing is often described as being *like* other art forms. It's *like* sculpting with clay, in a way, because you can add bits or take them away. It's *like* architecture, because visual structures are created, with foundations and an eye to grace, proportion, and balance. It's *like* choreography, except that instead of organizing movement in a three-dimensional space over a given amount of time, movement is organized in a two-dimensional plane, and instead of music giving the movement its shape, it may be dialogue. It's *like* writing, when rearranging the order of shots creates a new meaning. Editing has been referred to as the final rewrite of the script. Others have said you make a movie three times: once in the script, once in the shooting, and once in the editing.

Editing is like all of these other art forms, yet unique. A painting presents itself to the viewer as a totality. When we approach one in a museum or gallery we see the entire work, and only as we get closer do we see its details. The artist exerts only some control over the order in which we see these details. We can start looking at the top, the bottom, or wherever the composition leads our eye. With a sculpture, we walk around it, seeing it from different perspectives to grasp its entirety. Buildings' designs reveal themselves even more gradually. First we see the exterior, and then the interior through a number of different paths. Only later, when we mentally reconstruct our experience, do we "see" the entire work. The architect can exert only limited control of the order in which we experience the building's details.

Literature reveals itself to the reader in a different way. The reader must follow the path created by the author. Unlike in the visual arts, the details are meted out in precisely the order chosen by the author, divulging information in a carefully considered way. We grasp the totality of a written work only when we have completed the predetermined journey through it.

Music is similar, with a big exception: the rate at which we travel on the path is determined as well. A book may be read in a single session or

over the course of weeks or months. Music comes to us at a controlled pace, and it is in this regard that film most resembles it. Filmmakers need to consider not only in what order to deliver the information but also when and at what pace.

Film has become the preeminent visual art of our time because it combines many of the arts at once. It manifests many of the concerns of the painter, for beautiful or expressive images; it tells stories that reveal character and observations about the human condition; and it controls the rate at which the elements of the picture are delivered to the audience, slowing or accelerating as the needs of the picture require. It employs all the cinematic arts to reach not only the eyes and ears of the audience, but also their hearts.

The language of cinema has evolved since the earliest films. The limits imposed on the creators of silent films led to ingenious and sometimes poetic visual solutions to problems. The advent of sound set visual storytelling back for a while, but over the years, directors have found new and exciting ways to move the camera. Audiences now accept fragmented time (with stories moving backward and forward), alternate realities (like dreams and memories), and compressed or elongated time (such as slow motion or time lapse, even changing seasons in a single shot). The pace of cutting can become frantic, with audiences barely able to keep up with the action.

Editing is central to creating the magic. In the obscurity of the cutting room, we transform painstakingly filmed records of staged but actual events into love stories, space fantasies, mysteries, comedies, journeys to the far ends of the galaxy, back into prehistoric time, or far into the future. It is great fun. Or can be, depending on whom you are working for.

The first complete assembly is also called the *editor's cut*, but I prefer *first cut*. To me, *editor's cut* implies that it reflects our vision of how the film should be cut. Actually, it includes all the scenes that were shot, in their totality, and usually in the order the screenwriter originally specified. Often this is not the ideal sequencing, and even more often there are scenes, or parts of scenes, that would contribute best to the finished film by being cut out. I have been asked how to tell if a film has been well edited. It's not always a simple matter. Sometimes my major contribution on a film is taking a scene out. With the scene removed, the film may

acquire a better flow or even a sense of mystery and tension. As Michelangelo said, "Beauty is the purgation of superfluities."

The real reflection of how well a film has been cut is the totality of the finished film. Identifying what is superfluous, and choosing how to put together what remains, make the difference between a good version of a film and a great one. In putting the picture together, we often have a keen sense of this before anyone else. An actual editor's cut would reflect how we think the film should be and might be very different indeed from the first cut. However, including all the material at the outset is the most sensible way to proceed. With everything up there, the director and editor can begin to pare away and restructure until the final form is achieved.

In practice, the first cut is hardly ever satisfactory, no matter how hard the editor has worked to make it brilliant. It occasionally does happen that the script was written to perfection and the shooting went well too. In this case the film can be locked—stay unchanged—very soon after the end of shooting. A crucial part of finishing a film, or any work of art, is knowing when to stop.

What goes into the choices that I make? My approach to editing has always been strongly related to music. Part of my response is as a dancer, feeling the tempo of the music and reacting to it. What if there is no music? As editors, we are always dealing with tempo, whether there is music or not. The rhythm may be in the way the actors speak—slowly or rapidly, the stressed syllables like beats in music and the unstressed syllables like the space between the beats. A pace is created, and a pattern of beats to come is implied. My choice of cutting point is made by feeling the pace and placing the change of image at a moment that fits into the rhythmic pattern. Like when a dancer counts "Five, six, seven, eight" to set the pace of the dance to come, I have to be sensitive to the ideal moment between the beats.

It's not just speech that creates rhythm and tempo. Each action has a beginning, a middle, and an end. The time between the beginning and the end can vary tremendously and sets up a tempo that must be observed to gauge the correct placement of the cut. I had an assistant who, when he started cutting, would say, "Every frame is a potential cut." This is both true and not, and it is my job to choose those cutting points with care and artistry. Walking or running is another example of rhythm in motion. I have

found that when cutting a horse galloping, the ideal point to cut is when all four of the horse's hooves are in the air. It is similar to the bar line in written music. It is not on the beat but just before the beat that is often the best place for a cut. Sometimes I think of cutting as swinging from vine to vine; you let go of one and grab the next at precisely the crucial moment.

Beyond choosing the cutting point, I decide what order to place the shots in. Different angles have different uses. Each shot in a film sequence is like a container. It has within it sound and picture information. Wide shots contain a lot of information, but they're weak and require more time on the screen for the viewer to take them in. Close-ups have less information but are strong and are read more quickly. They are similar to *forte* and *piano* in music, and I can employ them in the same way. Often in scripts you will read, "SMASH CUT TO: . . ." I joke about getting out my smash splicer. What this means, I think, is an abrupt cut to a close-up, preferably with accompanying loud music or sound.

I make judgments about how long to keep a shot on the screen not only to register its content but also with regard to its context in the scene. Pauses are a particular concern. Because films are shot out of sequence, actors may inadvertently pause too frequently. I am careful to ration the pauses so that the overall pace doesn't suffer. Pauses are like salt; they must be used in moderation. They can be particularly problematic in comedies, where much of the humor rests on the element of surprise. The dialogue has to go fast and not let the audience get ahead of the action. Pauses are also a form of punctuation, a way of making clear to the audience when we have reached the end of a sentence, a paragraph, or a chapter. Timing is crucial.

It's a strange collaboration, between actor and editor. I spend day after day going over a performance, rewinding an actor, then playing her forward, stopping, going back, playing lines from different takes over the back of her head, cheating lines into her mouth, stealing syllables, all to make her look as good as possible. It's very intimate, in a way. I see all her moments, the mistakes, the weak takes; everything she does is exposed to me. But it's all a one-way intimacy. The star has no greater knowledge of me than she has of some fan in Sandusky, Ohio.

When I am putting together a first cut, I go into a sort of trance, an alpha state or flow in which there is no awareness of time passing and I

am completely absorbed in the task at hand. I am operating nonverbally. If something doesn't match, I fix it. If a shot is too short, I lengthen it. If it is too long, I trim it. If it is in the wrong sequence, I move it. If the sound in a wide shot is poor, I may cheat the dialogue from a close-up into the actor's mouth. I don't think in words: I just do it. If the actor stumbles, if there is a false note in the reading of a line or a hesitation when there should be none, I react. I must leave myself open, to empathize with the emotions expressed by the actors. Is the actor's psychological state consistent when I cut from one angle to another? I have to feel what they are feeling. Sometimes that can be painful. Is this take more gut-wrenching, or this one? Which of these takes is more heartbreaking? In a way, editors are host organisms. We take into our minds all the film shot for a picture. It lives in there for months, until the film is completed, and we have to be careful what we ingest. It can keep us up at night, causing us discomfort if we take in something toxic.

During shooting, the script supervisor keeps careful notes of everything that is shot. Sometimes the director will indicate that he prefers a particular take, and that will be noted. I don't mind this. After all, I am there to help the director achieve his vision. I don't feel that my autonomy as a creative person is endangered, although when I am given carte blanche, I do feel liberated and empowered.

In the era when movies were still shot and edited on film, an assistant sat next to the director and me while we screened dailies in a projection room and took down our notes about the footage. Watching dailies back then was critical in evaluating the material. It wasn't as easy as it is now to review everything. Finding line readings and comparing takes was tedious. John Hughes used to shoot takes that lasted until the film ran out and they were forced to reload. Each take might contain several resets, and finding the different readings was difficult. Keeping notes at dailies was essential.

Hardly anyone screens dailies together anymore. Everyone gets access to a secure online site where they can watch digital dailies on their individual viewer. It's a shame, because those screenings at the end of the shooting day were an opportunity for artists working on a film to communicate with each other. Now I am often in the dark about the intended function of a given setup, especially when there is so much use of blue screens. But it is undeniable that dailies are boring. Joel Schumacher shot

less film each day than any other director I ever worked with. I asked him why he shot so little, sometimes only one take.

"The reason I shoot so little is that watching dailies is *so boring!*"

"What if the negative breaks or gets scratched?" I asked. Fortunately, this is no longer a concern.

My dear friend and fellow editor, educator and author Ron Roose, likes to say, "No one has ever plunked down ten dollars to go into a theater and watch dailies."

When I was cutting a scene in the film era, I would review all the dailies for the scene. In doing so, I would form a mental picture of how the scene should go together, roughly. Then I would pull out the best pieces of each setup, using the notes from the daily screenings, put them aside on a rack on three-inch cores, and assemble the scene from those selects that I had made. I did this for twenty-five years.

Then, when I first started working on the Lightworks, a computerized system for editing, I realized I could use the power of the computer to help organize the material in a way that I couldn't do when I was cutting film. I had my assistants stack the lines, cutting together all the instances when an actor spoke any given line of dialogue. I was then able to play, in quick succession, all the options for each. This is an invaluable time-saver, and I do it to this day. The power of editing with the computer is extraordinary, and when combined with some of the visual effects (VFX) I can achieve, it's as if I can reach in and edit the image inside the frame, not just trim a shot's beginning or end.

During production, I have an extraordinary degree of autonomy. I am busy each day putting on a show using the elements I have been given the day before. I am not only a storyteller, which editors often profess to be. I must also be a showman. I put together the film with as much style and pizzazz as possible. I once heard someone say about Mozart that his music produces a combination of surprise and inevitability. Your first reaction is *Oh!* Then you think *Of course!* I decided that this was something to aspire to in my own work.

I prize clarity, so that the audience "gets it." If they become confused, they tune out and soon get bored. My fellow editor Donn Cambern, in teaching students, says there are only two rules in editing: don't confuse the audience and don't bore them.

Editing is not only about smooth cuts and exciting montages. It's also about helping create the whole package. When I worked on *Star Wars*, I would think, with great satisfaction, *The VFX guys only worked on one part of the movie. The actors only worked on one part. But I got to work on all of it.*

And there are many ways for editors to contribute. Sometimes it's a question of finding just the right piece of music for a scene. Sometimes it's about making a really nifty transition from the previous scene. On occasion, I will suggest a line we need, or a shot. When do I play a line on camera? When do I focus instead on the actor listening to the speaker? That line is weak in this take, but the camera move is the best. I'll just use the sound from the other take instead. When I am making these choices, I feel like I am king of the world.

Operating this way, without the director's input yet, I may want to get a feel for how something is playing, and I'll call my assistants in to watch a scene with me, to be my focus group. Just the fact of showing it to other people makes a difference, and sometimes, without them even voicing their reactions, I will realize I need to make a change here or there. It's as though a thought is lying just below the level of consciousness, and watching the scene with other people makes the thought pop up. Then I act on it.

Later, after principal photography is complete, I begin working with the director, making changes to the cut to have it more closely reflect his or her sensibilities. We start to challenge the cut. Do we even need this scene? What happens if we take it out? I am a firm believer in removing scenes to see what the effect is. If the scene is really necessary, it will be obvious. Good film always finds its way back into the movie (as in the school bus scene we'd originally removed from *Ferris Bueller's Day Off*, which we later used during the end credits).

There are four crucial steps in making a motion picture. The first and overwhelmingly most important is the script. If it's not on the page, it's doubtful that the outcome will be satisfying. (I have worked on numerous films for which the endings needed to be rewritten and reshot. Some people have jokingly speculated that this is because the powerful executives who green-light films may not have read them all the way through.)

The second crucial step is the casting. Put a weak actor in a lead role and it won't matter how good the material is or how clever you are later on.

The third step is the filming.

And the fourth step is the cutting and postproduction—the sound design, the music, and the mix.

Oddly, the least important of these is the third step. A film can be shot indifferently and still succeed if the script and the cast are great, and you don't screw it up in post.

We editors can have a powerful impact on our movies. It's true that we can be overruled, but we do affect the final film in a very personal way. British writer-director Jonathan Lynn once told me about a prime minister who had gone to Buckingham Palace to get the Queen's approval for a cabinet appointment he was considering.

"I don't understand," I said. "I thought the Queen had no power in the government."

"That's true," he replied, "she has no power, but she does have influence."

"I see. Editors are like the Queen of England!"

We don't have power, relative to the director, the producers, and the studio executives. But we do have influence. On *Mission: Impossible—Ghost Protocol*, I sat in a room with J.J. Abrams, Tom Cruise, and Brad Bird. It was liberating. Since I couldn't impose my opinion, I felt free to say what I thought, and often they would endorse my suggestion. Powerlessness can give you power.

I have worked with over twenty-five directors in my career. Not that many, I suppose, compared to actors or sound mixers. But our collaboration is a prolonged one, so the opportunity to work with a great number is limited. There are some lucky editors who find a happy fit with A-list directors, like Michael Kahn with Steven Spielberg, or Thelma Schoonmaker with Martin Scorsese. They have enjoyed a "happy marriage." But I have found it stimulating to "sleep around." I do take it as a point of pride to be invited back by directors. It is an affirmation of good work. I have worked on eleven pictures with Brian De Palma, four with Herbert Ross, two each with John Hughes, Ron Underwood, Taylor Hackford, and Duncan Jones. George Lucas hired me twice, although he was executive producer and not director on *The Empire Strikes Back*. It's always interesting to get to know new directors. They are all different,

with different priorities, different methods, and different audiences. For some directors, what matters most is box office; for some it is how the critics react. Others crave invitations to festivals. They all have particular bugaboos. De Palma doesn't like overlaps; he wants to be on the actor who is speaking. One director reacted in horror to a cut I had made. "You punched in!"

I had never heard the term. "I cut from the wide shot to the close-up."

"Yes, you can't do that."

"D. W. Griffith was doing that at the turn of the century. It is basic film grammar."

"No. You have to cut to the reverse angle first, before you can cut back to the close-up."

OK.

George Lucas hated laying lines of dialogue over the exterior of a building as a way of getting into a scene. "Is the building talking?"

And they all have unique ways of communicating with their editors. There are always cuts that don't quite work, and directors have varying ways of expressing that. Lucas would say it looked "goofy." Underwood would say, "That cut is hard for me." Others might say, "That cut bumps me." De Palma would simply snap his head back, as if he had been slapped in the face with a mackerel.

Editors are largely invisible, and this is partly because many directors don't like to admit they need someone else to help make their films. Actors don't like to acknowledge it either, for the most part, although the gracious Lupita Nyong'o is an exception. The great actors craft their performances with the knowledge that they are being edited. It takes nothing away from their art. They rely on editors to put the finishing touches on their performance. Looking at the final product, it is hard even for actors to know that what they see on the screen may have been carefully assembled line by line, sometimes word by word or even by the syllable.

I tell young people interested in the movie business that the only reason to become an editor is that you enjoy doing it. You won't get rich, although you can make a nice living at it. And you won't get famous, except maybe to other editors. But I consider myself extremely fortunate to have been permitted to get my hands on such wonderful material. Baz Luhrmann says that the best we in the industry can hope for is to work

on a film that becomes part of the culture. I have been lucky enough to have that happen to me a number of times. It has been a wonderful, absorbing, and rewarding experience.

The trick to extending a career as an editor is to make it past *old* and reach *venerable*. If you manage to reach this status, you can become a "film doctor," called in to help out on projects that are going badly. I have fortunately reached this point, and now, closer to the end of my career than to the beginning, I can look back and see my entire journey. I haven't listed all the accomplishments of the gifted artists I worked with. If you don't know them and want to learn more about them, I encourage you to look up their credits.

I've also worked for a few less talented souls, but I am not writing to settle scores, I am writing to relate my experiences during the last fifty years as I recall them. My first feature film opened in 1970, forty-three years after the first sound film. My career has spanned more than half the sound era. It is a stretch that produced many memorable films that helped shape our culture, and I was privileged enough to have had a hand in some of them.

Here's how it went down.

1

My First Hit: *Carrie*

IN 1975, WHEN I WAS STILL IN MY TWENTIES, Brian De Palma approached me about his next project, our fifth together, a film called *Carrie*. It was to be based on a first novel by an unknown writer, Stephen King. In it, Carrie, a shy girl who secretly possesses telekinetic powers, is mocked and shunned by most of her classmates. Her ultimate humiliation takes place at the senior prom, when she is elected queen in a rigged election and, at the moment of her triumph, has a bucket of pig's blood dumped on her. I read the book and liked it, but it seemed to me to be a step backward for Brian. He had already done horror (*Sisters*) and musical comedy horror (*Phantom of the Paradise*), and moved on to romantic thrillers (*Obsession*), pictures that I had edited for him. Why go back to the B movie genre? Coming in the wake of *The Exorcist*, a story about a young girl with magical powers seemed imitative to me. Little did I know that *Carrie* was destined to become much more than a hit movie; it would become part of the culture.

I expressed my reservations to Brian, but he was undeterred. He correctly saw the potential there and went out to Hollywood to start pre-production and begin casting for the film. Coincidentally, at that time, George Lucas was casting actors for his next picture, a sci-fi epic called *Star Wars*. Brian and George had become friends in 1971, when they were both in Burbank directing pictures for Warner Bros. Since the actors in their upcoming films were in the same age range, they decided to hold their casting sessions together. They agreed to have George do the opening

speech and Brian do the closing speech. If the actor looked hopeless, Brian would launch into the closing speech before George had finished the opening one.

One day, Brian called. "George wants to speak to you." I had an image of Brian with his arm wrapped around George's neck in a headlock, dragging him to the phone.

"Hi, Paul. I just wanted to tell you that I like your work, and I'd love to work with you someday."

Wow! I thought. This was exciting. I had met George and his wife Marcia, a fellow film editor, a year earlier at a screening of *Phantom of the Paradise*.

"I have already hired an editor for this picture that I'm doing now"— my heart sank—"but I'm going to be doing another one right after it, so maybe you can do that one."

"That's great, George," I said.

But I thought, *Why couldn't it be this one?* I had done four pictures by now, all for Brian, and as much as I appreciated his support, and as proud as I was of the pictures, I didn't want to just be one director's editor. I wanted to get a chance to work with other people, with other sensibilities, and George's previous film, *American Graffiti*, was exactly the kind of picture I wished I could have worked on.

In any event, Brian wanted me for *Carrie*, and I was happy to be wanted.

The now-legendary casting sessions with George Lucas had yielded great results for Brian. For the lead, he chose Sissy Spacek, who had appeared by then in Terry Malick's *Badlands* opposite Martin Sheen. I had been rooting for her to get the part, because I believed her to be genuinely talented. My sympathies for her were also based on the fact that we had met on *Phantom of the Paradise*, and she is one of the friendliest, least affected people you can imagine.

In the cast too was Nancy Allen, whom Brian later married. Nancy has a great presence on the screen. She played the bad girl, but in truth she is quite the opposite: charming, gentle, and kind, with a graceful sense of humor and a ready laugh. Amy Irving, the good girl, had an extraordinary and unique beauty. Steven Spielberg married her after he met her while visiting the set. In the key role of Carrie's mother, Brian cast Piper Laurie,

who hadn't been seen on the big screen since *The Hustler* about fourteen years earlier, and who is a wonderful, extremely focused, and well-prepared professional. Edie McClurg, a funny and gifted character actress, and Betty Buckley, who later became a legend on Broadway, were also cast.

Brian had briefly dated Betty and had used her to revoice an actress in a small role in *Obsession*. Betty had been after him to put her in a movie, and he finally did. She turned out to be great, and Brian got to kill her character in dramatic fashion, something he always enjoys. It plays to his macabre sensibility. He really comes alive dreaming up perilous situations for his female characters to face. I don't think, in retrospect, that it reflected an animus against women, although that may perhaps be naive. I think his view was that in life men are more likely to be aggressors or predators than are women. Brian has been accused of misogyny, but if you think about it, all the characters in *Carrie* who have any agency are female. The males are peripheral to the drama, boyfriends who are merely doing the bidding of the girls, or the clueless teacher and principal. The main conflicts are all between females.

In the "bad boyfriend" role, Brian cast a young TV performer named John Travolta. Brian has always recognized great young acting talent. He has given many actors, if not their start, their first important role, a list that includes Robert De Niro, Charles Durning, John Lithgow, John Travolta, Dennis Franz, Michelle Pfeiffer, Mary Elizabeth Mastrantonio, and Kevin Costner, who was a surprise choice to many when Brian chose him for *The Untouchables*. It made him a star.

Despite this undeniably sharp eye for acting talent, Brian's focus on camera movement and brilliantly creative ways of assembling shots into memorable and extravagant set pieces is offset by a diminished interest in the human aspects of cinema, namely what the actors bring. Character and performance seem to leave Brian cold. Films with a focus on these he derides as "talkfests." He finds filming close-ups of actors a bore, and he has little interest in film unless it pushes the visual boundaries of the medium. Yet, despite his oft-stated indifference to filming dialogue scenes, both Sissy and Piper were nominated for Academy Awards for their work in *Carrie*.

Near the end of principal photography, Brian asked me to come out and show him the partial rough cut as it currently stood, to see how scenes had shaped up and if there was a need for any additional shooting. After we screened the film and Brian pronounced himself satisfied with it, I visited the set, which at that point was the gym where the prom is held. The prom was the major set piece in the film, and it was to take weeks to shoot. Outside the soundstage, Paul Monash, the producer of the picture, came up to me. "What do you think?" he asked.

"I think everything is fine," I answered, knowing it would be catastrophic to hint at the slightest concern. In fact, I had none at that point.

"I'm worried," said Monash.

The issue was something I found relatively trivial; in fact, I don't remember what it was, but what struck me was his lack of confidence in how things were going. This concern would soon blossom into major disagreements between director and producer, but my loyalties were, of course, to Brian.

It is one of the strictest rules in my makeup that the editor must be loyal to the director. I have occasionally been asked by producers or studio executives to show them something without the director's permission. This is a no-no, and by and large, the "suits" know this and respect the rules. It was much later in my career that I found a way to deal with those occasional awkward situations. It was suggested by 20th Century Fox chairman Joe Roth, who, when I hesitated after he had asked me a somewhat delicate question, answered for me by saying, "I know, you can't answer me. The editor's code and all."

From then on, I would joke to people who asked me questions I found awkward to deflect, "I can't tell you that [or show you that] because it would be a violation of the Editor's Code, and I could be brought up on charges."

Some people actually believed there was such a code. In any event, Paul Monash would prove to be someone who would test my loyalty to my director.

Brian designed the prom scene in three major sections: the first was shot in normal, real-time photography, with dialogue. This section established the

characters at the prom and how happy Carrie was to be able to be there. The last shot of this first section was a long tracking shot that detailed the substitution of the false ballots for king and queen of the prom and set up the geography, with the bad kids (played by Nancy Allen and John Travolta) under the stage stairs, then the rope leading up to the bucket of pig's blood, followed by the announcement of the winners of the (rigged) election, Carrie and her date, Tommy Ross. All this in one magnificent crane shot.

The second section began at this point and was shot all in slow motion, without dialogue, only music. This covered Carrie and Tommy's march to the stage; the discovery by Sue Snell (played by Amy Irving) of the rope and the plot to humiliate Carrie; her subsequent effort to break it up; the sympathetic gym teacher (played by Betty Buckley) misinterpreting Sue's actions as motivated by jealousy; her throwing Sue out of the gym just as the rope is pulled; and the bucket tilting down, drenching Carrie from head to toe in pig's blood (actually Karo syrup dyed red). The music ends, and all we hear is the sound of the rope creaking. The bucket then falls onto Tommy's head and knocks him out.

There then follows a brief montage during which Carrie hears in her head the voices of the people in her life mocking her, accompanied by a kaleidoscopic effect we achieved at the optical house. Her rage builds, her telekinetic power is turned loose, and she begins to wreak her vengeance on her tormentors. The screen splits and Carrie looks around the room, making objects fly at her bidding.

This split-screen sequence is the third part of Brian's design for the scene, and he was so committed to it that in many instances, but (importantly) not all, he protected only half of the frame as he shot it. That is, as he was concerned with only one half of the screen, if a light stand or some other piece of movie equipment or even a crew member happened to appear in the frame, he didn't care, since he only intended to use the other half.

This was a bold choice. It prevented the editing of the scene in a conventional, full-screen manner. He also decided that all the action should take place in red light and turned off all but "emergency" lighting. But after a week of shooting, he decided that he couldn't play the whole scene that way and had one of the extras being blown around by Carrie's supernatural power accidentally point a fire hose at the lights, causing a short circuit that brought the original lighting back on!

The prom scene is a tour de force, a set piece with a strong and original graphic design. The slow-motion section alone had over a hundred setups, or camera angles. The split-screen section had even more. We shipped it off to the optical house to combine the halves of the screen into a single piece of film so it could be projected.

We screened the film for a group of Brian's friends and for the studio. When you show a rough cut to a group of people and ask them for criticism, they will, in trying to be helpful, be critical. If they all seize on different points, you can safely assume that they are each responding to a personal idiosyncrasy. If they all give the same note, though, you have a problem.

In this case, the overwhelming response was that people didn't like the split screens. They felt it took them out of the movie, just at the moment when they were most involved. Split screen can be interesting, but it's not emotionally affecting.

At this point, Brian had had enough. "I don't care anymore! Cut it however you want!" he said to me.

I went back and looked at all the footage again. I picked out all the shots I could find that would work in full screen and cut them in. The rest could only be used in split screen, so I left those alone. The final result is a mixture of full and split screens that is actually pleasing. The action doesn't get bogged down in one style or the other. Or perhaps I am simply making a virtue out of a necessity.

———————

Brian has based much of his approach to shooting films on the point of view (POV) shot: the camera shows what a character is seeing from his or her particular vantage point. In *Carrie*, this principle was essential. Carrie was able to move objects or people through the power of her mind. Communicating this cinematically meant extensive reliance on POVs.

CU Carrie: She looks intently at something offscreen left. Her eyes flick to the right.

Cut to: A knife suddenly leaping out of frame left.

Cut to: That knife flying right to left through the air.

Cut to: The knife embeds itself in the body of the murderous Margaret White.

The grammar is intuitively understood. *Post hoc, ergo propter hoc.* First this, then that; therefore, this *caused* that. It is a logical fallacy: The rooster crows immediately before sunrise; therefore, the rooster causes the sun to rise. Or the drunk who kicks a lamppost at the precise moment of a citywide blackout and thinks he caused it. Obviously not true. But it works in movies. Carrie caused the knife to fly and directed its flight.

When that scene was shot, many different kitchen utensils were filmed leaping out of frame, pulled by an unseen monofilament, followed by a separate shot of each one flying through the air, again along a monofilament. For the second shot, each utensil was filmed once flying straight and then a second time tumbling end-over-end. I used the tumbling version only once, as a capper. Audiences howled appreciatively every time we screened it.

The split-screen sequence at the prom, however, got us into trouble. You will perhaps have noticed in the description of the sequence above, Carrie looks left to right, but the knife moves the opposite way. This is because the shots are reverse angles. In one case, the camera is pointed one way; in the other the camera is pointed 180 degrees in the opposite direction. It is like someone with binoculars watching a horse race coming down the stretch: if we look at the horses, they are running left to right on the screen; if we cut to the person in the stands, his gaze (following the horses) moves right to left.

In the prom scene, the split screen is introduced only after the blood has been dumped on Carrie. Because Brian had shot Carrie looking right to left, we placed Carrie on the right side of the split screen, with the left side showing what she was doing. Carrie looked sharply off to the left three times, and we intercut three shots of doors slamming shut, sealing the gym. Looking to the left posed no problem, but when she looked off to the right, she was looking off screen, which was confusing. Our solution was to have Carrie's close-up, on the right side of the screen, slide across the screen to the left side, so that when she did look right, her gaze would be directed correctly, in this case at the overhead lights exploding.

During the editing of *Carrie*, Brian was invited to show his previous film, *Obsession*, at the Naples Film Festival. Before he left for Italy, he instructed

me that no one was to screen *Carrie* until he got back. I presumed the studio had consented. A couple of hours after his plane left the ground, though, my assistant got a phone call from someone at the studio asking us to deliver the print across the street to United Artists' offices so that one of their executives could run the picture. "What should I tell him?" he asked.

"Tell him no," I answered.

He delivered my reply. Some time went by. The phone rang again. "Paul?"

"Yes?"

"This is Paul Monash."

"Hi, Paul."

"I am the producer of the film, and I am ordering you to deliver that print right now, do you understand?"

"Yes, Paul, but I can't do that. Brian left me strict instructions that the film not be screened while he's away."

"If you don't deliver that print right now, I am going to fire you and your crew, do you understand?"

"Yes, I understand." Pause.

"Are you going to do it?" he asked.

"No," I replied.

"OK, you're fired." I got off the phone and turned to my crew.

"We've been fired," I said. I was a little unnerved, but I trusted that Brian would set things straight.

I started trying to reach Brian in Naples. By this time, he should have landed. This was before cell phones, so it was a little complicated, but I finally did get hold of him. I told him what had happened.

"What should we do?" I asked.

"Well, you've been fired. Go home."

The implication was that it was really nothing to worry about. So we went home. We essentially had been given the rest of the day off. The next day, I got a call from Brian.

"Go back to work," he said. "You've been rehired."

I don't know exactly what transpired, but we were left alone after that. But that was not to be the end of the tension between Brian and his producer.

During the cutting of *Carrie*, my wife Jane and I were having dinner at the home of writer Jay Cocks and actress Verna Bloom. We had met through Brian when Jay was the movie critic at *Time* magazine, and he appeared as an extra in Brian's movie *Sisters*. He was friendly with many people in the business, including Scorsese, Spielberg, and Lucas, and had been instrumental in helping Brian get permission to film in the actual *Time* offices. He no longer reviewed films and was pursuing a career as a screenwriter.

Jay and Verna had just returned from England, where they had visited the set of *Star Wars*, and brought with them a book of production stills from the movie. I looked through it in awe. I stared at these fabulous images—what I now know to be the Wookiee, the droids, the Jawas, the sandcrawler, the stormtroopers, the desert landscape—and although the stills were in black and white, I could sense that the picture was special. When we went home that evening, I turned to Jane and said, "You know, it's very nice that George wants to work with me someday, but I really wish it could have been *this* picture."

Around this time, Steven Spielberg was prepping *Close Encounters of the Third Kind*. His editor on *Jaws*, Verna Fields, had taken a job as an executive at Universal, and he was looking for someone to take her place. He called me, but unfortunately he was starting in the spring, and as I would still be working on *Carrie*, I was unavailable. He then hired Michael Kahn, who went on to cut almost all of Steven's subsequent films, with the notable exception of *E.T.*, which Carol Littleton edited. Michael won three Oscars, for *Raiders of the Lost Ark*, *Schindler's List*, and *Saving Private Ryan*. In life, as in movies, timing is everything.

After the death of Bernard Herrmann, who had written the score for *Sisters* and *Obsession*, Brian was without a composer for *Carrie*. Many people wanted the job, as Brian had already established a style in which long passages in his films were dialogue-free, and this gave composers a great canvas to display their art.

It was Jay Cocks who came up with the composer for *Carrie*. His name was Pino Donaggio, and he had written the score to *Don't Look Now*, a psychological thriller directed by Nicholas Roeg and filmed in Venice. Pino was Venetian and had enjoyed a large measure of fame in Italy as a singer-songwriter. He was best known for his song "You Don't Have to Say You Love Me," made famous by Dusty Springfield and covered by Elvis as well. Pino would break into this melody at the drop of a hat. He was a charming man who spoke practically no English, but I spoke some Italian, having studied it in college. Brian decided to hire him, and I was dragooned into being the interpreter, although Brian found a way to communicate with Pino without a common language. In the spotting, when Brian wanted to build suspense, he would turn to Pino.

"Pino!" he would say, gesturing broadly as he sang, "*Dunh*-tunh *dunh-*tunh!" then turn to me and say, "Tell him."

And I would translate: "Pino! *Dunh*-tunh *dunh*-tunh!"

Pino got it. He turned out to be a good choice for the picture. His music warmed up the sentimental scenes, underscoring Carrie's vulnerability. He also wrote a song for the prom. Most important, he would help supply some of the jolts Brian had planned.

Brian and I had gone to see *Deliverance* together a couple of years previously, and when we came out of the theater, Brian said, "How about that arm coming up out of the water at the end, holding the rifle? What a great idea, but it really missed. I could do it much better." That was the inspiration for the jump scare at the end of *Carrie*, when her hand comes shooting out of the grave and grabs Sue Snell's arm.

When I was cutting the temp track for the picture, which would be a guide for what we wanted from Pino, I laid in Albinoni's Adagio for Organ and Strings during the slow-motion walk to the grave. This set up the audience for the shock. As Sue kneels down to lay a bouquet of flowers at the base of a cross, Carrie's arm comes shooting out of the ground. I cut abruptly to the main title theme from *Sisters*, which begins with an anvil strike. By making the cut in a rhythmically inappropriate place relative to the outgoing slow piece, and turning up the volume, the scare was tremendous.

Brian wanted Pino to faithfully reproduce the effect, down to the anvil, and Pino delivered. The screening room at MGM in New York has seats whose backs are sprung and recline deeply. Whenever we screened the picture there, every seat in the room would simultaneously shoot backward as the audience reflexively recoiled violently. Brian and I, sitting in the back, would watch with glee.

Many times I have lost arguments in the cutting room, and there is almost always one moment or another that I wish were cut differently. But *Carrie* is an exception. If I could change anything I wanted, I wouldn't touch a frame of it. The final cut represented exactly what I believed was the best version of the film. Seen today, when movies regularly run two hours or more, it is impressively simple and concise.

By the time we had locked the cut of *Carrie*, George Lucas had finished shooting *Star Wars*. He and Marcia were on their way back to California from the UK and stopped off for a few days in New York. George was a bit demoralized. The shoot had been very difficult for him, and he had even checked into the hospital at one point with chest pains, thinking he was having a heart attack. They turned out to be only anxiety attacks, but they took their toll on him emotionally. In addition, he was unhappy with his UK editor, a solid and experienced pro. He never got the spirit of the piece and apparently made his scorn for the project known. George was very unhappy with the first cut and decided to replace him at the end of principal photography.

Brian screened *Carrie* for him and Marcia. They loved it, made no suggestions for changes, and flew off to the West Coast to begin post-production on their picture. About two weeks later, I got a phone call from Marcia.

"Paul, I know you are just about finished with *Carrie*. How would you like to come out and help us edit *Star Wars* when you are done?" she asked.

Would I! But the timing! My wife Jane had just become pregnant with our first child. "I have to talk to my wife and get her OK."

I was thrilled, but a little apprehensive too. How would Jane take this news? I told Brian about my conversation with Marcia. "What? You didn't accept? Are you crazy?"

He grabbed the phone and called Marcia right back. "Marcia? It's Brian. He'll do it." He told her how much I was making on *Carrie*. "Can you pay him that?" he asked. "OK, then, it's all set."

He hung up and turned to me. "You don't tell her your problems. She doesn't need that. Just work it out."

I raced home to tell Jane. "Honey, I've gotten a great job offer, but it means having to go away. Do you remember that book of stills we saw at Jay and Verna's? Well, George Lucas wants me to come on the film."

Jane gazed at me and without hesitating said, "Do it!"

I called the next day, and it was agreed I would begin work as soon as *Carrie* was in the can, around the end of September 1976.

We set about finishing our film. We finished mixing the picture in New York and went out to L.A. to oversee the color corrections in the answer print, the first seamless print made from the cut negative. I moved into a room at the Chateau Marmont, a Hollywood landmark where John Belushi from the original cast of *Saturday Night Live* was to die of a drug overdose years later.

While I was staying at the Chateau, George Lucas had a copy of his script sent to me. It was titled "The Adventures of Luke Starkiller as taken from the 'Journal of the Whills'" by George Lucas, and then "(Saga I) *Star Wars*." It was the revised fourth draft. I read it and frankly didn't quite know what to make of it. The pages were filled with words like *Wookiee*, *Jawas*, *Jedi knights*, *TIE fighters*, X- and *Y-wings*, and so forth. It was impossible to imagine these things, but I had seen those production stills and was excited at the prospect of working on the film.

George's office called and asked me to meet him at Industrial Light & Magic (ILM), a special effects company he had opened to produce the effects shots for the film. ILM was located in an industrial warehouse in Van Nuys. When I got there, George greeted me and gave me a tour. He showed me the motion control camera and the tracks on which it traveled. I had never seen such a thing before. He explained that a computer memorized the movement of the camera so that the precise movement could be repeated exactly, again and again. This was necessary to photograph different models and combine them into a single shot.

The computer data was stored on punched paper tape, which was then state of the art. He showed me the model shop, where a crew was busy

constructing the various spacecraft for the picture. There was an enormous pile of boxes of model airplanes and warships that they had cannibalized to make all the intergalactic cruisers and X- and Y-wing fighters, as well as the *Millennium Falcon*. He showed me the star field that was used as background in all the space shots. Then we went through a glass-paneled door into a small air lock. As we stood on a metal grille, a large vacuum cleaner started noisily under our feet, sucking all the dust off the soles of our shoes. After a few seconds, the motor died down, and we passed through a second door into the optical department.

In the film era, optical effects were achieved by rephotographing original negative, either with mattes or through filters and lenses, with an aerial head, which permitted the image to be enlarged or reduced, tilted or reversed, or other elements to be superimposed, and various other tricks. The result of this rephotographing, however, was a loss of quality, in which the sharpness of the original negative was greatly reduced. To counter this, George had decided to shoot all the effects in a larger film format called VistaVision. It had been developed in the 1950s, when movie studios were competing for audiences with television. The idea was for theaters to project an image that was bigger, wider, and sharper than ever, in contrast to the small screen. In VistaVision, each frame was eight perfs (perforations) wide, and the frames were side by side. In standard 35 mm film, the frames are stacked one above the other and are only four perfs high. The result is that each frame of a VistaVision negative is much sharper. When the optical process we were using degraded the image, the resulting quality, theoretically, would be very close to the look of standard four-perf original.

The studios had abandoned the format some years before due to the high cost of shooting pictures this way. VistaVision required twice as much footage, on top of which the dailies would have to be reduced to four-perf just so the editors could cut it using their regular Moviolas and splicers. The Moviola was the workhorse standard editing tool of the industry even before sound came in. Originally intended as a home movie projector, it was named after the Victrola, the early record player. Too expensive for home use, it caught on with film editors. George wanted to revive VistaVision, only to discover that there were no surviving compatible optical printers. His team, headed by John Dykstra, had

to build new ones so that they could shoot the models in the eight-perf format, preserving the quality he hoped for.

I was awed by the high-techness and cutting edge–ness of it all. I had been cutting 16 mm just a couple of years earlier! This was a whole new ball game for me. George suggested we go get something to eat at the nearby Hamburger Hamlet on Van Nuys Boulevard. He ordered a cheeseburger and a glass of milk, and we started to get to know each other a bit. We agreed that I would come up to San Anselmo in Marin County, where the editing rooms were, as soon as I completed my work on *Carrie*.

After a while, I felt compelled to say something that was weighing on me a bit. "You know, George," I began, "I have a confession to make to you."

"What's that?" he asked.

"Well, I feel it's only fair to tell you that I've never worked on anything this big," I said.

"Oh, don't worry about that," he said. "No one ever has."

I laughed, relieved.

"Film is film," he went on. "You'll be fine."

I was grateful for his vote of confidence.

"By the way," he asked, "can you cut on a moviola? Is that a problem?"

"No problem at all," I answered. "That'll be fine."

I had experience cutting on a Moviola. I had cut De Palma's *Hi, Mom!* on one, but starting with *Sisters*, except when I was on location, I had been cutting on a German flatbed machine called a Steenbeck, in which the film lies flat, like on a reel-to-reel tape recorder. Steenbecks had a couple of significant advantages over the workhorse Moviola. They were able to fast forward and rewind at high speed, and they were much gentler on the workprint, which had to endure repeated playing. With Moviolas, there was a higher risk of scratching the film and breaking or tearing it. Repairing the workprint was often time consuming, and sometimes even impossible, which meant reprinting the film, an expense to be avoided. Yet Steenbecks hadn't really caught on in features, although they were my machines of choice.

On Steenbecks, the control was a joystick that was intuitively easy to use. Push it to the right to go forward, to the left to go back. Steenbecks' larger screens made viewing by both the director and the editor

possible without their having to stand cheek to cheek over the five-inch-wide Moviola screen.

KEM Editing Systems, another German company, also made a flatbed, but the controls were buttons. While Steenbecks were more common in the East, "Kems" had taken root out West, although there were many editors on both coasts who swore by Moviolas and continued to do so until the advent of true computerized editing in the mid-1990s. When George asked me if I could cut on a Moviola, I wanted to say that I would prefer a Steenbeck, but I wasn't about to make that a deal-breaker.

———————

Meanwhile, on *Carrie*, the fireworks were about to begin again. Merrit Malloy Monash, Paul's wife, had written lyrics for a song Pino had composed for the prom scene. A demo was recorded using a studio singer and mixed into the soundtrack. Paul Monash decided that the song should appear under the main title too and set about hiring a well-known singer to perform it in the film. Brian was opposed to the idea of using a song under the credits at the head of the film. The title sequence was a series of slow-motion shots in the high school girls' locker room. The camera tracked slowly through the room, passing beautiful young girls in various states of undress, including full frontal nudity. In fact, just as my name appears on the screen, the camera reveals Nancy Allen, completely naked, with a big smile on her face, bouncing in slo-mo toward camera. Many people have asked me why I didn't get a credit on the film. I resolved I would never again get upstaged by full frontal nudity if I could help it.

The titles continue as the camera pushes slowly into the stall where Carrie is showering after the volleyball game, until she suddenly discovers that she has gotten her period. Brian felt that it would be inappropriate to have a song over this scene. It was a convention of studio pictures of the 1950s and early '60s, and he preferred using the score.

Monash arranged for singer Minnie Riperton, who had a phenomenal five-octave range and a big hit with "Lovin' You," to see the picture. A screening was arranged for her at Deluxe, the film lab where we were working. Brian and I were waiting when Monash got there with Ms. Riperton. Brian addressed him.

"Paul, I am not putting this song under the main title, I'm telling you that right now." A huge row broke out.

"I am the producer of this film, and if you don't put this song in at the beginning, I will tear up the release for the lyrics."

Soon they were yelling at each other in anger, and poor Minnie fled the room in terror, which was probably exactly what Brian had hoped to achieve.

Monash's threat meant that the picture couldn't be released as it was. If we didn't have the signed rights to the lyrics, we couldn't use them, and the prom scene would have to be remixed. Brian told me to arrange to have the melody played by an instrument instead of sung. I called our music contractor in New York, who immediately lined up a saxophonist and a flutist to go into a studio and give us two versions without a singer. Brian asked Jay Cocks to sit in on the session to make sure it sounded OK to him.

Meanwhile, reports of the horrendous fight at the lab had gotten back to the studio, and Brian, Monash and I were all invited to Mike Medavoy's office to talk it over. Mike was then head of production at United Artists. In the historic offices in the Thalberg Building on the MGM lot (now Sony), first Monash, then Brian, laid out his argument for and against using the song under the main titles. Mike listened to them both and then turned to me. "What do you think?" he asked.

This is rich, I thought. *I am the lowest-ranking person in the room and he is asking me to settle the dispute.* "I think lyrics are out of place in that scene," I said.

"Why?" Mike asked.

"Because it's too much. You have the backgrounds, you have the titles, and adding on another layer of text would be more than anyone could absorb."

Mike looked at me. "How do you know? Oh, never mind," he interrupted himself, "you're just going to support your director, aren't you?"

"I really believe what I just said, Mike," I replied.

Which was true. But he was right too. It would have been impossible for me not to support Brian at that moment. When Monash had fired me, Brian got me rehired. I owed him my loyalty. Medavoy finally got Monash to relent, and he agreed to let Brian use the sung version in the prom scene.

It was Friday evening, and a celebration was in order. Brian had been invited out to dinner by his then agent, the redoubtable and much in demand Sue Mengers. He asked me to join them. Sue's other guests that evening were Marty Scorsese and Steven Spielberg, both of whom I had almost worked for. We were all in high spirits, and everybody wished me good luck on *Star Wars*.

Saturday morning, Brian and I met at MGM to listen to the alternate lyricless versions of the prom song, one played by a sax, one by a flute. Either way, it sounded like Muzak. The song stayed in, and *Carrie* was finished.

"Well, Brian," I said, "I have a noon flight to San Francisco. Thanks for everything, including negotiating my next deal."

"I think I'll go with you," Brian said suddenly. "I'll just drop in on old George. Come on, I know a shortcut to the airport, just follow me."

We each jumped into our cars and took off. Sure enough, we got lost, and by the time Brian parked and I had returned my rent-a-car, we were running to the gate. We got there just as they were closing the door on the plane, dashed in, and dropped into our seats.

My greatest adventure—one that would profoundly alter the course of my life—was just beginning.

2

Ten Years Earlier

I HAD ALWAYS LOVED GOING TO THE MOVIES, but I never imagined working in the industry. It never even occurred to me to go to film school. I got my BA at Columbia University in New York City in 1966, majoring in art history, and in my senior year applied to and was accepted at the Columbia School of Architecture. There was just one problem. I didn't have enough points to graduate at the end of the academic year. I was facing the prospect of having to spend my summer in New York City taking a couple more courses to get the required number of credits. Fortunately, I heard about a Columbia summer program in Paris. I rushed over to the French Department and applied. It was the last day to apply, but I got in. I was elated. Instead of a summer in steamy, smelly New York, I was off to the city of my childhood for six weeks. My parents had moved the family to Paris for four years when I was three, and it has always felt like home to me.

Students in the summer program were housed at Reid Hall, 4 rue de Chevreuse, in the Sixième arrondissement, near the metro stop Vavin. My room was upstairs, with a wall of tall greenhouse-style windows facing north. There were two one-and-a-half-hour classes a day, one in conversation and the other in French culture and literature. We were free starting at noon every day, and that's when I discovered that the French were passionate about American movies. Art houses all over the left bank were showing Hollywood movies from the 1930s, '40s, and '50s. There was a Howard Hawks festival in one theater. I'd sort of heard of him, but I wasn't

sure who he was. He was a director? What does a director do, anyway? There was a Raoul Walsh festival in another. Who were these people? I went to see *The Enforcer*, and a title card before the movie informed me that although the directing credit on screen would read DIRECTED BY BRETAIGNE WINDUST, the actual, uncredited director was "the Great Raoul Walsh himself." I'd never heard of either one, but the fact that the French regarded Hollywood directors with reverence was a revelation to me.

At the Cinémathèque next to the Trocadéro, there was an Orson Welles festival one week. On Monday night, I went to see *Citizen Kane*. It was in English, without subtitles, and the theater was packed. I was struck by the fact that since it was highly unlikely everyone there spoke English, they came to study the cinematography, the mise-en-scène, and the editing and to hear the music. These were movie buffs of an order I hadn't met before. In New York, I had often been to art and revival houses on the Upper West Side, the New Yorker and the Thalia. But they were more likely to be showing French films than old Hollywood pictures. I had heard of but knew nothing about *Citizen Kane*, and when the secret of Rosebud was revealed at the end, I was annihilated. It was the perfect way to see the picture.

I went back on Tuesday and saw *The Magnificent Ambersons*. On Wednesday, I saw *The Lady from Shanghai*, on Thursday was *Touch of Evil*, and on Friday they were showing *Othello*. Welles himself was going to be there, and you couldn't get near the place. Those films sparked something in me that would change my life.

In the fall, I went back to New York as planned and began my studies at the School of Architecture. A couple of months into my first semester there, I turned twenty-one and decided I had had it with school. A friend of mine, a fellow Columbia alumnus, was cutting a documentary in his apartment on West End Avenue in New York. I visited him and was intrigued by the tools he was using. Especially striking was the Moviola. It was the first time I had ever seen one.

This was years before the invention of the Betamax, the first videotape recorder for consumers. In the mid-1960s, there were only two ways for an average person to see a moving image: either in a movie house or live on TV. And it always played at sound speed, never rewound, never fast-forwarded. Here in front of me was a machine that enabled you to stop

on a frame! And go back! This was astounding. The rest of the equipment was also cool. Rewinds, splicers, synchronizers and squawk boxes, trim bins, rolls of colored tape, colored markers, razors, rulers with frames marked on them—they were all things I wanted to get my hands on. I had always liked working with my hands, so this was part of the appeal. I decided then and there I wanted to try to get into editing, without really knowing what it was.

When I was nine, one of our neighbors worked at 20th Century Fox in New York and was able to borrow 16 mm prints over the weekends. Another friend of the family had given us a 16 mm projector, with sound. I would set up the screen, the speaker, and the projector. I learned how to carefully thread the film, making sure the loops were just right, and we would watch movies at home. It's funny to reflect that this childhood pastime became my life's work. I have been handling film and threading it over sprockets from an early age.

A dear friend of mine from childhood, Tom Bellfort, who would one day win an Oscar for his sound work on *Titanic* and an Emmy for *The Pacific*, had an uncle who was the head of a small industrial film company called Dynamic Films. He offered me a job there at sixty-five dollars a week, running errands and manning the shipping room. Dynamic had about half a dozen employees. They would film stock car races, hiring as many as ten or twelve cinematographers for the event, and turn the footage over to three editors who worked in the home office on Park Avenue. They would cut a twenty-minute version of the race and then splice on a promotion for various auto products at the end—AC spark plugs, Goodyear tires, STP fuel additives, or whatever—and sell them to the respective companies for showing at their annual sales conventions.

I was given a VW bug to drive over to the West Side, where the film labs were. My job was to deliver workprints to the negative cutter, Seymour Smilowitz, and pick up cut negative rolls from him and take them to the lab for printing. There I would pick up prints and bring them back to the office, where I was to mount them on reels. I didn't know what any of this was, but it was all exciting. Not the least of it was getting to drive

the VW. After just a week or so, Seymour asked me if I was interested in coming to work for him. He was looking for someone to train, with no previous experience required.

I asked one of the editors at the office what he thought. "Well, you'll be handling film instead of packages," he pointed out.

The salary was the same, so after only two weeks at Dynamic Films, I gave my first benefactor two weeks' notice and went to work for Seymour.

His workplace was in the DuArt Building on West Fifty-Fifth Street, just off Eighth Avenue. Sy, as he preferred to be called, was a screamer. Whenever something went wrong, he would yell. I hated working for him, although as long as I was learning, it was worth it. I learned a lot of technical things from him: how to match negative (16 mm exclusively), how to prepare film for printing, and how to use a pedal-operated hot splicer. Cutting negative is a difficult job; even though it's tedious, you have to pay strict attention to what you are doing. You just can't make mistakes. These were skills that were initially interesting, but once I had learned them, the work became deadly boring.

In addition to his negative cutting business, Seymour had a deal with a small-time producer who had a show called *TV Twin Double*. It was based on trotting races and was used as a supermarket sales promotion in upstate New York. The show was totally forgettable, but it was how I learned to thread a Moviola. Seymour also let me lay in some narration, a rudimentary task, but interesting if you've never done it before. After six months working for him, he screamed at me one too many times, and I quit.

My mother had recently met a young editor at an art gallery opening and gave him my name. He was working as a trailer editor and was looking for an assistant. I met him and told him about my experience, and he offered me the job. His name was Chuck Workman, and he was working for a boutique movie marketing company called FLP. He later gained fame by cutting montages for the Academy Awards shows; it was Chuck who directed (edited) the Oscar-winning short film *Precious Images*, a subliminally quick-cut montage of the greatest moments from all the great pictures Hollywood had ever made. Back then, he had been hired to cut trailers by the eponymous Floyd L. Peterson (FLP), who had started as a radio announcer in Minneapolis. While Floyd had

a flamboyant personality, he was married to an intelligent and demure woman from Queens named Eileen and had formed a company producing radio spots for MGM and United Artists with fellow Minnesotan Don LaFontaine. Don later became legendary as the voice narrating almost every trailer made for decades. His signature line, delivered in his smooth baritone voice, was "In a world where . . ." That was Don.

He and Floyd decided to expand their business into TV spots and trailers and had hired Chuck as their film guy. Supervising the Spanish-language version of the spots was a pudgy, bespectacled man named Justo Lacomba, who delighted in making me uncomfortable. He really was charming, though. One morning he said to me in his heavy Cuban accent, rolling his *r*'s, "How are you today, my ex-friend?"

"Why ex-friend, Justo?" I replied, biting.

He leaned close to me. "Because you are now my luff!"

Chuck was working on a promotion for a new Richard Lester film, *How I Won the War*, starring Michael Crawford and John Lennon. He had put together a piece focused on the director, using moments from Lester's other films, *A Hard Day's Night*, *The Knack*, *Help!*, and *A Funny Thing Happened on the Way to the Forum*. One of my first tasks was to go to the lab and inspect the materials from the various films he had ordered from the studio to make sure we had everything and that it was all set for printing. Although I had no experience with 35 mm film, I noticed that the frame line was inconsistent and that some of the pieces were out of frame. I came back and asked Chuck if it was important for them to be in frame.

"YES!" he screamed. "Get back there and fix it!"

That was when I learned that Chuck was a screamer too. I worked as his assistant for a few months and was regularly subjected to his temper tantrums. When he finished working in the editing room, it looked like a gale had swept through it, with unlabeled trims all over the place. I, a neat freak, kept his house in order.

Floyd was a colorful character; tall and slim with blond hair that fell over his forehead, he would continually toss his head to get his hair out of his eyes, or he would sweep it back in a grand gesture. He had an announcer's voice and, like all radio personalities, was never at a loss for words. His father was a military man, and Floyd's life was an act of

rebellion. He snorted cocaine, smoked a lot of pot, and kept a bottle of Johnnie Walker in each cutting room. He would come in and give a speech about something or other, talking about his plans and dreams, reach down into the cabinet with the Scotch, take a swig out of the bottle, and whirl out.

On Floyd's thirty-third birthday, he turned to me. "Now I am the age of Christ," he said, raised his eyebrows at me, turned, and walked out of the room. Floyd was obeying a self-imposed rule. He always needed a good exit line. Sometimes if he came up with a good line, he would leave the room whether or not he had actually finished his business there.

Soon Chuck had more work than he could handle. I was given the task of turning out a shorter version of a featurette they had produced on the film *The Thomas Crown Affair*, starring Steve McQueen and Faye Dunaway. A featurette is a documentary about the making of a film. The original was ten minutes long, and they wanted one lasting three and a half minutes. The client, a woman at United Artists, liked it well enough that I was given one to cut from scratch, on the movie *Chitty Chitty Bang Bang*, with Dick Van Dyke. That was received well also, and from then on I was an editor, on and off.

Meanwhile, my brother, also named Chuck, was working at Universal in New York. His job was to scout young writing and directing talent, and among the young filmmakers who came to Universal looking for financing for new projects was Brian De Palma. Chuck invited me to join him and Brian at a lunch at Reuben's, the famous restaurant that invented the Reuben sandwich, now long since closed. Brian had just directed a picture called *Murder à la Mod*. It was 1967, and this play on words in the title was already behind the curve. The picture was Brian's second. He had codirected a first feature titled *The Wedding Party*, starring a very young Jill Clayburgh and an equally young Robert De Niro.

The lunch at Reuben's was jocular, and Brian exhibited a smart, acerbic sense of humor. When he made a humorous comment, his face would light up in an infectious grin. He wore a safari jacket with a belt and breast pockets with flaps, which became his standard uniform. Brian is five years older than I am, a fellow Columbia graduate, and he also wore a beard like mine. He was from Philadelphia, which gave us another connection, as both my parents were from there. He had two older brothers,

which fired in him a competitiveness I could relate to. In high school, he had built computers and won a regional science fair prize for a project called "An Analog Computer to Solve Differential Equations." His father was an orthopedic surgeon, and Brian had attended a number of his father's operations, which gave him a high tolerance for gore that was reflected in his films. He described witnessing gouts of blood shooting across the operating theater. As he became more and more adept at directing, his singular visual imagination enabled him to design intricate sequences with the complexity of Swiss watches, sequences I refer to as *set pieces*. He had a gruff demeanor, but he could also be very charming. As I learned later, with his big, expressive blue eyes, women found him extremely attractive. We would work together over decades, and no one had a more profound influence on me and my work. He encouraged me, supported and empowered me, and it was through his patronage that I would land the job on *Star Wars*.

Chuck and Brian then went on to cowrite a script about young people, loosely based on Jean-Luc Godard's *Masculin Féminin*. They pitched it to Universal but the studio passed, so Chuck resolved to produce the film himself. He raised $36,000 from family friends, and on his annual two-week vacation, he and Brian shot *Greetings*. Brian's editor on the film resigned, and he took over the cutting himself.

After Brian completed his cut of *Greetings*, Chuck made a deal with Sigma III to distribute the film. A trailer was now needed for it, and thanks to Chuck, I was given the assignment. I cut it after hours in Floyd's place. I used the title song, which went "Greetings, greetings, greetings, would you like to go away? Greetings, greetings, greetings, come and see me, don't delay. Spend a day or two with Uncle Sam." I would play a little bit of the song over a quick montage of silent images from the movie, then stop suddenly and cut to one of the comic lines of dialogue, then cut abruptly back to the song and more montage, and so forth. Chuck and Brian loved it.

I was running it late one night on a Moviola at work when I looked up and there was Floyd, who lived upstairs. "What's that?" he asked.

"It's a trailer I cut for my brother," I said.

"Is that one of our jobs?" he inquired.

I gulped. "No, they didn't have any money, so I did it for them on the side, Floyd."

"Let me see it," he said. I ran it for him. "Why aren't you doing work like that for us?" he asked. From then on, I was a full-time editor cutting trailers.

Greetings made a splash of sorts. It won the Silver Bear prize at the Berlin Film Festival and turned a profit because it cost so little to make. So Sigma III gave Brian and Chuck the money to do a sequel, to be called *Son of Greetings*. Chuck hadn't liked the way *Greetings* was cut and wanted to help me, so he asked Brian to hire me as the editor. Brian and I had hit it off, and he agreed. I decided to leave the world of advertising behind, said goodbye to FLP, and quit my steady job. At the age of twenty-three, I had become a freelancer.

3

My First Feature Film

HI, MOM! WAS MY FIRST FEATURE FILM. Originally titled *Son of Greetings*, the project was the sequel to *Greetings*, the story of three friends in New York facing the draft during the Vietnam War. In the sequel, one of them, now a veteran, returns from the war and becomes radicalized by the hypocrisy of the middle class back home.

The main character was played by Robert De Niro in his first starring role. The opening scene is all point-of-view shots, with a tenement superintendent (played by Charles Durning in his first film role) showing Bobby, as we all called him then, an apartment, an absolute pit of a place. Durning speaks to the camera, and Bobby's voice is heard off-camera.

The handheld camera swings around, viewing the decrepit apartment, including at one point a bathtub littered with cat droppings. "Can someone take that out?"

"Yeah, well, you can take it out," Durning mutters.

We don't actually see Bobby until he goes over to the window and pulls aside a curtain, revealing a perfect view of the rows of windows in a middle-class high-rise apartment house across the street. We finally cut to Bob.

"I'll take it!" he says, and the movie begins.

As I have written, Brian built his directorial style around the point of view. In his use of the film grammar, the POV is (almost) always sandwiched between two close-ups. Cut 1 (close-up): The actor looks. Cut 2

26

(POV): We see what he sees. Cut 3 (second close-up): The actor reacts to what he has just seen. It's a simple formula that puts the audience inside the actor's mind without the use of dialogue. This helps create a natural empathy with the character. It is part of what Brian calls "pure cinema" and is what he aspires to in his work. He has constructed long set pieces in many of his films around this technique, which draws on the audience's role as voyeur. Brian himself is fascinated by voyeurism: Bobby's character in *Hi, Mom!* chooses the apartment in order to carry out a project involving filming people unknowingly, through their windows.

"You've heard of pop art?" he asks. "Well, this is peep art!"

Normally movies are based on screenplays. *Hi, Mom!* was based on two or three pages of handwritten notes on yellow legal paper that Brian carried around with him. The movie interwove several different stories: Bobby and his "peep art" efforts, shot in 35 mm color; a revolutionary biracial experimental theater group, whose organizer and star was played to hilarious effect by Gerritt Graham and whose activities are the subject of a multipart documentary filmed in 16 mm black and white; and a bored housewife who is shooting a home movie in 8 mm color. All the characters live in Greenwich Village, and with all this filming going on they are constantly wandering in and out of each other's films. The structure was quite complex, and to make it work was more of a challenge than I ever realized, being utterly inexperienced at the time. Fortunately, I didn't know how little I knew.

Although I had edited a fair number of trailers, I had no credentials as a feature editor. That summer, in 1969, I had applied for a job on *Woodstock*, the film. The project had amassed miles of footage, uncatalogued, which needed syncing up with the soundtrack.

Editors in New York had just begun to move toward flatbed editing machines, primarily Steenbecks. The *Woodstock* producers had bought two or three Kems, the first ones in New York. With massive amounts of film, they were hiring three shifts of assistant editors working around the clock to get the syncing done so they could begin editing the movie. I was offered a job as an assistant editor syncing footage during the graveyard

shift, from midnight to eight in the morning. I considered myself an editor and turned it down.

Hi, Mom! began shortly after that, and the cutting room was located in a building on Broadway's Upper West Side, on Eightieth Street, above the well-known H&H bagel bakery. My brother Chuck had, in an expansive moment, signed a lease on an enormous space on the top floor, the same floor on which our father, who was a painter, had a studio. Unable to use all the space for other projects that he couldn't get off the ground at that time, Chuck offered some of the space to the producers of *Woodstock*, who were cutting across the street and were bursting out of their small offices. They moved into our suite, and Marty Scorsese and Thelma Schoonmaker, among others, were cutting in our space while I assembled *Hi, Mom!* It was a lively place.

As I put *Hi, Mom!* together, I realized that I had never cut dailies before, except for the featurettes, and I hadn't done too many of those. This was a different ball game, and although I was confident about taking it on, I really didn't know what I was doing. In fact, Brian's friend who was the first assistant director on the picture, Bruce Rubin, who later won an Oscar for his original screenplay for *Ghost*, came to the cutting room, and I showed him a little of what I was working on.

"You seem to be cutting in the middle of actions, instead of waiting for them to complete," he said.

The penny dropped, and suddenly I was armed with an extremely useful piece of information. It's astounding to realize now how little I knew.

The most memorable part of *Hi, Mom!* was an episode of the mock PBS documentary in which a white middle-class audience attends a performance of *Be Black, Baby!*, the avant-garde theater piece by the biracial revolutionary group. The white actors playing the attendees were given only the instruction to react to what was going on, as was the cameraman. The black actors and Gerritt Graham welcome the audience members and proceed to introduce them to the experience of being black in America. This progresses from putting on blackface and touching the cast's Afros to see what their hair feels like, to eating soul food, made deliberately disgusting. When they refuse to eat it, they are abused by screaming cast members. When they try to flee, they are trapped and confronted by the black cast posing as white racists, who call them the *n*-word, and they

wind up getting beaten. One unfortunate woman is raped. At this point the audience is truly terrified and calls the police. The policeman who shows up is a cast member as well (Bobby De Niro) and doesn't believe them because they are "black." They are expelled from the theater into the street. Outside, the documentary camera crew that has recorded all this abuse asks them how they liked the play, and the audience members all rave that the *New York Times* was right; it was just wonderful.

It's a harrowing set piece, in which the viewer isn't quite sure where the boundaries between fact and fiction lie, and much of its verisimilitude is due to the unrehearsed handheld camerawork, which gave the spontaneous feel of a real event. My experience cutting the little documentaries about the making of films came in handy, and I was pleased with the results, as was Brian.

Finally, I had put the whole picture together. It was time to screen it from beginning to end. The financing for the picture had come from the company that had released *Greetings*. The head of the company was Marty Ransohoff, a "big-time Hollywood producer," who I later learned had a reputation as a tough customer. Out of inexperience on all our parts, Marty was invited to watch the picture with us. Or maybe he insisted; I don't know. As we screened the film, it became obvious that there were some serious problems. First and foremost, it was way too long, almost two and a half hours. I had assumed that if all the individual scenes were well edited, this would mean the whole picture was well edited. Logical, right? This is not the case. It was an important lesson that I never forgot, although one I would have preferred to learn in private.

Ransohoff was furious. He raged about how bad it was. The only question he addressed to me was why the TV simulation looked the way it did. When I tried to describe the process we had used, he interrupted me. "It looks like shit!" he shouted.

I later learned that he was already suspicious of me, since I was Chuck's younger brother, and he thought Chuck was just padding the payroll with relatives. Chuck's wife Tina, now an important editor in her own right, had been my assistant for a short while before moving over to *Woodstock*. In any event, we got the picture down to ninety minutes, and I learned a lot about pace and structure. We had to toss out a lot of material that didn't work, and some that did, but as we tightened it

up and made stronger connections between related elements, the picture improved in its totality. *Hi, Mom!* was an important first lesson for me in the aesthetics of feature editing.

Upon completing *Hi, Mom!*, I was asked to cut the trailer for it. I moved to a small room at 1600 Broadway. This was the center of feature filmmaking in the city, and Dede Allen, the star editor in New York, cut all her pictures there. Her credits include *Bonnie and Clyde*, *Alice's Restaurant*, *Serpico*, *Slaughterhouse-Five*, *Dog Day Afternoon*, and many other classics.

I was installed in a single small room. The only telephone was a pay phone mounted on the wall, and I had to bring a handful of dimes to work to make calls. I was lonely, as well as tired of the material, and now forced to look at it all again in a new way—as material for a trailer. I struggled with it, and when I was done, I was exhausted, used up.

Hi, Mom! opened disastrously in the cavernous Loew's State Theatre. Once one of Times Square's giant first-run road-show houses, where *Ben-Hur* had premiered, it had recently been split in two. The balcony was separated from the main theater downstairs, and a screen installed at its foot. It still held perhaps a thousand people. In this forbidding, steeply raked amphitheater, *Hi, Mom!* played on opening night to thirty brave souls, all of whom were connected to the picture in some way. The release, which would best have started in some small art house and built on word of mouth, was a big bust.

I had been its editor, my own assistant for most of the time, its sound effects editor and music editor, and its trailer editor, all for the grand sum of $200 a week. I was profoundly disappointed. It was also the end of Brian's collaboration with my brother Chuck, who had visualized their partnership in somewhat more permanent terms. Brian went off to Hollywood to seek greater fame and fortune.

Disillusioned, I went to Mexico and then to Oregon with some friends and experimented with a countercultural lifestyle for a while. I quickly discovered that communal living was not for me, because people who said "What's mine is yours, and what's yours is mine" were usually destitute and took everything you had. One morning, as I was straining to break

hard-packed ground with a spade in our vegetable garden in Eugene, Oregon, a neighbor leaned over the fence and jokingly commented, "There must be an easier way to make a living!"

I thought *Hell, yeah!* and decided editing wasn't so awful after all. I broke free from the groupthink I was mired in and returned to New York. I was determined to get another opportunity to cut a feature film, no matter how long it took me.

It would be three years.

4

Back to Trailers

DURING THOSE THREE YEARS, I survived by cutting trailers. I made fifty copies of my résumé and walked around Midtown Manhattan, armed with the addresses of postproduction companies, going door to door, handing them out one by one. I made up another fifty and handed those out as well. I finally got a job for a fly-by-night company called Plaza Inc. This nondescript entity was the brainchild of Sig Shore, a vulgarian entrepreneur, who had made a deal with some Italian distributor for the American theatrical rights to a bunch of genre films. The first of these was *Detective Belli*, starring Franco Nero. The films had been dubbed into English, and I was to cut the trailers for them. I was set up in the back room of an office belonging to a negative cutter named Charlie Diana. His company was named CD Films, or as I thought of it, Seedy Films. They were located on a high floor of a building at 630 Ninth Avenue called the Film Center. It contained a film laboratory on another floor, and there were a number of related businesses sprinkled around the building.

At CD Films, cutting the trailer for *Detective Belli*, I felt I was truly in the lower depths of the film business in New York. Charlie, the proprietor, a man in his sixties, suffered from muscle weakness in his eyelids. Unable to afford an operation to remedy the problem, he wore a small Band-Aid running from each eyelid up onto his forehead, keeping his eyes open beneath his Coke bottle–thick glasses. His prescription was one that

magnified the wearer's eyes, and the combination of that effect with the Band-Aids holding his eyelids up gave him a curious look.

His son worked there, and Charlie Jr. was always involved in small scams. I was forever being offered a deal on a set of kitchen knives, or on Italian shoes, suspiciously in only one or two sizes. In the mornings when I got in, they would be screening prints of porn films the lab had run off during the night. I was in my back room, cutting on a Moviola that barely worked. When I wanted to back up, I had to reach out and wind the reel by hand, because the reverse take-up mechanism was broken. The place was filthy with dust, and the metal shelves were crammed with cans and boxes left over from years past. My room was so narrow I could touch both walls at once.

The negative for *Detective Belli* was to be made in a lab in L.A. from materials supplied by the Italian distributor, and I was dispatched there in late 1971 to make sure everything was copacetic. Brian De Palma was also in Hollywood then, editing his picture *Get to Know Your Rabbit*. It was Brian's first studio picture, and he hadn't been able to hire me to work on it because I wasn't even in the New York union, not to mention L.A.'s.

I called him to say I was in town. He invited me to come see a rough cut of his movie, which he was screening that afternoon out at Warner Bros. I went and watched the picture with Brian, his editor, and his producer. When the house lights went up, all eyes turned to me, since mine were the only fresh eyes in the room. The producer asked me what I thought, and I tentatively offered that there was one scene in particular I thought they could do without, a scene in which Tommy Smothers is up in a tree.

As soon as the words were out of my mouth, a silence fell on the room, and I could feel a kind of tension. Brian thanked me, and we made a date to get together for dinner later. He explained to me that night that the scene I had mentioned had in fact been the subject of a bitter struggle between Brian and the producers, Brian wanting it out, them wanting it in. They wrongly assumed that Brian had told me what to say. I went on to give Brian a more detailed list of suggestions, which hadn't seemed appropriate to offer in front of anyone else.

I returned to New York and shortly thereafter left Sig Shore's employ.

I soon found work at Calliope Films, which was Chuck Workman's new company. Chuck had gone into business for himself, cutting trailers

and cheapo commercials. Among the silliest things I ever cut was a commercial for a collection called *Great Italian Love Songs*. Chuck had filmed it at an Italianate villa in Florida with Louis Prima as the announcer. Louis had a hard time, as it had been a windy day. At the start of each take, he would be sitting with one hand holding his toupee on. On "action!" he would bring his hand down and start his spiel. He would end in his inimitable style with "Listen to your goombah, da chief!"

The commercial played endlessly on late-night TV and kicked off a whole genre of spots for record anthologies, which were just coming in.

I was grateful for the work, as cutting anything is better than nothing. Even in those small films, you had to start with looking at dailies, making your selections, and cutting them together with an eye to pace and smoothness; follow up with sound, music, and titles; mix; and go to answer print. These are the steps necessary in the biggest of pictures as well, and I always encourage assistants to cut anything they can possibly get their hands on. The process is the same and the practice invaluable.

5

My Next Big Break: Benny

BRIAN WOUND UP GETTING FIRED FROM *Get to Know Your Rabbit*. He got himself into a political struggle and was ousted. He came back to New York to try to pull things together, but it was a devastating experience, and it left him with a lifelong distrust of studio executives. I was working at Calliope when I heard that Brian was going to direct a picture for Ed Pressman, an independent producer whose family owned Pressman Toy Company. Ed was prematurely bald, wore wire-rimmed spectacles, and spoke in a soft, halting voice. He dressed better than most of us did in those days and had an old-fashioned air about him, wearing felt fedoras and seeming older than he actually was.

The film, *Sisters*, was about a pair of formerly conjoined twins who are involved in a murder. They were both played by Margot Kidder, who would later play Lois Lane opposite Christopher Reeve in the *Superman* films. Brian told me he planned to edit it himself. He had just cut the picture he had shot in the interim after *Hi, Mom!* It was a film of an avant-garde theatre adaptation of the Greek play *The Bacchae* called *Dionysus in '69*, staged by the Performance Group and involving a lot of nudity. Brian shot it in 16 mm black and white and put the whole thing together in split screen, from beginning to end. For *Sisters*, he planned to do all the editing once the shooting was over. Luck intervened for me, however, when Fox announced the start of production on a project called *The Other*, which also involved twins. Ed was afraid we would be upstaged if *Sisters*

came out later, so Brian was forced to hire an editor to cut while he was in production. He called me.

After the *Greetings* trailer and *Hi, Mom!*, *Sisters* was my third big break.

In a way, it wasn't all that surprising that Brian had wanted to cut *Sisters* himself. He had started out editing his own films, and when I cut *Hi, Mom!* it was clear how little experience I had. Brian is extremely intelligent and very sure of himself. Although he and I had bonded through our work together, I knew he was also very unsentimental.

In any event, Brian became very supportive of me, and as our relationship grew over the years, I felt myself in a partnership with him—in a subsidiary role, of course, but free to express my ideas and just be myself. We were very close for a long time and socialized together, sharing many thousand lunches.

Brian was very jovial in those days, and the life of the party. He had a big personality and became friends with other young directors, such as Lucas, Scorsese, and Spielberg. He was very inclusive and always praised me as much as he teased me, loving to give me the needle at times.

Brian was a total believer in Hitchcock's approach to cinema—namely, telling the story by visual means as much as possible. He was accused of stealing from Hitchcock at the outset, but as time went by he developed a style distinctly his own, no matter who shot, edited, or acted in his films. No one moved the camera in more interesting ways. His films always contained complicated visual set pieces that were fabulously fun to edit. Eventually we worked on eleven pictures together.

Brian was already fascinated by split screens; he loved the juxtaposition of two images alongside each other and the resulting effect. He had employed it throughout *Dionysus*, and he was excited about the technique, so he decided to use it in *Sisters*, introducing it at the moment of the murder. It happens as the unsuspecting young man who has dated one of the twins approaches the sleeping figure of Margot with a surprise birthday cake.

With startling ferocity, she leaps unexpectedly at him and stabs him repeatedly with the large carving knife he had brought from the kitchen to cut the cake. The most horrific moment, the coup de grace, is when she stabs him in his open mouth.

The effect was achieved by having the actual thrust into his mouth played in a shadow shot on the wall, then cutting to a close-up of the knife as it cut through a small sack of makeup blood next to the actor's mouth, and finally back to another shot of the wall with a spray of blood hitting it. There were three takes of the final shot: The first one looked as if the special effects man had taken a small artist's brush and spattered red paint on the wall. This was barely visible on film. The second take looked as if he had used a three-inch house painter's brush, which left a large constellation of droplets on the wall. The third take looked as if he had just taken the whole bucket of paint and thrown it against the wall. It was comical but unusable.

At that point in the scene, Margot vanishes into another room, and the murder victim drags himself over to the window and tries to summon help by drawing on the pane in his own blood. The split screen is introduced at this moment, as two cameras rolled simultaneously in different neighboring apartments, one in the apartment where the stabbing had taken place, shooting out the window, and the other shooting into the same window from outside and pulling back to reveal Grace, a neighbor who happens to be a reporter for a local newspaper, watching from a nearby apartment.

We then follow Grace's actions as she calls the police. Simultaneously, a strange, tall, bespectacled Frenchman arrives and discovers the crime. He proceeds to clean up and conceal all the evidence. The conventional way of shooting and cutting the ensuing action would have been to intercut the two lines, the cleanup proceeding in parallel with the reporter while she waits for, and meets, the detective who gets there at the precise moment when the cleanup is finished.

In conventional single-screen cinema, almost always used in narrative films, simultaneity can only be suggested. Since you can have only one story line on the screen at a time, the appearance of simultaneity is achieved by cross-cutting, alternating bits of one of the story lines with bits of the other. As the two lines go back and forth and the story is advanced

in each line, the impression is created that these two sequences of events are happening at the same time.

It is an efficient way of generating tension, or compressing time, since when the action in one story line slows down you can simply cut to the other. Brian rejected this technique for this scene in *Sisters*, choosing instead to play the two lines simultaneously in split screen.

On one side was the cleanup, and on the other was Grace, doggedly convincing the reluctant and skeptical police officer to accompany her to investigate what she saw. It is perhaps Brian's most successful use of split screens. There were moments in which the action on both sides of the screen was filmed simultaneously with two cameras, and the audience experiences a kind of expansion of consciousness, or omniscience, by seeing two different views of the action at the same moment.

One of these is the opening shot, of the victim writing on the windowpane in his own blood. Another is when the mysterious Frenchman almost bumps into Grace and the policeman as they emerge from the elevator just as the Frenchman is leaving. In trying to avoid being seen, he slips from one side of the screen to the other. It is a delicious moment.

Sisters was a big step for me. I had only one picture under my belt, and that one was shot in a very low-budget, underground style. Many scenes in *Sisters* were being filmed slightly more conventionally, with close-ups and over-the-shoulder shots. I was inexperienced with that kind of footage. It is called coverage, gathering different angles on the same action without a precise notion of how it is to be put together. Its virtue is that it affords great freedom in the cutting room. The downside is that it is so unimaginative. Good directors resort to it only when they don't have a definite idea about how to shoot a scene.

The plainness of the dailies worried me until one night, on TV, I happened across a broadcast of *Psycho*. I was watching the scene in which Janet Leigh is driving and being followed by a police car. The tension was amazing, and I began to study the angles Hitchcock had used to construct the scene. To my amazement, there were only three: a close-up of Janet Leigh at the wheel, glancing nervously into the rearview mirror; a shot of the mirror with the police car reflected in it; and her point-of-view out through the windshield. I turned down the sound, and to my astonishment, the tension vanished with the music. I turned it back up, and

the lesson was clear. It was the music that generated the emotion I was feeling. I looked up the credits and learned the composer was the great Bernard Herrmann.

Ed Pressman had begun shooting *Sisters* before he had secured all the necessary funds, and he was still trying to raise money. He called the cutting room and asked me to prepare the murder sequence to show to some potential investors. When you present your work, you have to show it in the absolutely best way, first impressions being critical. I knew even then that I couldn't show the killing without music. It just wouldn't work. Music is often derided as "telling the audience what to feel." But I believe it is one of the most effective, legitimate tools a filmmaker has. I decided to use Bernard Herrmann's score from *Psycho* to accompany our murder. I went to Colony Records on Broadway and asked the clerk for the score. The store didn't have it in stock, and I had to order it. I had to spell Herrmann's name for the clerk, two *r*'s, two *n*'s, and he placed the order. When it came, I mixed it in, and Pressman presented the scene to his investors. When Margot Kidder lunged forward with the butcher knife in her hand, Herrmann's violins started their shrieking, simulating the musical equivalent of a stab. The small audience was riveted, and Ed got the money.

A year or so later, an article in the *Village Voice* began with the observation that "in making a film so obviously beholden to Hitchcock in so many ways, it should have been equally obvious that the score had to be composed by Hitch's long-time collaborator, Bernard Herrmann. However, Brian De Palma admits that the idea to use Herrmann's music came from his editor, Paul Hirsch":

> Paul had been cutting the film during the shooting and wanted to show me the murder scene, accompanied by some music off an old record. He threaded up the viewer, turned off the lights, and switched on the machine. I was jolted to hear that extraordinary shriek of violins from the "Psycho" shower murder. Suddenly a scene I had viewed 20 times before took on new visceral dimensions. Bernard Herrmann's music had breathed a new emotional force into my film.

(Partial) From the *Village Voice*, October 11, 1973

Ed Pressman had wanted to use Michael Small to score *Sisters*. Small had written the score for the 1971 film *Klute*, and it was very much in the style of the day, performed by a rather small jazz combo. Symphonic scores had fallen out of favor in the late 1950s and early '60s, when Henry Mancini's jazzy style brought in a breath of fresh air. The big, brassy, distinctive theme of the James Bond series, with its twangy electric guitar, is the prime example of what film music was all about in those days.

By 1972, that "new" style was itself growing old. I thought Michael Small's music was inadequate to the job on *Sisters*. Since the picture was shot on a low budget and looked small, I thought it would benefit from having a symphony orchestra on the soundtrack to make it seem bigger. I pushed for Herrmann, as did Brian. It turned out he was living in London, having left Hollywood after Hitchcock threw out his score for *Torn Curtain*. "Same old shit!" Hitch is reported to have said upon hearing the score.

Herrmann was terribly wounded and left for Europe in despair. He scored some Hammer horror films and a Yugoslav war film called *The Battle of Neretva*, but he was out of favor with the studios and the major directors of the day. When he agreed to come to New York to screen the picture, I was beside myself with excitement. I was a music major at the High School of Music & Art in New York and have always loved music. Composers rank high on my list of great men, and the idea of meeting Herrmann was thrilling.

Once Brian saw how effective the *Psycho* music was for the film, he had me adding it all over the place. I had cut the music on *Hi, Mom!*, but that was a rock score, and I had no experience with cutting orchestral music. I would place a cue over a scene, and if I had to make an edit in the music, it was usually jarring.

"Don't worry about it! Broad strokes!" Brian would cry, dismissing my concerns and encouraging me. I would then make another bad cut, knowing it wasn't musical but assuming Herrmann would understand that these were just rough ideas of what we hoped the music would accomplish in any given scene. "Broad strokes!" was our mantra.

The day came for Herrmann to arrive in New York to view the film. The screening was to take place in a small room at Movielab, way over near Eleventh Avenue in the Fifties. It was the only screening room in the city at the time that could run two tracks in sync with the picture. The projectionist there was a small man named Charlie. He was only about five foot four, but he possessed a fierce, Mussolini-like personality. White-haired, slim, but with a gravelly voice common to Italian men his age in New York and New Jersey, he ruled his room with an iron hand. He was not happy at the prospect of having to load an extra reel of sound for each reel of picture. Nevertheless, he showed me where the "pots" were that controlled the sound levels for each of the playback machines on each projector, as I was to be doing the mixing, live, while Herrmann watched the film. I was filled with trepidation, but only I knew the picture well enough to do the job.

"What do we call him?" Brian wondered. "Mr. Herrmann? That sounds a bit formal, don't you think? I'll call him Bernie, I guess."

At last, the great man arrived, and we were introduced. He was a small man but not tiny, about five foot eight or so, and sixty-one years old. He was the image of the absentminded professor, bearing some resemblance to Peter Ustinov. He was overweight and wore his pants pulled high over his belly. He had on a blue suit, very rumpled, a not-too-clean white shirt, and a tie knotted around one tip of his shirt collar, which stuck up. Dandruff lay on his shoulders and lapels, and he peered at us with small porcine eyes from behind rather grimy eyeglasses. Nearsighted, he would perch one of the lenses of his glasses on the bridge of his nose in order to read. His hair was graying and curly, and he absentmindedly twirled one of his curls around and around with his chubby fingers. His gaze was sharp, however, and as we sat down to screen the film, we would soon be exposed to the force of his personality.

The instant the first note of the first cue sounded in the room, Herrmann roared, "Turn that off! It's all wrong! Let me see this picture in silence, will you!"

I was terrified. I pulled the pot all the way down, but a little bit of the music still leaked through.

"Turn it off!" he yelled again.

"I can't, it won't go down any further." I glanced at Brian. He was sweating too.

"We won't hear it after this reel, Bernie," he said.

I called in to the booth to tell Charlie to put up only the work track from then on. I was talking low, so as not to disturb the screening.

"What's that? Speak up! I can't hear you!" Charlie shouted.

He could be heard in the room itself, without the intercom. I dashed out and into the booth to quietly give him the word.

"Aw, fer Chrissakes!" he fairly shouted. "I already threaded up the damn thing!" He was a joy.

I went back inside, and we watched through to the end without further incident.

Herrmann began to talk to Brian about the score. "What do you have in mind for the title sequence?" he asked.

"Well, Bernie, we were planning to put titles over the first scene," Brian replied.

"Over a dialogue scene? Impossible! You need a main title to prepare the audience psychologically for the experience they are about to have." These words were burned into my brain.

"I thought we could wait to introduce the music later—"

"Absolutely not!" Herrmann interrupted. "How far in does the murder take place?"

"About half an hour," Brian replied. "Hitchcock's done it—"

"For Hitchcock, they'll wait half an hour, not for you," Herrmann interrupted again. "You need a main title."

And that was that. Then he softened a bit. "The picture reminds me of *Psycho* when I first saw it," Herrmann said. We were thrilled to hear our film being compared to a classic. "You know, Hitch didn't really believe in *Psycho* at first. When he saw the rough cut, he wanted to cut it down to an hour and put it on TV." I was astounded.

"I have a wonderful idea for the theme of the sisters," Herrmann continued. "A sort of musical equivalent of Siamese twins." I wondered what that could be.

It was now lunchtime, and Ed Pressman took us to his club. There were just the four of us. Herrmann began to lay out his needs. "I will need at least eighty musicians for six sessions," and so forth. When Ed grasped how much this was going to cost, he remonstrated mildly. "That's a lot of money, Bernie."

Herrmann roared, "I'm not used to working for chintzy productions! That's what I need!"

Ed excused himself, asked Brian to step into the next room for a brief tête-à-tête, and left me sitting with Herrmann. I was thrilled.

"When you buy a Rolls-Royce, you don't ask how many miles you get to the gallon," he said to me. "It's nine, by the way. I know, because I own one."

In any event, the problems were worked out and Herrmann was hired to do the picture. A celebratory dinner was arranged before his return to London, and Ed's mother, Lynn, was invited as well. As always, she wore a large, broad-brimmed hat.

Lynn Pressman was the CEO of Pressman Toy Company, having taken over after Ed's father had died. The toy business is very much like the film business. Both try to anticipate future trends and rely on original ideas as well as past successes on which to build franchises. She was a sharp businesswoman, and I am sure that some of the money to hire Herrmann came from Pressman Toy.

She was charmed by Herrmann, as he was at his best. He was a great raconteur and loved to tell stories about the people from Hollywood's Golden Age with whom he had worked. His first film was *Citizen Kane*, and he had many tales about Welles and Hitchcock, as well as Cary Grant and Joan Fontaine, Grace Kelly, and other stars. He had us all spellbound. At dinner, Brian leaned over to me and whispered, "By the way, I found out he likes to be called Benny." Oops.

Editing *Sisters* was all consuming. Brian had decided to shoot a dream sequence in three parts, intended to be an homage to Todd Browning's groundbreaking *Freaks*, and a group of sideshow performers from Florida was imported for a day. The first part was handheld and shot in 16 mm black and white. The second part was, unfortunately, underexposed and half of the footage involving the "freaks" was unusable.

When Brian went back to reshoot the middle section of the dream, the cinematographer used 35 mm color negative, to be used as black and white. The last part of the dream was shot in 35 mm black-and-white negative. Each section of the dream was bracketed by a zoom in to Grace's

pupil, which was shot in 16 mm color reversal stock. All these different stocks had to be combined into one sequence, and there wasn't enough money in the budget to make blowups of the 16 mm dailies.

I was cutting on a Steenbeck with two picture heads, one for 16 mm and the other for 35. This would have been ideal, except for the fact that there could only be one head at a time, so my assistant John Fox and I were constantly removing and swapping picture heads, a two-man operation. The pressure of the schedule was unrelenting, as I had also gotten dragged into cutting the sound effects. John and I worked sixteen-hour days regularly for ten weeks with just one day off.

The main title sequence Benny had insisted on began to take shape. We found a Swedish documentary that featured the world's first intra-uterine photography of developing fetuses. Borrowing shots from it, I constructed a montage of close-ups of body parts: a hand, an eye, an ear, and so on. In the final shot we reveal that there are two babies, twins. It was very effective and laid the groundwork for the movie's backstory.

Benny's music, when it arrived from the sessions in London, was astounding to me. The main theme was based on the universal child's singsong playground taunt, *nya-nya nya-nya nyaahh-nyaaah*. His deranged version of this melody included metallic sounds; tubular bells struck with hammers, which suggested knives; and also Moog synthesizers howling a kind of demented accompaniment. The effect is immediately unsettling, even overwhelming. *Variety*'s review of the film would later say that "Herrmann's score would make blank film compelling."

This assessment was fair, though not particularly complimentary to the rest of us who had worked on the picture.

———————

In the film there is a faux documentary we created for our heroine to view during the course of her investigation of the suspected murderess's background. The documentary consisted of actual photographs of the original eponymous Siamese twins, Chang and Eng, who married a pair of Quaker sisters and fathered families, as well as other real-life conjoined twins. Into this montage of real subjects we introduced fictitious footage of Margot, playing both twins before they were separated.

It was to accompany this documentary that Benny had written the Siamese twin theme he had alluded to when he first watched the picture with us. His notion, which is typical of the way he related his music to its subject intellectually as well as viscerally, was to have the cue consist of twin mirrored chromatic scales, one rising and the other descending, in slow, alternate steps, so that they cross in the middle, forming a sort of conjoined musical theme. Brilliant.

———————

The day came when we were to begin our mix. John Fox and I had worked until four in the morning the night before, and we dragged ourselves in at nine to begin our thirty-sixth day of work in a row. We actually carried the reels with us in a taxi to the studio. Benny had requested that we employ a mixer especially for the music, a practice common in Hollywood but highly unusual in New York at that time. Bob Fine was hired for the job and a special console was brought in.

Benny arrived, and the first couple of days were pretty smooth. I told Benny how much I regretted not being in London for the recording. He shrugged but regaled us during the slow stretches (of which there were many at mixes in that era) with stories about the old days.

One story he related now seems significant in light of what was about to happen. The story was from *The Brothers Karamazov*, by Dostoyevsky. "One day, two friends are walking in the street in St. Petersburg, when one says to the other, 'Oh, no. There's Nicholas. Let's cross over to the other side of the street, I don't want to see him.'

"'Why?' asks the friend. 'Nicholas is the kindest person. He has never done harm to anyone.'

"'I know,' comes the rejoinder, 'but I did a terrible thing to him once, and now I can't stand him.'"

We all laughed, but the story proved to be prophetic.

———————

After the main title, the first really big musical cue in *Sisters* comes a half-hour in, with the murder. Benny had been seated on a couch in front of the

console, dozing off and on while the mixers worked their way through the reel toward the big moment. Brian and I were seated behind the console with the mixers, the better to hear what they were hearing and to communicate with them.

The murder came up and . . . no music. With his back to us, and without turning around, Benny called out, "Where's the music? Isn't there music there, Paul?"

Bob Fine started to answer, "No, I just missed the cue, Benny," but Benny didn't hear him past the first word and erupted with volcanic rage, directed at *me*.

"What do you mean, no?!" he fairly screamed. He rose to his feet as quickly as his physical condition would allow, shouting at me as he rose, "I wrote it! I conducted it! I recorded it! How dare you? You are insolent!"

I was thunderstruck. I hadn't said a word.

"How dare you speak to me that way?" His face was bright red. "Your cue sheets are wrong!" Spittle was flying out of his mouth. "You are incompetent!" The veins in his forehead seemed about to burst. I prayed inwardly that I wouldn't be the (innocent) cause of his death. "I'm going to call the union and report you!" I wasn't even in the union.

No one said a word. I looked at Brian. He looked back at me. I was crushed. Nobody knew what to do or say. They all knew I hadn't spoken a word.

Finally, Bob Fine spoke up. "The sheets are OK, Benny, I just forgot to open the pot."

He was only slightly mollified. In this tense atmosphere we resumed work, and in Dostoyevsky-like fashion, from then on, if I made a suggestion, Benny would shout it down immediately.

I finally started whispering my suggestions to Brian. "Benny," he would say, "do you think the doorbell is too loud?" and so forth. If it came from Brian, Benny would consider it. From me, no way.

At the end of the day, Bob Fine went over to him and pleaded for me. "The mistake was mine, Benny. I just didn't react quickly enough. Paul's cue sheets were right."

But Benny was having none of it, and from then on, to the end of the picture, I was the whipping boy. I was devastated.

My feelings aside, the mix was interesting and educational for me. When Bob did play the murder cue, Benny stopped him. "It's too distinct! Can you put some echo on it?"

Fine had a gadget that is primitive by today's standards. It was a small recorder with a continuous loop and two playback heads that you could move closer together or farther apart. By feeding the sound through it, he could manipulate the timing of the echo.

"It's still too clear," Benny said. "Can you smear it so much that I can't make out any of the notes?"

This was a surprise to me. Normally you would expect the composer to want to protect his music and make sure every note could be heard. But Benny was a filmmaker and was in pursuit of an effect, no matter what it did to his music.

In a later reel, he suddenly cried out, "Stop!"

We stopped.

"Brian, my boy, if you keep this scene in the movie, we may as well all go home right now," he said. Brian and I exchanged looks. "With this in, you give it all away. You don't need to explain all this. It will all be quite clear in the end, anyway."

We hurried back to the editing room that night after the mix and started experimenting. We thought it through, and he was right. We made the cuts.

Ed Pressman made a deal with a picture editor to cut the negative. He was not a full-time negative cutter, but he seemed to know what he was doing. We screened the answer print at the lab. Until the answer print is produced, you have only the workprint, a mosaic of many bits of print held together by tape splices. The answer print, on the other hand, should be smooth and seamless, but for some reason about a third of the splices seemed to jump, and the image would sort of pop, as if someone were standing behind the screen with a broom and giving it a good whack every

time a cut went through. All the effort I had put into making every cut as smooth as possible went out the window.

First the lab claimed there was no problem, and then that they had never seen anything like it before. At last, after trying various fixes, someone thought to measure the splices made by our editor/negative cutter. With a micrometer, they measured the distances between the sprocket holes on either side of the problematic splices and found that the splices were crooked. He had been using a hot splicer that was out of alignment, and there was no way to remedy it. We just had to learn to live with it. As I have said many times, "Problems have solutions. If there's no solution, there's no problem."

Ed Pressman had yet to make a distribution deal for the picture, and a number of screenings were arranged for potential buyers. One of these was for an agent from L.A. named George Litto. I ran the film for him one afternoon in the small screening room in the basement of Rizzoli's, the bookstore on Fifth Avenue. George was in his forties and had made his success by representing the principals of *Hawaii Five-O*. He showed up wearing a turquoise-colored blazer and white slacks and looked very out of place in New York. He smoked nervously throughout the picture. George became instrumental in arranging the sale of the picture to American-International Pictures, or AIP. This was a small studio that made its money from low-class horror and Hell's Angels pictures.

I suggested a slogan for the ads: "Whom God hath joined together, let no man put asunder."

AIP's version became "What the Devil hath joined together let no man *cut* asunder." This approach was characteristic of its B movie history. As for Litto, who had ambitions as a producer, he developed an interest in Brian and saw in him a way to further his own career.

Sisters was shown at the Filmex Festival in L.A. in 1972. I flew out to attend. My sister-in-law, Tina, was living in L.A. then, and we went out for a bite at

Figaro on Melrose Avenue. A bunch of people in their twenties were at the dinner, and I was seated next to a young director who was already legend among our crowd. A couple of years younger than me, Steven Spielberg was admired because he had sneaked onto the Universal lot, set himself up in an empty office there, and started pursuing his career from the inside.

Steven had directed a TV movie called *Duel* but had yet to direct a theatrical feature. However, he displayed such talent in *Duel* that everyone expected big things from him. We chatted, and he told me how much he was looking forward to seeing *Sisters*. He was enthusiastic about every aspect of filmmaking and was eagerly anticipating hearing Benny's score.

The picture was being shown at midnight at Grauman's Chinese Theatre, and word had got around that it was Bernard Herrmann's comeback film. Every film buff in Hollywood was there that night, and Benny's name got a big cheer when it came on the screen. I sat in the audience in a state of semi-shock and excitement.

My film was being projected on one of the biggest screens I had ever seen. I considered it mine because I had made every splice. I had been running it back and forth on my Steenbeck for months. I couldn't have been more intimately familiar with every frame, and here it was, huge, in one of the world's lushest movie palaces, in the heart of Hollywood.

It was the most exciting screening of my life. I was twenty-six years old.

Sisters was mostly well received by critics. Vincent Canby of the *New York Times* wrote it was "just the thing to see on one of those nights when you want to go to the movies for the old-fashioned fun of it." Many, however, criticized Brian for making a more or less overt homage to Hitchcock. But Ed Pressman was sufficiently encouraged by the results to want to produce another of Brian's pictures.

My only regret when it was all over was that despite worshiping and championing Herrmann for the job, he would never be able to look at me without remembering how badly it had gone between us.

I would have to develop a thicker skin.

6

Phantom and Its Horrors

IT WAS TO BE ANOTHER YEAR before I got to work on another feature film. I survived that year by returning to Calliope, Chuck Workman's company, cutting my usual mix of trailers, featurettes, and record commercials. More important, during that time I met and wooed my wife-to-be, Jane Brown. I had traveled down to the Club Med in Guadeloupe for some R&R at the end of *Sisters*. There, I saw this startlingly beautiful young woman in a bathing suit with a million-dollar smile on her way to sailing lessons. Love, if not at first sight, then when? But I was too timid to approach her at first, so we left the club without ever learning each other's name or address. The universe was not going to let this go, however, because six months later we met again by chance in front of a supermarket on the Upper West Side of Manhattan on a picket line for the farmworkers' union. That time, I made sure to get her phone number.

On our second or third date, I played her Benny's music for *Sisters*, describing in lurid detail the action it was meant to accompany, including the knife murders by a schizophrenic Siamese twin. She told me later she had reservations about seeing me again after that evening. And yet she did. We have been married for forty-five years.

Brian had written a script for a musical called *Phantom*. Ed Pressman was able to raise the money, and once again I arranged for the job to be done at Calliope. The shooting was to begin in L.A., followed by a month in Dallas, where an old, ornate movie palace would serve as the theater in

the movie. I went on location for the first time. The story line followed the outlines of *The Phantom of the Opera*. A young composer named Winslow (played by Brian's old friend and college roommate William Finley) is disfigured in a terrible accident (involving a record press), falls in love with a young girl singer (Phoenix, played by Jessica Harper), and, living in the shadows of an old theater called the Paradise, writes music for her to sing. There was a second story line involving the composer's exploitation by a rock music producer named Swan. He turns out to be the devil himself, and the contract they sign is a Faustian bargain.

I was very excited about the prospect of cutting a musical, given my love of music and the opportunity it would afford me to cut sequences to music, which is a kind of editing I particularly enjoy.

On the first day of shooting in L.A., I was on the set, since there was no film to cut yet. We were filming in a recording studio, and suddenly smoke started coming in through the air ducts. We evacuated at once and the problem was quickly solved, although there were many jokes about the consequences of making a movie involving the devil.

Late in the day, Brian came over to me and said, "I am having dinner tonight with George Litto, who is producing *Déjà Vu*. It's a kind of celebration of my first day of shooting on this, and since you're going to be cutting the next one, you should come along too."

I happily agreed. *Déjà Vu* was a script by a young writer named Paul Schrader. He and Brian, who was tabbed a Hitchcock imitator after *Sisters* opened, had gotten together to do a script very similar to *Vertigo*, set in Florence and New Orleans. It was to be Brian's next, and I had read it and was very enthusiastic about it.

That night, I went to La Dolce Vita in Beverly Hills. At the table when I arrived were Brian, George, and Jackie, George's beautiful wife. Dinner was pleasant, with toasts of good luck on *Phantom*, and when dinner was over George ordered a Rémy Martin. Jackie immediately excused herself and, pleading fatigue, left for home alone. Perhaps she sensed that the conversation was about to turn to business.

With just the three of us at the table, George downed his drink, ordered another round, and took up the subject of *Déjà Vu*. "I've been shopping this around town, Brian, and people are reluctant. To get this made, we're going to have to get someone else to direct it."

I was stunned. This was supposed to be a celebration of starting *Phantom* and of the prospect of doing the next one together. I couldn't believe what I was hearing, nor, apparently, could Brian. "George, I want to direct this picture, and I'm going to," he said. "I developed it and I am going to see this thing through."

George then embarked on an hour of working Brian over. He flattered Brian, cajoled him, demeaned him, got angry with him, accused him of getting angry with George, even tried to bribe him. "I'll give you $50,000 not to do this picture, what do you say, *nnh*?"

Brian refused the offer.

"Look at that, Paul, *nnh*?" he said, turning to me. "Your pal here is turning down $50,000, *nnh*?"

I was wishing I were anywhere else at this point. I finally found a way to excuse myself and left.

The next day, I saw Brian on the set. "What was that about?" I asked.

"Yeah, that was something, wasn't it? I don't know. I've never seen him that way before," he said.

Later that day, Schrader came by to visit. I told him about the evening with George.

"Well," he answered unsentimentally, "you don't come to Hollywood to make friends."

I stayed on, however, and soon had plenty of film to cut. My cutting room was in the Movielab building, on the corner of Santa Monica Boulevard and Highland. Since I was used to walking to lunch in New York, I would go out in the street at midday and walk along Santa Monica Boulevard to La Brea, where there was a McDonald's. It was a fair distance, but I never encountered a single other pedestrian. I soon understood that people just don't walk around in L.A.

In December of 1973 we moved to Texas to continue filming. My setup was in a facility in Denton, just outside Dallas. There was a screening room there, and while the rest of the company was out and around town shooting on location, Jack Fisk, the art director, was building sets on a small stage there. While the camera crew is shooting today's material and the editing room is dealing with yesterday's, the art department is dealing with tomorrow's.

Jack was married to the as-yet-unknown Sissy Spacek. Sissy was otherwise unemployed and was helping Jack by painting the sets, often covering herself just as thoroughly with paint. So we found ourselves together back at the facility in Denton and became friendly.

It was there that Brian filmed his wonderful parody of the *Psycho* shower sequence, in which Beef (played by fellow Columbia and *Greetings* and *Hi, Mom!* alumnus Gerritt Graham) is singing the Phantom's song in the shower, when he is suddenly attacked with a toilet plunger clapped over his mouth. The Phantom warns him never to sing his music again. In this deft sequence Brian managed to send up both Hitchcock and himself.

Next door to me was a group of local filmmakers who were cutting a movie about a dog. I remember feeling very superior, coming to town with a hip "Hollywood" movie, and thinking that these guys were amateurs. Their room looked like my room would have if a bomb had just gone off. There were stacks of film boxes and cans everywhere, with no apparent organization, and empty takeout food containers lying around.

They did have a Kem, though, which I didn't, and I remember seeing them search endlessly through miles of footage looking for a close-up of the dog turning his head to the right just so. Of such moments are performances made. I have yet to work on a film where we didn't wind up at some point searching for a head turn. I learned not to feel too superior, however. The film they were cutting was *Benji*, and it went on to become one of the most popular and profitable independent films ever made.

———————

Our dailies were screened in a large room there and were attended by the cast and crew. One evening we were screening the previous day's work, which featured Jessica Harper's audition song for Swan. She played much

of it to the camera, making love to it with her eyes, both in close-up and extreme close-up. She was magnificent. The only problem was, to my horror, she was out of sync.

The dailies were being synced up in New York, where the film was being processed, and then sent on to me to avoid the expense of carrying an assistant editor on location. I watched closely as each take came on. The clapper was in sync, but once the playback music started and Jessica began to lip-sync, the music seemed to be about four frames late, which is horrible. I never did find out why. It was just some inexplicable technical glitch. After three or four takes like this, Jessica's voice rose out of the darkened room.

"Who do you have to fuck to get in sync around here?" she asked. Everyone laughed. I raised my hand, tentatively. Big laughs.

Brian continued his experimentation with split screen in one of the musical numbers. It was a Beach Boys–style song parody that Paul Williams had written, and Brian conceived of it as the scene in which the Phantom plants a bomb onstage as a first warning to Swan.

Two cameras rolled simultaneously. On one side of the screen, Swan's house band, the Juicy Fruits, now called the Beach Bums, starts singing, "Carburetors, man! That's what life is all about!" while on the other side, in a tribute to Welles's masterpiece *Touch of Evil*, the Phantom plants his bomb in the trunk of a prop car backstage.

There are no cuts until the explosion, and the scene is a tour de force of narrative tracking shots combined with the technique of split screens.

I got a chance to try my hand at directing a musical sequence on *Phantom*. There was to be a montage showing the Phantom composing while time passed, accompanying a slow ballad Paul Williams had written. Brian let me have a shot at it. The challenge was clear. Composing is an extremely static activity, so I had to liven up the screen somehow. I came up with a classical Vorkapich-style montage in which I combined images in layers, all shot against a black limbo background. Slavko Vorkapich was an artist and experimental filmmaker who was employed by Hollywood studios to create montages in the 1930s and '40s. He employed a number of tricks to compress time and space, both in the camera and in optical printers, and his name

became synonymous with montages. As much a theoretician as an artist, he later became chair of the USC School of Cinematic Arts. Inspired by his work, I superimposed shots of clock hands spinning forward to show time passing, over images of the Phantom hunched over a keyboard or at a desk, writing. The clock face was made from a gold record, and I tilted down to it and back up while zooming into it so that it would appear to rise into frame, float toward us, and then slip down and out of sight. I shot close-ups of music being written, candles melting down, stacks of sheet music rising, and also shots of Phoenix discreetly clad only in a feather boa, her face seeming like a blossom on a flower stalk made of feathers. Back then, there was no way to try out this sort of effect without actually executing it, and as we were a low-budget show and optical houses could be expensive, I was to get only one shot at it. As it was all connected by dissolves, it had to be done in one go. When I finally saw it, there were some changes I wish I could have made, but that was not in the cards. I'm still pretty happy with the way it turned out.

Back in New York, I continued cutting the movie at Calliope. I was having a great time. One of the running gags in the film involved the Juicy Fruits morphing from doo-wop greasers to a surf band to a KISS-like glam rock group with stark black-and-white makeup on their faces. The big number in the film was the show at the Paradise's opening night, a trio of the band's songs. The group, now called the Undeads, open the performance by going out into the audience during the song and, using glitter-covered fake "swords" on the necks of their guitars, "slicing off" limbs and a head (from dummies planted in the crowd) and bringing them up onto a gurney on the stage, which was dressed as Frankenstein's laboratory.

They pantomime stitching all the body parts together, still singing, and then the gurney rises slowly up to the top of the stage. A neon lightning bolt flashes, there's a clap of thunder, the gurney comes down, and Beef climbs off it dressed as a glittery Frankenstein/Liberace/Harpo in platform shoes, singing "Life at Last!"

As Beef is performing, ignoring the threat made to him earlier, the Phantom works his way up into the wings of the stage, gets hold of the neon lightning bolt, and hurls it down at the hapless Beef, electrocuting

him. Phoenix is hurried out onto the stage to calm everyone down, and a star is born.

I went through every take of every angle, and there were quite a few. The entire performance had been filmed both facing the stage and facing the audience. I made careful notes of which parts of the songs were best covered in each angle, and which take was best. I then cut it all together, syncing up each cut to the master track as I laid it in. This is where some experience and a music editor would have helped make my task much easier, but I was working these things out without the guidance of a mentor.

I had never apprenticed to a feature film editor and never learned any tricks from anyone else. I had to learn it all by doing it, working on my own. It wasn't very efficient, but it was terribly exciting, as if I were reinventing the art of editing itself. The discoveries I was making, although others had made them before me, felt as if I were making fresh tracks in virgin snow. I think my love for editing is partly due to the way I learned to cut. By myself.

For the moment when Beef is electrocuted, Gerritt Graham panto-mimed a brilliant comic take of thousands of volts of electricity coursing through his body, but I wanted to give it something more. I took each pair of frames and reversed them. That is, if you had ten frames numbered 1 to 10, I recut them so that the progression went 2-1, 4-3, 6-5, 8-7, 10-9, and so forth. It was three steps forward and one step back. It took a while to try it out. I had to cut the film one frame at a time, but it turned out to be worth it. The result was that the film was neither sped up nor slowed down. I had preserved the photographic reality of the event, but the action was herky-jerky, and Beef seemed to be vibrating from the current.

––––––––––

Jane and I were married during the finishing of *Phantom*. We had only a hurried two-day honeymoon before I had to come back to the city for the final mix. The wedding was held at my mother-in-law's home in New Jersey. Brian offered to film the proceedings, which was really extraordinary when you think about it. A wedding film by a professional director! To shoot it, he borrowed an 8 mm camera from Chuck Workman. He brought twelve rolls of film with him and worked for hours without stopping. The day was

hot, and the ceremony took place outside, but Brian was tireless. He shot me getting dressed, signing the marriage license, walking down the path to where the wedding would take place, angles on Jane, angles on me, a close-up of my foot breaking the glass, and Jane and me cutting the cake. After shooting eleven rolls, he noticed a small switch on the camera.

I wonder what this is, he thought (as he later told me). *I think I ought to shoot one roll with the switch in the other position.*

Sure enough, when the film was developed, we got back eleven rolls of black leader, with no image at all, and one roll of a few stragglers dancing tiredly at the end of the wedding. The switch was a fader, and the camera had a nonreflex viewfinder, so Brian was unable to see it was closed. He assured me, a bit ruefully, that it would have been a great film. To this day, I appreciate the effort he put in.

When *Phantom* was finished, Brian and Ed took the picture out to the coast to shop it around. The reaction was electric, and 20th Century Fox agreed to buy the film for more than it had cost to produce it. The price was a record for an independent negative pickup at the time.

Brian called. "You've got to get out here. The excitement is amazing. You don't want to miss this. There's a screening planned for this weekend, and a cocktail party."

I hurriedly made plans and flew out with Jane. We went to the screening at the Little Theater on the Fox lot. Afterward there was a party with drinks and hors-d'oeuvres. A young, animated woman came up to me smiling. "Are you the editor? Your work was just great!" I liked her immediately. "I'm Marcia Lucas," she said, introducing herself. "My husband George wants to meet you."

Marcia was a young editor like me—we were born only six weeks apart—and had edited *American Graffiti* with Verna Fields and a picture for Marty Scorsese, *Alice Doesn't Live Here Anymore.* She was warm and open and took my arm and pulled me through the crowd. We came up to George, a slight, small man with a full beard like mine but, unlike me, a full head of hair. He was wearing sneakers, a white shirt, and blue jeans, his shirttails hanging out, very unassuming looking.

"This is the editor, George," Marcia said, introducing us.

"Great work," he said.

I was honored. *American Graffiti*, which he had cowritten and directed, had opened a year earlier and spoke very strongly to me. It was all about my generation, with the music I grew up with used very adroitly as score, one perfectly chosen song per scene. The ad line, "Where were you in '62?" hit home. That was the year I graduated high school. I thanked George for the compliment and left town with a warm feeling about the Lucases and a lot of hopes for the future.

———————

It was after I got back to New York that the bad news hit us. Three different parties were suing Fox over the picture. First, Universal had gotten wind of the film and sued over our unauthorized use of its property *The Phantom of the Opera* as source material. Second, King Features Syndicate sued over infringement of its superhero comic strip title *The Phantom*, and in the third, most bizarre suit, Led Zeppelin was suing over our right to use the company name Swan Song Music.

In the film, Swan's record label was Death Records, and its logo was a dead sparrow lying on its back with its claws up in the air. His publishing company was called Swan Song Music, in keeping with both his name and the death motif, but it coincidentally happened to be the name of Led Zeppelin's company.

In a grisly further coincidence, Led Zeppelin's manager had been a close friend of the real-life musician who died onstage, electrocuted by his malfunctioning equipment, on which the scene in the film had been based. Not only that, but the manager had also been there and witnessed the incident, was badly traumatized by it, and was deeply offended by the scene in the picture. He swore that he would spend every cent he owned to keep the name Swan Song from appearing in the film.

Normally, when a picture is hit with lawsuits charging copyright infringement, the problem is dealt with by an insurance policy carried by the producer called an "errors and omissions" policy. This protects the filmmakers from liability resulting from accidental, inadvertent use of someone else's intellectual property.

Ed Pressman made the biggest error and omission, however. He inadvertently failed to carry such a policy, and when the executives at 20th Century Fox learned that, they told Ed they wouldn't go through with the purchase of the picture unless he could dispose of each of these suits.

The following solution was worked out: to deal with the King Features lawsuit, we would retitle the film *The Phantom of the Paradise*; Universal would share in the box office receipts in return for dropping its suit; and as for Led Zeppelin, who were absolutely intractable, we had to remove all references to Swan Song from the picture.

I have always been a fan of wipes, transitions between scenes that have a line or shape traveling across the screen, erasing the outgoing scene and "wiping" on the incoming. They evoke for me the Golden Age of Hollywood, when the pictures I grew up viewing were made. In my first film, *Hi, Mom!*, we used many, not only as transitions but also as a cheap way of rendering an explosion we couldn't afford to stage. In *Phantom*, I made up wipes of our own designs. One used the dead sparrow silhouette and zoomed through it. Another took the stylized swan from the Swan Song logo and had it glide across the screen from right to left. This logo, which our art director Jack Fisk designed, was all over the film, plastered on sets, props, and costumes. It was everywhere.

This meant that we were forced to recut the picture. It was heartbreaking to take what we had slaved over and polished to perfection and make brutal cuts just to please the lawyers. Beautiful, graceful crane shots had to be abruptly cut short because the logo came into view in the next frame. Wide shots were replaced by tighter angles when possible, and if there was absolutely no way to cut out the shot with the offending swan symbol, we had to blur it and throw it out of focus with traveling mattes. Today's tracking technology didn't exist yet in 1974, and the optical house had to do the best it could, which unfortunately wasn't great. And it all had to be done quickly. It was awful. When people compliment me on *Phantom*, I think of what the picture was like before the recutting. It's as if someone dear to you had a terrible accident and had to have her face reconstructed. No matter how good a job is done, it will never compare to the original.

The picture opened and was not well received by the critics of the day. It got one star from the *Daily News* and disappeared from New York City screens immediately. Oddly, it was a huge hit in Paris and played continuously in a theater on the Left Bank for ten years before finally closing. The picture was also a massive hit in Canada, in Winnipeg.

A few years ago, I was contacted by a man who had somehow managed to get access to the original footage and created a website devoted to the film. On the website, to my astonishment, are clips of the scenes before they were recut. I had thought they were lost and gone forever. His name is Ari Kahan, the principal archivist, and I am ever grateful to him for his enthusiasm for *Phantom*.

In the summer of 2014, I was invited to a fortieth anniversary screening of *Phantom* at the Cinerama Dome in Hollywood. I was on a panel with several members of the cast, including Paul Williams, Jessica Harper, and Gerrit Graham. Bill Finley, who played the Phantom and was Brian's college friend, had recently passed away, but his widow, Susan, was there.

The reaction to the film was stunning. The event was sold out, and the crowd was pumped. They cheered the entrance of each character; they applauded every musical number and laughed in all the right places. It was the kind of screening we had dreamed about forty years earlier, and that evening it seemed like I was still dreaming.

Talk about delayed gratification.

7

Obsession

BY THE FALL OF 1974, and after the disappointment of *Phantom*, Brian had patched things up with George Litto, and *Déjà Vu* was on again. I was excited about the project. I had picked up some small jobs in the interim, one of them a documentary about a martial arts tournament in Puerto Rico, and wanted to get back to cutting features. But the prospect of working with George made me nervous. He was an important Hollywood agent, and I had seen him in action.

I got a call from him offering me the job. "The deal is $650 a week for twenty weeks."

I had been making that much on a two-bit documentary about a martial arts tournament and wanted a bit more. I also knew I had Brian in my corner. "I don't think that's fair, George," I said. "I want $750."

"What, are we going to negotiate, *nnh*? I made this call as a courtesy, *nnh*?"

I was taken aback. It's very uncomfortable to hear someone telling you directly that you aren't worth what you are asking for. "What are you saying, George? Take it or leave it?"

"Do you want me to speak those words, *nnh*?"

"What if it goes over twenty weeks?" I replied.

"Take as much time as you want," he says. "Twenty-three weeks, twenty-six, whatever you want. You only get paid for twenty, *nnh*?"

And that was the deal. I wound up working for twenty-three weeks, but I got paid only for twenty, a total of $13,000. George understood what

I was just learning, that the only leverage you have in any negotiation is a willingness to walk away. He knew I wasn't going to turn down this project over a few dollars. It meant too much to me at this point in my career, and he had me.

———————

During preproduction, Brian made a change in the script that made Paul Schrader furious. The original version took place in three different time periods twenty years apart, but Brian, finding the script too long, simply cut the bit in the future.

George Litto was happy with the script but not with the title. "It sounds like a foreign film," he announced. "How about *Double Ransom, nnh*?"

I thought it was a terrible title. It sounded like a bad movie-of-the-week. Fortunately, Brian came up with *Obsession*, the title by which it is now known to the world.

———————

The production began shooting in Florence in March of 1975. The cinematographer was the great Vilmos Zsigmond, perhaps the greatest I ever worked with, and he gave the film a magical look. There were scenes shot on the Ponte Vecchio over the Arno at dusk, at the Church of San Miniato al Monte, in piazzas around town, in a local cemetery, and in a hospital.

For budgetary reasons, I was not brought over to Europe but was to meet up with the production when shooting shifted to New Orleans. When I arrived, I was driven to the set by my local assistant. When Brian saw me he let out a warm cry of welcome and put his arms out to embrace me. We hugged, and I got the feeling he needed a friend. George didn't greet me quite as warmly.

"Our art director is already on a plane out of here," he said. "You could be next."

———————

I was given a Moviola to cut on in one of the hotel rooms where the production had rented offices. One day George dropped in when I was cutting a particularly tricky scene, in which the main character, played by Geneviève Bujold, begins to remember the past, and the audience gets to relive a pivotal kidnapping sequence from a new perspective, different from the one they had seen earlier in the picture.

The scene involved a very bright daytime angle, shot in sunlight and intercut with a dark interior. As the camera pushed in to a close-up of Geneviève's face, I cut in little flashes of the past, just a few frames at first, interrupting the move in to her face, then a little longer the next time, so that the interruption itself started to become decipherable, then back to Geneviève again, but not for as long, as we complete the transition into the past and the camera completes its move. What made it tricky was getting the rhythms just right. George came in and looked over my shoulder. He must have liked what he saw. He grunted and went away.

One day, I visited the set and was chatting with Geneviève. She was concerned about the previous day's shoot, because Cliff Robertson was taking inordinately long pauses when he was off-camera feeding her lines in her close-ups. You could actually see the growing impatience in her eyes as she waited for him to give her the next cue. She asked me how the dailies were. I said they were fine. "When I tighten up some of those pauses, it'll be perfect."

I thought I had reassured her. The next day, Brian came looking for me, and he was not happy. "What the hell did you say to my star?" he demanded.

"What do you mean?" I told him what I had said to her.

"I was up half the night trying to talk her down," he said. "Don't ever say anything to the actors! You don't understand. They can't handle the slightest hint of a problem. You have to say everything is wonderful."

I have never forgotten that.

A few days later, after that faux pas had blown over, Brian came to me and said, "I want Benny to write the score for this picture, but George wants somebody else. We've got to convince him the way we did last time."

To George's credit, the composer he wanted was John Williams, and this was before he had written *Jaws*, which really put him on the map. However, George's reason for wanting him was off base, in my opinion. "We're shooting in New Orleans, and Johnny can write that kind of jazz."

I didn't think this was what the picture needed. Ideally, the music would be a reflection of the characters' internal lives, of their emotions, not of the location. Benny understood that approach better than almost anyone, and we had to have him, as far as Brian and I were concerned. I got a copy of the soundtrack from *Vertigo*, the inspiration for *Obsession* and perhaps Benny's finest score, and started tracking the cut picture with Benny's incomparable music.

My cutting room was right next door to George's office. When I started laying in *Vertigo* with Brian, George came rushing in excitedly. "What is that?" he asked. "*Romeo and Juliet?*"

"It's *Benny!*" Brian said.

And that was that. Benny had the job.

The picture was shot in thirty-six days, and we had a cut one week later. Spielberg and Brian had become friends, and Steven would always visit the editing room when he was in New York. He had come to New York for the premiere of *Jaws*, and Brian invited him to screen the picture. We ran it for him in a screening room, and afterward he came to our editing room in the southeast corner of the Brill Building, overlooking Times Square. We ran it reel by reel for him on the Steenbeck. Occasionally he would ask, "Do you have a shot of something-or-other?" and we would invariably reply, "No, if we had, we would have used it."

When we got to the end, Steven turned to me and said, "Verna would be pleased."

A high compliment, as he was speaking of the legendary Verna Fields, a.k.a. Mother Cutter, who had edited *Jaws* for him. Now she has a building named after her on the Universal lot. We went that night to Steven's

premiere across the street. It is a fantastic picture, and we all know how it turned out. The grosses were astronomical. *Jaws* is still one of the most successful pictures of all time.

As I watched the film, I noticed something odd in one of the later reels. In a low-angle close-up of Roy Scheider showing the early evening sky behind him, I saw what looked like a brief fiery streak in the sky. Later that evening at a party at Steven's hotel to celebrate the opening, I asked him about it.

"Hey," he called out, "Paul Hirsch saw it! He saw the UFO!"

As I had suspected, that streak was deliberate; it was a little foretaste of Steven's next picture, *Close Encounters of the Third Kind*.

Benny arrived from London. I braced myself. I didn't know what to expect. I worshipped this man for the magnificent scores he had written, and yet he had acted so irrationally and treated me so badly on *Sisters*. I was prepared for the worst. We met him in the lobby of the MGM screening room where we were to run the film for him. Although still only sixty-four, he had aged quite a bit since we had seen him last; he was frailer, leaning heavily on his black, gold-topped cane as he walked.

When Benny saw me, he beamed and called out, "Paul, my boy! How are you? It's good to see you!" I was stunned and relieved. The reason was clear to me, though. Benny must have read Brian's article in the *Village Voice*, giving me credit for putting Benny's music in *Sisters*. He realized that I had been instrumental in the resurrection of his career and reversed his attitude toward me 180 degrees. I had gone from whipping boy to golden boy, and we became friends. The score to *Obsession* has always held great emotional resonance for me as a result.

But it did not proceed smoothly. "Brian, I can't do the picture!" Benny complained. We were in the MGM lobby and hadn't yet run the picture.

"Why, Benny? What's wrong?" I thought, *He came all the way from London to tell us that he isn't doing the picture?*

"It's that Litto!" he exclaimed. "He sent me a fifty-page contract that I have to hire a solicitor just to read it and tell me not to sign it!"

George had also apparently asked Benny to take a physical for an insurance policy in case he became too ill to finish the work. This was not unreasonable, as he was a sick man, but it was an indignity to which he did not wish to be subjected. Brian called George and they worked it out.

We decided to run the picture in a room where we could go forward and back on the projector. Screening rooms with that capability are called rock-and-roll rooms. As we watched, Benny chuckled at one point when we were changing reels.

"What's so funny, Benny?" Brian asked him.

"I was just thinking I can hear the music already, and you have to wait six weeks to hear it." He laughed some more.

At lunchtime, Benny and I walked over to Sam Goody's on Forty-Ninth Street. In contrast to a few years earlier, when I had had to spell his name for the record-store clerk, there was now a bin of recordings of his scores, with his name on the divider. We looked through it together. "This is rubbish, this one," he instructed me. "This one here is quite good, though." I bought all the ones he recommended.

I invited Benny home for dinner. We lived in a large, sparsely furnished apartment on a high floor on 106th Street and Broadway. "Wherever did you find this flat?" he exclaimed delightedly.

I had invited Brian, my brothers Chuck and Peter, and their respective girlfriends. The evening was an enormous success, with Benny very relaxed, flirting with all the young women and telling his tales of Hitchcock, Welles, and other legends of whom we had only heard, with his incomparable raconteur's prowess.

Benny and I talked about music and recordings in a way that reminded me of my godfather, Nicolas Moldavan, a Russian émigré who had played viola in the Flonzaley String Quartet, the leading quartet of its era, the 1920s and '30s. Moldy had died a year earlier, at eighty-four. He had been trained in traditional nineteenth-century techniques and theories, as had Benny. In the mid-twentieth century, many concert hall composers had veered into the sterile, dead-end world of twelve-tone music. Film music gave Benny the opportunity to write in an idiom that would not have been permissible in the "serious music" world of that time.

The Romantic style that evolved from Tchaikovsky and Wagner to Mahler, Ravel, and Richard Strauss made great use of the creation of anticipation and climax. Wagner pioneered the use of underscore in his operas. Emotional music played in a sometimes unsubtle, yet powerful way was

the best kind of music to accompany the storytelling in feature films. This is why the first great wave of Hollywood composers, such as Steiner, Newman, Korngold, and Rosza, all nineteenth-century-trained musicians, were so well suited to the job. Their scores helped tell the story.

Benny called music the "emotional link between the action on the screen and the audience," helping to create the suspension of reality and the sense of intimacy that we feel when seated in the dark, part of an anonymous crowd, watching shadows projected on the screen.

Benny went back to London to write. One day, he telephoned. Once again, he had an idea for a main title. He wanted me to alternate shots of the church of San Miniato with pictures from a slideshow that Cliff Robertson's character puts on at the beginning of the film. He told me how long to hold each shot and laid out the entire sequence as he envisioned it. What set him apart as a brilliant film composer was that he was a magnificent storyteller. The title sequence in the film is just as he designed it.

The recording dates were set. The score was to be recorded in London in early August. I asked George to fly me to London for the session, not really expecting he would. He didn't disappoint and refused. I was determined to be there, however. I had missed out on the *Sisters* recording, which Brian had described as the most exciting moment of his professional life, and I didn't want to miss this one. By that time, since my twenty weeks of employment were up, I decided to take my vacation in London, and Jane and I flew there at our own expense.

The recording was to be held in a medieval church, St. Giles-without-Cripplegate, in the Barbican Centre. We were scheduled for four evening sessions with a mobile recording unit. Benny had chosen St. Giles because of its organ, which figures prominently in the score, and its acoustics, intending to record the chorus live with the orchestra, with no overdubbing.

We went out to lunch the first day, and Benny was in a fine mood. Geneviève Bujold was there, and Benny was spinning his enchanting tales for her.

"Did you know that Milton is buried in that church?" he asked. "His tomb is not ten feet from where I will be conducting. If I do a good job,

perhaps he will whisper to me," he added. Then, addressing Cliff's somewhat wooden performance, he said to her, "Don't worry about him, my dear. I made love to you with my music."

The recording was problematic. The organist was in a choir loft, way above the orchestra, with his back to the podium. He could only watch the conductor in a large mirror suspended over the keyboards. To compound his problems, the air that was forced through the giant organ pipes took about a second after he depressed the keys to make a sound. This meant that to stay with the orchestra, he had to anticipate the downbeat by a second. Not an easy task. Benny intended to conduct as much of the score as he could, but knowing how ill he was, his friend and fellow composer Laurie Johnson was there to share the duties with him.

The atmosphere was charged. Benny had told me that it was safe to go ahead and cut the negative before he recorded the music. In my inexperience, and with the limited amount of time I had been given, I did it. It seemed like a good idea, since it meant we could record the score to a color print instead of a murky black-and-white duplicate copy, or "dupe."

I have never done it since, if I can help it. Benny tried and tried, but he just could not hit the cuts in one of the climactic scenes, at the airport when Cliff is stalking Geneviève. It would have been a simple matter for me to move the cuts a few frames one way or the other, to catch the beats in the music, but it was too late. The negative was cut.

As he struggled with this, the orchestra had to play the cue over and over. This put a strain on the French horn players' lips, and at a key moment, with the horns carrying the melody, the lead horn played what is known as a clam. French horn players are considered a bit high-strung, as they often play parts that do not blend into the background. Theirs are the bravura parts, the solos played *fortissimo*, and if they make a mistake everyone knows it. They don't have the luxury of a rear-stand second violinist, who, if he hits a wrong note, can bury his mistake in the ensemble.

When the horn player cracked the high note, Benny threw down his baton. "That's the most erratic horn playing I have ever heard!" he bellowed. The first French horn player stood up.

"And that's the worst bleeding conducting I have ever seen!" he roared back and started packing up his instrument to go home.

"You're leaving? Fine!" Benny said. "Get someone else to take his place."

The music contractor flew into a panic. It was eight o'clock at night. Where would he be able to find a horn player and get him down there while the orchestra waited? "Can we do without him, Benny?" he asked.

"No, we have to have four horns. Just get someone else."

More panic. The contractor called a ten, giving the musicians their scheduled hourly break. The horn player was approached, the contractor begged him to stay, bought him a drink, settled him down, and finally he agreed. Laurie Johnson took over for Benny, and the session was saved. By the end of the week the score was completed, and we headed back to New York for the mix.

When film music is being recorded, the usual way is to begin with the cues that require the largest number of musicians, working down toward the smaller cues, releasing players as they are no longer needed. This is done for budgetary reasons. The cues are almost never recorded in scene order. Each cue is rehearsed and played a few times before a take is deemed satisfactory. Then, as the film is being mixed and the music is combined with the dialogue and sound effects, an entire day may be spent on ten minutes of finished film. The process takes weeks. Only when the mix is finished does anyone, including the composer, get to hear all the music written for the film in the proper order and in the time span for which it was designed. As the cues are analogous to movements in a larger work, the composer won't really know the cumulative effect until then.

After we had mixed all the reels, one by one, we went to the MGM screening room to play back the whole film. Benny had developed a kind of crush on my assistant, a young woman named Deborah. "Sit next to me, my dear," he said. Deborah was happy to oblige. We were glad if she could keep him calm, as his volcanic rage was never too far from the surface.

When we got to the end, the lights came up. Everyone knew they had heard a magnificent score and applauded loudly. Benny was weeping. He wept without stopping for a very long time, long enough for the people

in the room to become embarrassed and leave. At last he calmed down. Only Brian, Deborah, and I were left. We talked about a few minor fixes we wanted to make in the relative levels in some scenes and agreed to go back to the mixing studio. Brian and Deborah went ahead, and I stayed behind with Benny, who walked very slowly and said not a word. I carried his attaché case as we made our way out to the sidewalk. It was August in New York, very hot, and still early in the afternoon. We managed to get a cab, but traffic was heavy and we weren't going anywhere. Benny was still sniffling. I was touched and put my hand on his arm.

"It's a beautiful, beautiful score, Benny," I said.

He looked up at me and right into my eyes. "I don't remember writing it," he said quietly.

Despite the heat, a chill went through me.

"All I know is, I woke up at two o'clock one morning and thought, *There's got to be a chorus.*"

———————

Two nights later, as we were finishing up, Deborah asked if she could leave early, as Benny had asked her out for a drink. All that was left to be done was to wait for a messenger to pick up a package going to L.A. I agreed to cover for her, as it seemed churlish to stand in her way of getting to spend some time with a living legend. But as it got later and later, I started resenting her.

She's my assistant, I thought. *So why is she at Sardi's with Benny while I am in this dingy room by myself?* The phone rang. It was Deborah.

"Benny wants you to join us as soon as you can," she said. "He will wait for you."

I immediately felt better. At last the messenger came, and I was able to go join Benny and Deborah.

"I wanted to explain to you why I was so upset the other day," he said. I was curious and listened closely. "It's because when the picture ended and I realized I was done, I felt as if the characters in the picture had left me."

In writing the score and with the psychological approach that he used, imagining and then expressing each emotion of the characters' interior lives as the story progressed, Benny had fallen in love with the character

Geneviève played in the film. When she "left," it was as if he had experienced a grievous personal loss.

———————————

With the picture completed, Benny went back to London, Brian and George went off to L.A. to try to arrange a distribution deal, and I set to work trying to find employment. It was the fall of 1975, and I found a job on a short film for the United States Bicentennial, about Benjamin Franklin. It was to play every half hour at the Benjamin Franklin Museum in Philadelphia during 1976. I was happy to be working on anything. I was newly married and had a big ($500) rent to pay each month.

While I was working on this short film, I would get phone calls from Brian from time to time. "How's it going?" I asked him one day. (Spoiler alert.)

"Well, George Litto has been holding screenings around town for the various studios, but they are having trouble with the ending. They like the picture, but when they realize that Geneviève deliberately slept with her father to get revenge on him for what she thinks he did to her, it scares them away. They don't want to have anything to do with incest." In the picture, Cliff's character Court marries Geneviève, who is the double of his dead wife, not realizing that she is his daughter, whom he believes to be dead. She has been lied to and blames him for her mother's death.

I thought about this. It was a real comedown, after the emotional high of finishing the picture, to realize that in the world of show business, business comes first. I wondered if we could cut the incest out of the picture, but it seemed too radical—it would require such deep cuts that the story wouldn't make sense.

Suddenly, out of nowhere, I got an idea. What if the incest never happened, that Court just dreamed it? My idea involved changing only one shot.

I met with Brian, who was back in New York, and laid it out for him: "What if instead of the wedding actually taking place, we present it as a dream? Instead of cutting from the dining room to the day exterior of the house, we cut instead to a close-up of Court asleep, which we already have. Then we do a ripple dissolve or something and we show the wedding, just as it is, and him taking her to bed, but this time we are saying this never

really happened, it is just a dream he is having. Instead of a depiction of reality, we are getting a glimpse inside his mind, getting a sense of his 'obsession.' The only shot we change is that shot of the house to a close-up of Court, and it's done. The incest never happened. And you don't have to reshoot anything."

Brian understood at once. He called George and told him the idea, but George rejected it. I was convinced it would work. I sat down and wrote George a long letter detailing all the reasons why I thought we should do it and how it would work. I dropped it in the mail, and at that point I had done all I could.

I went back to work on the Ben Franklin film. Two months went by. One day, I got a call from George. "You know, I don't always recognize a good idea when I hear it the first time," he began, "but I reread your letter, and I think we should do it."

I was pleased. I felt that this would give the picture a fighting chance. Brian had grown a bit reluctant but went along. We shortened some of the material of the daughter in the bathroom, as it didn't fit with the subjective realm of a dream, and designed a kind of flickering candle effect to lend the images a dreamlike quality. We remixed and recut the negative. Armed with a new print, George got the executives at Columbia to rescreen the picture, and they agreed to distribute it. George rewarded me with a bonus check for $5,000.

Brian has come to publicly reject the change and believes today that it was a bad compromise of his artistic vision. But it is one of the best examples that context is everything. The exact same footage is used to achieve a different meaning simply by replacing a shot of the exterior of a house with a shot of our main character asleep.

I saw Bernard Herrmann only one more time. He had come to New York in November of 1975 to screen the rough cut of *Taxi Driver*. I had almost gotten a chance to work on the film. At one time, Brian was going to direct it. The script was by Paul Schrader, who had also written *Obsession*, and it was to star Bobby De Niro. But it didn't work out with Brian, and Marty Scorsese stepped in.

One day the previous summer, out of the blue, I'd gotten a call from Marcia Lucas. We had spoken just the one time, at the cocktail party after the screening of *Phantom* at 20th Century Fox in L.A. Marcia is a very engaging woman and has a wonderful camaraderie with fellow editors. "Hi, Paul," she said. "You know I am cutting Marty's movie. Well, we need help. Marty shot a lot of footage, he went over schedule, and we are kind of pressed for time now. And I thought since you had worked with Benny, and he's going to do the score, you would be perfect to come help us out. Will you do it?"

"Of course, I'd love to," I answered.

I was thrilled at the prospect, but the next day Marcia called back. "The studio refused. When we brought your name up, they had a fit. They said there are too many good editors out here in Hollywood. They are not going to spend the money to bring somebody in from New York." I was disappointed, to say the least.

In any event, when Benny came back to the city from London to work with Marty, he called and invited me to dinner at his hotel, and I gladly accepted. When I arrived at the dining room of the Regency, he was with his daughter Taffy. He was very happy. He was getting lots of offers for the first time in a long time. "The young guys, they want me," he exclaimed.

Scorsese wanted him for another film, Brian wanted him for *Carrie*, Spielberg was thinking of using him for *Close Encounters*, and Herb Ross (not so young, but still) had spoken to him about *The Seven-Per-Cent Solution*, the Sherlock Holmes film based on a script (and novel) by Nick Meyer, whom I have known since childhood. Benny had an idea for its main title, which he suggested to Ross. In the Holmes stories, the detective was an amateur violinist, and Benny's idea was to open with a wide shot of a symphony orchestra playing the main title music. As they played, and the titles came and went, the camera would be pushing in very slowly from the back of Albert Hall all the way in to a close-up of the last stand of the second violins, where we would find Holmes. I thought it was an ingenious and delightful idea.

We also talked a bit about *Taxi Driver*. "I wrote the theme when I read the script," he said. "It's a very strong picture, very dark, very violent. It makes *Sisters* look like a Sunday-school picnic."

I couldn't imagine that.

At the end of the meal, the maître d' came over. "Mr. Herrmann? There are two young men out in the lobby waiting to see you. I think they want your autograph."

"Tell them to go away!" he nearly shrieked. "Why don't they leave me alone?!" He was shaking with rage.

The maître d' retreated—a good move, I thought. Finally, we got up to leave. As we entered the lobby, two young men in their late teens or early twenties sitting on one of the divans stood up and came hesitantly toward us. I cringed at the thought of what might ensue. They held large coffee table–sized books in their hands. I think they may have been the Truffaut interviews with the Master, Alfred Hitchcock. They held them out in Benny's direction and asked shyly if he would sign them.

I fully expected him to dash the books out of their hands with his cane, maybe give them a couple of whacks for good measure. To my astonishment, he took the first proffered book and pen, opened the flyleaf, drew five parallel horizontal lines, a treble clef, and some musical notation. Then he signed it with a flourish. He did the same for the second young man. They thanked him and left, elated.

"What was that? What did you write, Benny?" I asked.

"I wrote them the first four notes of *Psycho*," he answered, smiling. There were definitely two sides to the man.

I suspect that Benny was never truly happy. His rage consumed him, and that rage had been his response to the wounds that life inflicted on him. He was terribly sensitive, like an exposed nerve walking around, and slights that most people can shrug off hurt him deeply.

His score for *Obsession* is a towering work, at times deeply romantic, moody, gloomy, mysterious, and joyous. For the reliving of the kidnaping scenes, it seems to become almost unhinged, a shuddering chaotic storm of notes that resolve finally, after a grim death march, into a deliriously triumphant waltz. Listening to the recording I experience a full range of deeply felt emotions.

Benny died about six weeks after that dinner. He was conducting the score to *Taxi Driver* on Christmas Eve in L.A. The session ran long, and Scorsese suggested they stop. They could complete the recording after the holiday. But Benny insisted they had to finish, so they worked overtime and got it done. That night, he died in his sleep at his hotel.

I went to the memorial for Benny at the Riverside Memorial Chapel on Amsterdam Avenue in New York. His brother, an optometrist, spoke. I am sure his love for Benny was genuine, but he was not gifted either as a writer or a speaker. I felt that a great composer such as Benny should have had a great poet speak at his funeral, but it was not to be.

As for me, I finished the Benjamin Franklin short and went on to cut *Carrie*.

From then on, I edited only feature films.

8

Star Wars

ONCE *CARRIE* WAS IN THE CAN, Brian and I made our mad dash to the airport, heading north to San Anselmo, where George Lucas had his cutting rooms. It was the fall of 1976. The next eight months were to have an immense impact on the rest of my life. It was a period of great personal change, as well as a watershed in my professional life.

Brian and I landed in San Francisco around midday. I rented a convertible and put the top down. We climbed in, and off we went.

"It's up the freeway from the Golden Gate Bridge," Brian informed me. "Just follow the signs to the bridge," he added, and thereupon went promptly to sleep.

As I drove, my excitement was building. I was going to work for the director of *American Graffiti*. I was being paid to move across the country to edit for him, based on his liking my work. I had seen all the stills at Jay Cocks's house, read the script, and visited the model shop and the optical facility. I was heading off to a real adventure. If I had known then what was coming, I might have driven off the road in excitement.

As we drove onto the bridge, I was swept away by the magnificence of the structure in that most dramatic and stunning setting. Looking up at those red towers over our open-roofed car, I cried out, "Brian, Brian!"

"What?" He stirred, opening one eye.

"Look! The Golden Gate Bridge!"

"Ummm. Very nice." He went back to sleep.

We drove on through the rolling hills of Marin County, got off the freeway, and turned onto Sir Francis Drake Boulevard, a main artery in Marin. After a few miles of what in the East would be a country road, we got to San Anselmo, a sleepy little suburb of San Rafael, the largest city in the county. The town consisted mostly of a single main street, two or three blocks long. It had a drugstore, a hardware store, a dry cleaner's, and a few small clothing stores and restaurants.

Brian called from a pay phone in one of the eateries. "George!" He adopted a mock anguished tone. "We're lost! Come get us!"

George figured out where we were and came to lead us to our destination. Shortly after, we arrived at his home on Park Way, a narrow street leading to the top of a small hill just a few blocks away.

The property occupied the entire hilltop, and we were admitted through an electric gate with a security code. There were several cars parked in front of the huge, one-story, hundred-year-old farmhouse, with a large porch. This was George's headquarters. I was introduced to Lucy Wilson, his bookkeeper, who had worked for George for the longest time. I also met Bunny Alsop, a friendly dark-haired woman who worked for Gary Kurtz, the producer of the picture.

Also occupying offices in the main house were writing partners Hal Barwood and Matthew Robbins, friends of George's from his days in film school back at USC. I was to learn that the USC connection was very important in George's life. Matt and Hal had written the screenplay for Spielberg's first feature film, *The Sugarland Express*. They were working on a script for Matt to direct as his debut film.

The cutting rooms were in back, in a separate building, a converted carriage house. Stairs on the outside of the building led to George's personal cutting room on the second floor. This was where Marcia Lucas worked, on a Kem Rapid, which used a joystick like the Steenbecks that were my preference. It was by far the nicest cutting room I had ever seen. It put to shame most studio apartments in New York. It had skylights, redwood paneling, a full bathroom (with shower), a full kitchen, and a comfortable couch facing the Kem's screen. It was as if a wealthy editor had created his dream space to work in. Which was exactly the case.

Downstairs were the other rooms, where I was introduced to Richard Chew, our coeditor, and the rest of the crew. Richard is a few years older

than me. His manner is pure West Coast, friendly and laid-back. In the style of the day, he wore his hair longish and had a mustache. Richard cut on a Kem Universal. He had worked on, among others, two extraordinary films: *The Conversation* and *One Flew Over the Cuckoo's Nest.*

There were three assistants: a tall, dark, quiet, bearded young man named Jay Miracle, who had played basketball at the University of North Carolina and would become a documentarian; an intense, rather intellectual, bespectacled young Todd Boekelheide, who later shared an Oscar for Best Sound for *Amadeus*, then became a film composer; and a pointedly nonintellectual but extremely friendly, cheerful, and likable novice to the editing rooms, Mike Kitchens, who was sort of like Huck Finn come to life. His experience had been mostly in production, and he was a willing and energetic factotum.

In the basement of the main house, across a small walkway, there was a small suite where Ben Burtt worked. He was the sound editor and designer, and his suite was known as Ben's cave, after Ben Kenobi's home in the movie. As it turned out, Obi-Wan's home wasn't a cave at all, but in the original script George had written it that way, and he always called it that.

Ben was another USC find by George. At the outset of preproduction, George contacted the film school and asked them who was the most promising student there with a particular bent toward sound. Ben was in his midtwenties, married to a woman named Peggy, who had a friendly disposition and a hearty laugh. He had a photographic (microphonic?) memory for sounds, and an encyclopedic recall of all the major film studios' sound effects libraries. He could watch a movie and identify a Warner Bros. pre-1954 gunshot. He had traveled extensively over Southern California assembling a library of his own recordings, which he mixed to produce altogether new sounds. He had a map on the wall with scores of pins in it, showing all the places he had gone to record a sound. He had a small synthesizer in the room and used it to produce, among other sounds (and most notably), R2-D2's voice, Chewbacca's barks, Darth Vader's breathing apparatus, light sabers, laser bolts, and the spaceship sounds.

Sprawled on the walkway between the main house and the cutting rooms was George's dog Indiana, a large, relaxed, black-and-white Malamute. Harrison Ford's character Indiana Jones was named after him. The

walkway turned out to be Indiana's favorite spot to nap, and I was constantly stepping over him.

We had arrived on a Saturday, but everyone was at work. I had been hired because they didn't think they could meet their schedule, so working weekends was expected. I sat down to look over George's shoulder as he worked with Richard on the opening of the picture. As they ran the first reel, there was a cut to a young woman in a long white dress, with buns over her ears. It was my first view of Princess Leia. Carrie Fisher wasn't what you would expect in a conventional movie-star princess, but George— and Marcia, who had been instrumental in the casting—liked her spunk. They felt they needed an actress who could credibly stand toe-to-toe with Darth Vader. Carrie became much beloved as the princess.

We kept running the reel. Vader made his entrance, and I could feel the power of that moment, a combination of his build, his carriage, the costume (with its mask and Japanese-influenced helmet), and the sound of his breathing apparatus, as well as the low camera angle that emphasized his massive dimensions. This was exciting. This was going to be great.

Since I had seen him in New York, George had been spending half his workweek with John Dykstra and the crew at ILM in Van Nuys. Late Wednesdays, he would fly back to Marin to work with Richard and Marcia for three days. He took Sundays off, and on Mondays it was back to L.A. to work on the effects again.

All was not well between George and 20th Century Fox at this point. After considerable start-up difficulties, ILM had yet to produce a single shot. Also, the picture had gone over budget by a small margin, and the studio had penalized George 10 percent of his pay. He was upset, of course, but even worse, they were urging him to save money by eliminating the battle sequence that would be the big payoff at the end of the film.

"They've rescued the princess, what more do you need?" they asked. George is nothing if not doggedly stubborn when it comes to contests of will. He was determined that his film would have the end battle he always envisioned and put Marcia to work on it as soon as they got back from England. By putting that sequence on the top of the list of ILM's priorities,

he would begin it before the budgetary ax fell, and it would no longer make sense to cut it. The other shots, it was mutually agreed, were necessary. But he had to have the battle under production before the studio saw the picture, in order to save the scene. It was essential, for ILM's scheduling purposes, that the cut of the battle be completed by the end of October.

When I arrived around the end of September, Marcia was laboriously piecing the battle together, a Herculean task. Her material consisted of shots of various pilots in cockpits, set against a blue screen backing; various shots of the control room in the Rebel base, where Leia and C-3PO followed the course of the battle; and exteriors of the ships. Representing these latter shots, which didn't exist yet, were dodgy-quality black-and-white dupes of various planes from WWII documentary footage. Planes banking, peeling off, coming to camera, going away, some explosions in midair, and so on. Each of these stood for a shot that ILM was going to create. In the corner of the first frame of every shot was inscribed a number, up to three digits, sometimes accompanied by a letter. These corresponded to a master list of the shots that ILM was slated to produce.

Confusingly, the action in the placeholder didn't necessarily reflect what the shot would eventually be. A Japanese Zero crossing left to right might be a stand-in for an exterior of Vader's ship coming toward camera. A shot of a plane diving might stand for a shot of three TIE fighters in the trench. It was rather puzzling. The only thing you could be sure of was that if it was black and white, it was an exterior shot. The action could be almost anything.

The script was a guide, but it was a long sequence and it was easy to get lost in it. Marcia had been working on it for about eight weeks at that point. Meanwhile, Richard had come on the picture in July and was occupied with recutting the work that had been done in England. By the time I arrived, Richard was still mired in the early part of the film. George decided that I should help Richard with the recut, leaving Marcia free to concentrate on the battle. Whichever reel Richard was on, I was to pick up the next one. When Richard finished his reel, he would leapfrog over me to the next reel, and so on.

George and I sat down to look at the first scene I was to recut. It was called the "Robot Auction." In the scene, Luke's uncle Owen buys C-3PO and R2-D2 from the nomadic little Jawas, and we meet Luke for the first

time. The scene looked pretty good to me, although the actor playing the uncle was having trouble with the dry desert wind, and I was distracted by his constant blinking.

"What do you want to do with it, George? I have to say it looks pretty good to me."

"Yeah, I thought so too," he replied, "but Marcia thinks it can be cut better, so why don't you have a whack at it?"

OK, I thought. *Hmm.*

———

I was being put up at a local Holiday Inn, up the freeway a bit from San Rafael in Terra Linda. The route to the hotel took me through San Rafael, which looked a lot like *American Graffiti*—unsurprisingly, since that was where it was shot. The freeway took me over rolling hills past the Marin County Civic Center, designed by Frank Lloyd Wright in midcentury modern style.

The next morning at the Holiday Inn, I opened the curtains and almost fell over. The view was of the gently rolling Marin hills, golden brown, so round as to suggest bodily shapes—backs, hips, or breasts—with dark green trees growing in the seams where two hills met. OK, maybe I was missing Jane. I called her excitedly.

"Honey, it's so beautiful out here! I can't get over the view out my window!"

I was used to living and working in New York City, with the crowds, noise, dirt, and traffic. The idea that a person could live and work in such beautiful, natural surroundings was beyond my imagining. That day, Sunday, I drove to the summit of Mount Tamalpais, the tallest mountain in Marin County, from which there is a magnificent view of the entire Bay Area. I could see San Francisco off in the distance, floating in the clouds surrounded by banks of fog rolling in from the Pacific Ocean, with the Golden Gate Bridge looking like a miniature, and all of Marin spread out under me.

———

Monday morning I reported to work, ready to tackle the Robot Auction. Before beginning, I had a short meeting with Richard and Marcia. We talked about how we would proceed. The thrust of the discussion was mainly that since we were all going to have our names on the film, all our work would be subject to review by one another. None of us wanted to have to live with something that we had a personal problem with. That settled, I asked for the trims and outs. I was cutting on a Moviola, as I had agreed with George.

Without getting into too much detail, cutting on Moviolas is different from cutting on the newer flatbeds, and because the work is physical, practice made the work easier. Conversely, lack of daily repetition made the work that much more difficult. I had now been using the newer machines for almost seven years and had lost most of whatever dexterity I ever had on the older machines. A lot of film editing relied on muscle memory.

Among the advantages of flatbeds was that they were gentler on film and permitted easier viewing by collaborators, like the director. The film was always kept in long rolls (by assistant editors) so that editors reviewed the footage over and over. Many is the time that, while running down to the end of a thousand-foot roll looking for a specific shot, I will notice an action that I had forgotten about that I realize can be of help. With Moviola editing, trims are rolled up individually and can be hard to view. They are sometimes never referred to again. So flatbeds began to make inroads.

At the same time, videotape editing had been invented and was improving. The problem with videotape editing was that it was linear—assembling a series of cuts into a sequence was analogous to slipping rings onto a curtain rod. After putting ten rings on, if you wanted the third ring to switch places with the fourth, as often happens in editing, you would be obliged to remove all the rings except the first two and put them back on in the new order. Film didn't have this problem. It was more analogous to putting coat hangers on a curtain rod. You could simply open up the splices at the beginning and end of a shot and splice it back in anywhere. With rings, you had to slide them off the end. With hangers, you could easily rearrange them to your heart's content.

When more automated systems began to be invented, the goal was to achieve this nonlinear ideal. Flatbeds were a half step back from nonlinear editing, since the long rolls of film meant that if you wanted take 5, you had to wind through takes 1 through 4. While I preferred the flatbed

system, many editors liked the true nonlinearity of the Moviolas, which is why they clung to those machines despite their many drawbacks. On Moviolas, the action was controlled by two foot pedals, two toggle switches, and a hand brake. It was a hands-on, physical relationship with the machine and the film too. Because we deal in rhythms in cutting, it sometimes seemed to an observer like some sort of dance.

So there I was, working on a Moviola, which I hadn't done in a long while. But I had agreed to it. When the Robot Auction trims and outs were brought to me, they were broken down into small rolls. I began by looking at what had not been used, to see what was there. I discovered a shot that began in darkness, and a light began to appear in the corner of the frame and grow as it crossed the screen. At first I didn't know what I was looking at. Then I realized it was an angle from inside the sandcrawler as the door slid open. The shot wound up looking out at the Jawas gathering around in excitement. I pulled it out and used it to open the sequence.

I continued, finding material that had been ignored and reviewing the edited footage as well. I started reshuffling some of the shots, shortening them, tightening the cuts to the action. A rhythm started to develop. I moved on to the dialogue section of the scene, in which Uncle Owen interviews C-3PO. I shortened the head and tail of Owen's shots to minimize the actor's blinking and played more of his dialogue over C-3PO. Some of these trims were just a couple of frames, since there are ideal cutting points in shots, and I felt that the first cut had missed these points, while getting close. But it is the sum of all those missed points that can make a scene feel awkward and prevent it from flowing in an elegant rhythm.

When I was done, the sequence was a minute shorter, a bit over three minutes instead of four, but there was more in it. I called Mike Kitchens to ask him to replace the trim bin, which was now full. He looked at the myriad two- and three-frame trims I had made, which were hanging from the pins in the bin. "What did you do?" he asked. "Put the film through a fan?" He was going to have to cut all those little trims back into the Kem rolls.

"Sorry," I replied. Well, that's how it goes sometimes.

I showed the sequence to Marcia. "That's wonderful, Paul," she exclaimed. "I think George will be pleased."

Marcia is a very warm, supportive person. She values her instincts highly and approaches the work from an emotional perspective. She worked by assembling things in a very rough fashion, even with mismatches, and then she would go back and "finesse the cuts." Personally, I can't work this way. More of a perfectionist, I find it impossible to leave a cut that doesn't work. I will keep at it until I find a solution, although as I've often told my assistants (with apologies to the Rolling Stones), you can't always cut where you want. Marcia was very supportive of my work and gave me constant encouragement, which I deeply appreciated.

One day George came back from his weekly trip to L.A. with a three-inch core in his hand, around which was wrapped about twenty feet of film. In the center of the twenty feet was about one second of usable film.

"Well," he said, "this shot has cost us a million dollars!"

It was the first shot for the end battle, of two antiaircraft guns on the surface of the Death Star firing at the ships overhead, their barrels recoiling as they fired. None of us quite knew what to say. It was a bit disappointing, to say the least. There was a long way to go.

I had ultimately changed so much of the Robot Auction that I decided to change my approach on the next scene and cut it from scratch. I would have the film restored to dailies, and I'd approach it as a first cut. That way, I wouldn't be influenced by the first editor's work, and the result would be more purely mine.

The scene was called "Ben's Cave." It took place in Obi-Wan's home, after he rescues Luke from the Sand People, and during the course of which they hear Leia's holographic appeal for help for the first time. It took a while for the assistants to restore the dailies. Editors rely on the "slates," those clapboards at the beginning or end of every shot, to organize the footage. On *Star Wars*, however, the British slating system was used, which was new to me, and I found it unnecessarily and frustratingly complicated. For the assistants to locate any specific piece of film required consulting up

to three large notebooks, which were cross-referenced. It was ridiculous, and I vowed that it would never again be used on any film I had anything to do with. Over the years, British crews learned to humor the Americans and adopted the American system of slating for American editors. But the British system persists to this day.

Eventually, the assistants located all the film, restored it into original daily rolls, and brought it in to me. I almost fell over. There was so much film! *What have I done?* I thought.

And the takes were rather lengthy too. How was I going to hold them in my hand to feed them into the Moviola? I decided to try to work from the bench, the way Hollywood editors did. I was all thumbs. The film broke repeatedly. It wound up on the floor, and I would roll my chair over it inadvertently. I would start the film playing forward, not realizing my chair was on it, and all of a sudden there would be a tremendous *SNAP* and the film would break, sometimes tearing a length of sprocket holes. I would then have to repair it, spending time and energy fruitlessly. I was miserable and I didn't think I could go on that way. I had to take it up with George. "Listen, George," I began. "I'm really sorry. I know I said I could work on a Moviola, but I didn't realize how long it's been since I did it, and how used I've become to working on flatbeds. I would gladly pay to rent one out of my own per diem."

"Oh, you don't have to do that!" Marcia interrupted. She had been listening to my confession of ineptitude. "I'll work on the Moviola. You can work upstairs on the Kem. Honestly, I'd rather cut on the Moviola. That's what I'm used to."

God bless her. I don't know if she was telling the truth or if she just took pity on me, but I thanked her profusely. She couldn't have been more gracious about it. I moved upstairs to George's personal cutting room, and Marcia moved down to my small one, next door to Richard. The upstairs Kem was a Rapid, and as close to the Steenbecks I was used to working on as you could get in Marin at that time. I thought I had died and gone to heaven.

———————

Ben's Cave is the scene in which the light sabers are introduced. I was fascinated and mystified by the effect. Turning on the swords was accomplished simply: one prop was just the handle, and one had the sword fully extended. The actors would freeze, and the prop man would run into the shot, take the handle away and substitute the full sword, and run out. All we had to do was make a jump cut, imperceptible because the actors hadn't moved, and lay in the sound of the sword going on, provided by Ben Burtt.

What puzzled me, however, was that the sword glowed. I couldn't figure out how they did it. I thought at first that I was looking at an optical, so I checked the key numbers on the edge of the film, which reveal if the film is original camera negative or optical. It was original, which meant the glow had been achieved in the camera. When we started working on the scene together, I asked George how it was done.

It was, typically, very clever. "Front projection," he replied. The wooden blade was wrapped in special light-reflecting tape, like the reflectors on bicycles or on the backs of athletic shoes. A light on the set would make the tape light up. But this would create unwanted shadows. To get around this, the light source was reflected off a one-way mirror directly in front of the lens. The shadows cast by the light would be completely hidden by the very objects casting the shadows. Their outlines would match perfectly. The light wasn't strong enough to affect the actors' faces or costumes, but enough to make the sword glow brilliantly.

I asked George if that was to be the effect in the final film. "No, that's just meant to be a guide for the animators." He explained they would rotoscope (trace) every frame to put color into the swords. The light makes it easier to see them in the blurred frames when the swords are slashing through the air.

"By the way, any thoughts about the colors?" George asked. "I was thinking of making Luke's sword red and Vader's blue."

"I do, actually," I said, harking back to my studies in art history. "In Renaissance painting, the generally accepted Christian iconography had always painted Jesus and Mary in red and blue, with red representing the earthly and blue the celestial. So actually, it would be better to have Vader's be the red sword, and Luke's the blue."

George and I continued going through Ben's Cave. The script describes Luke at this moment as having "stars in his eyes." As he turns to Ben

and asks, "You fought in the Clone Wars?" there actually is a star-shaped highlight in the corner of Mark Hamill's eye.

"Wow, George," I said. "You really shoot the script, don't you?"

But as the scene went on, something began to bother me. "George, I've been thinking, there's something wrong with this scene."

"What?"

"Well, as it stands now, Leia's message plays at the beginning of the scene. Then Luke and Ben sit and talk about the Clone Wars, and how Ben knew Luke's father. He gets up and gives him his light saber, and only after all that, Ben announces that Luke must accompany him to rescue Leia."

"So?"

"Well, it's as if they've just heard this awful news from her, and they don't react. 'The world is on fire!' and they just sit there, talking."

"Hmm, I see what you mean," George replied.

"Can't we restructure it so that they get all that talk about the old days out of the way *before* they play the message?" I asked. "Then, as soon as they hear it, they can react to it."

We moved the beginning of the scene, as written, to the middle. Now when they hear the full message, they react to it immediately instead of ignoring it.

Working for George was a new experience for me, as I had only worked for Brian De Palma up to that point. Brian has a brusque way about him at times, and I was used to vigorous discussions about the cut. Maybe growing up with older brothers, as we both did, made us used to this. George was the youngest of his family but the only boy, so he was more soft-spoken but firm in his ideas. The fact that Marcia was one of the editors as well as his wife made the working dynamic in the editing room a bit tricky at times. Some discussions with George that began with all three of us editors present evolved into a one-on-one wrangle between George and Marcia. Uneasy with these heated moments, Richard would leave. I reckoned that as long as they were talking about the film, I would stay. If it became too personal, I assumed they would ask me to leave, but they never did. I would just stay put and throw in my two cents.

I once asked Marcia, "Is George happy with my work?"

"Oh yes, he thinks you're doing great. Just keep it up."

Bless Marcia. She kept me going when I found it hard to get a read on what George was thinking. "Great" was his standard response, but I began to realize that his lack of enthusiasm was due to his generally glum feeling about getting the job done right and in time.

I settled into a routine at work. I started not to notice the beautiful landscape on my commute. It became the norm, just as the filthy, crowded streets of the city were the day-to-day background of my life when I worked in New York. As Jane is always quoting Dostoyevsky, "Man grows used to everything, the scoundrel."

And I was getting used to the beautiful editing room. Every Friday, the crew cooked lunch for everyone. If I wanted a trim on Friday mornings, I would often discover that no one was around, because they were in the kitchen making a huge pot of pasta, salad, and garlic bread for whoever happened to be around, usually including Matt and Hal. Other filmmakers sometimes came over too. We would lunch in the main house, and Bunny, perhaps sensing the specialness of the time, would snap pictures by the hundreds.

I met the Marin County regulars: directors Michael Ritchie, John Korty, Phil Kaufman, and Carroll Ballard, and some below-the-line folks like Robert Dalva and Walter Murch, who later got their shots at directing. ("Above the line" and "below the line" distinguish producers, directors, writers, and stars from film craft workers such as cinematographers, editors, etc.) Ritchie had just directed *The Bad News Bears*, and he and I talked about his use of Bizet's *Carmen* on the soundtrack and how essential that had been to the success of the film. Phil Kaufman turned out to be a really warm and friendly person and invited me into the city to visit his extraordinary Victorian home. I was told that Ballard was actually talked about by his peers as the "legendary" Carroll Ballard, based on his film school reputation and promise. He was widely thought to be the most talented of them, although there were certainly a lot of gifted people around. He was a dour, grumpy guy, but obviously smart. He was considered to be more comfortable with animals than with people. He had yet to direct *The Black Stallion*, a visually stunning film classic. The first half of the film, in which the young boy is stranded on an island with the horse and

gradually establishes a relationship with him, is told in purely cinematic terms, without dialogue, and is powerfully moving. Many in this community were USC film school graduates, and I felt a little envious, both of their college experience and of the bond between them.

I spoke frequently with Jane, who was still in New York. We decided that she would join me in December. It was a major decision, because the baby was due in March, and Jane had to accept the idea of giving birth away from New York Hospital, a teaching hospital where she was working and for which she had the highest respect. Jane was working in the anatomy department at Cornell University Medical College. They were experimenting in early artificial intelligence. Now, it made her more than a little nervous to think about having the baby at a suburban hospital like Marin General. But we didn't want to be apart.

October slipped by, and *Carrie* was scheduled to open on Halloween, at midnight. George was an early riser and was almost invariably in bed by ten o'clock. It was a real honor when he and Marcia offered to join me at the midnight opening in San Rafael, especially since they had already seen the picture in New York. Afterward, it was getting late, so we talked about the picture the next day.

"Brian's two smartest ideas are at the beginning and end," said George. "It's very unusual to see full frontal nudity in a film, and it's almost always near the end of the film, in reel 9 or so. Brian has that scene in the girls' locker room as the second shot in the movie! Doing that completely unsettles the audience and sets them up for the entire rest of the picture. It's a great way to throw everybody off balance. They see that and think, 'This director is liable to do anything!' The other brilliant stroke was to have that big scare come so close to the end. The crowd for the ten o'clock show, waiting in line outside, hears a big shriek from inside the theater. Then, seconds later, the doors burst open and the audience comes out bubbling with excitement. So you go in with that in the back of your mind, and you're wondering what could have caused it. You're on your guard, but then the movie seems to be over when it finally comes and takes you unawares anyway. Brilliant!"

George was very analytical in his approach to directing. As I had only worked with Brian before, it was interesting to get to know someone new, especially someone as gifted as George. Saturday mornings, the pressure on him was off, and we would engage in long, rambling conversations about various aspects of filmmaking.

George lived by certain principles in his work. "You should always end your pictures with your best scene. You should start with your second best, and in the middle, you need another, sort of tentpole scene, to prop it up and keep it from sagging." He wasn't using *tentpole* in the sense that the term has since acquired.

In *Star Wars*, George's tentpole was the cantina sequence, which he planned to reshoot. The first time around, he wasn't happy with the aliens. They looked too much like something out of *Peter Rabbit*, with giant hedgehog-looking creatures. He had an artist design a couple of dozen different space aliens and asked me and others to vote on which ones we thought were the coolest. The reshoot would take place much later, in February, and it definitely helped that sequence become the stunner that it was. Up to that time, directors pointedly shied away from showing aliens too clearly, because they usually looked like men in rubber suits. The cantina sequence changed that.

George also used to say, "One bad idea can spoil ten good ideas, and one minute of bad film can ruin ten minutes of good film." For instance, if a set or prop looked phony, if the makeup or hair stood out in a bad way, if the writing or performance was poor, or even if a bad extra did something distracting, it could destroy all the good work that went into everything else.

He also said, "Better a bad cut than bad film." This went against the grain for me. As an editor, I wanted every cut to be smooth and elegant, but the truth of that statement was undeniable. "A bad cut only hurts for a fraction of a second; bad footage can spoil the movie."

George compared making a movie to an ocean voyage. "You know when you have set sail, and you hope you know where you're going, but there are times when you're out there in the middle of the ocean and there's no land in sight anywhere."

These Saturday morning bull sessions were the best times I spent with George. He had obviously thought a lot about these things, and he was

relaxed and communicative. He shared with me a conversation he'd had with his mentor, Francis Ford Coppola. Francis had told him he had to be able to write, that he wouldn't get anywhere in the business without that ability. George then went on to tell me that editing was his first love, and that he only directed in order to have something to cut, and he only wrote in order to have something to direct.

George had a full beard, as I did, which was almost de rigueur among filmmakers our age. (George is exactly eighteen months older than me.) He hadn't grown his hair long but kept it in an Elvis-like pompadour. It wasn't jelled or anything, but he has wavy hair, and the combination was unique. Occasionally, during our chats, he would pick up a pair of scissors, absently reach behind his head while continuing to talk, and snip an errant curl that had grown out too far.

He was always fascinating and was in many ways the most remarkable man I have known. He combined an artist's free imagination with hard-headed business sense. He had a strong work ethic and an equally strong emphasis on economy and thrift. To outward appearances, he was just another guy in jeans and a plaid or blue oxford shirt and running shoes. He was unpretentious and, in his own way, very generous. He had given many of the crew who worked on *American Graffiti* a car as an end-of-the-picture bonus. He was a tough negotiator, but after the deal was done he could show largesse.

He was not, however, generous with compliments. "You're a genius!" Brian would exult at me at times, in mock over-the-top praise. There was nothing comparable from George. That wasn't his style. I had to go to Marcia for reassurance that everything was OK. But George was very forthcoming when talking about film theory. He told me he had calculated that he could approach the casting of the princess in one of two ways. He could have cast a woman who would have appealed more to the *Playboy*-reading male audience, or he could go younger and try for the prepubescent audience. He chose the latter.

"This is basically a Disney movie," he said, "and those movies always make $16 million. You can look it up. This picture is going to cost about $10 million, so it probably won't turn a profit, but we should be able to make some money if we sell some toys based on the characters."

When the picture opened and became the highest-grossing picture ever at the time, George proved to be just a bit off in his calculations. Adjusting for inflation, *Star Wars* grossed over $3 billion in its first run.

Jane came to visit one weekend, and we started looking for a place to rent. She would be coming out to stay in December, and while the motel would do for me, it wouldn't for the two of us. Or three! We found an apartment in Sausalito, overlooking the bay. I was a little nervous about it, as it was built on stilts. But Marcia offered to come check it out for us, and pronounced it safe. I loved it. At night, we could hear the seals in the bay barking, and the fireplace made it very cozy.

Around that time, Gary Kurtz showed up at Parkway, as the office/cutting room was known. He had produced the film but deferred to George. Gary's concept of his job was to make sure George could execute his vision without interference. I liked him right off. I found him to be stolid, good-natured, friendly, and technically knowledgeable in an engineer's sort of way. I kidded that he was sort of half man, half slide rule. He was soft-spoken, unfailingly polite, had a full beard sans mustache, and his hair was always well groomed. It turned out that he and his family were Quakers and were very warm and hospitable. He had also attended USC film school and had met George back then.

As I made my way through the picture, recutting scene after scene, George never wanted to let me see more than the reel I was working on. So as I finished each reel, each new one was a surprise and my excitement grew more and more. This looked like it could be a terrific movie. It was a combination of many genres. There were elements of westerns, with Indians ambushing the settlers in the pass and gunfights in saloons; Arthurian references, with round tables, sword fights in the corridors of the castle/Death Star, dungeons, and a maiden in distress; sci-fi, of course, with its robots and alien creatures; and WWII Pacific air battle films, with pilots

in jetlike cockpits and command centers with large see-through maps. All these familiar ingredients had been stir-fried into something fresh and new.

George even drew on foreign films as inspiration, acknowledging the great Japanese director Akira Kurosawa's *Hidden Fortress* as a major influence. The result, however, was quintessentially American. It was as if that boy from a farming community out in the Central Valley had conjured up this dream from all the movies he had ever seen. As the son of an office supplies store owner in Modesto, George knew what it felt like to be Luke Skywalker, far from the action and longing to be more a part of it. It was no accident that the main character was named Luke.

———————————

As we went on, the deadline for completing the end battle was approaching, and the cut was still not done. George decided to break the scene in two and put me to work on the last third of it. I was to start with Luke's trench run, the third of the attempts at blowing up the Death Star. As I set to work, I had to decipher what the black-and-white shots actually represented. There was one shot in particular for which we had nothing, not even a placeholder. Someone, I presume it was Marcia, had taken about a foot of painted leader, or blank film, and scribbled a series of loops on it, like a string of cursive *e*'s, in black ink. When projected, it looked like an animated blob pulsing for about two-thirds of a second. This was a key shot in the sequence: it represented the *Millennium Falcon* coming straight toward camera with the sun behind it.

The shot comes at the moment Han Solo returns to save Luke just as Vader has him in his sights, and we cut from it to a shot of Han and Chewie in the cockpit cheering "Yahoo!" Marcia was fixated on that moment, not without reason. It combines Luke narrowly escaping death with Han revealing himself to be more than the cynical money-grubber he pretends to be. "If the audience doesn't stand up and cheer at that moment, the picture's not going to work!" she said more than once.

She was right. But I was sure the moment would work and constantly assured her it would. As I began to understand the workings of the sequence and the shots that were still to come, an idea came to me. As a New Yorker, this was my first experience working someplace that

people drove to, and it had struck me one morning that you could tell who was already in the office by which cars were in the lot. If I saw George's beloved Camaro parked outside, I knew he was there.

In the editing of Luke's run, I found myself confused about which ship Vader was in. "George, why don't you make Vader's ship look different from the other TIE fighters?" I asked. "It'll be a lot clearer."

He agreed. The model shop altered the wings of one of the TIE fighters, folding them top and bottom, to give Vader a unique vehicle.

————————

It soon became clear that there really wasn't enough material yet to create the tension that would make the end battle scene fully satisfying. I thought we needed more shots to cut back to that would show that the Death Star was about to blow up the planet. The new material would serve as a clock, dramatizing that time was running out. To do it effectively, though, we first had to set the example, constructing a similar sequence earlier in the film when General Tarkin orders the Death Star to destroy Alderaan. This earlier sequence would serve as the model for what would happen if Luke failed at the end. George agreed and added a few more shots to the reshoot list.

Finally, our time for delivering the battle was running out, and we had to finish the sequence. Marcia and I combined our two parts, hers being longer and mine being the climactic bit, and we set to work locking the sequence with George. We worked as a tag team at the Kem. At first, I would "drive"—that is, sit at the controls—and make the changes while George and Marcia sat on the couch calling out suggestions. Then, after a couple of hours, I would take a break and Marcia would drive, and I would sit back on the couch with George. We went on like this for two or three days, until finally we were done. George took the sequence down to ILM, and I went back to recutting the reels.

————————

The head of 20th Century Fox, Alan Ladd Jr., was coming to see the film shortly before Christmas, and we needed to get through the whole picture in time for his screening.

"Why don't we screen the picture as is, and target the areas most in need of work?" I asked George. "If a scene looks like we don't need it, we could save the time spent on recutting it."

"No, I want to get every scene working as well as possible before we do that."

So, we went through every reel to the end before we screened the whole thing. This is when the really interesting work begins, after you have seen the whole picture. Certain things were apparent right off. Beginnings and endings of movies are often problematic areas. Once the plot is in motion, it's normally smooth sailing. But setting up the premise and giving the audience the information they need to follow what's going on can be tricky.

George's inspiration for the opening of *Star Wars* was Kurosawa's *Hidden Fortress*, in which two lowly serfs stumble around in the midst of a war, arguing with each other. Following their story eventually leads to the real story of the film. It's an ingenious way to begin, and surely would be new to American audiences. I did not know the reference at the time. The problem came soon enough, however.

During the course of the battle in space over Tatooine, we cut to the flashes of distant laser-gun fire seen through binoculars. The binoculars belong to Luke Skywalker, who is watching the battle from the planet below while doing chores on his uncle's farm. He is standing in a seemingly endless desert next to some large metal "vaporators" that would not seem out of place in an oil field. He addresses a few words to a robot, or droid, then jumps into his landspeeder and takes off.

After more scenes on the spaceship involving Vader and Leia, we cut back to Luke arriving at Tosche Power Station, a local teen hangout. He gets into a long expository scene with his friend Biggs, back from the academy, where he has been training to be a Rebel starfighter. Luke expresses his deep longing to be involved in the Rebellion against the Empire. We then go back to the spaceship as R2 and 3PO escape to the planet below.

I saw several problems with this construction. First of all, the shots of Luke standing next to the vaporators didn't cut well from one to the next. Second, there was nothing to identify the Tosche Power Station set as a teen hangout. There were a couple of young people lying around, but what they were meant to be doing was ambiguous and the result was confusing. Finally, the scene with Biggs was talky, covering information we

would eventually learn anyway, and was not terribly well acted. To make matters worse, the character was wearing a cape. The scene was shot on a windy day, and the cape kept being tossed around in editor-maddening ways, sometimes over one shoulder, sometimes over the other, making continuity impossible.

It occurred to me that we could lose the whole sequence, so we tried it. It worked great. We didn't miss the film we took out at all, and there was an unintended benefit. Now, when R2 and 3PO land in the desert, we know nothing about the planet they are on. It becomes a mysterious, ominous, and lonely place. We don't know if it is even inhabited, or by whom, and the first sign of life that we see is a skeleton of a large dinosaur. We still don't know if there is intelligent life on the planet. Then we meet up with the Jawas, who capture the droids, which brings us to Luke at the robot auction. Our main character had now been introduced organically into the story, instead of arbitrarily cutting to him in the midst of the battle.

I am a big believer in taking scenes out—if you never try it, you will never know what the effect will be. I was later to learn that some directors are afraid to experiment that way.

There was also a scene in which Han Solo walks into the hangar housing the *Millennium Falcon* and Jabba the Hut accosts him. An Irish day player was playing Jabba. He was awful. There's no other way to put it. I told George. He agreed.

"Why don't we just lose the scene?" I asked. "We don't really need it. He is just repeating the same information as was in the Greedo scene. We don't actually learn anything new."

George was reluctant, but he agreed that the actor was truly bad. We couldn't even revoice him, which is sometimes done with a really poor performance. In this case, his hand gestures were grotesque, exaggerated, and mannered, and there was nothing to help that.

"What I'd really like to do," said George, "is to matte him out and replace him with an alien of some kind."

This struck me as one of the funniest things I'd ever heard. I could just imagine this poor actor going to the opening and discovering that he'd been replaced by a creature. The notion of matting in an alien struck me as comical. But George was serious. He actually conferred with the wizards at ILM about it.

"They can't do it," he told me, "because at one point, Harrison sticks his finger into Jabba's chest, and it disappears into the fur of his costume. That means they can't pull a clean matte. Otherwise I would do it."

I thought the movie played fine without the scene, but twenty years later, when the technology had caught up with George's vision, that's exactly what he did in an enhanced rerelease. By that time, he had redesigned Jabba as we know him today.

––––––––––––

Around this time Jane, five months pregnant, came out to join me. All the wives in the local film community were aware of this, and Janet Robbins, Matt's wife, hosted a baby shower for her at their home in Inverness, a tiny town another thirty or forty minutes away near the ocean. Barbara Barwood made Jane a quilt for the baby. The warmth with which we were accepted into a cozy community of filmmakers and their families struck me profoundly. They didn't know us but couldn't have been kinder and more welcoming. It remains a wonderful memory.

Christmas 1976 was fast approaching, and a buzz started to go around the community: Francis was coming home for the holidays. Coppola was off in the Philippines shooting *Apocalypse Now* and had decided to take the traditional Christmas hiatus and return to the States. His crew were just in the process of setting up their cutting rooms in San Francisco, and editors were arriving from New York, Jerry Greenberg among them. Jerry was a hero to New York editors, including me, as he was a local boy, a graduate of City College of New York, and at that point the only New York editor ever to win an Oscar, for *The French Connection*.

First to arrive from the location, however, was Vittorio Storraro, the cinematographer who had worked previously with Bertolucci. Vittorio spoke hardly any English, and I was invited to join George and Marcia, along with Gary Kurtz and some others, to lunch with him at a local French restaurant. George knew that I spoke Italian, so here I was being an interpreter again, even though my Italian is nothing to brag about.

"Vittorio," someone asked him, "when you are shooting the big helicopter battle"—word had already gotten back about this famous scene—"and

you have ten cameras all over the place, can you really say that the cinematography is *by* Vittorio Storraro?" I duly translated.

Storraro bristled, and answered in English, "Yes! Yes! Is mine! Is all mine! Everybody shooting my cinematography!"

From Storraro's impassioned defense of his credit for all the camera operators' work we then moved on to the subject of style. "Do you have a style?" I was asked.

This is a difficult issue for editors, and I have at different times been on both sides of the debate. That day I answered, "I try to cut based on the needs of the film, not based on some personal philosophy. So, no, I would say I don't have a personal style that I apply to all my projects."

Vittorio harrumphed. "You can't call yourself an editor if you don't have a personal style." He was certainly not worried about being diplomatic with me. I know what he meant, though. Editors have to bring something that is particular to us as individuals when we cut, and we do. We all have different sensibilities and instincts. Give any number of editors the same material for a scene, and we will turn out just as many different versions of the scene. You can't be a "dissolves" editor or a "quick cuts" editor. You have to use what is appropriate for a given set of aesthetic problems. But each editor will have a different approach, so in a sense, Vittorio was right too.

Coppola had been gone the whole time I had been in Marin, and I hadn't fully appreciated to what extent he dominated the film community there. He was a towering figure, on the heels of directing *The Godfather* and *The Godfather, Part II*, and George wanted to show his mentor the picture when he returned, to get his advice and approval.

Matt and Janet Robbins decided to have a party at their home in Inverness to welcome Francis back, and everyone was invited. He arrived late, making a dramatic entrance by driving up in a Tucker 48, a car with three headlights invented by the subject of Francis's later film *Tucker: The Man and His Dream*. I had never seen one before. It had a midcentury *Popular Mechanics*, sci-fi-modern look to it.

Everyone was very excited that Francis was back, and at the party he went around the room greeting people. When we were introduced, he

extended his hand without offering his own name, as if it were common knowledge who he was—which was, in fact, the case.

I wandered into the kitchen and was standing near the refrigerator when he came in and engaged me in conversation. "So, I understand you're here to work on *Star Wars*," he said. "In what capacity?"

I told him, as an editor.

"Oh, an editor, well, you'll surely appreciate this."

Conversations in the room stopped to hear what Francis had to say. I realized that, in Marin, Francis was like the old EF Hutton commercial: when he spoke, everybody listened.

"I am bringing this fellow out from New York, Jerry, Jerry . . ."

"Greenberg," I supplied.

"Yeah, Jerry Greenberg. I'm going to say to him, 'I've shot about a hundred thousand feet of film for this one scene. Just take the next six months and give me the greatest six-minute helicopter battle that's ever been cut!'"

I was aghast. Let me explain. Jerry Greenberg, the Academy Award–winning editor of *The French Connection*, was being relocated across the continent along with his family, with all the attendant strains on them, such as school and lives interrupted, to work on *six minutes of the finished film*! What a colossal insult! I was stunned into silence. The kitchen was quiet.

Francis went on, "What do you think? Wouldn't that be great?"

I thought it was the worst idea I'd ever heard.

"Imagine not having to worry about anything else! Just the one scene!"

Everyone was waiting to see what I'd say. I had only just met the man, and he was *Francis Ford Coppola*, for God's sake. *The director of perhaps the greatest movie of all time.* I couldn't very well tell him what I really thought. But I couldn't bring myself to lie either. I looked down at my shoes, then up at Francis again, then down again. I was mute. To me it was as if he were hiring a great architect and asking him to design only one room in his house. I thought it would be terrible to be in such a position. I would hate to have such limits placed on my contribution to the film.

The pause grew until it reached truly awkward proportions, and I finally muttered, "It sounds like either an editor's dream or an editor's nightmare."

Francis gave me a strange look, replied, "I guess it has to do with your attitude," and walked away.

Well, as they say, you only get one chance to make a first impression, and I knew I had not made a very good one on Mr. C.

The deadline toward which we had all been working so hard for months arrived: the head of 20th Century Fox came up to see the picture. Alan Ladd Jr., or Laddie, had an extremely low-key, relaxed manner. Even though the film was in the best shape it had been in since I started, I wondered what the studio chief's reaction would be. It was still very rough looking, especially the end battle, which could only really be deciphered by referring to a list of yet-to-be-completed shots.

At the end of the picture the house lights came on. Laddie turned to George and simply said, "Great."

I have always wondered if he simply decided that he was committed to it no matter what he thought. In for a penny, in for a pound. Or perhaps he didn't know what to make of it and was embarrassed to say so. Or maybe he really did think it was great. Who knows? George explained all the reshooting he wanted to do, and all the effects work that ILM had yet to deliver, and Laddie just nodded. And that was that.

My contract to work on *Star Wars* was up at the end of the year. Marcia, who was my contact in things like this, came to speak to me. "Marty Scorsese's editor, Irving Lerner, has died."

"Oh, I'm sorry." I hadn't known the man.

"Marty has asked me to come down to L.A. and take his place," Marcia continued. Scorsese was working on his director's cut of *New York, New York* at the time, and he and Marcia had a close working relationship, having collaborated successfully on *Alice Doesn't Live Here Anymore* and *Taxi Driver*.

"Is that something you want to do? And would George be OK with it?"

"Oh yeah, I would love it. It's really more my kind of movie, with real characters and relationships. And George is fine with it. He realizes that

Marty is in trouble, and anyway, he wants to finish the picture with just one editor, and he's decided he wants it to be you."

I was surprised and thrilled. I had assumed that Richard had been hired through the end of the film, but apparently his deal was the same as mine, only through the end of the year. I assume he was disappointed, as I would have been. We have never discussed it. I was immensely flattered that George chose me. There were reshoots planned, and all the ILM shots had to be cut in and the fine cutting completed. This was exciting.

———————

Marcia decided to have a New Year's Eve party. A hundred or so guests were coming, everyone who was anyone in the Bay Area.

"I've made a deal with Francis for you," George announced. "He is having a New Year's Day party, and we are inviting his production designer to our party, so you can go to Francis's."

I thought that was great. Park Way became the venue for a party complete with a Zydeco band for a hundred of George and Marcia's closest friends. All the familiar faces from the previous three months were in attendance, as well as many new faces from the Coppola tribe.

Jane was six months pregnant by then. At the party, she met Marcia Dalva, who was seven months pregnant. They began talking and comparing notes, with Marcia, who was expecting her second child, advising Jane about what to expect. It turned out that they even shared the same doctor. Marcia is a gifted artist and sculptor, and her husband Robert had been given the task of shooting new wide shots of Luke in his landspeeder in the desert. Robert was an editor as well as a cameraman and became a good friend. A bluff, good-hearted man with a great sense of humor and a hippie's full beard and head of hair, he is an avid reader and is curious about anything and everything.

The next day, January 1, 1977, the party was at Francis's home in Pacific Heights. He owned a beautiful Victorian mansion, known in San Francisco as one of the Painted Ladies. They are beautifully restored examples of the style that was prevalent before the great earthquake and fire of 1906. Francis's was on Broadway, and magnificently appointed. Upon entering, there was a Miró on the wall in the foyer, alongside a

player piano that had paper rolls cut by Chopin himself. In the front parlor was a Warhol with multiple portraits of Marilyn Monroe, next to a long seat in the bay window facing the bay, naturally. The inner parlor's ceiling was decked with wooden coffers with ornate knobs hanging down. The long dining table seated at least twenty, and behind the kitchen was an aviary two stories high. Downstairs, there was a screening room with two 35 mm projectors, for continuous projection. Just outside in the hallway was a Scopitone, a 1950s French jukebox that showed film with each song selection, an early ancestor of the music video. Eleanor Coppola had a fully equipped color darkroom down the hall.

Francis presided, dressed in Viet-Cong-like black pajamas, and was at his slimmest. There were many luminaries present, a great number of whom came from a slightly more artistic, European branch of the film business. Francis had chosen to show a movie from the USSR about a soils engineer in Siberia or something. I remember it as tedious, beyond its built-in curiosity factor. Dennis Hopper was there, drunk or high on who-knows-what, and was overreacting vocally throughout the picture, to the point of embarrassment to many others in the room. The food was great, of course, and with a dazzling array of film celebrities on hand, the experience was memorable, to say the least.

———————

Then it was back to work, and from that time on I was the only editor on the picture. I liked the challenge and the responsibility, and it simplified things. When there had been three of us cutting, we would consult on each other's scenes. Now that I was alone, I only had to clear my suggestions with George.

Some significant reshooting was scheduled for this period. Additional footage of R2-D2 traveling through a canyon was shot, with Jawas lurking in the surrounding cliffs. George also reshot portions of the cantina sequence as planned, with new cutaways of the various aliens around the bar, as well as of the band. As a temp track in the cantina I laid in Benny Goodman's "Avalon" from his Carnegie Hall concert. It was really perfect, a kind of bouncy, light cue that played well under the dialogue. I thought it would be funny to have Benny Goodman actually playing in this bar

at the end of the galaxy, but George nixed that idea and John Williams came up with something equivalent but better, of course. If you listen to "Avalon," you can tell how John retained its spirit. George designed a shot of the band, with the leader playing a clarinet-like instrument.

I had been coming up with ideas for temp music all through the cutting. George had asked me early on if I knew classical music. He had been using Holst's *The Planets*, as well as the *New World Symphony* by Dvorak and parts of Stravinsky's *The Rite of Spring*. He had laid in the "Dance of the Adolescents," the rhythmic, pounding stuff from the *Rite*, in some of the early battle scenes. I suggested using the introduction from the second part, the "Pagan Night," in the desert. We used it when we first land on Tatooine with R2 and C-3PO. Later we used the vaguely Middle Eastern–sounding theme on the English horn with the tambourine accompaniment when the Jawas are carrying the stunned R2 to the sandcrawler.

Ben Burtt also came up with some good musical suggestions from old movies. For the scene in which the *Millennium Falcon* is captured by the Death Star's tractor beam and pulled inside, he suggested the music accompanying the approach to Kong Island from Max Steiner's score to the original *King Kong*. Although John Williams followed our temp track to a surprising degree, in this instance he departed from our suggestion. Instead of playing tension and foreboding at being drawn into the Death Star, which was what the Steiner cue had done, he played tension but added the Empire, with trumpet flourishes as might accompany a victorious Roman general's triumphant return to Rome.

When stormtroopers are searching the ship and our heroes pop up from a hidden compartment below the deck, I laid in a cue from *Psycho* beginning with its famous three-note signature in the low strings as a little homage to Benny. John recognized it and actually quoted it when he composed the score, a detail that gives me pleasure. It did not appear on the soundtrack album, though.

Ben also came up with Erich Korngold's Oscar-winning theme from the 1938 *Robin Hood* to play under the crawl at the beginning of the movie. George had experimented with something from Kurosawa, but we all ganged up on him and got him to change it. It was just too bizarre and didn't capture the heroic spirit.

The special visual effects started rolling in from ILM. I was cutting them one by one into the battle, and the process was fascinating. The blue screen backgrounds were being replaced by star fields or shots of the Death Star trench walls, and the sequence started coming to life. Pilots would suddenly appear to be in moving spaceships instead of on static wooden sets. And the exterior shots began to make story sense instead of being random WWII planes diving and banking.

From time to time, the shots would come in a frame or two short and I would try to make them work, but sometimes there was dialogue in the foreground and I couldn't spare the frame that was missing without the shot feeling cut short. I would have to ask ILM to recomposite the shot with the proper number of frames. I'm sure it drove them crazy.

In addition to the canyon and the cantina sequences, I also completed the destruction of Alderaan, with the new "clock" footage, and integrated similar shots into the last part of Luke's trench run, leading up to the explosion of the Death Star. I stole a few frames of a profile close-up of Peter Cushing as Tarkin to insert just before the actual explosion, to give the moment a more personal quality, to remind the audience that the villain was getting his at last. Without that shot, we would have been cutting from one visual effects shot to another, without people in the action. It seemed too cold and impersonal. It was the same technique I had used in *Carrie*, when I cut to a huge close-up of Nancy Allen's smile just before the blood splashes down on Carrie. I also worked a lot on the sword fight between Ben and Vader. George was never really happy with it. When Richard and Marcia were still on the picture, he had all of us try our hand at it, but it never was as he imagined it.

That fight directly precedes one of my favorite editorial moments in the picture, when Luke, Han, Chewie, and Leia join 3PO and R2 in the control room off the hangar where Ben is dueling Vader. I like that convergence of all the characters to one spot simultaneously. I put the sensibility I had developed working with De Palma to good use. We see and understand the geography by virtue of using the angles as POV shots from the different characters' vantage points. The timing of their break for the ship, intercut with Ben's self-sacrifice and Luke's anguished reaction in the

middle of the gunfight that breaks out, all contribute to a very satisfying moment, hugely amplified by John Williams's brilliant music.

And of course, like almost all the action scenes in the picture, all the explosions are double-cut, using A and B cameras on the same action, to make the production seem bigger than it really was. In many ways, *Star Wars* really is a kind of a low-budget movie, and very often we used every single usable frame of a given shot. Richard even stretched a shot of one of the Sand People waving his weapon over his head, making it longer by rocking it, optically rephotographing, and repeating frames.

The low budget reflected itself in other ways too. Jane and I had been given one rental car for the two of us. Every day, Jane would drive me to work, drop me off, and go back to the house to dream about the baby and do some sporadic work. Cornell, where she worked, had equipped her with a terminal that connected to the mainframe at the school via an early phone handset modem.

At the end of each day, she would come pick me up. There were days, however, when George and I weren't ready to knock off, so she would sit quietly in the editing room, knitting away. I have often thought that there are many film students or historians who would have loved to be a fly on the wall during the cutting of *Star Wars*. But Jane is not a film nut, and since there was no way to know that the picture would become what it became, she didn't pay much attention.

One evening on the way home, however, she offered me a piece of advice: "Honey, you've got to let George win *some* of the time."

I have always believed that you can't be shy as an editor. If the director doesn't endorse a choice you've made, you have a responsibility to defend your point of view. By arguing for your position, you subject the director's ideas to challenge, so that even if eventually the director still overrules you, he is made more secure in his position by having had to defend his ideas. Good directors understand this and know that in Hollywood, you can "die of encouragement." A friend of mine said that the way to measure the thickness of a director's skin is with a machete and a yardstick. The job is not for people who are oversensitive. In fact, a certain degree of insensitivity seems to be required to be good at the job.

As I have aged, I have become less insistent. If the director is torn, I tell him or her, "Follow your instinct." The director has gotten to be a

director by using that instinct. And the director has the most on the line. Directing careers can crash and burn with a film's failure. There is nothing worse than listening to someone else against your own better judgment and having the picture fail. If you're going to fail, at least let it happen because of your own choices. Herbert Ross had an embroidered pillow that read, ARTISTIC SUCCESS IS DELIBERATE. COMMERCIAL SUCCESS IS ACCIDENTAL.

Some directors have difficulty making decisions. They operate out of fear that there is a better possibility they haven't thought of. My philosophy about decisions is simple. If there were a huge difference between two courses of action, the choice would be obvious. If the two possibilities are very close and the choice is *not* obvious, then choosing one over the other won't matter much. I prefer making a slightly worse choice to getting hung up in indecision.

We were now working at a furious pace, six days a week being normal. I had missed out on the presidential election in November, too busy to really notice when Jimmy Carter was elected. Now, while the rest of the country was transfixed by the TV miniseries *Roots*, which became an absolute cultural phenomenon, I missed that too, cutting and recutting, refining and polishing.

We were so absorbed in the picture that we started to speak to each other only in lines from the script, because that was all we were exposed to. One line that got a lot of use was "It's not over yet." Also popular were "Easy? You call that easy?" and a riff on Luke's line "Sand People . . . or worse." We would say, "Sound people . . . or worse." And of course, the famous "I have a bad feeling about this."

The cuts we made at the very beginning of the picture came into play at the end. Biggs, Luke's friend from the power station scene that we cut from reel 1, comes back in the end battle. We had to cut out a scene where he and Luke run into each other in the hangar before the battle. There are still shots of him getting killed, but the audience feels worse when R2 gets blasted.

One day we went into San Francisco, about forty-five minutes away over the Golden Gate Bridge, and visited the *Apocalypse Now* cutting rooms. Richie Marks was there and showed me a few minutes of the film on his Moviola. Richie was a fellow New Yorker who had been an assistant editor on *The Rain People*, directed by Coppola, and then coeditor on *Serpico* and *The Godfather, Part II*. He was a genial but intense man, endowed with a full, dark mustache. We'd met through mutual friends in the Dede Allen orbit and became friends ourselves. Now, years later, here he was, supervising editor on *Apocalypse*. He was finding, as I was, that the West Coast offered opportunities way beyond what came along in New York.

Editors usually never show cut film to anyone without the director's permission, but we make an exception with other editors, because we know how to keep our mouths shut. Richie ran the arrival of the Playboy bunnies by helicopter and the ensuing riot, cut Creedence Clearwater Revival's "Susie Q." It looked spectacular.

Around this time, George decided to screen *Star Wars* for some of his friends and colleagues, the now-famous "directors' screening." The screening was set for late morning, as some of the guests were flying up from L.A. As it happened, there was a great deal of fog that day, and the flights were delayed. I kept working all morning, never getting up from the Kem until it was time to start the screening. Steven Spielberg was there, along with Brian De Palma, Jay Cocks, Willard Huyck, and Gloria Katz, as well as Marin regulars Hal Barwood and Matt Robbins. Scorsese had been invited but had bowed out at the airport in L.A., claiming that his asthma was acting up. I think it came out later that he was just afraid he would hate the picture and didn't want to embarrass George or himself.

The group that assembled were all young, all in our thirties, and accomplished players in a new generation of professional filmmakers. Everyone seemed excited by one another's presence, and the mood was collegial and even bubbly. I was still working furiously, making last-minute adjustments almost up until the very moment the screening began, so I missed a lot of the repartee as each of the group arrived.

The screening room at Parkway was the plushest I had ever seen. Every seat was a large, upholstered armchair, such as you would have in your living room. Down front, there were several couches with ottomans, which allowed viewers to stretch out as if they were at home in bed.

"Boy, you really are confident," I told George when I first saw it. "With a room as comfortable as this, a picture has to be really good to keep the audience awake."

After the screening, we all went to lunch at a local French restaurant. I remember the mood as being very supportive, and the general feeling being that the picture basically worked in terms of storytelling and that there was still an enormous amount of work to be done on the visual effects.

Brian was the most skeptical and critical. He couldn't resist tweaking George, deploying his barbed sense of humor. "What's that stuff about a tractor beam, George?" he asked, teasingly.

When it was explained, he said, "Oh, you mean the big magnet?" and on and on.

"And what about the Force? *Pull-leeze!*"

By this time George had had enough. "Well, maybe if your movies had the Force in them, they would make more money!" he snapped.

He had been smarting under the taunting and lashed out, and Brian was stung. But apart from that moment, which passed relatively quickly, the mood was positive.

On one comment there was general agreement: the opening text was not right. Many of us thought it was not specific enough and didn't deliver us properly into the first frame of the movie. We went back to the editing room, and Jay Cocks, Brian, and the Huycks rewrote the three paragraphs.

The following week another screening was held for Fox executives. They flew up and arrived at the Parkway house in a chartered Greyhound bus. Their suits were in stark contrast to the jeans and sneakers we all wore. They watched the picture and departed, agreeing that time was awfully short to get everything done by the release date, May 25. I heard years later that many of them thought the picture was a disaster.

The next step was to spot the music, which means identifying the specific moments in the film, down to the exact frame, where we would introduce music and where it would end. We would also talk about the character of the music for each of these instances, listening to our temp track, and how it should modulate depending on the action. The spotting session included John Williams (composer), Ken Wannberg (music editor and sidekick), Lionel Newman (head of the music department at Fox), and George, Gary Kurtz, and me. I sat at the Kem in the upstairs cutting

room, running the film back and forth as we discussed the particulars of each cue. The others were arrayed on the couch facing the Kem.

John, Ken, and Lionel were quite a trio. They had flown up from L.A. for the session and were in a bantering mood. The quips and jokes were flying, and George, Gary, and I were a sideline. Lionel had a wicked sense of humor, as did Kenny, who also had a decidedly dark turn to his. John was very complimentary of our choices of music in the temp track.

As we discussed where to have the music begin and end, often we would only be pausing for a brief time, the cues running closely together. So, George would say, "You may as well keep the music going, since if you take it out, we'll feel the absence of it."

I am a big believer in music in films and in how much the score adds to the enjoyment for an audience. But if you never stop, the music never gets to make an entrance. In any event, the action in the picture is so relentless that we really did need almost wall-to-wall music. We eventually spotted over 100 minutes of music for a 120-minute film. John went off to compose, and George and I went back to work.

The landspeeder was a particularly difficult effect to pull off. The wide shots of it tooling along in the desert weren't working and had to be reshot. The speeder itself was a car fitted with a special body. The floating effect was to be achieved by attaching a long mirror to its side, masking the tires, and reflecting the fast-moving ground next to it. The problem was that you could always make out the outlines of the mirror.

Bob Dalva was put in charge and went out into the desert to get it right. He finally solved the problem by noticing that after each take, the crew would diligently wipe the mirror clean of dust.

"No, no! Leave the dust on!"

That did the trick. It was still a bit dodgy though. There were only a limited number of frames that really "sold" the illusion. But that was enough. Later the shadow under the speeder had to be added optically, because in the original shot, there was none. The best that could be done with the technology at the time still fell short of what we had hoped for.

When the technology finally did catch up with the problem in the late 1990s, George set about fixing it for the twentieth anniversary rerelease. The landspeeder was the impetus for this effort. When that had been fixed, he decided to focus then on the next-weakest shot. As John Knoll of ILM told me, it was like polishing the fender of your car. The rest of the car then looks shabby by comparison. George eventually remade around one hundred shots, including, of course, replacing Jabba the Hutt and reinserting his scene with Harrison Ford. George is dogged in his determination to see an idea through.

———————————

On one of my Saturday mornings in the editing room with George, the subject of my working in Hollywood came up. As a New York editor, there hadn't been a jurisdictional problem while I was in Northern California. We were allowed to work up there. But in L.A., a catch-22 applied. To join the union, you had to have a job for at least thirty days, but to get work, you had to be a member. George arranged to have me moved from the production's payroll to the ILM payroll, and I got my thirty days of work in before the union found out. This qualified me for membership and got the associate producer an earful from the business agent at the local. But by then it was too late.

———————————

When you're cutting, there is a constant process of discovery, and you never stop getting ideas about how to improve things. As we kept cutting, I kept diligent notes for Ken Wannberg of how the picture had changed since we spotted the film for music with Johnny. I would point out that the changes we were making would complicate his job, but George would say, "He'll just have to deal with them. We have to make these changes."

When George was about to leave for England to attend the recording session, he told me to send Kenny a telex with the changes. A telex was a way to send text over the phone, before fax machines. This one was about twenty pages long. Kenny called me from London with panic in his voice.

"We're recording in three days! We can't make these changes!"

"I know, I understand."

"We're going to record to the version you guys gave us," he said. And they did. Kenny then managed to cut the music to fit the revised picture. It's not the ideal way to work, but it turned out fine.

───────────────

Gary Kurtz showed up one day with some loot: a *Star Wars* baseball cap. "I want one," I yelled out. He came another day with a mug or something. "I want one of those too."

"OK," Gary said.

"I want one of everything," I said.

Little did I know what I was asking for.

───────────────

George came back from ILM one day with an idea: he wanted to show Vader getting away.

"Leaving a loose end like that seems like you're setting up a sequel," I said. "Wouldn't it be better to tie everything up at the end? It's kind of blatant."

"I don't care," said George, demonstrating a commercial instinct far sharper than mine.

There was no money left in the budget to order new shooting, so we managed to construct a mini sequence using elements from existing shots but composited with new backgrounds. There had been a shot of Vader in his cockpit, which was filmed with the camera on a circular track standing on end. The actor went through all the beats of the scene, and when he is blasted at the last minute by Han, the camera was sent spinning rapidly around the small set, which, when projected, made it appear that Vader himself was spinning around. There was a light mounted on the same track, to enhance the illusion. It made it appear as though Vader's ship was spinning in space.

At the very end of the shot, after George had yelled "Cut," the camera rocked back and forth on the track until it came to rest. We used this last bit of the shot to make it appear as though Vader had regained

control of the spinning ship. We then cut to a shot of the exterior of his ship, borrowed from an earlier shot of him taking off into battle with a TIE fighter on either side of him. We eliminated the other two ships and placed it over a star field, and the sequence was complete: an interior shot showing Vader righting his ship, followed by an exterior of him flying off into space and into the sequel. We found an appropriate moment in the continuity to insert the two shots, and on this last-minute change depended the whole saga. It was a brilliant idea. And it was the last change we made.

Jane and I were now faced with a dilemma. Our baby was due on March 3, but the company was relocating to L.A. in late February for the mix. We wanted to stay in Marin until the birth. George and Marcia were fine with me delaying my arrival in L.A., but we were faced with having to rent our Sausalito apartment for another month when we probably wouldn't need it for more than a few days. And then we would have to rent a place in L.A. But we couldn't afford to pay rent for the month of March in two places.

Marcia came up with the perfect solution. "Why don't you and Jane move into our house until the baby comes? We won't even be there. George and I will be in London for the recording of the score. Then, after the baby is born, you can come down to L.A."

After George and Marcia assured us they didn't mind, Jane and I moved into their house, a relatively modest but extremely comfortable house in San Anselmo that they had bought after *American Graffiti*. There was an old-fashioned jukebox in the living room, filled with hit 45s from the 1950s and '60s.

Days passed and no baby. Finally, Jane went into labor on March 8. We reported to Marin General Hospital and went to the labor room. Thirty-eight hours later, Gina Katherine Hirsch was born by Caesarean section.

We went back to the Lucases' house to wait for Jane to get well enough to handle the move to L.A. By this time, however, with the birth coming a week later than we expected, George and Marcia came back from England to spend a weekend at home. The master bedroom, which we were occupying, was on the ground floor. The guest rooms were upstairs, but because

of the Caesarean, Jane couldn't make it up a flight of stairs yet, so George and Marcia moved into one of the guest rooms and we slept in their bed!

This was an act of generosity and self-sacrifice unmatched in my experience. They couldn't have been nicer or sweeter about it. I will never forget it.

When we were plotting the logistics of the move to L.A., Marcia told me that Steven Spielberg had just moved out of his house in Laurel Canyon and we could rent it.

Then Amy Irving heard about it. Amy had been dating Steven since they met on the set of *Carrie*. She and I had discovered that we had both attended the High School of Music & Art in New York City, so there was an affinity between us. When she heard we were going to be renting Steven's house on Lookout Mountain Road with a newborn baby, she had him repaint and recarpet the entire house before we moved in, which was lovely. My daughter Gina spent the first eight weeks of her life first in George Lucas's house, then in Steven Spielberg's. Her career in film was destined at an early age.

We set up the L.A. cutting room in a building on McCadden Place in Hollywood. We settled into a routine. A number of local assistants were added to our group. They would fan out across the city each day, going to the five optical effects houses working on shots that ILM was just too busy to handle.

One of them was turning out laser bolt shots, the red flashes that came out of the blasters; another house was doing the light saber shots; one was doing some blue screen compositing; another was handling the wipes; and so on.

At this point, with the cutting pretty much done, my job was to supervise the cutting of the negative and to cut in the remaining opticals and VFX shots as they were brought in by the assistants each day. Because of delays from the original schedule, the production had lost their mix studio bookings and were forced to work on a night schedule. This would have been impossible for me. I couldn't be gone all night, leaving Jane with a

newborn, and sleep all day. So we arranged for me to work days while George worked nights.

The negative had to be cut even though we were still missing a lot of shots. The plan was to cut in a slug, a blank piece of leader the proper length, wherever a shot had not yet been delivered. This would enable the timers, the lab techs who adjusted the color, to be able to begin their work on the shots we did have.

I went over the workprint myself, checking every splice and marking the cuts and run-throughs with white grease pencil so there would be no confusion. I didn't want any mistakes.

I went to see the negative cutter at the lab. He was in the middle of cutting one of the reels and had stopped for lunch. The workprint and the original neg were in the synchronizer on his table, going from the reels on his left to the take-up reels on his right. He was sitting in front of this eating a sandwich, which shocked me. When I had worked around negative, it was stressed to me how delicate the emulsion was, and how careful I had to be to avoid any scratches or dirt getting on the film. I had a bad feeling about him.

I asked him how long he thought it would take. "I don't know, this reel here is cut up pretty bad," he said. Everybody's a critic.

Without going into too much detail, the negative cutter made a couple of technical mistakes that, although they weren't disastrous, made me begin losing more and more confidence in him.

Then I got a phone call from him one day. "Hi, Paul? I'm sorry to bother you, but I made a mistake reading some edge numbers, and reversed them. I should have cut at 98, but I cut at 89 instead. I cut nine feet off the end of the shot."

Yikes. "What shot are we talking about?" I asked.

"The explosion of the Death Star."

I was stunned. This was a special effect, and we only had one take. "What should I do?" he asked.

"Cut it back on!" I replied.

"But you know, I have to lose a frame," he reminded me.

I knew that. Negative cutters cut in the middle of the frame after the last frame in each cut in the workprint, so they have a bit of film to overlap and make the hot splice.

"Well, add a frame onto the end of the shot to make up for the lost frame," I told our benighted negative cutter. This was to keep the overall length the same and the picture in sync with the sound.

So that's what he did. When the film was projected, at a point about six seconds before the end of the shot, the explosion suddenly pulsed outward for one frame and then resumed its previous slow expansion. I've been told that many people noticed this but assumed it was a desired effect. Nope, it was our man at the lab.

George and I worked out a routine. Since he was working nights and I was working days, we would meet every morning at seven at the lab and screen silent prints of the various reels, with blank leader cut in in place of any missing shots. We would give the technician notes about color, and then at eight, George would go off to bed and I would go off to work. Then, at seven in the evening, George would come into the cutting room, review that day's deliveries in context, and approve or reject them. At eight, he would go off to the sound mix and I would go home.

One morning we finished quickly and decided to go get something to eat. I had discovered a great breakfast place called Duke's at the Tropicana, on Santa Monica Boulevard in West Hollywood. It was very popular with out-of-work actors, and there were always copies of trade papers scattered around that they would browse while they were waiting for their orders.

As we were sitting there waiting, one of our neighbors recognized George. "You're George Lucas, aren't you?" he asked.

I groaned inwardly. I had really touted this place, and George hated being recognized. I was afraid he was going to hold it against me.

"No, but I wish I were," he replied.

One of the last shots delivered was the first of a two-shot effect, the jump to hyperspace. The second shot was one of the simplest that ILM ever made, and we had had it for months. It shows the *Millennium Falcon* from behind, the wide arc of its engines glowing brightly. It fills the frame from left to

right, then rockets away from camera, disappearing into infinity in only eight frames. The shot that preceded it, and for which we had waited for months, was from the back of the cockpit, shooting over Han and Chewie. It showed the stars out in front of the windshield streaking and disappearing. The streaks had to be animated, which was why it was so late in coming.

I looked at it and frankly, by itself, it didn't look that impressive. I cut it in, letting the streaks just begin to go out of frame before the cut. I made the splice and ran it.

Wow, I thought, *that makes a snappy cut.*

There were a handful of assistants in the room behind me when I did it, and they all reacted similarly. That jump to hyperspace turned out to be one of the most memorable cuts in the film.

———

The sound mix was a difficult one. The picture was being mixed in four-track stereo, which was cutting edge at the time. The mixing panels were primitive compared to the boards that came even just a few years later. There were three rerecording mixers, one for the dialogue, one for the sound effects, and one for the music. But there was only one recorder, onto which each mixer was outputting four tracks—the left, the center, the right, and the surround track for the speakers in the back of the theater.

That meant the mixers had to record the whole reel without stopping, because to pick up again at some point in the middle would have meant each mixer had to precisely duplicate the volume and equalization of every track at the exact same moment, which was impossible.

Later, the boards were automated. Further innovations included having a separate recorder for each mixer. This meant it was much easier to punch into a reel that had been partially recorded. But in 1977, on stage D at the Goldwyn lot on Formosa Avenue, these later inventions were not available. So they would rehearse each reel over and over until they were ready to try for a take. They would go until someone blew it, and then they would have to start from the top again. Since I was on the day shift, I wasn't there, but I can imagine the tension building in the room as they got closer and closer to the end of a reel.

When the mix was finally completed, George decided to have a preview for the public at the North Point Theater in San Francisco. He told me that he had asked Marty Scorsese to free Marcia for a week so she could come back onto the picture to help make changes after the screening.

"What do you think we would change?" I asked. This was new to me. Brian had never had test screenings of the pictures I cut for him, and besides, George and I had been over and over every last frame of the film, and I have to say, it looked pretty good to me.

"Previews mean changes," George replied.

I just sort of mentally shrugged. The day came, and the Fox executives arrived. A large audience had been recruited, and we ran the picture.

It was, from the very start, the kind of preview you dream of. The titles came on: "A long time ago in a galaxy far, far away. . . ." This was not in the original shooting script. George had added this card to prevent the film from being labeled science fiction. He thought of it as a space fantasy. He didn't want to hear about the impossibility of hearing sound in space or get caught up in any sterile arguments about what was scientifically possible.

The music began, the now-famous theme ringing through the theater. The audience was captivated immediately. The titles sailed away into the distance, and the camera tilted down to the Rebel ship fleeing the Imperial Star Destroyer. As the Imperial ship comes into frame from the top and goes on and on and on, you could hear the audience react: laughter, sounds of amazement, cheering and applauding. The screening went on like this. The audience was vocal throughout. The cantina sequence created a huge reaction. When our heroes take off from Mos Eisley and make the jump to hyperspace, that cut I thought was pretty snappy had people jumping up out of their seats, something I had never before and have never since seen. It was as if they were rooting for a baseball team that had just won the seventh game of the World Series with a walk-off home run in the bottom of the ninth. Bodies seemed to be flying around the auditorium.

Then the moment came that Marcia had been so concerned about, the *Millennium Falcon* coming straight toward camera with the sun behind it when Han Solo returns to save Luke just as Vader has him in his sights, the shot that had for months been represented by a squiggle on leader.

Again, the audience leaped out of their seats cheering. I looked over and caught Marcia's eye. She was grinning, and so was I. She shrugged as if to say, *I guess it works.*

The audience cheered at the destruction of the Death Star and reacted audibly when they saw little R2-D2 restored in the ceremony at the end. George had decided to place the credits at the end of the movie, and I chose a fast iris out of the final shot, a tableau of our heroes with their medals facing the cheering rebels. The wipes throughout the movie were a reference to the old-fashioned films on which *Star Wars* was based, and the iris brought on the "directed by" credit.

George had used Dvorak's *New World Symphony* as the temp music for the scene and had asked John to closely model the cue on that. He was especially keen on the change in tempo, when the pace picks up, and the music has a bubbling, fun feel to it. I timed the iris to the downbeat of the beginning of that up-tempo section, and it was like an exclamation point at the end of the picture. It brought down the house.

The applause was thunderous, tumultuous. It was the most exciting screening I have ever been to in my life. When we got outside, everyone was euphoric, including the Fox executives.

I turned to George. "What do you think?" I asked.

"I guess we'll just leave it alone," he replied, in his understated way.

———————

Back in Hollywood, we went to work putting on the final touches. At this point, I got a call from Brian. "I'm starting a picture this summer. I want to talk to you about it."

Over lunch at Musso & Frank's, Brian excitedly described the film for me. It was called *The Fury*, and it was a sort of horror-fantasy-spy-thriller. Again, I had a sinking feeling that Brian was pulling me back into the horror genre, which I was really not interested in. As he told me the plot, about a couple of young people with special powers, including the ability to make people bleed from the nose, mouth, ears, and eyes, he finished up with the big finale: "And then, his head explodes!" he exclaimed gleefully.

I thought Brian had lost his mind. *This is what he wants to make movies about?*

But I couldn't refuse him, since he had been my only patron until then, hiring me on five pictures. He made the connection for me with George and essentially got me the job on *Star Wars*. He had a cast with real movie stars, like Kirk Douglas and John Cassavetes, along with some of his regulars, like Bill Finley, Charles Durning, and Rutanya Alda, as well as Amy Irving, in her first feature film role since *Carrie*. As a new parent I was grateful to have another job, and I accepted the offer. My days in California were drawing to a close.

————————

Jane and I had decided on a vacation after the end of the film. Marcia urged us to go to Kona Village, a resort on the big island of Hawaii where the rooms are separate little huts, albeit very luxuriously appointed.

George and Gary Kurtz arranged a farewell lunch for me, also at Musso & Frank's. The whole crew was there, along with Jane and two-month-old Gina. At the end of it, I turned to say goodbye to George. We had been in the trenches together for eight months. "Thank you for saving my movie," he said.

I was the last editor hired on the picture, and the sole editor for the last five months of work. I am very proud of my work on the picture, but I don't believe I am the only person on earth who could have done it. Fate smiled on me and gave me the opportunity, for which I am grateful. I have been dining out on it ever since.

————————

After my farewell lunch, we took off for Hawaii. The vacation was truly welcome. I had been working long days and weeks for months. But I was away when the picture opened and didn't know what had happened. I did see that *Time* magazine had a big piece calling it the best picture of the year. I read it avidly on the beach.

Just before we were to leave to go back to New York and real life, Marcia called, all excited. "We're a hit!" she said. The lines were around the block, people waiting for hours. "How long are you going to be there?" she asked. "George and I are thinking of coming to see you."

"That would be great, but we're leaving tomorrow," I said. So, sadly, we weren't able to celebrate with them, and we went back to New York. After stopping overnight in San Francisco, we arrived back to our 106th Street apartment with our two-month-old. I went to the bodega across the street to buy some milk, and a headline caught my eye: 44 CALIBER KILLER STRIKES AGAIN.

This was the first I had heard of the Son of Sam. New York was abuzz about the murders. I thought, *What am I doing here, with my wife and baby?* The city felt very threatening.

I took a trip to L.A. the following month, to solidify my work status as a union member there. I also had to get on something called the Industry Roster in order to be qualified to work. This roster was a hard nut to crack. Administered by the Contract Services Administration, it is a list of people approved to work in the film industry. I don't know how it came into being, but it was clearly designed to keep newcomers out. One of the requirements was to have a physical by one of the doctors on an approved list, and it had to be done within a certain number of days after the end of the job on which I had gotten the qualifying hours. So I took care of that while I was in town.

Before flying back, and as a new member of Local 776, I went to meet the business agent at the union, a polite—as distinct from friendly—man. He wore a primly trimmed gray moustache. Sitting behind his desk, he told me, "There are members of this local that I could send out with a hundred-dollar bill pinned to their chest, and they still wouldn't get the job."

But he went on to make clear that "we don't want New York editors coming in and taking our jobs away from us."

OK. This wasn't going to be easy. But I had laid the groundwork for being able to cut in Hollywood.

———————

As on *American Graffiti*, George rewarded the people who worked on the picture, not with a car this time, but with cash. I got a check for ten weeks' pay, a very generous bonus.

My hometown critics were not universally kind to *Star Wars*. They tended to praise the special effects, but even in reviews that were generally

positive overall, they couldn't resist condescending remarks. Those reviews do not stand up well today.

Pauline Kael of the *New Yorker* criticized the film, claiming that "there's no breather in the picture, no lyricism," and that it had no "emotional grip."

Kathleen Carroll in the *Daily News* wrote that it was "somewhat grounded by a malfunctioning script and hopelessly infantile dialogue" with "slow, lackluster moments," adding, "Harrison Ford hams it up terribly."

Archer Winsten, in the *New York Post*, dismissed its "juvenile level of plotting and dialogue," concluding that the "performances are without distinction."

In the *Village Voice*, Molly Haskell called it "childish, even for a cartoon," and wrote, "What little tension there is, is superficial."

But the public couldn't have cared less, and the film made history and changed the face of the movie business forever. In 1989 the US National Film Registry at the Library of Congress selected the film as a "culturally, historically, or aesthetically important" film.

Because we had finished *Star Wars* so late, the lab hadn't been able to produce more than a few 70 mm prints, and each print had to be striped with a magnetic application onto which the stereo track was transferred in real time. I don't know if it was by design, but the picture opened in only thirty-five theaters the first weekend, and the resultant want-to-see pressure was enormous. And building.

Release patterns today are completely different. The first weekend is basically it. Studios expect a new release to command the top spot each week. They advertise widely and heavily, and release in so many theaters that they use up the audience in one weekend. A friend told me he had recently worked on a film that they hadn't even bothered to preview, since word-of-mouth was irrelevant. How good was the picture? Also irrelevant. All that mattered was successfully marketing it and getting that first weekend crowd in the seats.

The first weekend *Star Wars* was out, it grossed about $1 million. That sounds unbelievable today, when pictures open to hundreds of millions of dollars. However, the grosses then began building, each week bigger than the last. The demand seemed insatiable. More and more theaters were showing it every week. This expansion continued and revenues rose for

six months before they started tapering off. A disco version of the theme became a hit on the radio.

The fever was amazing. A friend whose father owned a chain of theaters in the South reported the following to me: A man called up and asked if the seven o'clock show was sold out. This was after the picture had been playing for several months already.

"No" he was told, "there are still seats."

"Oh," he replied. "When can I come when it *will* be sold out?" He wanted that packed-house excitement that he had experienced when he first saw the picture.

One of the factors that made *Star Wars* so successful is timing. Filmmaking is like making a surfboard. You make the best possible board you can and put it out there, hoping to catch a wave. The wave that we caught was tremendous. The American public had been deeply divided for over a decade, by the Vietnam War and the rise of the counterculture.

Star Wars gave people a reason to cheer that transcended the fault lines in American society in the late 1960s and early '70s. It harked back to a more innocent time, and people were able to leave all current concerns at the theater door. It also featured computers, both in the plot and in the making of the film, and it gave the public a glimpse of the coming cyber age.

Working on *Star Wars* changed my life for the better. It made my career. People always ask me, "Did you know how big the picture was going to be?"

How could we? There's hardly ever been anything like it before or since. No one could possibly anticipate how influential the film would be on American culture. Hardly a day goes by without seeing some kind of reference to the product of George's imagination.

In 2015, J.J. Abrams directed the first *Star Wars* sequel in ten years, *The Force Awakens*. The excitement in anticipation of it was tremendous. To my surprise, J.J. invited me to watch a cut of the picture three months before its release and give notes.

"But you can't reveal to anyone that you saw it," he admonished.

The picture was in very good shape, and my comments were just details. I was invited to the premiere in December of that year. Disney, which now owned the rights to the franchise, closed down several blocks

of Hollywood Boulevard. It was the biggest premiere party anyone had ever seen. The picture was screened in several different theaters, and my daughter Gina and I were seated in the same theater as George. At the end of the picture, I managed to catch up with him as he was leaving.

"Boy, that was something, wasn't it?" he said. "Compared to this, we were playing with model planes on strings."

"Yes," I said. "Thank you."

"For what?" he replied.

"For my career," I answered.

Then he said it again. "You were the last man standing. You saved my picture."

I will be grateful forever.

9

The Fury

BACK IN NEW YORK, I decided I didn't want to have to negotiate directly with producers anymore. Before going into negotiations on *The Fury*, I got the name of a young lawyer from my friend Richie Marks. His name was John Breglio. John agreed to represent me and did for many years. He went on to become the most important lawyer on Broadway, representing Michael Bennett (*A Chorus Line*, *Dreamgirls*) and Stephen Sondheim, among others.

I needed John because the producer of Brian's next picture was Frank Yablans. Born in Brooklyn, Frank was a smart, tough man. He was bald, short of stature, and had a small man's pugnacity. Frank knew Brian from the *Greetings* and *Hi, Mom!* days. He had been working in the sales department for Sigma III, the company that released the films. Frank became president of Paramount during its "golden years," from 1971 to 1975, when the studio turned out *The Godfather*; *The Godfather, Part II*; *Chinatown*; *Paper Moon*; and *Serpico*, among others. After leaving Paramount, he had become a producer and had just produced *The Other Side of Midnight*, a big hit for Fox.

Breglio made my deal, and got me a significant raise.

The first week of production on *The Fury* took place in Israel. I set up a cutting room at 1600 Broadway, where I had cut *Carrie*, as well as the *Hi, Mom!* trailer eight years earlier. Brian generously offered to partner with me in an editing equipment rental business. We would buy state-of-the-art

124

flatbed editing machines and all the other equipment needed, and rent the whole package to each production company we worked for. This is a standard industry practice, known as kit rental, paying crew members a rental fee for their tools. We called the company Paradise Associates and set up in rooms on the third floor of the building.

The ceilings were a good twelve feet high, and in my room there was an enormous window in the corner facing the intersection of Forty-Eighth Street and Broadway. Just west of us was a fire engine company, and I often had to stop work when the fire trucks hit their sirens and air horns to get through the traffic. You literally couldn't hear anything else. We were also above a Popeyes fried chicken franchise, and just before lunchtime the odors of grease would come floating up.

As the dailies started coming in, I realized that the film was filled with set pieces that challenged me as an editor. The opening sequence depicted an Arab terrorist raid on an Israeli seaside resort village. Kirk Douglas was terrific in it, every bit the star I had worshiped in *Spartacus*. Another of my heroes, John Cassavetes, played the villain in the piece. After filming moved to Chicago, set piece after set piece came in, each one requiring an understanding of what Brian intended. I had to cut in a rhythm that would create feelings of tension and anticipation leading to the climax. Brian's dailies are a like a jigsaw puzzle; the pieces are usually designed to fit together in a certain pattern.

On one occasion, there was a big close-up of Amy Irving's hands scratching the arms of a chair in which she was seated. I wasn't sure what Brian had intended, so I called him long-distance. I guess I caught him at the wrong moment. "You're the editor," he said with a certain amount of heat. "*You* figure it out!"

I was irritated at his response, but it gave me the motivation to come up with something interesting, intercutting the scratching with distant but simultaneous action.

Finally, a scene came in that I had been dreading. In the sequence, Andrew Stevens, who had a prosthetic pulsing vein in his forehead, lifts his tutor Fiona Lewis into the air through telekinesis and spins her around while causing her to spew blood. The crew had constructed a turntable for Fiona to stand on, and they spun her around and around while she pleaded for mercy. Then, slowing the camera to make it appear that

she was speeding up, as it would have been too dangerous to do for real, the blood spurts onto the furniture and the walls, and in one angle, onto a pale silk lampshade, as she begs for mercy. After a number of takes, Brian brought Fiona down off the turntable. They finished the fastest spinning shots with a dummy in her place.

The whole sequence takes perhaps a minute on the screen, but it took eight hours to edit. I can handle violence in movies, but this scene had a sadistic quality I found very upsetting. To mitigate the emotional impact of the blood while I cut the scene, I placed a transparent red gel over the Kem screen. With everything red, I couldn't see the blood. I cut much of it silent, so as not to hear Fiona screaming, which also helped me get through it.

As usual, about a week before the end of shooting, I went out to L.A. with the incomplete workprint to show to Brian, to see if there were any shots he might have to pick up in the last few days. I visited the set and met Kirk, which was a thrill. Brian was happy with what he saw, and I flew back to New York to finish the cut.

The final scene also involved a dummy. Cassavetes thinks Amy is going to go to work for the government (and him), but Amy has no intention of collaborating with him. Using her special powers, she makes his head explode.

The way this was staged was ingenious. They rigged a standing lamp with a hinge, anchored to a spot on the floor. They set up a full shot, filming John from the top of his head down to the tip of his shoes. He started to convulse as if he were having a fit, waving his arms around, accidentally knocking over the lamp as he grabs his throat.

Because of the hinge, when the lamp fell over, it could only move in a predictable arc. As it fell, halfway down, it triggered a strobe as well as several still cameras, producing a still of that exact frame from several angles. Using the stills as reference, they built a dummy of John to match that precise frame in the chosen take. They then reshot the scene with the dummy, rigged with bags of fake blood stuffed inside it, along with some explosive. They used the same camera position and lens as before. Again, the lamp was knocked over, this time by a grip offstage, but instead of triggering a strobe, it triggered the explosion.

The blast was shot on six or seven cameras, from different angles and with different lenses. Most of the cameras were slow motion, at various

speeds, from slightly to extremely slow. All I had to do was to take the "hero" shot of live John, the take they had used to design the dummy, and match the action of the lamp as it fell. At the strobe frame, I cut to the first frame of the explosion. The action appeared to be continuous, and it looked like John's head blew off.

They did two takes with the dummy, with multiple cameras. In both takes, the blood erupted in huge gouts, like liquid lava. I used all the camera angles in both takes, cutting to various shots, tighter, from the other side and so forth, using increasingly slower shots. As the final shot, I used the angle from directly overhead, and John's head falls onto the floor. There were thirteen cuts in all.

We showed the picture to Frank Yablans, who was pleased. He had only a couple of good suggestions, which Brian was happy to adopt. Brian had invited my wife Jane to the screening. As the house lights came on at the end, because she was the "fresh eyes" in the room, Frank asked her, "What do you think?"

"I don't like the ending," she announced.

I was shocked. Editors are in the business of delivering criticism, but we try to do it in the most palatable way. Jane was too blunt, and I was embarrassed by her candor.

"Next time, just say you liked it," I told her.

Jane drew from this that in Hollywood you shouldn't say what you think. But I was wrong in telling her to lie. When asked, you should always say what you think, although a corollary to that is that there is no point in criticizing what can't be changed. If you have cast a bad actor in a key role, for example, what's the sense of pointing that out? The filmmakers will find out soon enough. I address myself only to things that can still be changed. In this case, it was obvious Brian and Frank were committed to that ending, and there weren't going to be any reshoots at that point anyway, so there was nothing to be gained by criticizing it. But they had asked her, and by golly, she told them.

———

We locked the picture for sound and music and prepared for the final mix. John Williams had agreed to write the score, the only one he ever wrote

for Brian. His usual music editor, Ken Wannberg, was unavailable, so John used George Korngold. The son of the great composer Erich Korngold, George had a pronounced Viennese accent and a lovely, gentle, and quirky manner. He loved to find some bit of news or information in the newspaper and tell you about it, always followed by an astonished, "You didn't *know*?" his voice rising comically on the last word.

The recording took place on the Fox lot in L.A. on their scoring stage. I flew out for the session and took my place in the booth. At these recording sessions, the booth is populated with people working on the recording, engineers, and the mixer, as well as orchestrators and copyists. I was there, as were Brian, Yablans, and the head of Fox music, my old friend from *Star Wars* Lionel Newman. John Williams conducted, and he would come into the booth between takes to listen to the playbacks. At times, Yablans and Lionel would get into a bit of a pissing match, but they never allowed it to go too far.

Back in New York, we finished the mix, and Brian organized a screening for Pauline Kael of the *New Yorker*. One of the most influential critics, she was a big De Palma fan and had complimented me specifically in her review of *Carrie*, calling the editing "spiky." Her unfriendly review of *Star Wars*, on the other hand, had referred to the editing style as "smash-and-grab." At the screening, upon being introduced to her, I asked her what she meant by "spiky" and "smash-and-grab." She giggled and said, "Well, in *Carrie*, the cutting gave you a little spike every once in a while, which is good. 'Smash-and-grab' is not."

Subsequently, in her review of *The Fury*, which she loved, Pauline began by saying Brian had five great collaborators on the film. I was not one of the five. That taught me.

The Fury opened at the top of the box office charts, as had my three previous pictures.

Shortly before finishing, I got a phone call from Frank Pierson, whom I had met in Marin while working on *Star Wars*. He was directing a picture for Paramount Pictures based on a book by Peter Maas, who had written *Serpico*, and Frank wanted me to cut it. It was titled *King of the Gypsies*.

10

King of the Gypsies and *Home Movies*

KING OF THE GYPSIES WAS to be shot in New York City and edited in L.A. It was the story of a clan of Roma people living in the eastern US and the struggle over passing the torch of leadership to a new generation.

The film was being produced by the famed Dino De Laurentiis, whose filmography in his own publicity included the Oscar-winning *La Strada* and *The Nights of Cabiria* but neglected to mention the director of those films, Federico Fellini. Dino had started producing pictures in Italy in 1946. He came to the US in the late 1960s and worked with writer Peter Maas on *The Valachi Papers* and *Serpico*. He was a producer in the mold of the men who invented the business. He was a real impresario. He was a showman who loved movies, but above all loved making money. He was five feet, four inches tall but wore lifts.

A vigorous man, with bristling eyebrows and an intense gaze enhanced by the massive frames of his eyeglasses, he spoke with a heavy accent. His biggest recent hit had been the remake of *King Kong*, starring the then-unknown Jessica Lange.

Gypsies was to be produced by Dino's son Federico. Federico's mother was the Italian star Silvana Mangano, and he was strikingly good-looking. He was twenty-three years old, and this was to be his first film as producer.

I was excited at the prospect of working for director Frank Pierson. He had won an Oscar for Best Original Screenplay for *Dog Day Afternoon* and had written the screenplay for *King of the Gypsies* based on the book by Maas. What's more, the film was to be shot by Ingmar Bergman's longtime cinematographer, the legendary Sven Nykvist. This was heady stuff for me. It was early 1978, I was thirty-two years old, and these were all accomplished veterans whose work I admired and respected.

I met with Frank and Maas at a bar in Manhattan, just to renew our acquaintanceship and chat about the project. It was the only time I met Maas, who was not involved in the making of the film. Frank was still in the middle of casting the picture. For the Gypsy patriarch, he had wanted Anthony Quinn, who would have been perfect, but Dino balked at Quinn's asking price. They also could have had Eli Wallach, who would have been almost as good, but Dino had settled on Sterling Hayden, who is, to me at least, a real reach as a Gypsy.

Frank was an affable man, tall and slim with a full white beard. He was enthused about his lead, a young man named Eric Roberts, whose younger sister Julia was still unknown. Frank told me Federico was only nominally the producer and that the real producer on the film was to be Dino, whom I had yet to meet.

When I met Dino, he was in his salesman mode, talking up how "fantastic" Sterling Hayden would be. With his Neapolitan accent, it sounded like "Stareling Hide-en." His accent was nearly impenetrable, and, as his English was limited, I trotted out my Italian, such as it was. It was well received, although my Italian was only slightly better than Dino's English.

Apparently, Dino had all the scripts he read translated into Italian. It was clear that he was playing a large role in casting the picture. It was on this film that I learned how crucial that process is; if you make a mistake in casting, it doesn't matter how clever you are, you can never overcome it.

In the case of *King of the Gypsies*, we were in trouble from the get-go. The story was an epic saga of a Gypsy family in America, but with our cast, there was no way it would be believable. Not that the individual actors in the picture were untalented. It was the ensemble that was problematic. Sterling Hayden looked more like the captain of a New England whaling ship than a Gypsy king. His character was married to Shelley Winters, a wonderful actress but equally hard to believe as a Gypsy. Judd Hirsch

played their son Groffo and resembled neither of them. Groffo was married to Susan Sarandon, who was wonderful in the picture, but Eric Roberts and Brooke Shields played their children. It strained credulity that Judd Hirsch could be the father of either of those good-looking people. So what was meant to be a family of Gypsies looked more like a Hollywood Halloween party, with everyone dressed up in bandannas.

The first forty-five minutes or so are backstory to what follows, and they are for me the most interesting part of the movie. The story is told in a sort of episodic/montage-y way, with Eric's voice-over supplying the information needed. We meet the various family members and witness some of the scams run by the family, including the children. For transitions, Frank had devised a charming device, a solitary dancing Gypsy we would cut to as a way of demarcating the passage of time.

The music was supplied by an occasionally on-screen Gypsy band led by yet another legend, violinist Stéphane Grappelli, who had played for fourteen years with jazz great Django Reinhardt in the immortal Quintette du Hot Club de France. David Grisman, an accomplished mandolin player from the Bay Area, wrote the score. Stéphane's solos were, as always, improvised.

One day at dailies, Frank told me that he and Sven had been up on a crane, shooting a shot on a Manhattan side street. Sven started to laugh. Frank asked him what was so funny. "I've never been on a crane before," he replied. He was no longer a young man then, and I was surprised.

Another time, they had been out shooting in the street when there was a sudden, heavy snowfall. Frank, on impulse, had Eric lie down for several minutes on the sidewalk, the snow accumulating rapidly over him. They quickly grabbed a shot of Eric asleep under a blanket of snow. He wakes, shakes the snow off himself, and walks away. When the dailies were projected the next day, however, the shot was badly underexposed, practically black, and unusable. Sven's reaction? "Oops."

He was endearingly soft-spoken.

During the production, the nominees for Academy Awards were announced, and *Star Wars* was nominated for ten awards, including for editing. I immediately went on a diet. The American Cinema Editors also nominated us for their award, called the Eddie. I flew out to L.A. to attend the Eddie ceremony at the Coconut Grove in the Ambassador Hotel, where Bobby Kennedy had been assassinated fewer than ten years earlier.

When the time came that night for the award for Best Edited Feature Film, my heart started to pound so hard that it felt as if it might burst out of my chest. I had expected to be able to stay cool, so it took me by surprise. I had thought we might win, but much-beloved veteran Bill Reynolds, winner of two Oscars, took home his third Eddie, for *The Turning Point*.

I was simultaneously disappointed and relieved. I was unhappy that we didn't win but glad I didn't have to get up and speak while I was nearly having a stroke. I was able to calm down in the anonymity of the crowd.

An editor named Donn Cambern, whom I had never met but whose name I knew because he had cut *Easy Rider*, sought me out. "Don't give up on the Oscar," he said. "The award doesn't always follow the Eddie."

I thought that was very kind of him, and I always remembered the gesture. I went back to New York empty-handed but was back in L.A. a week later for the Oscars.

The ceremony that year was the fiftieth, and Bob Hope was brought back as the emcee. Since 1939 when he first hosted, he had emceed the Academy Awards a record eighteen times. The fiftieth awards proved to be the last he would host. Fox flew Jane and me out, first class, and put us up in a hotel in Westwood. Gary Kurtz had organized a lunch for the *Star Wars* crew, which was very thoughtful. Small Lucite stars inscribed with STAR WARS or MAY THE FORCE BE WITH YOU decorated the tables.

I confided to George that I was nervous about perhaps having to give an acceptance speech. He said, "Well, look at it this way: forty-five seconds of hell, and then you get to keep the award forever." George was always pragmatic.

We were picked up in a limo and delivered to the red carpet outside the hall. I don't remember much about the show, other than seeing a staggering, inebriated Edmond O'Brien in the men's room, which I found sad.

As the categories came and went and awards were handed out, I steadied myself for the physiological reaction I now knew to expect. During

the commercial breaks, the audience in the hall was addressed over the public-address system.

"Don't think about the three hundred million people watching, just keep your remarks short! Multiple nominees must choose a spokesperson!"

Marcia, Richard, and I had talked about it, and we decided that we would ignore this and would each speak, in order of our credits on the film. I was to go first, then Marcia, then Richard. When it was finally time for the film editing award (for some reason it's always rather late in the show), the presenters were Marcello Mastroianni and Farrah Fawcett, a strange pairing. My heart was beating wildly, as before, but this time I was prepared for it, sort of. I was not expecting to win. The obvious choice would have been Bill Reynolds for *The Turning Point*, as he had won the Eddie.

But the other nominees were no less impressive: Michael Kahn, who would later win three Oscars, for *Close Encounters of the Third Kind*; Walter Murch, also with three later wins, nominated along with Marcel Durham for *Julia*; and Walter Hanneman and Angelo Ross, for *Smokey and the Bandit*.

"And the winner is . . . *Star Wars!*"

As the band played the great John Williams fanfare, I kissed Jane and started toward the stage. I glanced back and saw Walter, who has become a great friend, patting his disconsolate young son Walter Jr. on the shoulder. It was touching, but this was my big moment.

I made a serious mistake in my acceptance speech; I neglected to thank the members of my family, specifically Jane and my brother Chuck, who took it especially hard. He was the chairman of the film department at the School of Visual Arts in New York City at the time and was watching the broadcast with many of his students. When I failed to mention him, he was badly let down. In addition, I thanked Brian De Palma, which probably engendered feelings of jealousy. My reasons for thanking Brian were clear to me. He had hired me on five films, which had brought me to George's attention, and he had highly recommended me and even negotiated my deal. But I should have thanked Chuck and I still regret I didn't.

My thank-you speech mentioned Gary Kurtz, paid compliments to the other nominees and to my fellow editors, enumerated several of the

assistants who worked on the film, and finished with "and last but not least, a great editor in his own right, George Lucas."

At that point, the band started up again. I turned to Marcia, who was to speak after me, but she turned and started off the stage, along with Richard. When we got in the wings, I asked, "What happened?"

Marcia said, "As I was getting up, George said, 'Don't thank me!' and you had already thanked Gary and the assistants, so I just figured I wouldn't say anything."

"I saw Marcia turning away," added Richard, "so I did too."

When the ceremony and the broadcast were over, I found myself back onstage. Bob Hope looked at the statue clutched in my fist and said, "Lucky man!" as he shook my hand. His not getting an Oscar was a running gag through all the shows he had hosted. I had been a fan of his until he took a position in support of the Vietnam War. Still, it was kind of cool meeting him.

The Best Director award had gone to Woody Allen for *Annie Hall*, and later as I went over to George in the audience, he was standing next to Steven Spielberg. "Oh, George," I blurted out, "you should have won!" forgetting that Steven, too, had been nominated. There I was again, saying the wrong thing at the wrong time.

At the Governors Ball afterward, Jane and I were seated with George and Marcia, Richard and his wife, Gary Kurtz, John Williams, and for some reason, the Golden Age director George Cukor. I thought, *I must introduce myself to him.* As I did, saying my name, he replied, "I know who you are." I was thrilled.

I also shook hands with Bette Davis that evening. I think people in the movie business are the most starstruck of all. If we weren't, we would probably not have made such an effort to get into the business.

A day later, Gary Kurtz and I had dinner at El Coyote, a Mexican restaurant on Beverly Boulevard in Hollywood. "How would you like to have profit participation in the *Star Wars* sequel?" he asked.

"Would I!" I exclaimed.

He said they would probably start shooting in about a year's time.

Back in New York, I was toasted with champagne the next day at dailies.

We continued shooting until the end of April. Sterling Hayden was pivotal in the film, as the patriarch of the Gypsy clan. He didn't have a lot of screen time, but one key scene took place in the back of a limo, in which he tells his grandson Eric Roberts that he is skipping over his son, Judd Hirsch, to anoint Eric as the new King of the Gypsies. Sterling was an enthusiastic pot and hashish smoker and would light up a pipe between takes. In the course of shooting the scene, he had apparently been pretty high.

When I watched the dailies, I was shocked. The scene was a mess. Sterling didn't know his lines, didn't know his cues, and would occasionally interrupt Eric before he finished getting his lines out. Other times he sat there in silence, not knowing it was his turn to speak. He would stammer, change the dialogue, and repeat himself. Eric hung in as best he could.

After the screening of the dailies, I turned to Frank and said, "You're going to reshoot this, right?"

"Well, see what you can do with it," he replied.

I tackled the scene, trying to find takes in which Hayden spoke the words that were in the script. Sometimes I would have to assemble a sentence from two or three different takes, cutting away to Eric to disguise the cut in the sound. I managed to put together a scene that, while not exactly the one that was written, nevertheless kind of worked and contained the essential plot points and information necessary to move the story forward. I was surprised at how much you can do in the cutting. There was no need to reshoot. I was still learning.

At the end of principal photography, the cutting room moved to Dino's offices in Beverly Hills. Jane and I rented a house in Benedict Canyon, about ten minutes away. Brian rented me a little Fiat two-seater convertible sports car he owned, a fun car to drive. The only problem with it was that I had to add a quart of oil every time I filled the tank!

One morning on my way to work, I found myself driving along Canon Drive behind an enormous old Rolls-Royce. It was spotless and gleamed in the morning sun. An older man was at the wheel, alone in the car.

Curious, I pulled alongside as soon as I could to see who it was. He was dressed immaculately in a light gray suit and a white shirt and tie, with French cuffs and gold cufflinks. The large, flat, side windows presented the occupant as if he were in a department store display. It was Fred Astaire. I was beyond thrilled.

While I was in L.A. that summer, I determined to pursue getting onto the Industry Roster. I had partly fulfilled the requirements by getting a physical, but I needed help going further. There was no clear way for outsiders to break in. Around that time, though, the Contract Services Administration had decided to designate a period of twelve months that would be regarded as an open period retroactively. This meant that if you could show you had worked within the CSA's jurisdiction during that time, you could get in. The problem for me was I had been cutting *Carrie* in New York.

I was stymied, but I was advised that a certain lawyer could help me. I called him and explained my situation in detail. I was in L.A. working on a film for Paramount Pictures, and although I was in the union, I was not on the roster yet.

"Well, you can't do that. We have to get you on the roster, or Paramount will be in violation of their contract." It occurred to me that he might have been thinking more about protecting the studio than helping me. He asked, "Where were your checks issued from when you were working on *Carrie*?"

"From Beverly Hills," I replied.

"OK. Here's what you do. Get a letter from the producer or director stating that you were working in New York at their request. That should satisfy the requirement for technically having worked in L.A. during the open period."

Brilliant! I thanked him and asked him how much I needed to pay him for his advice.

"That's all right," he replied. "When you make it big and you need some help with contracts, call me then." A real gentleman.

Armed with a letter from Brian, I presented myself to the bureaucrats at CSA. They told me I needed to give them copies of the check stubs. Luckily, I had saved them. I made copies and went back.

"OK," they said, "now you need to give us four frames from the film with your on-screen credit on them."

I felt really jerked around. It was almost eighteen months after the picture had come out. Where was I going to get four frames from the film? "The picture is going to be on TV tonight," I said. "Can I take a photo of the TV screen when my name comes on?"

"No, you need to give us four frames of film."

I called DeLuxe Laboratories, where *Carrie* had been printed. I remembered the name of our contact there, a very friendly man named Mike Lamendola. "Mike," I asked, "I need some help." I explained the problem. "Is there anything you can do?"

"Let me see. I'll call you back."

Mike came through! "I found an old print here and I asked them to send you what you need."

I've been indebted to Mike ever since. I will never forget how he helped me at a critical moment in my career. I got a package the next day from the lab and delivered the four frames. Finally I was enrolled on the roster and fully legitimate to be working in L.A.

Federico, Dino's son, asked me one day, "What's your ambition, what do you hope to do some day?"

"I'd like to be king of the world for life," I joked.

"Well, what would you do if you were?" he replied.

I realized that for Federico, this question was not an idle one. He really sort of *was* king of the world for life, and he had to decide what he wanted to do with that freedom. He was only twenty-three and still finding his way. He invited me to his home for lunch one day. We drove just a few minutes away, to a mansion on Sunset Boulevard. Separate from the main house was a twelve-car garage, with its own gas pump.

To my surprise, we headed toward the garage. On the second floor was a small apartment where we were going to be served lunch by one of

the household's servants, the wife of Dino's personal barber. This couple had been working for the De Laurentiis family for years, and they set a table in the kitchen of their modest apartment.

Federico was seated at the head of the table, and they fussed over him, treating him like a prince. It was also clear that they adored him, and he beamed in a way I hadn't seen before. These people had probably actually raised him while his parents were busy with their film careers. They treated him like a favorite son. This was a place where Federico could truly relax and be himself. It was poignant to me. He had been forced to find surrogate parents among his family's employees.

———————

Frank and I finished his cut. I got a message from Dino that he wanted to screen the picture at his house the next day at 7:30. He had a screening room next to his twelve-car garage.

"In the evening?" I asked.

"No, 7:30 tomorrow morning." I guessed Dino didn't sleep much.

The day after the screening we met in the editing room. I threaded up reel 1 on the Kem, and we started going through the picture. Dino would just watch, and then at some point he would stop me and ask to go back. He would find a moment and say, in his deep, gravelly voice, "Paul! Stop! From here, play! OK, from here, take out, out, out, out, out. Here! Stop! Come back."

We went through the whole picture that way.

"Out, out, out, out . . ."

I took notes of all the changes Dino wanted. I met with Frank afterward and we went over them. "Dino doesn't understand English," explained Frank, "so he wants to take out all the dialogue. I'll talk to him, don't worry about it."

I was impressed with how Dino was able to exert a lot of influence over the picture without devoting a lot of time to it. He ruled on the final cut, the score, and the mix, and most of his comments were carried out.

Not all, however. "Never end a picture in a cemetery," he intoned. Unfortunately, we had, and there was no way to change that. And Dino was right. He spoke as if he were invoking a superstition, like *never walk*

under a ladder, but I think there is a desire among audiences for stories to end on a note of hope, and they don't like to be reminded that all life stories eventually end the same way. The cliché ending of the boy kissing the girl implies love, marriage, babies, and the continuity of the human race. What could be more hopeful than that?

A few days later we ran the picture for Paramount in Dino's garage. There had been a regime change at the studio, and the old guard had been replaced by a couple of young executives whose experience had been in TV, Michael Eisner and Barry Diller. They came driving up in a little two-seater convertible, Diller at the wheel, and Eisner's head, tall as he is, sticking comically up above the windshield.

My first impression was that Diller was the brains and Eisner was sort of a spear carrier, but it's clear I was wrong about that. I don't recall them saying much about the picture. I suppose that since they were inheriting it, so to speak, and because it was Dino, they decided to take a soft approach. More likely, they just didn't see anything to be gained by getting involved.

We continued to finish the film. Dino came into the editing room to sign off personally on each reel. After we finished, he said, "Good. Now take one frame out of every cut in the picture."

I wasn't really sure if he was joking or not, but I checked with Frank. "Oh, just forget it," he said, to my relief.

―――――――――

In addition to appearing in the film as the solo violin in David Grisman's Gypsy band, Stéphane Grappelli was brought back to record the score. A young man named Bill Wolf, from the recording business and a friend of Grisman's, was the music supervisor, and with Federico's approval he asserted himself in the recording and mixing of the music.

I had by then worked with Bernard Herrmann and John Williams, so I took a rather dim view of the proceedings on our film. The musicians were, to my eye, undisciplined and indulgent. They would straggle into the studio hours late and screw around for a while. This was what they were used to, when they would take weeks or months to record an album. But I was accustomed to an orchestra turning out twenty minutes of score a day, so I simply steered clear of the process.

We mixed the picture at Fox, in the Daryl Zanuck Theater, which was the largest room I had ever mixed in. We were so far from the screen that the sound was out of sync by the time it reached our ears. Sound travels much more slowly than light. At sea level, its speed is about 1,125 feet per second. Film travels at twenty-four frames per second. That means sound travels about forty-five feet each frame. As we were sitting a good ninety feet from the screen, the sound from the speakers behind the screen took two frames to get to us. But the image was traveling at 186,000 miles per second and had arrived instantaneously. It drove me crazy, and I asked them to delay the film in the projector by two frames to compensate, which thankfully they did.

The lead mixer was a crusty old guy named Ted Soderberg. One day, he couldn't quite catch a cut with an incoming track. He turned to me and said, "Can you put a six, eight, and ten on that for me?"

"A what?" I asked, confused. I had never heard the term before.

"Oh, never mind," he snapped, "I'll do it myself!" and stormed out of the room.

I learned that he wanted me to mark a cross in grease pencil on the sixth, eighth, and tenth frames preceding the cut in the dupe they were projecting. This enabled him to press the key at exactly the right frame, when the picture change occurred. I would have happily done it for him had I known what he wanted.

The wedding scene early in the picture begins with a close shot of Stéphane playing an improvised violin solo that is followed by the band joining in after a few seconds. The production had recorded the music on the set, as the band was actually playing, but the sound quality wasn't the greatest and dialogue was being recorded at the same time. This meant that both the dialogue and the music had to be rerecorded separately in order to mix the levels properly.

Stéphane was a great improviser, but he was congenitally incapable of playing anything twice the same way. When the time came to rerecord what he had played that day on the set, he couldn't do it. He was game and he gave it a good try, but it just wasn't right. We even had his original solo transcribed so he could play exactly the same notes, but reading from the page, it just didn't have the same freshness or excitement as the original.

Bill Wolf, however, preferred it, which astonished me. "The great thing about Stéphane's playing is his tone, which the original recording doesn't capture," he said.

"No!" I countered. "The great thing about Stéphane's playing is his extraordinary creativity and inventiveness, and the spontaneity you hear in the performance. Not only that, but he's not even in sync with his hand on the screen!"

To my added astonishment and dismay, Federico supported Bill. We went ahead and mixed in the new performance. The room was a bit tense because of the exchange between Bill and me, which was rather heated.

"Federico," I suggested, "why don't we just start out the scene with the original recording while the camera is on Stéphane's fingers? Then, once the band kicks in, we can switch to the new recording."

"No, we don't have time," he replied.

I was outraged. I had never before had anyone reject an idea at a mix without even trying it. It would have taken no time. It was absurd.

The following morning we were working on the same reel. I arrived at nine sharp, but the mixers and I were the only ones there.

"Ted, just do me a favor," I said. "Try laying in Stéphane's original solo, then switch over to the new track. Can you do that?"

"Of course."

It took him less than a minute to do what I had suggested. "Fine," I said. "Let's go on."

Federico and Wolf rolled in around eleven, as was their habit. By this time, we were ready to play back the whole reel. They watched and realized I had made the switch, but at that point they let it go and we moved on to the next reel.

Dino summoned me to see him. He was at the far end of an enormous office, which meant you had to cross the entire length of the room to get to him. He sat behind a massive, dark wood desk that would not have looked out of place in the Oval Office. The desk was on a raised platform, so that when you sat facing him, he was looking down at you. Standing discreetly to one side was Dino's aide, Fred Sidewater.

"Paul," Dino rasped, "I vant you to cut Arrghdigan."

"Excuse me?" I asked.

"Arrghdigan, I vant you to cut Arrghdigan!" he said with increasing impatience.

"I'm sorry, Dino, I don't understand . . ."

Dino, irritated, waved at Fred. "He wants you to cut *Hurricane*," said Fred.

"Ah, *Hurricane*," I replied. This was to be Dino's next picture. It was a big disaster movie about a South Seas storm, starring Mia Farrow, Timothy Bottoms, Jason Robards, Trevor Howard, and Max Von Sydow.

"We are shooting in Bora Bora," Dino went on, pitching me on the idea. "We are building hotel there. You go, with your wife, ees fantastic!"

His daughter Rafaella, in her twenties at the time, was to be in charge of the hotel, and they had already roped in Sven Nykvist. The only problem was that I was committed to cut the *Star Wars* sequel, and I was going to be getting points. "I'm sorry, Dino," I said and explained the situation.

He kept after me for some time about it but realized that he wasn't going to change my mind and eventually gave up on the idea. When I read *Cut to the Chase*, Sam O'Steen's autobiography, I was glad I hadn't been available. Sam had edited the film, which turned out to be a disaster all right, but not in a good way.

With *King of the Gypsies* finished, we packed to go back to New York. As we left our house in the hills, its pool, and the little oil-burning Fiat, it crossed my mind that of all possible lifestyles, this was a pretty good one.

I had about four months before we were to leave for England, where the *Star Wars* sequel, titled *The Empire Strikes Back*, was to be filmed. George had hired Irvin Kershner to direct the film. When I asked him why he wasn't going to direct it himself, he replied jokingly, "As executive producer, you do the least work and pick up the biggest check."

He had hated directing the first film and had suffered physically from the stress of it. He didn't want to go through that again. His friend Matt Robbins had suggested Kershner to him. Kersh, as he was called, had directed a sequel before, *The Return of a Man Called Horse*, and George admired the job he had done with it.

I got a call from De Palma, who was directing a low-budget film called *Home Movies*. He wanted my help with the cut. Brian had followed a pattern he would continue for many years. After directing *The Fury* for 20th Century Fox, he chose as his next project something more personal, a script of his own, this one based on his own family history. Later he would share with me the thinking behind this: "I do a picture for them [the studios], and then I do one for me." If he had a commercial success, this gave him the freedom to shoot one of his more adventurous or at least idiosyncratic projects. "As long as they keep giving me money to put my sick fantasies up on the screen," he told me once, "I'll keep doing it."

Aside from the fact that the plot of *Home Movies* was based on his parents' divorce and Brian's role in it, the interesting thing about the project was that he shot the picture with students from Sarah Lawrence College as his crew. Some of the class went on to have successful careers in the industry. The producers were novices as well. They had produced an off-Broadway show, but *Home Movies* was their first experience in film.

In my absence, Brian had hired a woman named Corky Ohara to edit. He called me in to look at the cut. I told Brian I couldn't take over, because I was committed to *The Empire Strikes Back*, which was starting in March of the following year. It was agreed that Corky would stay on, and I would advise and get a credit as "Editing Consultant." I had fun and maintained my relationship with my mentor. I used Rossini's *The Barber of Seville* and *La Gazza Ladra* as the temp score. Italian comic opera lent just the right absurd touch to the action. Brian brought in Pino Donaggio to write the final score.

When I was working on *Star Wars*, Gary Kurtz came in one day with a baseball cap inscribed with STAR WARS. Not realizing what I was asking for, I jokingly said, "I want one of everything." In December of 1977, the company had been unprepared for the enormous demand for toys and games based on the movie, and retail stores had been forced to give out coupons redeemable for the toys when they became available. By the following year,

the manufacturing process was in full gear. One day, an enormous carton was delivered to our apartment. I opened it up, and it was filled to the brim with *Star Wars* toys and games of all kinds: board games, action figures, model X-wings, remote control R2-D2s, and so on. Those cartons kept coming every six months or so for many years. That was an amazing perk.

———————

As generous as George can be, he is one tough negotiator. When John Breglio started working out my deal for *The Empire Strikes Back*, he discovered that the profit participation that Gary Kurtz had alluded to with me was 0.125 percent, an eighth of a point. I had never heard of points being divided into eighths. I had heard of half points, but usually as an addition to whole points. John tried strenuously, but George wouldn't budge. I also tried to improve on my salary, but no dice.

One day I got a phone call from Marcia Lucas. "Paul," she asked, "do you really want to do this movie? Because George and I thought maybe you didn't want to do it and just didn't want to tell us."

"No, no," I was quick to reply, "I do want to do it."

I then called Breglio to tell him to close the deal. I was not about to turn down the sequel to *Star Wars*!

———————

As we were working on *Home Movies*, I started going to the Carnegie Delicatessen every day for lunch. I had eaten there regularly several years earlier when I was starting out as an assistant at Floyd Peterson's place on Fifty-Fifth Street. The Stage Deli was *the* place in the 1960s, and the Carnegie was relatively quiet. I would bring my *New York Post*, sit in the back at a table by myself, and have a roast beef sandwich while reading the paper.

After I won the Oscar I went back there. The overworked maître d', a corpulent, curly-haired, red-faced, and usually perspiring man with the unfortunate name of Herbie Schlein, greeted me with undisguised enthusiasm. "I know you!" he fairly shouted, pointing a stubby finger at me. "I know you! You used to come here and eat your lunch every day! You sat in the back!"

"Yes, that's right," I admitted.

"And you won the Oscar, right? I saw you on TV!"

"Yes, that would be me," I granted.

"I knew it! I knew it!" Herbie turned to the waiter. "Linen napkins! Linen napkins for . . . what's your name?" I told him. "From now on, Paul always gets linen napkins," he bellowed.

The linen napkins were a perk awarded to regular customers at the Carnegie and a signal to the waiters that special treatment was in order. Herbie was a true fan of the movies, so when I showed up with Brian, he was beside himself. He fawned over Brian. Once, Spielberg, or as Brian nicknamed him, Spellbound, came to the city. We took him to the Carnegie. That nailed it with Herbie. From then on, we never waited in line again. Whenever we showed up, no matter how many people were in line before us, Herbie would give us the first table available.

"Who am I going to get to cut my film?" Brian asked me mock-plaintively one day. I was getting ready to leave town for London to work on *The Empire Strikes Back*, and Brian was in preproduction on his next picture, another thriller called *Dressed to Kill*.

"Well," I said, "the best editor in New York is Jerry Greenberg." Jerry had cut the mind-bendingly well-edited *The French Connection* and the famous helicopter attack scene from *Apocalypse Now*. "You can't do better than Jerry," I said.

In fact, Brian did hire Jerry, to great success: Jerry went on to cut five pictures for Brian, including *Scarface* and *The Untouchables*. *Dressed to Kill* turned out to be a big hit and is considered one of Brian's best.

At the time I thought of Wally Pipp, who played for the New York Yankees. He lost his job as the Yankees' starting first baseman to Lou Gehrig when he sat out one game with a headache. Gehrig went on to play in 2,130 consecutive games. *That was pretty foolish, introducing Brian to Jerry*, I told myself. *I may never get my job back.*

I did in fact work with Brian again, and I have never regretted fixing him up with the best replacement I could think of.

Now Jane, Gina, and I were off to London.

11

The Empire Strikes Back

I WAS EXCITED TO BE GOING TO England to work on the most highly antici-
pated film I could ever remember. The script for *The Empire Strikes Back*
was very bold in a way that could easily have backfired. It was not a "remake
sequel"—the structure was very different from that of *Star Wars*. The safe
way to go would have been to have the big battle in the third act, just as
in the first film, which had broken box office records all over the world.
Instead, the battle takes place close to the beginning of the movie, and then
the film focuses more on the characters and their deepening relationships,
as well as on Luke's personal development. Essentially, the whole picture
is but act II of the trilogy, without the happy ending of the first film. It
was a risky choice, especially given that the unresolved questions in the
picture wouldn't be answered for another three years, which is how long
it took to write, shoot, and release films as complex as these. The movie
introduced some new characters, notably Lando Calrissian, played by Billy
Dee Williams, as well as Boba Fett and Yoda, who I expected would blow
the audience's minds.

Gary Kurtz found us a place to live in the Hampstead area of London, close
both to Elstree Studios in Borehamwood, where I would be working, and to
the vast Hampstead Heath. Our home-to-be was a small, newly renovated

two-story attached brick home on Marion Mews. It was, as Gary had said, clean and neat, very modern in its furnishings, so not a lot of ambience, but warm and dry. We arrived in March of 1979.

The very first morning, we were awakened at 8:00 AM by the loud ringing of the front doorbell. A slim woman in business attire stood there holding a clipboard. "Inventory CHECK!" she barked. She pronounced *inventory* in three syllables, as if it rhymed with *infantry*. I was jet-lagged, so it was something like three o'clock in the morning for me, and I was baffled.

"Inventory CHECK!" she repeated.

I had no idea what she was saying. I thought it might be a foreign language she was speaking. It was my first taste of the phenomenon described by George Bernard Shaw: "England and America are two countries separated by a common language."

I finally grasped what she was after, although I still didn't know why she hadn't started with something like, "Good morning." We then went through the house checking every appliance and spoon in the place against her list. Finally, she left, and we went back to bed.

Adjusting to life in London in 1979 was an ongoing project. Television viewing was limited. There were only three channels, and on rainy weekend afternoons there might be a documentary on metallurgy on one channel, one on sheep raising in the Hebrides on another, and on the third, with luck, a sports match of some kind. Sometimes, though, the game would be rained out, and instead of running an old movie or some other alternate programming, they would simply broadcast a card that read, GAME POSTPONED DUE TO WEATHER. PROGRAMMING WILL RESUME IN THREE HOURS.

I had to make some adjustments at work too. My cutting room was located in the editing block, as it was known. The facilities were positively Dickensian and seemed to date from that era. The reels were made out of wire, and the racks made of wood. There was no central heating, and the place looked as though it hadn't been painted in decades. It was demolished shortly after we left. During the first weeks we were there, before the weather warmed up, Philip Sanderson, my first assistant, would come in early and turn on a space heater, or as they call it, an "electric fire," for me so I wouldn't be walking into an ice-cold room.

Philip was an experienced, considerate, and amiable young man with a plain exterior masking a witty and helpful interior. He wore a rumpled wool suit and thick glasses and spoke with a colorful accent, saying "wiv" instead of "with." He was a wonderful assistant.

The first thing I did was to order all the film equipment in the room to be taken out. They located a Steenbeck for me to cut on, a four-plate model with a wide-screen picture head. I cut *Empire* on this machine, with one picture and one track, and no search machine.

I would spend each morning screening the previous day's dailies on the machine and would extract from the big rolls the takes I intended to use in the cut. I would wind the selects onto cores and put them on a wooden rack next to me built by the carpenters at Elstree. Then I would assemble the scene from the small cores, attaching them to the workprint in order to view them as I went.

I began to get to know my director. Kersh was older than me, but he was at heart a big kid. He was wonderfully enthusiastic about almost everything. He was a singularly striking individual, with a wispy mustache and goatee and long, angular limbs and hands. His voice was reedy, high and nasal, and he alternated blithely between gleeful amusement and anger. During production, the editing room was a place for him to come and vent his rage about anything that was driving him crazy on the set. He would charge in, rant for a while, and then charge out again.

On one occasion, he was pulling out what was left of his hair about the set for the carbon freezing chamber where Han Solo is imprisoned in a block of carbonite. The floor and the ceiling were fantastic, beautifully designed with wonderfully intricate detail. But there were no walls! The set was suspended in a black limbo, so all the shots of the actors were backed by . . . nothing.

"There's no set!" he would cry. "I have to shoot from above or up the actors' noses!"

———————

Elstree was a relatively small studio. Stanley Kubrick had been filming *The Shining* there, and our company followed him onto the soundstages. He was now cutting on the lot. I never saw Kubrick in the commissary,

but from time to time I did see Ridley Scott there. He was finishing *Alien*. I recognized him, but we were never introduced.

Through the production office, I got an invitation to the premiere of *Alien*, at the Odeon in Leicester Square. We drove down from Hampstead and parked in a nearby underground car park. The picture was brilliant. When the creature burst out of the crewman's chest, I nearly died. Such a simple idea, a monster loose on a spaceship. The tension was tremendous. And the visuals were inspired. Kersh later enthused about the design of the entrances to the cave where the alien eggs had been laid. "They were vaginas! They were in the shape of vaginas! Did you see that?"

As I watched the picture, I couldn't help noticing the intricate design of the bulkheads of the spaceship as Sigourney Weaver crept through the passageways. I realized then, sensitized to the issue by Kersh's plight in the carbon freezing chamber, that the walls are where to put all your money and creativity if you want them to be visible in most shots of the actors.

After the screening, as we were going back to our car, a crowd of moviegoers were squeezing into the lift going back down. Jane and I managed to get in just as the doors were closing, but then a couple more people ran up and stopped the doors and jammed themselves in next to us. As we started down, I realized that I was pressed shoulder-to-shoulder with Ridley. I looked at him, his eyes less than a foot from mine.

"Good picture," I said, with a smile.

"No," he replied with a grin. "Great picture!"

The shots in *Empire* were usually very complex, especially the battle scenes on ice planet Hoth, with steam and explosions. After every take, the crew would reload explosives in the walls where laser bolts were to hit. To do another take, they first would have to paint over the black marks that the charges left.

It was often a long wait between takes, and at times they would shoot only one or two setups before lunch. It was easy for me to keep up with the shooting, and on many days I would have cut everything I had by early afternoon. So I would wander over to visit the set.

"What are you doing here?" I would hear.

"I've cut all I have so far. What's taking so long?" (This did not endear me to the crew.)

The first assistant director on the picture was named David Tomblin. He was the best at this job I have ever seen. The first AD runs the set, along with the cinematographer, also known as the director of photography (DP, or DOP in the UK). The first AD keeps the work moving forward, knowing what every setup requires and who must be ready and when. He or she coordinates the activity of all the various crafts so that everyone is ready at the proper moment. David was magnificent. He reminded me of an admiral standing on the deck of an English four-masted sailing ship. Tall, magisterial, with wavy gray hair and a booming deep voice, he would call out to each member of the crew by name, knowing each one's job, keeping things moving along.

The DP was named Peter Suschitzky. His crew called him Peter Soo. He had the look of an intellectual, with a sharp, aquiline profile. His camera operator was a friendly and jovial Aussie named Kelvin Pike, who had worked with Kubrick on several pictures, including *2001: A Space Odyssey*. I always feel an affinity for the camera operator. I tell him it's because he and I have the best jobs on the crew: he gets to look through the camera, and I get to cut the film.

A man named Maurice was the focus puller, in charge of making sure every shot in the movie stayed in focus. He had extremely poor vision and wore glasses with enormously thick lenses. I thought he might even be legally blind. But there was never a single out-of-focus shot in the entire production. Maurice would measure meticulously from the lens to the subject at every point in a dolly shot. The results were always perfect.

The production designer was Norman Reynolds, another lovely and gentle man. Production designers are amazing, because they build complicated structures that are meant to create an illusion only for a brief while and then are torn down.

The shooting was proceeding very slowly. At first, we were told the shooting would last about sixteen weeks. After just one week, Gary Kurtz told me that our departure would be a week later than planned. After another week,

it was up to two weeks. This kept up throughout the shoot and caused a lot of tension, as George was financing the film himself and every day of shooting meant ever-greater cost overruns. It also took its toll on Jane and me. Being on location, especially with a small child, is difficult.

Kersh would periodically check in with me to see how I was doing and to evaluate his own work. I showed him a scene in which Han goes out in a terrible blizzard to search for Luke, who has gone missing. Kersh looked at the scene, turned to me and, with one index finger raised, pronounced, "Physical difficulty is boring!"

This has stayed with me ever since. He was absolutely right. Audiences do not enjoy watching actors struggle. The exception, of course, is when the struggle takes place in the proper context. Watching a woman trying in vain to untie her hands will become tedious very quickly. However, if she is tied to a railroad track and you intercut shots of an approaching locomotive, then you have a scene that induces tension and can play for a good while.

After about a month, we had completed the portion of the story that takes place on Hoth. George flew over from the States to check on the production. He asked to screen what I had assembled, about thirty minutes of cut footage representing the first part of the movie. He was not happy with what he saw. He asked for a cutting room, and he took the thirty minutes or so I had cut in with him.

He proceeded to trim and restructure what I had done, exercising a kind of droit du seigneur, as editing had been his forte in film school. I was unhappy, because to recut a scene on film, you had to take apart the existing version. This no longer applies now that everything is digital and making a copy takes but an instant. But to cut a new version back then, George had to make it out of the old one. He then screened his cut for us in one of the theaters on the lot. As unhappy as I was, Kersh was even more so. Not only had George moved shots around and trimmed them—rather brutally, I thought—but he had also flopped a shot or two. This means instead of cutting in a piece of film with the emulsion facing up, you cut it in with the emulsion side facing down. The result is a mirror image of the original shot—that is, everything is reversed left to right.

Left and right are critical orientations in film editing. When cutting together close-ups of two people talking, the cutting is much smoother

and more graceful if one actor is facing left and the other is facing right. If they are both facing in the same direction, it will look odd and in some cases can even be confusing. So when George moved shots from their original context, occasionally he felt the action played better flopped. The depth of field of focus is so critical on a 35 mm projector that when you project a flopped shot, it will come up out of focus. This happened again and again as we watched his cut.

"It looked like I didn't know what I was doing!" Kersh moaned to me afterward. He was humiliated by the implied criticism. But George was just looking to make the picture better, and frankly, he had. The structure he came up with was definitely an improvement, although the cutting needed finessing. I went through the scene and made careful notes of all the cuts that really bothered me. I went to George later and asked him if he would be OK with me adding a few frames here, tightening a few frames there, all with an eye to making the cut smoother. He agreed to all my changes and I was happy again. I think he was just working very fast and wanted to get the basics in order.

————————

Around this time, Gary came to me and said, "We are going to need you to cut a trailer pretty soon."

"But we have hardly any shots!" I protested. "How can I cut a trailer without film?"

"Well, just keep it in mind. We don't need it just yet."

A week or two more went by. As I was hardly under a lot of pressure from the small volume of incoming dailies, I dreamed up a script for the trailer. The idea was to hark back to the serials of the 1930s and '40s, which, after all, were the inspiration for *Star Wars* in the first place. "Luke Skywalker and Han Solo rescued the princess and destroyed the Death Star, but their story didn't end there! Now the creators of the biggest smash hit of all time bring you the next episode in the *Star Wars* saga—*The Empire Strikes Back*! Blah blah blah. Coming to your galaxy next summer . . ."

Real hammy stuff. In between the lines of the voice-over, I cut a little montage of whatever shots I had at that point that related to the text.

When I listed the characters, I cut to a close-up of each one as his or her name was read aloud. Because I had so little footage at that time, I kept cutting back to a shot of the *Star Wars* title artwork, coming closer and closer to camera against a star field. I now had a cut of the trailer, but I needed someone to record my script before I could show it, and I wanted it to be an American voice.

Mark Hamill's wife Marilou was expecting their first child, and it was due any day. To deflect questions about the baby, Mark was walking around the lot, in costume, with a cardboard sign hanging from his neck that read, DON'T ASK!!! So I went to Harrison Ford. He was reluctant. I pleaded, "Come on, it'll take half an hour. We can go into one of the studios here on the lot after you finish shooting."

"You need an American actor, don't you?" he asked.

"Yes."

"So, I guess the pickings are kind of slim."

"Yes," I said.

So, he agreed. I got us a couple of beers and we went into the studio. I told him to play it like a newsboy announcing an extra edition, high pitched and excited. He knocked it off in one or two takes.

I laid it in against my cut, then had one of my crew add a few sound effects, and I cut a music track using the score from the first film. I mixed it and sent it off to George in California.

A few days later, I got a call from an assistant back in Marin. "George loves the trailer!" he said.

"Great!"

"He also loves the actor who did the voice-over and wants to use him in the final. Who was it?"

"Harrison," I replied.

"Who?"

"Harrison," I repeated. "You know, the star of the movie, Harrison Ford?"

Harrison had played it so differently from the Han Solo character that they hadn't recognized him. I ran to tell him. I found him outside one of the soundstages. "Harrison! They loved us," I said. "They want you to rerecord the narration for real!"

"Whoa, wait a minute," he replied. "They pay big bucks for this kind of work. I know because my father used to do this for a living. How much are they paying you for doing the trailer?" he asked.

"Me? Nothing. Just my salary on the film."

"What?! That's outrageous. I'm going to charge them $10,000 and give you half!" he announced.

Just about then, Gary Kurtz came walking up. "Harrison, I wonder if I could talk to you for a second."

"Sure, Gary," Harrison replied, wrapping one arm around Gary's shoulder as he walked away, giving me a wink as he did.

He came back a little later. "I only had the nerve to ask for five," he confided.

Sure enough, a few weeks later a check showed up in my mailbox from Harrison's production company for $2,500. It was a bit of spontaneous generosity that I haven't forgotten. As it turned out, despite George's initial enthusiasm for it, the theater owners hated the trailer. They felt it didn't have sufficient gravitas.

Larry Kasdan came to visit. He had taken over script-writing duties from Leigh Brackett, who, sadly, died before the script was finished. She had written a number of films directed by Howard Hawks, including *The Big Sleep*, *Rio Bravo*, *Hatari!*, *El Dorado*, and *Rio Lobo*, as well as *The Long Goodbye* for Robert Altman.

I don't know how or why George came to hire Larry. This was Larry's first credit, and, as the editor, I am not privy to many of the decisions that are made before I arrive on the scene. I am always getting on board an already moving train. George has story credit on *The Empire Strikes Back* but apparently did not want to be responsible for writing the screenplay.

I invited Larry to our Marion Mews flat for dinner, as a gesture of friendship to a lone fellow American. I learned to my surprise that Larry was from West Virginia. I didn't know any Hollywood writers came from there.

I bumped into Ray Lovejoy, Kubrick's editor, on the lot. I had heard they were using a video system to edit *The Shining*, and I was very curious about it. I asked Ray if I could come see it sometime. "Oh, of course," he answered. "Give me a call next week." I called him that Monday. "Oh, today's not so good," he said. "Try me later in the week." I called toward the end of the week and got a similar answer. "Maybe next week will be better," he offered.

Weeks passed. I figured that was that. Sometime later, George came back to London to check on why the production was so far behind schedule. Late one morning, he stuck his head into my cutting room. "Hey, I'm going over to Kubrick's cutting room to see this video system he's got. Want to come along?" he asked.

I didn't have to be asked twice. The only problem was that I had caught a slight head cold, and Kubrick was a known germophobe. But I knew this was my only shot at getting inside that room, and I wasn't going to let a little cold stop me. We went across the lot to where Stanley was cutting. I tried not to sniffle.

He had a large loftlike workspace, with racks of film all around. Ray was seated at a Kem flatbed editing machine. Stanley sat at a desk, with a small monitor and an addressable Betamax video player. He could enter a specific footage into the machine, and it would automatically wind down to that exact spot on the tape.

They had transferred all the film dailies to tape cassettes, and by referring to a log, Stanley was able to see in quick succession all the readings of a given line of dialogue. He would spend each day searching for the next piece of film he wanted to use. When he made his choice, the assistant would find the film on the racks and bring it over to Ray, who would cut it in. Meanwhile Stanley was searching for the next piece. It was state of the art at the time.

It took George's clout to get me into Stanley's cutting room. And although Kubrick eyed me with suspicion, I have never regretted going.

The schedule kept pushing later and later. The company had moved on to the Cloud City section of the movie. One afternoon, I wandered over

to the set and saw they were shooting a shot in which Darth Vader, using the Force, pulls a weapon out of Han Solo's hand and catches it. They had attached a monofilament to the end of Han's gun barrel and, with the tip of the blaster just at the edge of frame, pulled it out of his hands. This was followed by a handheld angle of the weapon flying through the air. The last shot was of Vader catching it. They had decided to replicate the same monofilament trick as with Han, except they would roll the film backward, making it appear that Vader was catching the gun.

After watching several takes of them trying to imagine what his arm motion should be, to make it appear natural when they reversed the action, I made a suggestion. "Why don't you just toss the gun to him and let him catch it?" I asked.

"Well, he has the mask on, he won't be able to see it," was the reply.

David Prowse, the actor in the Vader suit said, "Let me try it."

So they did, and on the second or third take, he caught it, and the company moved on. Sometimes they forget that simple can work too.

Prowse had been cast to play Vader because of his physique. He was a bodybuilder and weight lifter and had made his film debut as Franken-stein's monster in the James Bond spoof *Casino Royale*. Kubrick had cast him in *A Clockwork Orange* for the same reason, his build. He played the attendant who carries the crippled writer around his house. According to Prowse's biography, when he tried out for *Star Wars*, George had offered him his choice between Vader and Chewbacca. He picked Vader instantly. When asked why, he replied, "Everyone remembers the villain, George."

It was now summer, and had we kept to the original schedule, we would have headed home in the middle of June. The last sequence, featuring Yoda, had yet to be shot. The brilliant makeup artist Stuart Freeborn was working on the clay model for the puppet. Kersh visited his workshop from time to time, and I accompanied him to see how it was going. I had seen some concept art, and what I saw was a little worrying. Kersh was asking for changes that were taking Yoda in a strange direction, at least to my eye. The next time George came to visit, I mentioned to him that he ought to check in on that process. He did, and after that, Yoda became what we now know him to look like.

George introduced me to a couple of visitors one day: Jim Henson and Frank Oz. I was thrilled to meet Henson. It isn't every day you meet someone who changed the culture of a nation, as he had with the Muppets. I wasn't as familiar with Frank's name.

"Frank is Miss Piggy!" George told me delightedly. He was also Bert, Grover, the Cookie Monster, and Fozzie Bear. George actually wanted the credits to read "Yoda played by Miss Piggy." But Frank properly got the credit in his own name.

Henson was quiet and gentle, tall with a substantial beard. We only shook hands, but I will never forget meeting him. Frank was also very gentle and gentlemanly, and they were both enormously talented.

At last, the company started shooting the Yoda scenes. Kersh had all sorts of ideas for staging that would have required many more weeks of shooting. But George was running out of money and patience. He told Gary, "You tell him to get this done fast or I'm going to plunk that puppet down in one spot and shoot all his lines in close-up!"

So Kersh made some concessions to the physical limitations of working with a hand puppet. Oz was under the floor of a raised stage, with his arm up inside the puppet, watching himself on a video monitor as he performed.

We had now been in London for twenty-six weeks, and for tax reasons I had to leave and go back to the US—not that Jane and I were complaining. Jane was pregnant again, and we'd had enough of living abroad by then. We were eager to get back to familiar Marin, where our previous experience had been so wonderful. The company kept shooting for another three weeks, bringing the total to twenty-nine instead of the sixteen originally planned. We had lost thirteen weeks out of our postproduction schedule.

The cutting rooms were now in a building in downtown San Anselmo. The house on Park Way where I had worked on *Star Wars* had become George and Marcia's home. They restored it to its original two-story design and moved in with the intention of raising their family there. The new cutting room was not quite as extraordinary as that earlier one, but it did have a working fireplace, which proved to be wonderful on those raw winter days typical of Marin.

I finished the first cut of *Empire* quickly, and we screened it twice in one day. This was George's method. The first screening was to get the overall impression; the second was to take notes. George, Kersh, Marcia, Gary Kurtz, and Larry Kasdan were all there. The next day, we went to the cutting room, where I put up each reel in succession. I would play the reel until someone in the group had a note to make. I would stop, and there would then be a discussion about the proposed change. In case of a difference of opinion, George of course had the last word, but he agreed to every suggestion that Kersh made.

I compiled a master list of all the changes George had approved and started work. While I was doing this, George spent part of each day going through the outtakes of each scene on a Kem in an adjoining room. I was a little put out, since I thought it displayed a distrust of my work. But after a few days, his assistant said to me, "Well, you should feel pretty good. Usually George starts making lots of changes, but now he is just looking at the outs and saying that Paul has already used all the good stuff."

George was otherwise occupied during this period. He was building Sky-walker Ranch, a luxurious, state-of-the-art, and totally self-sufficient post-production facility in Marin. He had gone through a grueling process in acquiring a tract of land on Lucas Valley Road, which people mistakenly assume was named after him. George was now deep into the actual build-ing of the ranch. He had balked at the idea of paying contractors to do the work, so he formed his own contracting company and paid himself to build the place. All George's properties, at least the ones I have seen, share a luxurious but rustic aesthetic.

Marcia was drafted to help, in assuring that George's vision—or maybe it was hers—was carried out in the interior design. She was the designated hostess to the many prominent visitors George had begun to attract in the wake of *Star Wars'* success. George was into serious empire building at this point in his life and was feeling a lot of pressure from the overages on *Empire*. His plans for Skywalker Ranch depended on the success of the picture. It was difficult for him to relax, but one day George was feeling lighthearted. He was in the cutting room, warming himself near the fire, and

he turned to me and joked, "Judge me by my size, do you?" He was quoting Yoda from the film. "And well, you should not, for my ally is money!"

Personally, I never thought there was any doubt as to the success of *Empire*. Larry Kasdan had delivered a terrific script, and Kersh had done a great job working to make the relationships between the characters come to life. Yoda was our secret weapon. I anticipated he would knock people out when they saw him. Despite its darker tone, with an indeterminate ending and a few questions left unanswered, many people consider it the best of all the films in the saga.

The cutting went pretty smoothly. George asked Marcia to do a "guest cut" on a romantic scene between Han and Leia, because he felt a woman's touch was needed. She happily obliged. Kersh was gleeful about a small detail in the production design in that scene. There was a small metal bar in the machinery in the background that slid repetitively in and out of a hole. As I said, Kersh was in many ways just a big kid.

We locked the picture one month after the end of principal photography; even though the shooting had taken thirteen weeks longer than planned, we were able to stay on schedule in post. I spent my time reviewing and cutting in shots from ILM as they were completed, as well as reviewing the cutting of the ADR—automated dialogue replacement. This is also called *looping*. It's used when the original production recording of the actors' voices is marred by background noise or poorly recorded. Sometimes it is employed to improve the performance.

There had been a screwup with the Imperial stormtroopers' lines on the first film, and I wanted to make sure it didn't happen again. It was in the famous scene in which our heroes are stopped by stormtroopers.

TROOPER: Let me see your identification.
BEN: You don't need to see his identification.
TROOPER: We don't need to see his identification.
BEN: These aren't the droids you're looking for.
TROOPER: These aren't the droids we're looking for.
BEN: He can go about his business.
TROOPER: You can go about your business.
BEN: Move along.
TROOPER: Move along.

The troopers' lines, which were ADR, were laid in eight frames later than I intended. Since I hadn't been at the mix, I hadn't caught it until too late. Ironically, that screwup has become an iconic moment in the *Star Wars* lore. The slight hesitation by the stormtroopers to Obi-Wan's cues suggested that it took a moment for the Jedi mind trick to work. I suppose I could claim that I did it deliberately, but it was just a happy accident.

———————

On Christmas Eve 1979, it poured. We had rented a small house in Ross, near San Anselmo. It is just east of Mount Tamalpais and is recognized to be one of the rainiest spots in the entire Bay Area. That evening we heard a knock on the door, and there stood Marcia in the downpour. She had brought a gift for our three-year-old, Gina: a four-foot-high stuffed Chewbacca toy, wrapped against the storm. The gesture was typical of her, and I was really touched that she had taken the trouble to deliver it personally, especially in all that rain.

Once again, Jane gave birth in Marin General Hospital, this time to our son Eric. So our kids are native Californians, although our home was in New York.

———————

When the picture was completed, we screened the finished film for the cast and crew. Harrison was there. He had shot a couple of other films in the interim, neither of which did well at the box office. His original contract with George was only for two films, and I had heard that he was holding out for more money on the third. I had also heard that George had threatened that if Harrison didn't agree to appear in the next picture, he would carry around the prop of Han Solo frozen in the carbonite block throughout the whole film and then blow it up in the final reel. When I saw Harrison at the screening, I asked him, "Are you going to be in the next one?"

"You think I have a career without these guys?" he replied. He had landed the part of Indiana Jones in *Raiders of the Lost Ark* by then and was referring to both Lucas and Spielberg.

Many years later, at George's fiftieth birthday party, I saw Harrison again. I thanked him for the trailer money he got for me. He hadn't remembered. Then I told him how happy I was for him, the way his career had turned out.

"Imagine how *I* feel!" he answered.

We also screened *Empire* for the studio employees on the 20th Century Fox lot, in the same room where we had mixed *King of the Gypsies*. The biggest cheer from the audience came at the start, for the 20th Century Fox logo.

As the project was wrapping up, Larry Kasdan offered me *Body Heat*, his first film as a director, but I wanted to go home to New York and I turned him down. I felt that I would be able to have my pick of projects now that I was an Oscar winner. This was not the case. Nor would it be the last time I turned down what proved to be a good picture.

The following year, I was stunned when the Oscar nominations were announced. *Empire* received only three nominations—for sound, production design, and score—and only sound won. The VFX guys received a special achievement award. The editing nominations went to *Fame*, *The Elephant Man*, *Coal Miner's Daughter*, *The Competition*, and *Raging Bull*, which won. I have no problem with that, as it is a brilliant editing job. But, still young, I expected the Academy to recognize my work. I was very disappointed, but this experience led me to understand that in the long run, people don't remember awards or nominations. It's the work that matters.

I never worked for George again. When it came time to begin preproduction for *The Revenge of the Jedi*, before "Revenge" was revised to "Return," I got a call from Gary Kurtz telling me that George had hired a British director, Richard Marquand, out of anger at the Directors Guild of America. When the guild screened *Empire*, they claimed that the credits on the film were a violation of DGA rules and fined George $50,000. The violation was that the director's name was at the end of the film; because George wanted a

consistent look to the titles, LucasFilm was at the beginning. To the DGA this put the producer's name at the start, which was a no-no. Kersh hadn't minded at all. "When my name comes on, everyone applauds!"

The next day, the Writers Guild fined George too. He would neither forget nor forgive, which is how Marquand got the job on *Jedi*. Of the hundreds of crew members who work on films of this size, Marquand was allowed to hire only two: his cinematographer and his editor. I was out of luck and once again disappointed. Looking back, though, I respect what Marquand did. Loyalty is too rare in Hollywood.

When I am asked what it was like living through those few years that so deeply influenced my life and reputation, this is what I tell people: It was as if I were walking along, and a flying saucer landed near me. A hatch opened, and George stuck his head out. "Want to go for a spin?" he asked.

I got in and went for a terrific ride. Then the saucer landed again. I got out. George smiled, waved, and took off again.

It was the most fabulous adventure of my life.

12

Blow Out

BACK IN NEW YORK IN 1980, Brian De Palma was preparing to direct *Personal Effects*. Our sound editor from *Phantom of the Paradise* had inspired him to write the script. Brian was intrigued by the idea of someone going around with a tape recorder, recording sounds. He came up with a plot similar to that in Antonioni's celebrated film *Blow-Up*, in which a photographer accidentally gets a shot of what he believes to be a murder. In this case, it was the sound of a gun shooting out the tires of a car, causing a fatal accident. I didn't suspect it would one day become a bigger cult hit than Antonioni's film.

George Litto was producing again, a prospect that left me less than thrilled. Once again, George wasn't happy with the title, and this time he prevailed. The picture was retitled *Blow Out*. I thought this was unwise, since film critics had heaped accusations of plagiarism on Brian ever since *Sisters*, and this simply called attention to the similarities with Antonioni's film classic.

Nancy Allen, Brian's wife, was cast as Sally, the female lead opposite John Travolta, who played Jack Terry. I read the script and thought it needed rewriting. In particular, there was a chase through the subway system in which Jack tracks Sally and the killer, Burke (John Lithgow), using a wireless microphone hidden on her body.

It was a great idea, except that I thought the locations should have been chosen by their sounds. In a subway, there is not a lot of distinctive sound to give Travolta, listening on his headset, clues as to where the couple was

going. The finale takes place at a bicentennial celebration in Philadelphia, with fireworks. I thought it would have been better if the location had been an amusement park with sounds of a sledgehammer striking a gong, or Ping-Pong playing, or air rifles—unique sounds that would pinpoint locations.

The idea of the surveillance wire was left over from a draft Brian had done for a picture called *Prince of the City*, which was ultimately directed by Sidney Lumet. Not wanting to waste a perfectly good idea, he lifted the entire scene and used it in *Blow Out* as a flashback illustrating Jack Terry's backstory. Jack tells Sally of a tragic incident in his past involving tailing someone wearing a wire. Besides being a good scene, it also sets up the finale of the film.

Brian was not terribly interested in any of my suggestions, and they began shooting in Philadelphia, Brian's hometown. The great Vilmos Zsigmond was back on board as the DP. In the film, Jack Terry is a sound editor working for a director of schlock horror pictures searching for a more perfect scream. To act his part, John had to know how to use the tools of the trade: splicer, synchronizer, rewinds, and a Moviola. I was recruited to instruct him so he would look authentic.

John came to my cutting room late in the day, and I walked him through how to use the various tools. I showed him how an editor would scrub the sound to find the exact perf where a sound would start, and how to mark the film and sound to put them into sync with each other. He was very polite and friendly and picked it up quickly.

When we left that evening, we boarded the elevator, which was manually operated by a uniformed employee. As we were riding down, the operator started to hyperventilate. "Oh, my God!" he exclaimed. "Is that really you?"

John grinned and said yes.

I thought the guy was going to have a stroke. He stuck out his hand and they shook vigorously. "Oh my God," the man repeated. "I can't believe this! This is the greatest thing that has ever happened to me!"

I rolled my eyes mentally (I hope). I was embarrassed. When we got outside, John turned to me. "It's moments like that," he said in all seriousness, "that make it all worthwhile."

Shortly after the Kennedy assassination, when the Zapruder film came to light, it had been considered too shocking for the public to view as a moving image, so *Life* magazine published the individual frames as still photos. This inspired the scene in *Blow Out* in which Jack reverses the process. He creates a film by carefully rephotographing on an animation stand the still frames of the assassination printed in a magazine. He then adds to it the sound of the car accident he has recorded. He syncs up the sound by aligning the sound of the splash as the car hits the river with the corresponding frame in his reconstructed film. This leads him to discover the image of the gunshot just before the blowout of the tire.

Among the angles in the dailies was a close-up of the Moviola screen as the film plays forward and back, over and over, as it would while Jack is searching for the precise frame. As I ran the shot, looking for the precise frame where I wanted to cut, I realized that the back-and-forth action on my screen was the same whether I was running my machine forward or backward. This confused me so much that I had to actually look down at my hand to see which way I was running the film.

It is interesting to look at this sequence today, as we had documented for history a work process that is now obsolete. All those tools and methods that were my life's work for twenty-five years are no more.

Cutting the picture proved to be problematic. There was a structural flaw in the script: the antagonist didn't appear for about an hour, resulting in a lack of tension. To redress this, we started moving scenes around, which had a ripple effect. We took a scene and split it in two, separating the parts of the scene and using them in different parts of the film. In doing this, other scenes were dropped so that, ironically, while Brian had intended to make a film about a political conspiracy, the movie turned out to be about a lone assassin.

The climax of the film caused some contention between Brian and me. The scene called for Burke to drag Sally up to a high place overlooking the crowd under a massive fireworks display. This was intercut with shots of Jack fighting his way through the crowd to save her. When Brian saw my cut, he felt I had started intercutting Jack too early in the sequence. He made me recut it, starting Jack later.

When we screened the picture for George Litto, his first note was that Jack was starting too late. So I had to recut it yet again, putting it back the way I had it before. I also had an idea for the end in which Sally survives, but Brian would have none of it.

I learned an important lesson on *Blow Out*. A director deserves to have an editor who is solidly behind the project. My problems with the script should have made me turn the picture down. I unconsciously brought a negative attitude to the editing of the picture. This brought me into conflict with Brian and damaged our relationship somewhat. I resolved that I would never again accept an assignment only because of the director. I also had to like the script.

In my career I have had a number of mishaps involving the cutting of the negative for my films, as when the neg cutter miscut the explosion of the Death Star in *Star Wars* (chapter 8). Or when the splices in *Sisters* were all made crooked on a misaligned splicer (chapter 5). But the most horrendous negative disaster occurred on *Blow Out*.

In my very first job as a shipping clerk at Dynamic Films, I learned that you never *ever* ship anything on Friday. If the shipment should go astray, two days will go by before you discover the loss, which makes recovery that much more difficult. *Blow Out* was filmed in Philadelphia, so the processing was done in New York, at Technicolor. The studio decided that rather than cut the negative in New York, that would be done on the West Coast, so all the processed film was packaged for shipping to Technicolor Labs in L.A.

Somehow, the shipment went out on a Friday. We were at the mix the following Monday morning when we got a phone call from the lab in L.A. There were four cartons of negative missing, containing footage from four days' shooting. Apparently, the truck driver who collected the cartons from the lab on Friday had stopped on Fifty-Seventh Street to make another pickup. While he was inside, the truck was broken into and thieves stole the four cartons. They probably didn't even know what they were stealing.

Brian was beside himself. He went out into the street, digging through trash cans, hoping the thieves had thrown out the cans of film once they

saw they hadn't hijacked a shipment of stereos. Then a call came from the lab in L.A. with more bad news: Some of the four days missing involved the parade scene, in which Jack drives his Jeep through a marching band of Mummers, onto the sidewalk, and through a plate glass window.

The FBI was called in and rewards were posted for the return of the film, no questions asked. But we never recovered the footage. The sequence was reshot at a cost of half a million dollars, covered by insurance. Because the scenes were originally filmed in winter, all the extras had to dress in winter clothing even though the reshoot took place in the summer. In the end, we were able to patch all the "holes" in the film. We finished up, and I took off for a well-deserved vacation.

Blow Out opened in the summer of 1981. I went to see it in the Hamptons, where we had rented a house for the month of August. When Jack gets to Sally too late to save her at the end, the audience actually started booing at the screen. I had never seen such an angry response to a film before. And yet, unpredictably, *Blow Out* turned out to be one of those early De Palma pictures that survived its initial rejection and is widely admired today.

Earlier that year, Robert Dalva had called and asked me to edit *The Black Stallion Returns*. Robert had cut *The Black Stallion* and had gotten the chance to direct the sequel as a result. The job meant going to Rome for four months, which sounded pretty good to me. Unfortunately, my father had contracted cancer, and when I told him about the offer, he said, "Gee, I hope you don't take it."

So I turned Robert down. Although I would have loved spending four months in Rome, my father meant the world to me, and it would have been intolerable to be so far away from him in his final days. I have never regretted the decision.

Ironically, Dad died on September 21, 1981, the day shooting began. I had come back to New York hoping to pursue my career there, armed with an Oscar. But we were now in a recession, when people make fewer movies. There I was, with two children, a golden opportunity to spend four months in Rome gone, and no work.

Then a job turned up out of nowhere. I got a call from George Romero's producer. They were shooting an anthology film called *Creepshow*, inspired by horror comic books. Stephen King had written the screenplay, and they wanted me to edit one of the five stories, "The Crate." I agreed as long as I could work in New York. They were OK with that, but I would have to make a brief trip to Pittsburgh to meet George.

It was winter by now, and my plane landed on a snow-covered runway in Pittsburgh. I was introduced to George, a big, shambling bearded man of great personal warmth. We chatted briefly, and that was that. I headed back to New York the same day.

One day Stephen King came to the cutting room. I was excited to meet him, as I was a big fan of his. The fact that I had edited *Carrie*, his first novel and the first to be made into a movie, was probably why he wanted to meet me. I have met a number of great artists, and I place Stephen King in the same realm as John Hughes and John Williams, whose creativity is inexhaustible.

We talked about Kubrick's version of *The Shining*, which, apart from the spectacular performance by Jack Nicholson, I had some problems with. In particular, Kubrick had made a major change in the ending. In the book, one of the main character's principal duties is to keep watch on the old hotel's boiler, whose steam pressure tends to creep upward if left unattended, which is exactly what happens when he starts to go nuts. The book ends with a giant explosion. As I read it, I could imagine the suspense generated by cutting repeatedly back to the steam gauge during Jack's final murderous rampage.

I mentioned this to King, and he agreed strongly. There are certain conventional elements in these stories that you just shouldn't mess with. Freezing to death in the snow is a totally different ending, an anticlimax in place of a cathartic blast.

I finished my cut of *Creepshow* and showed it to Romero and his producers in my cutting room, and we parted company, never to meet again. I was still looking for a real project, but things were dead slow. It was spring 1982.

I didn't know it then, but *Creepshow* was my final project as a New York editor.

13

The Black Is Back

ONE OF THE THINGS I LOVE about the movie business is the unexpected phone call that changes your life. It had happened to me with *Star Wars*, and it happened again that spring. I had been out of work for several months when Robert Dalva called. He wanted to know if I could come out to San Francisco to help on *The Black Stallion Returns*. The editor he had hired in my place, David Holden, was taking too long, and they needed an extra pair of hands. The cut was still long too. It had started at four hours! I wondered what Holden had been doing in Rome for those four months. Having a great time, I suppose. The production would guarantee me only six weeks' work, but I had to make myself available indefinitely. John Breglio told me this was the worst deal he had ever heard of, but I agreed anyway. I needed the work, and I liked the Bay Area. And I liked Robert. With an infectious, booming laugh, he was a welcome presence in any room. I enjoyed discussing all manner of things with him, and he was always in an upbeat mood.

The cutting rooms were in Francis Coppola's Columbus Tower, in San Francisco, near both North Beach and Chinatown. The job turned out to be a fabulous lunch situation, within short walking distance of some of the best Italian and Chinese restaurants in the city. I landed there in June, wearing what would have been appropriate attire in New York that time of year, a seersucker jacket. I froze. That was when I first heard the aphorism "The coldest winter I ever spent was a summer in San Francisco."

David Holden turned out to be a thoughtful, intellectual-looking man. His temples were gray, he had patches on the elbows of his sport coat, and he smoked a pipe. We were preparing for a screening for Coppola, who produced the film, and I was set to work on the climactic race. The director of photography was Carlo Di Palma. He had worked with Antonioni and later shot eleven films for Woody Allen.

Much of the shooting had taken place in North Africa, in the Moroccan and Tunisian desert. In the film, Alex, the American boy whose horse has been stolen by Arab thieves, crosses the desert on foot with an Arab boy who has befriended him. There were many extremely wide shots, held for their full length, showing vast expanses of gorgeous, desolate landscapes, traversed very slowly by two tiny figures.

Robert worked with David on cutting the rest of the picture down while I worked on the race. For temp music, I chose the theme from *Chariots of Fire*, which won the Best Picture Oscar that year, in my opinion, on the strength of its score. I imagine editors all over Hollywood were temping their cuts with it. It worked just as well for our race, of course. I am more concerned with getting the desired effect than with avoiding the obvious.

When the time came for our screening, the editing crew traveled down to L.A. and met at one of Coppola's houses, a bungalow in Benedict Canyon. It was a smallish pied-à-terre but equipped with two 35 mm projectors in his bedroom. They were in a soundproof booth directly behind the head of the bed. The screen took up the whole wall opposite the foot of the bed.

Before the screening, Francis cooked dinner for us all: spaghetti marinara, garlic bread, and a green salad. He liked to create the feeling of a big family. When we moved into the bedroom to watch the cut, I took a seat on the floor with my back leaning against the foot of the bed. Francis stretched out with his head propped on the pillows. Other people positioned themselves wherever they could around the small room. We ran the picture, and just as we got to the final race, something happened to the sound. All of a sudden, the music sounded as if it were underwater, and all the detail was muffled. I was upset, since this was my opportunity to impress Francis.

After the lights came on, the line producer, seeing my reaction, leaned over to me and said, "Don't worry about the sound. Francis was asleep the whole time."

At work on
a Moviola,
*Phantom of the
Paradise*, 1974.

On the set
with the Crow
Women, *Phantom
of the Paradise*,
1974.

At the recording in St. Giles-without-Cripplegate
with (left to right) Bernard Herrmann, Brian De Palma,
and George Litto, *Obsession*, 1975.

With George Lucas
at Park Way,
Star Wars,
November 1976.

Clockwise from top left:
Jay Cocks, George Lucas,
Brian De Palma, the author,
and George's dog Indiana,
Star Wars, February 1977.

With (left to right)
Nancy Allen, Brian De Palma,
Jay Cocks, Jane Hirsch,
and George Lucas,
Star Wars, February 1977.

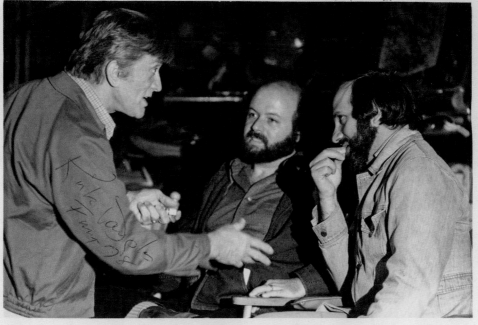

With Kirk Douglas and Brian De Palma on the set of *The Fury*, 1978.

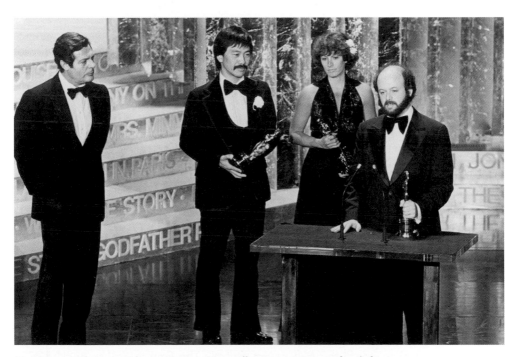

Receiving Oscar, with presenter Marcello Mastroianni (far left)
and fellow honorees Richard Chew and Marcia Lucas, *Star Wars*, 1978.

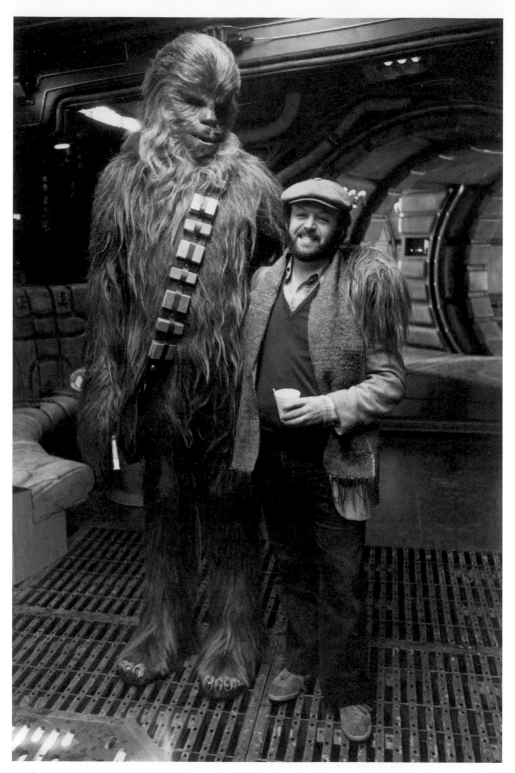

With Chewbacca on board the *Millennium Falcon, The Empire Strikes Back,* 1979.

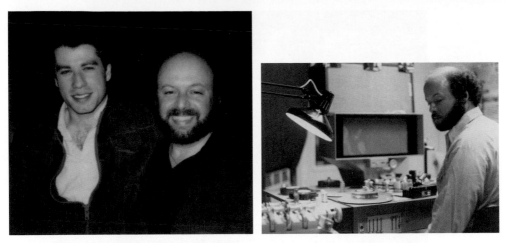

LEFT: With John Travolta. RIGHT: Working at the Kem. *Blow Out*, 1980.

LEFT: Droid Olympics, Worst Hand Anyway event (sitting on steps, last on right). RIGHT: Droid Olympics, Speed Splicing event, with referee Walter Murch (left) and C. J. Appel. *The Black Stallion Returns*, 1982.

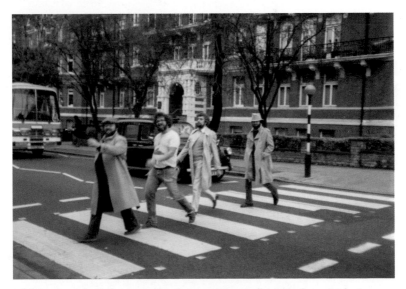

Abbey Road: (left to right) the author, Robert Dalva, Rich Stone, and Dan Carlin, *The Black Stallion Returns*, 1982.

Von Steuben Parade, Chicago, with Kenny Ortega (prone) and Matthew Broderick, *Ferris Bueller's Day Off*, 1985.

With John Hughes, watching take after take, *Planes, Trains & Automobiles*, 1987.

Once in a lifetime.

With Charlize Theron,
Mighty Joe Young,
1997.

Winning the Eddie,
with Jane Hirsch,
Taylor Hackford,
and Helen Mirren,
Ray, 2005.

In Montreal
with Duncan Jones,
Source Code, 2010.

Oscar night, 1978.

Soon after that, the production decided to let David Holden go and I was hired to finish the picture. I don't think David was terribly bothered by this turn of events. At least it didn't seem so. I wasn't sorry to see him go. We hadn't achieved any great chemistry, and as I have said, I enjoy working alone with the director. But now my stay in San Francisco was open ended. This meant that Jane had to come out with the children, prepared to stay for several months. Whenever we were on location and Jane had to find us a place to rent, I would tell her, "Just find a nice spot on the planet."

She did. We rented a house in Tiburon, with a view of the bay. Every morning, I drove over the Golden Gate Bridge to the city, an inspiring drive no matter how many times I have made it.

The supervising sound editor had started putting together a crew, and my dear friend Tom Bellfort lived in Berkeley. It was Tom's uncle who had given me my first job in the business, in the shipping room at Dynamic Films. I wanted to return the favor. Tom had been working as a photographer and was struggling. He needed a job.

"Why don't you come onto the movie as a sound apprentice?"

"I don't know anything about it," he replied.

"You don't need to know anything, it's an entry-level job. You'll be labeling boxes and making out leaders—there's nothing to it."

The sound editor, Leslie Schatz, agreed to meet him. He called me after the meeting. "I'm not hiring your friend," he said.

"What? Why not?"

"He's too old."

That really got me angry, since Tom and I are the same age. "Look, I'm not asking you to hire him, I'm telling you."

I was determined. I told Tom not to give up. Then I found out he called Schatz and told him, "Don't hire me just because Paul said to," which is indicative of what kind of a great, selfless person Tom is.

I wanted to insist, but Leslie saved me the trouble and decided to hire Tom after all. Maybe he was told that you couldn't legally refuse to hire someone because they were too old. Or maybe he just decided to appease

me. I didn't care. I was just happy that Tom was on. He was diligent and conscientious and took to the work as the proverbial duck to water.

He started taking on more and more responsibility. By the end of the film, he was functioning as the de facto first sound assistant. His next job was on *Rumblefish*, on which he was hired as the actual first sound assistant. He then went on to work on *The Right Stuff* and *Amadeus*, and his fifth film was *The Cotton Club*, on which he was ADR editor and Al Pacino was asking his opinion about which take he preferred!

His was a meteoric rise indeed.

———————

While we worked on refining the cut of *The Black Stallion Returns*, Robert told me that Walter Murch was going to stage another Droid Olympics. A few years earlier, Walter had the idea of staging a series of games based on editing room skills practiced by assistant editors. Since such work was repetitive and mechanical, he referred jokingly to the assistants as droids.

I had met Walter briefly while working on *Star Wars*. Tall and with an impressive baritone well suited for public speaking, he possesses a fascinating, divergent mind. His enthusiasm for arcane subjects led him to a second career as a lecturer on various topics. His well-known book *In the Blink of an Eye* was based on such lectures. In an odd coincidence, his father was also a painter who lived in New York, and he and my father had been friendly.

Walter and Matthew Robbins had devised several events for the Droid Olympics and given them colorful names such as Demolition Rewinding, Veeder-Root Sharp Shoot, and Worst Hand Anyway. Crews from each of about four or five feature films cutting in the Bay Area at the time formed teams to compete. I had participated once before, on *The Empire Strikes Back*.

The site for the games was the Murch residence at Blackberry Farm in Bolinas, up the coast from the Golden Gate Bridge. The events were staged outdoors, in front of the house and on the porch, and a potluck lunch was served. There were Moviolas, editing benches, synchronizers, splicers, racks, and trim bins. Families came in groups to cheer on the contestants, and the day was spent outdoors (an amazing treat for editors!) in a festive atmosphere of good-natured competition, with children and dogs running around in the glorious weather peculiar to that blessed part of the world.

Soon after that, the studio scheduled a preview in a theater in the San Fernando Valley. We flew down: me, Robert, the line producer, and three assistants. Another producer, Doug Claybourne, met us there. The screening was set for late afternoon so that families with young children could attend.

A recent innovation in theater projection had been to mount all the reels of the films into one continuous roll, which rested on a large metal platter. This was then made into one continuous loop so that the projectionist no longer had to make changeovers to the next reel. This also meant that the projectionist needed fewer skills and, moreover, could keep the many different projectors in a multiplex going at the same time. Eventually, kids from the concession stand were recruited to replace skilled projectionists to save money. Unfortunately, it took my crew longer than expected to mount the reels onto the theater's platter, so the screening got off to a late start.

As the screening progressed, I noticed a nearly imperceptible vibration in the projected image. As we got into the later reels, the vibration became more pronounced, as did my anxiety. Finally, in the middle of the trek across the desert, the film broke. The screen went white, then black, and the house lights came on.

I ran up to the booth, where, to my horror, I saw the film had cinched on the platter. It had pulled the film tighter and tighter, forcing the center of the reel up, until the whole mass looked like a volcano. It took forty-five minutes to unwind the mess, repair the damage, establish sync, and resume the screening.

By then it was dinnertime, and families with children had left. The screening, in short, was a disaster. After it was over, the company administering the screening, National Research Group (NRG), nevertheless distributed response cards to the remaining audience members. The producers and Robert and I met in the lobby for the postmortem, a morbid metaphor. Why not "postgame analysis"?

A white-haired fellow came out with some papers in his hand and interpreted for us how well the audience liked the picture. This was my first experience with a "research screening," as if science were involved. "The scene in the desert goes on too long," he announced.

I found this absurd. There had been a forty-five-minute pause in that scene. "You can't tell anything from a screening like this, where everything goes wrong," I protested.

The sort of research conducted by NRG is an extremely blunt tool for measuring responses, but it became the industry standard, and the practice of analyzing the audience by dividing people into one of four groups is sacrosanct. The groups are male or female, over or under twenty-five. The Holy Grail of all studio executives is the "four-quadrant" movie, one that appeals to everyone. In retail businesses, much more detailed analyses of consumer behavior are conducted by market research specialists, who can identify many different types of personalities—impulsive, analytical, and so on. But the simplistic way NRG did it became the standard tool of the studios, and hasn't changed in thirty-five years.

It is true that sometimes we can learn from previews, if the proper questions are asked on the questionnaires. But in fact a generic group of questions is usually posed at every screening, and sometimes what might have been useful to know is overlooked.

The screenings are often a political device, used both as a sword, to coerce the director into making changes he was resistant to, and as a shield, to protect executives from second-guessing by their bosses. If the preview numbers are good, they can justify the expense of marketing a dog of a film.

Here is the terrible truth about these previews: They are reliable only as a negative indicator. If the film scores high, there is still no guarantee it will do well at the box office. NRG knows this, and in its "Green Book," which summarizes the screening results for the studio, there is always a disclaimer that foreswears any relation between its numbers and actual box office success. There is a big difference between "marketability" and "playability." If a comedy plays well in a packed theater where audience recruiters have filled the house, it doesn't mean that anyone will ever see it that way, if the marketing can't deliver.

The only thing you can really rely on is a negative result: if the preview audience hates the picture, you have real problems, not the least of which are political. This is when editors can get fired. Or factions can form, with the director on one side, the producers on the other, and the editor caught in the middle. At the very least, you know you are in for a struggle to make the picture into something it may never be—a hit. The good thing about

these preview numbers is that they give the executives a way of knowing when to stop flogging a dead horse. If the numbers don't go up in the next screening, they realize that nothing more can be done, and they let you finish the picture and hope for the best.

Outside the theater in Canoga Park, our small band of discouraged filmmakers gathered in the parking lot. Although it was now night, it was still hot, and we hadn't had dinner yet. We trudged over to a Mexican restaurant across the lot. The seven of us sat down, and a waiter came over to take our orders. "What'll it be?"

Producer Doug Claybourne gave the perfect reply: "Twenty-one margaritas, please!"

———————

Georges Delerue was hired as the composer. An accomplished veteran with over 250 credits, he had scored many films for François Truffaut and Philippe De Broca. Georges spoke English badly, so he was pleased to discover I was fluent in French. He was enormously likable, quick to laugh, and as gracious and gentle as he was gifted. He was able to write beautiful melodies whose character was uniquely his own.

His music editor was a man named Richard Stone. Rich spoke French passably and was able to communicate with Georges. He worked for a company called La Da Productions, which was headed by Dan Carlin. Rich later became a celebrated film composer in his own right. Georges, Rich, and Dan became friends of mine, people for whom I felt a real affection. Sadly, Georges and Rich are no longer with us, but we were able to work together on more than just this one occasion.

Recording the score for *The Black Stallion Returns*, or *TBSR*, led to a memorable trip. We traveled to London and stayed at Truffaut's favorite hotel, according to Georges, the Montcalm. We recorded at Olympic Studios in Southwest London, where an astonishing number of great recordings have been made. The mix-down was done at Abbey Road, in front of which Robert, Rich, Dan, and I reenacted the famous Beatles cover. The studio staff keep a stepladder just inside the front door, which they use to get the correct angle to take the picture. Apparently, they have done this more than a few times.

We mixed the picture in L.A. at Goldwyn Sound, the studio where we had mixed *Star Wars*. Georges had delivered a beautiful soundtrack, with one particularly memorable cue. After traveling across oceans and continents, overcoming many obstacles, the young Alec is reunited with his beloved "Black." The cue for this has the longest melody I have ever heard and is filled with such emotion that I love to replay it to this day. I hoped I would someday get another chance to work with Georges.

As we were finishing up, around February of 1983, I got calls from two different films. Brian De Palma had started shooting *Scarface*. He had hired Jerry Greenberg again, but they had a lot of footage and were looking for a second editor. At the same time, Milos Forman wanted to meet me about cutting *Amadeus*. I was to fly to Prague, where the shooting was to take place. This was a thrilling prospect for me. Music has always been my first love, I had seen the play, and I was very excited at the idea of working with Milos on such a prestige project.

"When do they begin shooting?" I asked.

"Oh, they already started."

I didn't understand.

"Milos wants you to start in June, when he gets back from Europe."

"But doesn't he want someone assembling the film while he is shooting?"

"He has an assistant, a young woman doing that," came the answer.

Red flags went up. I was not happy about this. Clearly Milos didn't trust me and wanted to work closely with me from the get-go. I enjoy that sort of close collaboration, but only after I have had a chance to work autonomously on the first cut. I didn't relish that sort of close supervision right off the bat and didn't like the idea of an assistant doing what I considered to be my job. Still, it was *Amadeus*.

The problem was filling the time until June. I got an idea. I could work on *Scarface* for four months and then move over to work with Milos. But Brian's producers turned me down. They offered to guarantee me six weeks' work, but I had to make myself available to work for them until completion, an open-ended commitment. This hardly seemed fair, and I didn't want to

be relegated to second editor status, so I refused. My working on *Amadeus* sort of depended on *Scarface*, so I turned them both down.

Jane, the children, and I had been away from New York for ten months, and our daughter Gina had been enrolled in kindergarten in Tiburon. Now that she was school age, it would not be so easy to pick up and move anymore.

We could go back to New York, to an uncertain future. But work had been hard to find when we had been there last. My main source of work there had been Brian, but there was no job for me then, at least not as primary editor.

We could stay in Marin County, to an uncertain future. I had quickly realized that although the Bay Area was able to support a community of sound editors fairly well, there just wasn't enough work for picture editors there, at least not enough to keep me regularly employed.

Our other option was to move to L.A. We reckoned that there I would be able to find enough work and that I wouldn't have to always be flying off somewhere. The previous five years we had moved eight times, and Jane didn't want to do that anymore. The fact that we were shuttling between New York, London, San Francisco, and L.A. made it OK by me, but I agreed it was time to settle down.

Somehow, already being on the West Coast made it seem easier. So we flew briefly back to New York, packed up all our belongings there, and prepared everything for the movers. We then came back to Marin, where the lease on our house in Tiburon was coming to an end. Jane told me, "Go down to L.A. and find us a job, a house, and a school," so I started flying down on weekends. It was a disorienting and depressing experience. I was driving from one house to another, eating fast food, and making phone calls to realtors from pay phones in gas stations, couch surfing at my former sister-in-law Tina's and at Richie Marks's home in Santa Monica, and finding nothing I would want to spend even one night in. Finally, the end of the month came. The owner of the Tiburon house had a new tenant coming in on the first of the month, and we had to get out. We packed the car and headed south. We would ship our stuff from New York later.

We called it "the double move to nowhere."

14

Footloose in L.A.

We arrived in L.A. homeless. It was early 1983, and by now we had moved out of both our New York apartment and our rented house in Marin. Here I was with a wife and two kids, an Oscar, and nowhere to live. How did I get into this predicament? After a brief stay in an apartment hotel, a solution dropped into our laps. By sheer luck, the house we had rented five years earlier, in the summer of 1978, was available again. We were able to relax a bit. We moved in and I started to look for work.

While I had been working on *The Empire Strikes Back*, I had gotten a phone call from Herbert Ross's people regarding *Pennies from Heaven*, starring Steve Martin. I wasn't available, but Richie Marks was, having finally finished *Apocalypse Now*. I recommended him and he got the job.

Now Herbert had asked Richie to cut the new picture he was starting for Paramount, called *Footloose*. It was the story of Ren (Kevin Bacon), a big-city kid who moves to a small town and discovers that the local preacher has had the town council ban all dancing. Ren starts to date the preacher's daughter and meets a new friend whom he has to teach how to dance, and they organize and fight to have the ban rescinded.

But Richie had been offered another Paramount film by a TV writer-director directing his first feature film, and Richie had fallen in love with the script. The film was called *Terms of Endearment*, and the writer-director was Jim Brooks. They went on to work together with great success for another thirty years.

Knowing I needed work, Richie recommended me to Herbert. We met, and I reminded Herbert that it was through me that he had met Richie in the first place. I got the job on *Footloose*. The added bonus was that on my first picture in Hollywood, I had my friend Richie on the lot.

I was excited about working for Herbert. For the previous fifteen years, he had been the studios' go-to director for their big films, among them *Funny Lady*, *The Sunshine Boys*, *The Seven-Per-Cent Solution*, *The Turning Point*, and *The Goodbye Girl*. He had directed the biggest stars in the business, people like Barbra Streisand, Peter O'Toole, Michael Caine, Jane Fonda, Christopher Walken, and Richard Dreyfuss. He was at that point the epitome of the studios' big-time Hollywood director. Working for him was a big deal.

On leaving New York, I had decided to end my partnership in editing equipment rentals with Brian De Palma. There was no work for me there with Brian for the foreseeable future. Since I would no longer be working in New York, our business, Paradise Associates, no longer made sense, and I had the Kem Rapids we had bought five years earlier shipped out to L.A. I preferred them to the other machines that were available. I had been cutting on nothing else since *Star Wars* and was able to make a little extra money on the side in kit rental fees to each production I worked for. I told one of the producers I wanted to use my own Kems on the picture.

"Well, that's a bit of a problem, you see. Herbert owns a Kem Universal and he wants us to rent it from him."

"That's not going to work. I don't use Universals. The controls are buttons, and I prefer the joystick on my Kem Rapids."

"This is like a plumber telling me he can only work with one wrench!" he growled at me.

Thanks, I thought. *I'm a plumber, huh?*

Nevertheless, I insisted, and Herbert consented.

———————

Herbert liked to sneak a couple of extra days of makeup and costume tests into his shooting schedule just before principal photography. We watched some tests of Kevin Bacon's hair. Nora Kaye, Herbert's wife, joined us. She was an immensely important figure in his life. She was his confidante and

artistic adviser. She had been a prima ballerina in her youth and had revolutionized ballet, gaining international renown as a "dramatic ballerina."

According to Herbert, Nora had quit dancing during a trip to Europe, flinging each of her dance shoes, one by one, out the window of their VW Beetle. Over the years, she had put on some weight, and her voice had a nasal quality. She sounded like Judy Holliday, with a strong working-class New York accent. There was a disconnect between the seeming coarseness of her voice and the refinement of her taste. She had extremely high standards and could be quite critical. Herbert relied on her heavily in all aesthetic matters.

Once, when we were watching dailies, a close shot of Kevin Bacon's groin came up. The bulge under his jeans was obvious, which I found a bit embarrassing. Nora noticed it but had a very different reaction. From her career as a ballerina, she knew that most male dancers stuff their jockstraps. "Herbert, didn't you tell him?" she asked in her heavy New York accent.

"Yes, I told him and he did."

"But it's so small!" she exclaimed.

———————

The original idea was for Kevin to have a really extreme haircut, perhaps a Mohawk, to indicate just how far out of his element Ren was in the small town in the West he had moved to with his mother. But this was 1983 and that made the studio nervous. They agreed to have one of the most expensive and cutting-edge stylists in town cut Kevin's hair. The price was $1,500, and there were conditions. Only Kevin could be in the room, and he had to keep his eyes shut the whole time. But Kevin, during the haircut, couldn't help sneaking a peek. He discovered that the man had his eyes shut too and was cutting Kevin's hair by feel.

———————

"You don't want to come up to Utah for the shoot, do you?" Herbert asked me. I told him no, not if I didn't have to. He was fine with that. There is usually no need for the editor to be on location. Experienced directors know

enough to cover themselves with any angles that might prove necessary. They also know that they are usually too busy during production to spend any time in the cutting room, and any choices the editor makes can be revisited later.

I asked Herbert how he wanted to give me his preferred takes. With Brian, I would sit next to him while we watched dailies and write down when he liked a take or a line reading. Later, when we had bigger budgets, I had an assistant do it. "Would you like me to have someone sit next to you while you watch dailies and take notes?" I asked.

"No, just use whatever you think best," he said. "I have a very good memory. I know what I shot, and if I don't see it in the cut, I'll just ask for it."

This was incredibly liberating. I would be able to use my judgment and put the scenes together as I saw fit. And he was right about his memory. On one of his films, he said to me, "Didn't I do one where she played the line more suspiciously?" I looked for it, and sure enough, he had. I cut it in.

If you liken cutting a movie to driving a fine car, some directors like to sit behind the wheel, with hands-on control. Others, like Herbert, and Brian to a degree, like to be chauffeured. I prefer this, since I enjoy the "driving." It also affords me a great deal of autonomy, which for me is directly proportional to my job satisfaction. I have worked for directors who prefer to exert total control over the smallest minutiae. It is no fun. Herbert accorded me respect and gave me freedom.

The company went off to Utah to shoot, and I began work on the Paramount lot. Our cutting room was in a double-wide trailer that also housed the film's production offices. I loved walking around outside the soundstages where the famous directors I admired had filmed so many of the pictures I revered. Whenever I grew homesick for the big city, since I was still new to L.A., I would take a stroll on the New York street on the lot. The brownstones were made of wood and plaster, but they did alleviate the nostalgia. When I think about it, it was pretty pathetic.

One of the numbers in the movie is a dance lesson that Ren gives to his new friend Willard, played by Chris Penn, Sean's brother. It was designed

to play out in various locations, and Willard's dancing gradually improves over the course of the song. Because of this, the pieces came in gradually, one shot every so often when the company moved to a new location. For the same reason, it was tricky for Herbert to gauge the progression of Willard's skill level. He asked me to show him the sequence as it was up to that point. I didn't feel comfortable sending it off, so a trip up to Utah was arranged for me.

I showed Herbert the scene, he seemed satisfied, and I went back to L.A. I was still cutting the picture when production wrapped and the whole gang came back and reoccupied the trailer.

———————

Herbert had been a choreographer before directing his first film, the musical version of *Goodbye, Mr. Chips*. He had directed all the musical numbers in the film *Funny Girl*, including the famous tugboat sequence, which got him his shot at directing. When he was proposed for *Goodbye, Mr. Chips*, he told me, he had to go to London to meet the star, Peter O'Toole. Herbert was from humble origins and had been a chorus boy as a young dancer. He had never before flown first class. Before the plane took off, he was offered a glass of champagne, then another. Wine with lunch was followed by cognac afterward, and he arrived in London completely smashed. He was taken by car to O'Toole's hotel suite and ushered in, whereupon he promptly threw up on the carpet in front of the star. O'Toole approved him on the spot.

Herbert's background as a choreographer was noticeable in his walk. He strode. With his shoulders thrown back and chin held high, he would take long steps in a relaxed but regal manner. Several times I observed him taking a phone call and, when finished, without looking, he would simply hold the receiver out, expecting someone—an assistant or anyone—to take it from his hand and hang it up.

He had a verbal tic, saying, "Do you know?" at the end of sentences, making it sound less like "y'know" and more like "n'est-ce-pas?"

He could be harsh when he was unhappy about something he felt hadn't been done right. He would sometimes pick on some person in his cast or in postproduction. When I got to know him better, I realized that if the person he was berating exhibited fear, the situation would spiral into a worsening

feedback loop. But I hadn't yet understood this about him when we screened the picture in the Paramount Main Theater on September 21, 1983.

I remember the date, because it was the second anniversary of my father's death, and I was still feeling the grief of his passing. The screening had a small but important audience. Herbert had invited Nora for the first time, as well as a couple of close friends. As he relied so heavily on Nora, the screening was that much more important to him. He was nervous, wanting everything to be perfect for her. We were seated at the console in the back of the theater, while Nora and the guests were up front.

Early in the film, a cop stops Ren for playing the music on his car radio too loud. As the cop is giving him a hard time, he chucks Ren menacingly under the chin with his driver's license. I used this action to cut to the next scene, eliminating a couple of lines of what I considered to be unnecessary dialogue. Herbert suddenly began whispering angrily to me. "What did you do? I never told you to do that!"

"We talked about it," I answered, "and we agreed that would be where I would make the cut."

"That wasn't what I meant! I didn't mean for you to cut off the end of the scene! Now you've ruined the screening!"

I didn't say anything. He went on, piling on, until, feeling a bit sad in the first place and not having the patience to deal with his rant, I just got up and walked out. Once outside, I stood there for a few minutes and regained my composure. I thought, *Well, now what do I do?* I could leave and go home and probably forget about the job, or I could go back in. I went back in.

As soon as I sat down, Herbert leaned over and whispered an apology. "I'm sorry. I shouldn't have spoken to you that way. I was just surprised by that cut."

"It's OK," I replied.

After that, I never had any problem with him ever again. The cut stayed the way I had made it.

———

I learned a lot from Herbert. He once asked my advice on how to deal with an invitation he wanted to turn down but felt constrained to accept. "Just make up an excuse," I suggested.

"No," he replied, wanting more. "Give me the words."

Soon after we began to work together, I found myself having to deliver a criticism and didn't feel comfortable about it. Herbert was eighteen years older than me, an experienced director, and could be intimidating. I hemmed and hawed, trying to figure out how to phrase it.

"Just spit it out, Paul," he said. "I'd rather hear it from you than read it in the *New York Times*."

Herbert wouldn't get specific about what frame to cut on. He would say, "That's your art," and leave the detail of the timing to me.

He treated other people who worked for him with varying degrees of respect. I once asked him what he did if he saw on the very first take that an actor hadn't understood how to play a scene. "Do you stop them and tell them they are going off in the wrong direction?"

"Oh, no. I would never do that to an artist. I would never interrupt them. I let them present their interpretation in full, and then I pull them aside and talk to them privately."

This didn't always apply, though. Once, confronted with a day player who blew his lines, Herbert cut immediately and asked loudly, "Can we get someone in here who can act?"

Herbert never described anything as "funny." He would say, "That makes me laugh!"

He was brilliant at comedy and directed many scripts by Neil Simon, including the immortal *The Sunshine Boys*. He had originally cast Jack Benny opposite Walter Matthau, but Jack had taken ill and Herbert replaced him with George Burns, relaunching his career late in life. Both Jack and George had been huge stars, first on radio, later on TV. Either one would have been a great choice, but I've always wondered how Jack would have played the part.

Herbert had me come into his office one day. "Do you think we need a title sequence?" he asked. "There is some concern that we don't get to the first dance number soon enough in the picture, and if we had a main title that had dancing in it, that could solve it."

"Absolutely. I think it's a great idea," I agreed.

He got in touch with Wayne Fitzgerald, a well-known specialist in main title design, and asked him to devise a concept. He came up with a good one. The idea was to shoot close-ups of feet dancing to the title song by Kenny Loggins. It had been one of the first songs written and recorded for the film. Dean Pitchford, the brilliant lyricist who had written the screenplay, was collaborating with myriad musicians on the songs for the film. I called him Dean the Dream, or just Dream. Many of the songs had not yet been written by the time principal photography began, and the numbers in the film had been shot to placeholders, songs that were in the right spirit and had the necessary energy level. Dean was working with various composers on original songs to replace them. Although they were in many different styles, the unifying element was that Dean wrote all the lyrics.

The studio provided some money for a test shoot of the main titles. Some dancers were brought in, men and women changing costumes. Herbert directed the dancers, and Wayne shot about twenty variations of their feet improvising various moves to the music. The test was very successful, and everyone, including the studio brass, agreed it should be done for real.

When the time came to do the real shoot, in addition to the professional dancers, we were all invited to come in, step in front of the camera, and do whatever we felt like, in time to the music. When the shooting was done, Wayne had about 150 different choices. We screened the dailies, and Herbert was happy. I asked Wayne if he wanted me to send him a copy of the song so he could cut to it.

"No, that's all right," he said. "I don't think we will need it."

I thought that was rather a strange thing to say, but I was busy recutting all the musical numbers to adjust for the new songs Dean and his various collaborators were supplying me with. Dean at one point had a piano brought into the trailer so he could work with the composers.

When they recorded the final songs, a rough mix of each one was given me for final reworking of the picture. Each time I finished recutting one of the musical numbers, I would show it to Herbert on the Kem in my cutting room. He was always very appreciative. "Oh, this is so wonderful! Do you mind if I screen it for Dan?" he would ask.

"No, of course not," I would reply. And we would run it again for Dan Melnick, a former studio chief at Columbia who was our executive producer. He always dressed in black, and his office in the trailer had been

decorated the same way, with black walls. Dan would say, "I love it! We've got to screen it for Craig and Lew!"

Craig Zadan and Lew Rachmil shared producer credits. Craig was a fresh-faced young guy brimming with enthusiasm. Lew was a crusty old veteran who had been head of physical production at MGM. Craig and Lew would come in and say, "Oh, this is so great, can we show it to Dean and Becky?"

Becky Shargo was the music supervisor. She was a charming young woman who was being wooed by an admirer. An enormous bouquet of flowers arrived on her desk every day. She eventually succumbed and married him.

And we would all watch it yet again, and then spend another hour or so talking about how wonderful it was. It was the same with each song, and always in the same order, reflecting the hierarchy in the production.

———————————

Willard's dance lesson, the scene I had flown up to Utah to show Herbert, was a problem for me—specifically the song that the number had been shot to. It was one instance where the song used in the playback while shooting was not meant to be a placeholder. It was an original song Dean had composed for the film, called "Somebody's Eyes." Unlike the other songs in the picture, I hated it. The song felt slow and had no energy.

I asked Herbert how he felt about it. He agreed. We went to Dean, and Herbert asked him what we could do. It was decided that he would write a new song for the scene, but the new song would have to match precisely the "click" of the old song. The "click" referred to how many beats per minute the tempo was, and it had to match for the dancing to work.

So even though the old song felt draggy, we couldn't go any faster. The music editor supplied us with a few sample songs that were at the same click. Most of them had the same molasses feel, but then we happened on Michael Jackson's "Don't Stop 'Til You Get Enough." It was the same click, but it had energy, which came from a double-time, slightly syncopated percussion track.

This became the model for the new song, which, in keeping with the comedic intent of the scene, Dean titled, "Let's Hear It for the Boy." It was the last of the songs delivered to us by Dean, coming in only during

the final mix. "Let's Hear It for the Boy" and the title song, "Footloose," turned out to be the two biggest hits from the movie soundtrack.

Paul Haggar was the head of postproduction at Paramount and was entrenched there for forty years, through many changes of administrations. He was a fearsome figure with a powerful and intimidating voice that he deployed knowing full well the effect it had on people. He had absolute power over post budgets and was a terror to assistant editors and vendors. Editors too, if you got on his bad side.

A skilled bureaucratic infighter, he could prevent you from working at the studio if he so decided. To get to know you, he liked to swing at you (metaphorically) to see if you would flinch. He and I battled over who would cut the sound on the picture, a battle that, with Herbert's help, I won. But then the fellow I had hoped to hire, and whom Paul had resisted, turned out to be unavailable. So I crawled back to Haggar.

"You decide, Paul. Hire whoever you like to do the sound."

With this, Haggar started to mellow toward me. I went on to do many films at Paramount, and Paul became one of my greatest supporters. The other benefit was that I was introduced to a talented pair of young sound editors named Wylie Stateman and Lon Bender, as well as an avuncular older man named Stan Gilbert. Wylie and Lon later went on to found a company named Soundelux, which became one of the leaders in the industry. I resolved to use them on all my films going forward.

We previewed the picture several times, and it played well, but the audience was frustrated that there wasn't a dance number at the end of the movie. Herbert had thought it wouldn't be necessary; if the kids got the right to have the dance, that would be enough. But the audience wanted to see them dance. So, although the release date was fast approaching, a reshoot was organized.

Originally scheduled for a day, they shot for three. Herbert didn't have time to choreograph a whole number, so he staged a series of vignettes of the kids dancing to the same eight bars of the song over and over.

One of the shots he made was inspired by a shot in Carlos Saura's *Carmen*, which I had steered him to. The camera is low to the ground, and a line of dancers enters the frame from the side, moving swiftly in profile across the floor, the camera moving with them, showing only their feet. Then a second line of dancers enters from the opposite direction, crossing the first line, and the camera changes direction and tracks with them. It is a wonderful, exciting shot.

Another bit featured several of the kids taking solos during the instrumental break. Chris Penn, who had a wrestling background, entered with a somersault. I was fascinated by a loose-limbed young guy who "popped." Another bit had Ren stepping up toward camera, with the other kids on each side of him. Each of these bits ran for eight measures, and it fell to me to combine them into a full dance.

My approach to cutting musical numbers is an interpretation of the music as if I were dancing to it. I have been asked by some directors to cut on the beats, but I find this approach too restricting. It is better to have the music animate the action, rather than animate the cuts. If you cut on the beat, you may lose the action preceding the beat, and that is often the more interesting part of the shot. So I try to cut between the beats.

In *Carrie*, there was a scene in which the Travolta character, Billy, kills a pig, cheered on by his evil girlfriend, Chris, played by Nancy Allen. Billy is swinging a sledgehammer repeatedly, while Chris keeps repeating, "Do it!"

My original thought was to create a rhythm by intercutting her line with the impact of the hammer. "Do it!" *bam!* "Do it!" *bam!* "Do it!" *bam!*

But the result was that I had cut out the more interesting and dynamic part of the shot of Billy, namely, the arc of the hammer through the air. I was using the least interesting and most static part, the impacts. Since it clearly was not working, I had to take apart my first cut and revise my strategy. I intercut the shot of Chris with the swinging of the hammer and not with the impacts. So, the result was: Swing, "Do it!" swing, "Do it!" swing, "Do it!" with the dialogue lines occurring simultaneous with the impacts. Visually, the effect is much more dynamic. Even without music, the physical action generated the rhythm and tempo. The impacts were the beats of the scene.

With the final dance in *Footloose*, I had to shape the entire number using the fragments that Herbert had supplied me with. I had to find a beginning, middle, and end to the dance. And I had to work fast, since the final mix

was coming up shortly. There were some givens, thankfully. The opening was planned, and there was that stretch of improvisation for the instrumental break. For the rest, I experimented with various continuities, moving bits around until I found a shape that worked for me. I presented my cut to Herbert and Nora after a couple of days. They were pleased with what I had done and had only minimal changes to suggest. Nora paid me her highest compliment, which thrilled me: "You're good."

Meanwhile, we had begun mixing the film at a company called Compact Video. I had gone to meet the manager of the facility, a former mixer named Tex Rudloff. He was the most positive person I had ever met.

"How are you?" I asked.

"Fantastic!" he replied with a Texas accent. "I'm doin' so much better than most, you wouldn't believe it!" I'd never met anyone as enthusiastic.

"What part of Texas are you from?" I asked.

"I'm actually from Louisiana, but I got tired of being called Louise!"

He then showed me around and introduced me to the booth recordist, who monitored the output from the studios for quality. He was a young man suffering from macular degeneration who had gone blind. The combination of generosity to a disabled person and enlightened self-interest in hiring someone for the job whose sense of hearing was more acute than a sighted person won me over. I was sold.

The mixers were John Reitz on dialogue and Dave Campbell on music. In those days, three mixers were employed on movies in Hollywood. In New York, a single mixer did the work.

"Who is your effects mixer?" I asked.

"Well, we would like to use a young guy who we think is ready, if that's OK with you. He's done a couple of films. His name is Gregg Rudloff. He's Tex's son and we think he's ready."

I thought about it for a second. *Footloose* was going to be primarily a music and dialogue task anyway.

"Sure," I said. "If you are fine with him, so am I."

This team went on to become one of the star teams in the business, winning an Oscar for *The Matrix*.

Herbert was already in preproduction for his next film, a Goldie Hawn vehicle for Warner Bros. titled *Protocol*. Tied up as he was with prepping, he asked me to direct the mix. Wayne Fitzgerald had still not delivered the main title sequence, but we were using the earlier temp version as a placeholder so we could begin. We finished reel 1 and played it back for Herbert. He was not happy. "The main title music is too loud," he complained.

We played it again.

"Can you bring it down a bit?"

Dave Campbell complied.

"How much did you take it down?"

"Two dBs," was the answer.

"That's too much," said Herbert. A dB is a decibel, the standard measure of loudness. A single dB is the smallest change in volume level discernible by humans. "Make it one dB, please." They did.

"When you bring it down one dB, is that one dB in each of the channels?" There were three channels behind the screen, left, center, and right.

"Yes, that's right," replied John, who was the leader of the team.

I could sense that the mixers thought Herbert was being just a bit fussy. "Can you bring it down one dB in just the center channel?" he asked.

"My hand shakes more than that," Dave replied.

I learned three things. One, that Dave had a wonderful, wry sense of humor. Second, that he was one of the best music mixers I have ever worked with. And third, that Herbert had a thing about loudness. It seemed as though all his anxieties about how the film would be received were channeled into worrying that the picture was either too loud or too soft. This manifested itself at mixes, and also at screenings.

In previews, a remote fader is set up in the theater so that someone from the production can control the sound level during the screening. This task fell to me. When we screened the film at a premiere in Westwood, Herbert had technicians from Dolby set up the room, running pink noise through each of the speakers and making sure the film played at 85 dB, the standard level. He warned me, "If you play the film too loud, it turns the audience off."

So the moment the film began to roll, at the predetermined perfect level, Herbert turned to me in a panic. "Turn it up! Turn it up!"

I learned later that when people are stressed, their hearing blocks up. It's quite common.

After we got through the first reel, the mix went more smoothly. It may have been that Herbert simply wanted to impress upon the crew that he was a stickler for excellence. But he did have extremely acute hearing. We settled in over at Compact Video. Herbert was set up in a temporary office there, where he was busy making decisions about his coming production, *Protocol.* I would run the *Footloose* mix and would call Herbert in as we played back each reel. He would give his notes, the crew would make the adjustments, and we would go on.

Meanwhile, we were still waiting for Wayne Fitzgerald to deliver the final version of the main title. It was now the eleventh hour. Wayne finally presented it to Herbert. To say it did not go well is an understatement. Herbert called me in to look at it with them. In Wayne's cut, he had used every single dancer he had filmed. This meant that there were 150 cuts during the approximately two and a half minutes the title sequence ran. This was about a cut per second, although some were even shorter than that. The resulting effect was unsuccessful, to put it mildly. At that pace, it was impossible to absorb the various costumes and shoes, not to mention the different dance steps the dancers had done. It came across as a jumble. Herbert was clearly angry.

Wayne ran the workprint through the Moviola again. I was surprised that he had simply ignored the song, and realized that we were in some trouble, because we were running out of time. After we had watched it a second time, Herbert began to tear into Wayne.

"This is totally unacceptable! This work is completely uninformed by any intelligence whatsoever!" and so on, at some length.

Finally, with Wayne turning into a puddle under this assault, Herbert wheeled to me and said, "Paul, you're going to have to do this."

A cutting room was set up for me upstairs from the mix, and my editing machines were brought over from Paramount. There were about five reels of footage, pardon the pun, with about thirty dancers on each. I watched the dailies again, making note of which dancer did which step. Some of the dance steps were restrained, while others were extremely vigorous. To help in the cutting, because I had to be able to find the shots quickly, I had my assistant cut about eight frames from the beginning of

each setup and paste them into a ringed loose-leaf notebook that I could refer to and quickly see which roll of dailies the shot was on.

I devised a plan to build a montage starting from the lowest-key shots to the most extravagantly wild. The key was to find the dance movements that worked best with the song at each point in the montage. I calculated that I would need about twenty-one shots, with each one serving as the background for one title card.

I started with a shot of a man tapping his toe in time to the music, gradually increasing the breadth of the movements with each new cut. I also looked out for some of the wilder costume combinations, many of which were comical, and I wanted to be sure to use those. Many of the steps were funny too, like hopping in place, or one woman who managed to turn just one of her feet 180 degrees.

There is a buildup to the conclusion of the song, a crescendo that was to support a card with two names on it and would therefore have to be on the screen longer than the single card credits. I found a pair of feet wearing brightly colored leg warmers running frantically in place that was perfect for the crescendo, but I had to make a jump cut in the middle, joining two takes to achieve the necessary length. It generated a terrific energy that launched us into the final card, Herbert's directing credit. One of my assistants, a tall, gangly young man named Greg Scherick, had performed a goofy kind of mock ballet step, on his toes, the humor of which was enhanced by his big feet and the extremely ratty and torn sneakers he was wearing. I decided to use Greg under Herbert's card.

It took me about three days to complete the cut. Where Wayne had used 150 cuts, I used only 24 to create a dance shaped in the way a choreographer would. Satisfied with the result, I took it downstairs and gave it to the projectionist in the booth where the final mix was taking place. I went into the studio and told Herbert that the cut was ready, and as soon as he liked he could view it.

Shortly, there came an opportune moment and Herbert asked us to run it. Tex was in the studio at the time. "Do you want us to clear out?" he asked me.

"No!' I replied. "I want an audience for this."

We ran it.

"Well, that's just great," said Herbert. "Run it again, please."

We did, and then again, several times. Tex was also very complimentary. The main title was solved. We never changed a single frame.

Even so, by contract, Wayne Fitzgerald was given credit for "Main Titles by," which was fair, as he had filmed all the material. But when the picture opened, one of the reviewers, in typically condescending fashion, wrote that it was a shame that the picture wasn't made by the people who did the main titles. *Time* magazine even approached the production asking for an interview with Wayne. When Herbert heard this, he roared, "*NO!*"

The main title problem was solved, but we then ran into an end title problem. We had designed a semi-elaborate end title with reprises of moments from the film to identify the cast. I cut it to one of the songs Dean had written that hadn't found its way into the final film, "I'm Free." This was a way to get the song onto the soundtrack album, and it worked perfectly with the sequence that I had cut, transitioning from the final dance. But Paramount chairman Barry Diller had heard "Let's Hear It for the Boy" and wanted that in its place. The problem was that the songs were very different in mood and tempo, and simply plastering "Let's Hear It for the Boy" over the sequence didn't work, at least not in my opinion, nor in Herbert's.

We were near the final delivery date, so in order to come to a decision about which song to use, I was to prepare two different versions, one with each song. We screened them in the studio theater. Present that day were Herbert, Dan Melnick, Barry Diller, and Paramount executives Dawn Steel, Jeffrey Katzenberg, and Michael Eisner. Every person there, other than Herbert and me, had been or would become heads of studios. We ran the two versions and a debate began. We talked and talked until finally we had to vacate the theater for an incoming screening. As we left, I asked Katzenberg what we had decided.

"I have no idea," he shrugged.

As the group walked back toward the administration offices, I found myself in step with Diller.

"Here, I'll tell you what," I said, reaching into my pocket and pulling out a quarter. "Heads, 'I'm Free'; tails, 'Let's Hear It for the Boy.'"

"Go ahead," Barry said.

I flipped the coin in the air, caught it, and slapped it on the back of one hand. I pulled my hand away, revealing heads.

"Two out of three!" said Diller.

I knew there was no winning that one. Eventually we compromised. I did a version where we started out with "I'm Free" and segued to "Let's Hear It for the Boy."

———————

The picture was a huge success. The marketing was brilliant. They came up with a distinct treatment for the title and an iconic image of Kevin Bacon that never changed. In a masterstroke of timing, the title song hit number one on the charts the very weekend the picture opened. Sadly, the very weekend the picture opened, producer Lew Rachmil died suddenly.

Herbert had generously given me two points of profit participation, but such shares very rarely pay anything. And when they do, it takes a long time for any of the money to come through. Dean saw money almost immediately, from the sales of the album. He graciously presented me with a platinum record in a frame with my name on it. He also bought a huge house in the Hollywood Hills, on Queens Road. Dean is openly gay, so he got some teasing about his address. I asked him if the house wasn't too big for him. "Yes," he joked, "I just wander from room to room holding a candelabra, wearing my faded wedding gown."

My points eventually paid off, probably leading to someone in Paramount's accounting department getting fired for letting the picture slip into profitability. Every year ever since, I've gotten another check. Even though no single check was extraordinarily large, the total over the years paid for college for both my children.

I received a jolt, months after the release, when I received a complimentary copy of the VHS version. I popped it into my VCR and watched with increasing horror. The main title was out of sync! It was so badly out of sync that it was almost, but not quite, a full beat out. At the end of the sequence there was a momentary freeze-frame. I backed up and measured it, not believing my eyes. It was a five-frame freeze-frame! It looked like a blip, a hitch, a mistake. The wonderful dance I had put together, not a frame of which Herbert had altered, was out of sync with the music. It was ruined.

I called Paul Haggar, the head of post at the studio, in despair. "We have to fix the video," I said.

"Too late," he replied, "We've already made 275,000 copies."

I was in agony. "How did this happen?" I wailed.

A meeting was called in Paul's office, and the technician who was in charge of the transfer was called in so I could confront him. "What did you do? Why didn't you fix this? You put in a five-frame freeze-frame, so you must have known something was wrong!"

"Well, when we got to the first dialogue scene, we could see that it was out of sync, so we added five frames at the end of the titles to make up the difference."

"But why didn't you just go back to the top of the reel? It was only a couple of minutes more! It wouldn't have taken that long!"

I wanted to kill him. He had no good answer, and anyway it was too late. To this day, I wonder how many jobs cutting musicals I lost because of how terrible that sequence looked.

The videotape, and later the DVD and Blu-ray, have become the historical record of any film. In those days, directors and editors put a lot of effort in the color correction and quality control of the film prints but not much into the video transfers. Technicians without any sense of aesthetics supervised them, which was catastrophic in this case.

The problem with *Footloose* was finally addressed many years later. Fred Chandler, at that time in the Paramount post department, gave me the opportunity to sign off on a later rerelease in which the picture had been resynced. In 2000 a new master was made for the DVD version, and today the sequence finally looks the way it was intended to.

Despite Lew's death and the terrible TFU (technical fuck-up) at the end, *Footloose* was a great experience for me. It was the first picture I did after my move to L.A. It was my first picture working on a studio lot, and I was working for one of Hollywood's most respected directors. Herbert was the best director of actors I ever worked with. In one year, 1978, seven members of his casts were nominated for Oscars, for *The Goodbye Girl* and *The Turning Point*. He had given me points, had treated me with respect, and invited me to join him on his next picture, *Protocol*.

I will always be grateful to him.

15

Protocol

SHOOTING ON *PROTOCOL* BEGAN IN 1984. It was a comedy with a screenplay by Buck Henry, who also wrote the screenplays for *The Graduate* and *Catch-22* and, curiously, wanted more than anything to be an actor. Goldie Hawn was to star as a naive cocktail waitress who saves a visiting dignitary and, as a reward, gets a job in the Protocol Office in Washington, DC.

After several weeks of shooting in L.A., the company moved to Morocco for a week or two of location work. Sunny Davis, Goldie's character, had been secretly promised to the emir of Elohtar (hint: spell it backward). She arrives there thinking she is representing the US government, but the emir's people begin preparing for the big wedding.

Herbert shot various scenes of Goldie in the harem, being made up and dressed by the local women, going shopping in the local souk, and attending a banquet in her honor, where all the women sit apart from the men. None of this was scripted, and we wrestled with how to handle this material, which had great authenticity but no dramatic shape. Someone came up with the idea of framing it all with a voice-over of Sunny writing postcards home to her parents, describing her experiences.

My assistant Greg Scherick, whose big feet were the final shot in the main titles of *Footloose*, had an idea for a joke. One of the shots at the banquet was of a waiter placing a silver platter in front of Sunny. On it sat an entire roasted and garnished baby lamb, with black olives in place

of its eyes. The joke Greg came up with was "When you order a hot dog here, make sure you ask for a really big bun."

When we screened the picture for a test audience on the Warner Bros. lot, that joke was the only thing in the movie that the audience reacted to in the questionnaires. "How dare you kill a dog to use as a joke in your tawdry movie?" was typical.

It seemed everyone believed the lamb was a dog because of the joke. We learned only one thing from the screening: you can't make jokes about killing and cooking dogs.

The end of the movie was problematic, and in subsequent screenings our scores were under par. We worked hard to fix the problem, coming in on weekends at times. I brought in a friend, Lynzee Klingman, an experienced editor who had worked on *One Flew Over the Cuckoo's Nest*. She took on responsibility for some of the Morocco footage I just didn't have time to address.

Herbert and I were going over one of the later reels, which involved a lot of action and intercutting. We started moving scenes around, juggling the continuity and trying one option after another. After a full day of this, we were both getting fried. "If you had only gotten this right in the first place, Paul, we wouldn't be in this fix!" Herbert exclaimed, only half joking.

I wondered, *How **had** I done it in the first place?*

Because we were using film, every version we tried meant taking apart the previous version. It was easy to lose track of where you were and had been. But I had made a dupe of my first cut, and I dug it out and threaded it up. We looked at it, and then at each other.

"What's wrong with that?" I asked.

"Nothing."

So we put it back, after spending a day fruitlessly going in circles.

When it came time to choose the composer, I suggested a friend I had met through George Lucas. Basil Poledouris was another member of the USC

film school "mafia." Basil was known for the scores he had written for John Milius, *Big Wednesday* and *Conan the Barbarian*. He and Milius were surfing buddies, and when we moved to L.A., Basil and his wife Bobbie, whose kids were the same age as ours, were very welcoming and friendly to us.

Basil wrote big, sweeping orchestral music and was not who you would think of for a comedy, but I knew he had a good sense of humor and I believed in him. He wanted to stretch and do more than the types of films he had been doing. Herbert trusted me and hired him. But it didn't work out very well. Basil's music didn't have the lightness needed, and Herbert wound up going to his home studio and working closely with him to get the score he wanted. Both Basil and I felt bad about it, but at least he hadn't been fired. He went on to compose the scores for films such as *Robocop* and *The Hunt for Red October*, and for the miniseries *Lonesome Dove*. By the time of his death in 2006 at the far-too-young age of sixty-one, he had amassed a large and devoted following.

The final big scene in *Protocol* was a Senate hearing into the "Sunnygate" scandal. It featured a speech by Goldie reflecting the highest ideals of American democracy. Cannily, the scene anticipated a real-life scandal that erupted the following year, Iran-Contra. TV news featured Ollie North testifying at a Senate hearing, with the camera angles almost identical to those we had in our film. In our case, the US had traded a person for a military base; in reality, it was the reverse—the US had traded weapons to secure the release of some prisoners.

The ending wasn't satisfying, so again Herbert filmed a new ending for the picture, with Sunny herself running for office and getting elected. The new ending, unfortunately, didn't help. Much of the humor in the picture was based on the president's lack of intellect and predilection for napping. When the picture came out, Reagan had just been reelected in a landslide, and the American public was not in the mood for a picture that ridiculed him. Herbert worked tirelessly to try to salvage a doomed project. "It's all about hits and flops," he used to say. If you had a hit, you were OK, but if you had a flop, you were in trouble. Too many flops and you were out, or in director jail. Working tirelessly, he also exhausted me.

During this period, I was approached by Bob Zemeckis to cut his next picture. We met at a restaurant favored by Hollywood types, Ivy at the Shore in Santa Monica. He explained that his picture was starting shortly, even before I was done with *Protocol*, and that since I had just worked with Lynzee, he thought she could "keep my seat warm" for me. I would then join the project as soon as I was able. The film was about a young guy who travels back into the past and meets his mother, who falls in love with him. Besides overlapping with *Protocol*, it had to be out by the following June, which meant another crazy schedule. After toiling with Herbert to try to breathe life into a picture that wasn't working, I was really beat at that point. I turned Zemeckis down. The picture was *Back to the Future*. It was my most egregious error in judgment up until then. The editor Bob hired went on to win two Oscars cutting for him.

Deciding which offers to accept and which to turn down is tricky. When I have just finished a picture, my confidence is high and I am more likely to say no. When I have been out of work for a while, I am a lot less choosy. At the end of *Protocol*, I was approached by the studio about working for a first-time director doing a film called *Pee-Wee's Big Adventure*. I thought, *Surely I can do better than that*, and decided to wait for a more appealing project.

I had passed up the chance to cut Tim Burton's first film.

Around this time, I got a call from one of the students who had worked on Brian's *Home Movies*, Mark Rosman. He had directed a TV movie for the Disney Channel called *The Blue Yonder*, about a boy who travels back in time and meets his grandfather, who had been an early aviator. The grandfather, played by Peter Coyote, takes the boy, played by Huckleberry Fox (a felicitously named cast for a Disney movie), up in his biplane over the Mendocino countryside. Mark and his producers were unhappy with the cut as it stood.

They had so little money to offer me that I agreed to recut the picture just once, with no changes beyond that. Surprisingly, they were OK with that. I was asked if I wanted to bring in my own assistants, but I thought it would make more sense to keep the original crew, since they knew the material. The first assistant was Joe Hutshing, and the apprentice was David Brenner.

I went through the picture, tightening and clarifying and giving it a rhythm. I needed a piece of music to create a montage of the aerial sequence, and used John Willams's magnificent flying cue from *E.T.* It was perfect, capturing the thrill of flying for the small boy, and everyone loved the sequence. Then it came time to spot the picture with the composer, David Shire. David was married to Francis Coppola's sister, Talia. He was not happy about the cue from *E.T.* "You bastard," he said to me, sotto voce.

"What?"

"You had to go and use that, one of the greatest cues ever written? Now I'm going to have to match it."

I hadn't considered that. I had put him in a box and regretted it, but it was too late.

After we had finished, the apprentice, David Brenner, came to me and said, "I've been offered a job on a picture shooting in the Philippines."

"That's great, David, you should do it."

A couple of weeks later, he called back. "There's a revolution going on in the Philippines!"

"David," I said, "what better time to see a country than during a revolution!?"

He went. The picture was *Platoon*. David forged a relationship with Oliver Stone and brought Joe Hutshing in. Within a couple of years, Oliver trusted them to coedit *Talk Radio* and then *Born on the Fourth of July*. They shared the Oscar for editing that year. Joe went on to win a second one, for *JFK*.

It's interesting to look back now at *Protocol*. Its new ending, with Sunny Davis being elected to Congress, while unsuccessful at the time, foreshadowed recent political trends, with more women running and being elected than ever before.

Maybe we were just ahead of our time.

16

Ferris Bueller's Day Off

AROUND THEN, IN 1985, I signed on with the Gersh Agency, thinking that they could help me find work, and they did. David Gersh specialized in below-the-line talent, such as cinematographers, production designers, and editors. He called to tell me that Paramount was doing a picture with John Hughes, who had directed a number of teen comedies, including the well-regarded *The Breakfast Club*. John wanted an editor from New York. A meeting was arranged.

I went to the Hughes offices on the west edge of the lot, in a row of buildings along Gower Street that had once been the home of RKO and, later, Desilu. When Paramount made a deal with a filmmaker, a certain amount of money would be provided to do a makeover of his or her new offices. John had created a sort of black-and-white tiled fantasy that reminded me of the sushi bars on nearby Melrose Avenue. Tom Jacobson, his producer, warned me not to take up too much of his time, as he had a very full schedule that day.

John had a rapid but soft speaking style and smoked constantly. He was manifestly very intelligent, and he peered at me through wire-rimmed glasses, as if checking to see how his remarks landed. He wore an expensive-looking leather jacket, and his dark-blond hair was cut in a modified mullet. He had hired Dede Allen to cut *The Breakfast Club* and, as a consequence, had decided that he wanted only New York editors from

then on. That was fine with me. He spoke about his midwestern roots. "Where I come from," he said, "macaroni and cheese is an ethnic dish."

I told him I had liked his latest picture, *Weird Science*. He looked at me strangely.

"Really?" he asked, somewhat skeptically.

"By the way," I asked, "are you keeping the title *Ferris Bueller's Day Off*, or is it just a working title?"

"Keeping it," replied John.

After the meeting, Gersh told me that the choice had been between Jerry Greenberg and me, but I got the job because Jerry was still based in New York and the studio didn't want to pay him per diem. Whenever I told people about the project, they would invariably say to me, "They're changing the title, right?"

John was very hip and tuned in to teenage culture. He had an encyclopedic knowledge of the music of the teen generation at that time, and a real feel for the angst of that age. The script was about a high school student who decides to ditch school with his best friend and his girlfriend.

John employed a device that I hadn't seen in almost twenty years, since *Alfie* with Michael Caine. He broke the fourth wall and had Ferris address the audience directly. John was primarily a writer, and this device gave him the opportunity to write wonderful, thoughtful, and insightful monologues for Ferris. They were also very funny.

I didn't know it at the time, but *Ferris* was to become an iconic film. To this day, I get more positive feedback about it than almost any I have ever cut, including the *Star Wars* films. I think the reason is that high school is a universal experience. Everyone can relate to the feelings we have there. John conceived of it as a companion piece to the first film he had directed, *Sixteen Candles*. Where that earlier one had been about the worst day of a teen's life, *Ferris* was intended to be about the best day.

To play Ferris, he recruited Matthew Broderick, who despite his youth was already an accomplished stage and screen actor. Matthew brought in his friend Alan Ruck to play Ferris's best friend, Cameron, an anxious depressive with access to his domineering father's Ferrari. The fact

that Ruck and Broderick were already friends helped with their on-screen chemistry.

John cannily created a nemesis for Ferris in the person of the obsessed Dean Rooney, determined to catch Ferris playing hooky. He cast Jeffrey Jones, who had played the dim-witted monarch in *Amadeus* who complains to Mozart that there are "too many notes." Jeffrey played the dean as a sort of Wile E. Coyote in pursuit of his elusive quarry.

Mia Sara played Ferris's girlfriend, Sloane Peterson. She was eighteen years old at the time, very beautiful but without much acting experience of any kind.

The daffy Edie McClurg played the role of Dean Rooney's secretary, Grace. I recognized Edie from a small role she'd had in *Carrie*. She was perfect as Grace, the secretary who knew all about what was going on in the school, and she and Jeffrey, as the dim Dean Rooney, played off each other beautifully. John told me that their fraught relationship had been based on the one Hughes had with his own secretary.

Ferris's sister Jeanie was played by Jennifer Grey, who was dating Matthew at the time. A year later, Jennifer hit it big as Baby in *Dirty Dancing*. The actors who played Mr. and Mrs. Bueller, Lyman Ward and Cindy Pickett, met during production, fell in love, and got married.

The picture was shot mostly in and around Chicago, with some shooting in L.A. as well. John had been born in the suburbs of Detroit. He had moved to Chicago as a young man, worked for a time in the advertising business there, and loved the city. The picture is a love letter to the City of the Big Shoulders.

I went to the set on the first day, in a suburb north of the city by Lake Michigan. As usual, the first few days of shooting offered me nothing to do, as there was no film to cut yet, so I went to meet and greet the various members of the cast and crew. Alan Ruck shared with me that he was actually twenty-nine years old, playing a high school senior.

I continued visiting the various locations, as I had never been to Chicago before and was enjoying seeing the city. I went to the Art Institute of Chicago, which houses a world-class collection, when the museum scene was filmed. I also went to watch them shoot the parade sequence. Chicago has a large German American population, and every September they hold their annual Von Steuben Parade. John had Ferris lip-sync Wayne

Newton's "Danke Schoen" and the Beatles' "Twist and Shout" from a float surrounded by girls dressed in traditional German costumes. How he got the rights to the Beatles' "Twist and Shout" I don't know, but the script read, "The entire parade is singing and playing 'Twist and Shout.'" The idea was for the entire city to be swept up in the moment, and that's exactly what happened that day. We did three takes, and on the last one, all the people holding balloons were asked to release them on cue, which they did. The energy from the crowd in that last take was phenomenal, and when I cut the scene I held the wide shot as long as possible, because there was no way to match that energy with cuts.

During one of the earlier takes, one of the cameramen spotted a construction worker up on the open girder of a building rising next to the parade route dancing to the music. He tilted quickly up to him and caught a few seconds of life imitating art, the worker spontaneously acting out what John had written. I made sure to cut him in when I built the scene, and whenever we screened the picture, the audience would react audibly to this joyous guy in a hard hat rocking out on a steel girder. They sensed instantly that this was not staged, it was the real thing.

Our choreographer Kenny Ortega, later famous as the director of Disney's *High School Musical* franchise, had arranged a number of dance routines to use during Ferris's song. Some were successful, but others were not. The best of these was a dance troupe that performed atop a short set of stairs. Because of the framing and movement of the camera, they appeared to glide in magically from the left side of frame. Other bits of Ortega's that I used were a window washer and a kid on a trampoline behind the grandstand.

I had a lot of fun cutting this sequence. My favorite touch was during the "*Aah, aah, aah, aah . . .*" buildup to the climax of the song. I cut from one person in the crowd to the next, accelerating the pace until I reached the peak of the buildup, whereupon I cut to a little boy riding on his father's shoulders who had clamped his hands over his ears. It always gets a big laugh.

This fulfilled two goals. I got the laugh by setting up an expectation in the audience by repeated cuts to people singing, and then by cutting to the boy, foiling that expectation. Comedy often depends on surprise. The second goal was to dramatize how loud the crowd had become at the peak of the song.

When we mixed the sequence, due to the technological limits of the Dolby optical track, there were absolute limits as to how loud we could get. The mixers had to carefully start the song low enough so that they could build and reach the maximum volume at precisely that moment, increasing the volume of both the music and the crowd effects simultaneously to keep the proper balance through the scene up to the climax. They did it perfectly.

———————

Back in L.A., our cutting room was set up in the Fleischer Brothers building on the Paramount lot. The Fleischers were early animators, most famous for their Betty Boop and Popeye cartoons. The building was small and dark and had probably once been a vault for highly flammable nitrate film, as there was a network of water pipes across the ceiling. It had the vibe of a basement, even though it was above ground. My crew and I filled the small building, and working there with John had the feel of going over to a friend's house and hanging out in the basement rec room.

He would sprawl on an old beat-up couch and entertain me or whoever else was in the room at the time with hysterically funny routines. If John had been a stand-up comic, I would have paid to hear him perform. As it was, these spontaneous monologues were for our ears only. Often I was unable to work because I was laughing too hard.

———————

The first cut of the picture ran 2:45. It was the longest first cut of any picture I had ever done. When I was working with Brian De Palma, he would often call up during production to see if the picture was long enough, worried that we wouldn't have enough running time for a feature film. This was the opposite problem.

I had put in some temp music, as I always did, and when I showed the first cut to John, he was enthusiastic in telling me how much he liked my choices. In the case of the Ferrari flying over camera in a spoof of the opening shot of *Star Wars*, it seemed natural to use John Williams's theme.

I had also put in the most upbeat song possible, "Walking on Sunshine" by Katrina and the Waves, for the moment when Ferris pulls away from the high school with Sloane and Cameron, heading for the city. For the museum scene I put in a cue from Emerson, Lake & Palmer's version of "Pictures at an Exhibition," a solo guitar that was very quiet, evocative, and arrhythmic. I cut the still images of the paintings very closely to the music, so that the odd phrasing was reflected in the visuals. John liked all of it.

Cutting the picture down was no small task. My reaction to seeing the entire first cut was that there were too many monologues. We started pruning those out. There was one long speech at the outset in which Ferris described a friend of his who used to cry himself to sleep. This friend turns out to be the boy Ferris's sister Jeanie later meets in the police station, played by Charlie Sheen. It turned out we didn't need to set him up. The gag at the end worked perfectly well without the monologue.

There was also a bit at the Chicago Mercantile Exchange that we severely shortened, ultimately cutting out most of the dialogue and resting the scene on shots of Cameron making cave drip sounds with his cheek. We completely eliminated a scene on the Chicago River on a tour boat, where the trio talked about nuclear winter.

A real-life disaster forced our hand on one significant change. There was a bit in the movie in which Ferris is interviewed on a radio show, and the broadcast is heard at his high school. He announces he has been chosen to be the first high school student to go on the space shuttle. When the *Challenger* blew up in early 1986, we had to drop the scene.

One morning after our first preview, while I was in the shower, it occurred to me that the parade, being the biggest and most dramatic event of the day, should come last. The scene that followed it, the traffic jam scene, would have to come earlier. Then it occurred to me that if we saw a snatch of the parade before the traffic jam and played some band music in the background inside the taxi, we could make it appear that the jam was caused by the parade! *Post hoc, ergo propter hoc!* This made the taxi scene less arbitrary, and having the parade at the conclusion of the day made it more climactic.

I have thought about that moment when I came up with this change. One second I didn't have the idea, and the next second I did. It makes me wonder where ideas come from. They just seem to bubble up from our unconscious to the surface, breaking into conscious thought. It's very mysterious, but it happens all the time. When I am working on a picture, I am thinking about it literally 24-7. I dream images from the film, and I often wake up thinking about it as I emerge from sleep. It's a very fertile time of the day for me.

I told John and he was ready to try it, so we rearranged the scenes. It worked like a charm, although we had to deal with one other problem. By losing the radio station scene, we were cutting right from the end of the parade to the garage where the trio goes to collect Cameron's father's Ferrari. In that scene, Cameron, flushed with excitement about Ferris's stunt, yells out, "I can't believe you were on a radio show!"

We couldn't just lose the line, because at that very moment, the parking attendants who had borrowed the car for a joyride are returning it. So we rerecorded the line as "I can't believe you were on a parade float!"

The angle was wide enough for us to get away with the cheat.

John now decided he hated the music for the museum sequence. It was my first encounter with his mercurial changes of mind. He came up with a song that was sweet and not inappropriate but was too conventional for my taste. I liked the idiosyncratic choice better, but I dutifully recut the picture to the new song, and the rhythm of the images became more predictable. The scene still packs a punch, because the art is so powerful.

Another song change John made was taking out "Walking on Sunshine" and replacing it with what I thought was a far inferior song. The one advantage of the new song was that the lyrics were more on the nose about going to the city, but it didn't feel like a hit song.

We prepared to screen the picture for an audience again. We wanted to see if our adjustments would make a difference. They did, and the scores went up significantly. Women in particular scored it much higher, perhaps due to the removal of a line from Sloane that they found offensive. In the parade scene, she and Cameron are talking about life after high school.

SLOANE: The future's worse for a boy, isn't it?
Cameron doesn't understand what she means.
SLOANE: A girl can always bail out and have a baby and get some
 guy to support her.

When the second preview scored much higher, the studio thought it was due to removing the offensive line. I thought it was because we had restructured the day to have the parade come last. John thought it was because we had changed the music in the museum scene. Because we had done all three at the same time, it was impossible to know, but the cut played well, and we were ready to lock picture.

———————

While filming the morning scenes during which Ferris showers while addressing the audience, John had fooled around with some ideas for a tag for the picture. We had a few options. One had Ferris come up to the camera and, peering out at the audience, say, "Jim? Jim, is that you?"

But we went with "It's over. Go home." And Matthew waved his hand in a shooing motion.

"John, I love the idea, but no one is ever going to see it," I said. The final credits are usually what used to be called "hat-grabbing" moments. It was hard to imagine why anyone would stick around long enough to see the tag.

Once again, I was in the shower when the solution came to me. I couldn't wait to tell John. There was a scene we had cut out: a beat-up and defeated Rooney is forced to take a school bus home after his K-car had been towed outside the Bueller house. It was really funny. We took it out only because it interfered with the flow of the story where it originally fell.

"We can play Rooney on the bus while we run the end credits. We'll just put it in a box on the screen and roll the credits next to it. That way the audience will stay to watch the scene, and they'll still be there when the tag comes up."

The next time we previewed the picture, sure enough, the audience started to leave when the end song, "Oh Yeah," started up. But while they

were exiting, they realized the movie wasn't over and stopped halfway up the aisles to turn around and watch. It worked just as I had hoped. They stayed, saw Matthew telling them "It's over ... ," and laughed.

We began work on the finishing of the sound. Some of Matthew Broderick's lines had to be looped, but when it came time for Matthew to record them, John was a no-show. He wasn't interested in the picture anymore and didn't bother to come in. I had to stand in and direct the session. Matthew was upset at first, but we persevered, and in the end we were both happy with the result.

We started mixing, and John still didn't show. I called him. "John, we need you to come in and start signing off on some of these reels."

"Burn the negative."

He really had lost interest, but I insisted, and the following day he came in to the mixing stage.

As he walked in, he handed me a manila envelope. "Here, I wrote this last night. You want to cut it?"

He wasn't kidding. I went off to one side and started to read. It was the first sixty pages of his next script, *Planes, Trains & Automobiles*, all the way through the memorable scene where a car rental agent played by the redoubtable Edie McClurg responds to a frustrated Steve Martin. He rants loudly to her, dropping the f-bomb eighteen times, ending with "I want a fucking car, right fucking now!"

"May I see your rental agreement?"

"I threw it away."

"Oh boy."

"Oh boy, what?"

"You're fucked."

He had written for ten hours straight, about six pages an hour. He would go into these fugue states, during which he was not to be disturbed, and he wrote as if taking dictation from a muse. He never went back and rewrote, and he wouldn't allow anyone else to rewrite him either. These inspired first drafts got polished only if the picture was actually put into production, and even then only after it had all been shot, in the editing

of the final version of the film. I suppose production executives indulged him because the results were so good.

While writing his screenplays, he sometimes stopped and lost the thread he had been on and then was unable to pick up again from where he had left off. In those cases, he would simply abandon the script and start another. He was amazingly prolific, and he followed his muse. If she moved on, so did he.

He carried around a small notebook in which he wrote story ideas as they came to him. Occasionally he would pull out the book and read something in it or write in it. He used a pen with a very fine point, and his handwriting was spidery, very small and neat. There were more ideas in that book than all the ones that ever saw the light of a projector bulb. But I was sold on the idea of cutting *Planes, Trains & Automobiles*.

"Yes," I said, "absolutely, I'd love to."

Ferris was one of those pictures that become part of the zeitgeist, outlasting the moment in time when it came out. And not just in this country. I have met film students from Brazil who told me it was their favorite movie. The release of movies is their birth, and some go on to lead long lives. Some fall into obscurity, but others grow up to become important members of society. *Ferris* did just that and is one of my favorites.

The news of John's death from a heart attack in 2009 was shocking. He was only fifty-nine. As he had moved back to Chicago, I hadn't seen him in several years. What a talent he was, and how sad that all those ideas he had would never come to fruition. He had an emormous gift for making people laugh.

I attended a memorial for him at the New Beverly Cinema in Hollywood. They were screening *Ferris*, followed by *Planes, Trains & Automobiles*. At the end of *Ferris*, the projectionist turned the projector off too soon, cutting off Ferris's tagline, and turned on the house lights. The packed house, knowing the picture better than the man in the booth, groaned

audibly. They waited a few beats, and then when nothing happened, went out to pee or buy some more popcorn, whatever. After a few more minutes, without warning, the house lights went down and the audience cheered. When the film started up again, there was the tag, but it was upside down and playing backward.

This demonstrated what many people don't realize: the projectionist has final cut.

17

The Secret of My Success

FERRIS BUELLER'S DAY OFF CAME OUT in June 1986, just before I was to rejoin Herbert Ross on his next picture, *The Secret of My Success*. The timing was perfect. The project was at Universal and starred Michael J. Fox as a young man with dreams of making it to the top in the world of business. We were cutting on the lot at Universal. The picture was shooting in New York City, with Carlo Di Palma as cinematographer, but Herbert never needed me to be on location with him. He knew what he needed to shoot, and he trusted me.

When Herbert shot his extra days of hair and makeup or costume tests before the beginning of principal photography, he would often end up with usable footage for the movie. He also believed it helped the crew to get their feet wet. In this case, they went out into the streets and got shots of Michael arriving by bus and plunging into the crowds around the Port Authority bus terminal, a midwestern fish out of water. Herbert had recruited a number of supermodels, including Cindy Crawford, to appear in the opening title sequence. Di Palma also filmed some dazzling shots of the skyscrapers around town, as well as more prosaic street-level shots, but transformed by some alchemy of his lens and his eye into stunning shots of New York life. You could create a magnificent coffee table book of New York with a still frame from each of the angles they shot that day.

I flew to New York just to reconnect with Herbert, as for a long time we had spoken only by phone. I was still bubbling about the success of

Ferris Bueller's Day Off, and knowing how Herbert responded to dance music, I played him "Oh Yeah" from the soundtrack. He loved it, as I knew he would. "We have to use that in the film," he exclaimed. *John will kill me*, I thought.

On the set, I was introduced to Margaret Whitton, who was playing Michael J. Fox's aunt Vera. She was dressed in high style, her hair coiffed in an updo and heavily made up. "Pleased to meet you," I said. She leaned in toward me.

"Paul, it's Peggy! It's Peggy!" she repeated. I couldn't imagine where I might have met her.

Suddenly the penny dropped. "Peggy! I didn't recognize you!" We had met about sixteen years earlier. She had been dating a friend, and in those days she was a wild-haired young artist dressed in jeans and sandals with no makeup at all.

"Don't tell anyone. I'm Margaret now."

Playing a predatory cougar in the picture, she did a great job.

Working for Herbert again, I was reminded what a pro he was. He was also the producer this time and had final cut again, which helped smooth things politically. He was expert at dealing with studio executives.

I learned a lot from him about performance. He liked to begin production with a scene from the middle of the script. He thought that sometimes the actor hadn't yet found the character at the start of shooting. It was better to shoot the beginning scenes after the actor had a firm grip on the character. That way, when you got to the scenes in the middle that were shot while the actor was still searching, the audience would glide over them, since the character would have by then been firmly established in their minds.

Herbert shared with me that he was planning a ballet film called *Dancers* with his wife Nora as executive producer. It was to be based on the ballet *Giselle* and would star Leslie Browne, whom Nora had discovered and who had starred for Herbert in *The Turning Point* and *Nijinsky*, and Mikhail Baryshnikov.

"That sounds fantastic," I said.

"Would you like to do it?" he asked.

"Yes indeed I would," I replied.

Herbert was planning to shoot the picture back to back with *The Secret of My Success*. We would finish *Success* only after he filmed *Dancers*.

Shortly after this, I got word that John Hughes wanted to go into production on *Planes, Trains & Automobiles*, which we abbreviated as *PTA*, the following spring. If I did *Dancers*, I would have to pass on it. I couldn't do both, and I was determined to work on *PTA*. I had to tell Herbert that I couldn't cut *Dancers* after all. He didn't take it well, even after I explained to him that I had already accepted John's offer before Herbert had made the offer to me, and I hadn't known there would be a conflict. But no one takes rejection well.

As part of its design, *The Secret of My Success* was to contain a number of montages. I treated them like dance numbers and so needed music that I could cut to. I put in cues from some of the music I was listening to at the time.

"Oh Yeah" was a natural for a montage in the limousine in which we see that young protagonist Brantley Foster has caught the amorous eye of his aunt Vera, played by Margaret. The shots include suggestive and more blatant allusions to sex, such as an enormous close-up of a phallic lipstick emerging from a tube, orgasmic windshield wipers squirting, and so forth, intercut with shots of Margaret's lecherous eyes and mouth and Brantley squirming awkwardly.

Another montage came when Brantley impersonates a fictitious junior executive named Carlton Whitfield. Having changed into a suit in the previously empty office he has taken over, he ventures into the intoxicating world of the executives. I chose the song that John Hughes had rejected in *Ferris*, "Walking on Sunshine" by Katrina and the Waves. It also worked perfectly.

There were many more montages to come. Knowing that Herbert had chosen David Foster, a record producer who had written songs for films, to provide the score, I used a cue from his earlier *St. Elmo's Fire*. *Success* was to be only the second film for which he was doing the whole score, and I thought it might help him. It was also just right for the moment.

When Herbert came back at the end of shooting, I screened the picture for him, with music, one week after wrap, fully mixed. One gag I tried didn't fly for him, though. It involved a scene in which Helen Slater, defending herself from an unwanted advance from Richard Jordan, punches him in the groin. I had the mixer pitch up the next line out of Jordan's mouth, so it came out as a falsetto. Herbert thought it was cheap gag and nixed it, but otherwise he was pleased, and we finished his cut in five weeks instead of the ten he was entitled to. The DGA contract specifies that directors have ten weeks after the end of principal photography before they are obligated to show their cut to the producers.

We arranged to screen the picture for Tom Pollock, a lawyer and Groucho Marx look-alike who had been named head of production at Universal. When he arrived at the screening room, he announced that this was the first picture he would be screening in his new post. "What's the running time?" he asked.

"One-forty," I replied, meaning an hour and forty minutes.

When the lights came back on at the end, he said, "Well, it's great. We just have to figure out how to get forty minutes out of it."

Herbert and I looked at each other, puzzled. It seems that Pollock thought I had meant a hundred and forty minutes, or two hours and twenty minutes. I found it disturbing that Pollock's internal clock couldn't tell the difference.

Anyway, we locked picture and Herbert told me he was going off to Europe to shoot *Dancers*. It was 1986, and the Miracle Mets were making their historic run to the World Series. My crew and I, with nothing to do, watched every day game at work. I renewed my friendship with Donn Cambern, a gentle, courteous man with a ready grin who was cutting across the hall. Donn had been very kind to me eight years earlier when, nominated for *Star Wars*, I had lost the Eddie.

Never having been exposed to a real feature editor as an assistant, I am always curious to see how other editors work. Donn hung a full-length mirror sideways above his Kem like an enormous rearview mirror. This enabled him to see his director, who sat next to or behind him, without having to turn around. This struck me as eminently sensible, although I didn't think I would like sitting in front of a mirror all day.

When Herbert came back from Europe, he had some grim news to share. Nora, to whom he had been married for twenty-eight years, had cancer. Herbert adored Nora and told me he would be devoting himself to her care. I would have to take over the finishing of *Success*. The picture was locked. I supervised looping the actors and went to New York to direct a day of pickups, which was a lot of fun. Michael J. Fox was excellent at looping, and the work went smoothly. I supervised the mix, and on the last day, Nora died. The next day, Herbert needed to come to the stage to listen to and approve the playback.

"Please tell everyone that I understand that they are sympathetic, but I would prefer that they say nothing to me," he said.

I relayed his wishes, and we watched the reels in silence. Herbert was happy with the results and thanked everyone and left. A few days later there was a somber, star-studded memorial for Nora at their home on La Mesa Drive in Santa Monica. Herbert was devastated.

———————

When *The Secret of My Success* opened that spring, it got mixed reviews but was number one at the box office for five weeks in a row, something that never happened again in my subsequent films. It became the second film of Herbert's that I cut that went into profits.

I think of Herbert as someone who, despite the fact that he could be difficult, was a talented and knowledgeable director who really knew what he was doing. If he covered a scene, which was rare, it was because he hadn't come up with a visual idea for its design. Most of the time, he did. He was very generous to me, creatively as well as financially, for which I am grateful.

Rest in peace, Nora.

18

Planes, Trains & Automobiles

IN 1987 THE DGA WAS NEGOTIATING a new contract and threatened a strike against all the major studios, effective June 30. Production on *PTA* absolutely had to be finished by then. To add to the pressure, we were already booked into thousands of theaters on November 9, to play through the Thanksgiving holiday, which was the setting for the story: Upper-middle-class ad exec Neal Page (Steve Martin) is trying to get back home to Chicago from New York in time for the feast. In the face of endless obstacles, a massive blizzard being the first, he is forced by circumstance to team up with lower-middle-class Del Griffith (John Candy).

A comically mismatched pair forced together was not an original formulation, but as always with John Hughes, the delight was all in the details. I think of him as a skilled miniaturist, who could take a simple situation and from it weave endlessly elaborate and hilarious complications.

The exteriors were shot on location in various spots in the Midwest, although the company had a great deal of trouble finding enough snow. During a scene where a state trooper pulls over the pair's burned-out car in what is supposed to be very cold weather, you can see the snow on the car actually melting and dripping through the frame.

Meanwhile, I was faced with overlapping schedules. Principal photography on *PTA* had begun, but I wasn't quite finished with *Success*. At the end of every workday, I would travel from Universal to Paramount to watch John's dailies in the same rooms where we had cut *Ferris*. By the time I finished *Success* and was free, two or three weeks had gone by, so I was already behind when I started.

I flew to Chicago to join the company on location. I hadn't seen John in months. I arrived shortly before we were to begin screening that day's dailies. A banquet room in a hotel had been turned into a screening room, and the company sat on armless, upholstered dining chairs. I sat next to John, and the film began to roll as soon as he arrived, with barely time for a brief hello.

The scene we were watching comes near the end of the duo's journey as they part ways after finally arriving in Chicago. It reads as follows in the script:

> INT. TRAIN
> Neal slides into a seat. He breathes a huge sigh of relief.
>
> NEAL
> What a trip . . .
>
> He reaches across the aisle and snares a discarded newspaper off the seat. He opens it. The train jolts ahead.

That's it, the whole scene in less than a quarter of a page. The first shot of the dailies was wide, from inside the commuter train. There are one or two people on one end of the car; on the other side sits Steve Martin. The train is standing at the station. After a few seconds, it starts to move, the cityscape going by the large windows. The camera does not move.

After about three minutes, they cut, and another shot begins, same angle, new take. After another three minutes or so, a new angle, still wide but slightly closer to Steve. Then another take comes up, running until we get to the end of the roll of dailies, about ten minutes total.

The second roll begins, and it is the same thing, Steve just sitting on a commuter train, filmed from various angles. Another roll comes on the screen, then another. I sneak a look over to John next to me, wondering

what we are supposed to be looking for, but he simply sits inscrutably, smoking one cigarette after another. At the end of the fifth roll, we had been watching variations of this for an hour. A sixth roll came on, then a seventh, eighth, and ninth.

In the tenth roll, the camera was now shooting a close-up of Steve. As the train glided through the suburban landscape, he smiled to himself as if he was remembering something, then he looked up quizzically as if he had thought of something puzzling, then he shook his head. There was nothing in the script to give a hint about what that puzzling thought was. It was probably Steve feeling he had to do something when the camera was that close to him. At the end of that roll, the house lights came on. We had been watching coverage of this non-action for two hours. It seemed a bit nutty to me, and I don't think even John knew what he was looking for. But although none of us knew it at the time, that last close-up ultimately turned out to be crucial. It made the end of the picture work.

The volume of film shot every day kept increasing. It seemed that John would keep writing new material for each scene, either the night before or on the spot. Candy, who was playing the blabbermouth Del Griffith, was phenomenal in his ability to master pages and pages of dialogue. One day he couldn't remember his lines and kept asking for prompts from the script supervisor. I shuddered to think that this might become a daily occurrence. But it only happened that one day.

I have always taken the approach of including all the good material in the first assembly, even knowing that there's too much. It is simpler to pare down than to expand when you are doing the fine cutting. Following this strategy, I put everything in, and there was a lot.

The company came back to L.A. to shoot interiors at Paramount, and the dailies each day ran for hours. There was a scene in the first motel room, where Neal and Del are forced to share a bed, that was shot over several days. After viewing about three hours of film one day, eating lunch off paper plates in our laps in the darkened screening room, I emerged into the light and announced to my crew, "We've just watched more film for this one scene than the whole picture can run."

There was a scene in the script that was less than a page. Neal and Del are riding in a cab on their way to the first motel. In a CU of the taxi meter, it reads $124.50.

NEAL: How much longer, Doobie?

DRIVER: Not much.

DEL: Just out of curiosity, why didn't you take the interstate?

DRIVER: You said your friend's never been here. I thought he might like to have a look around. You don't see nothin' on the interstate but interstate.

NEAL (lowers his voice): It's the middle of the night.

DEL: He's proud of his town. That's pretty darn rare these days.

And that was it, at least as it was written. When the dailies came in, there was much more dialogue:

DRIVER: You see that cabin over there? That's where I lost my virginity when I was fourteen.

And so on, the driver pointing out various sights, so that the takes went on for three minutes or more. Then, when he reached the end of the lines, John would ask him to do it again, without stopping the camera.

Eventually you would hear a camera assistant yell, "Runout! Reload!" and they would stop and put a new roll of film in the camera. Each take lasted the full one thousand feet of the roll. There were two or three takes of each setup, and the coverage was massive. There was a wide shot from the front of the cab, a CU of the driver, a profile shot of the driver, a shot of the driver from the backseat, then a two-shot of Del and Neal in the backseat, a raking two-shot across them from each side of the cab, a side CU of each of them, and a front CU as well. Then there were insert shots of the inside of the cab, which was decorated with pinup photos. All in all, there were about forty thousand feet of film for this one scene, about eight hours of footage. To make things even worse, the repeated starts and stops within the takes made it almost impossible to find specific lines to compare line readings.

I went to see Paul Haggar, the head of post at Paramount. After the success of *Footloose* and *Ferris*, he was sympathetic to my needs. I told him that I wouldn't be able to have the first cut done until well after the end of shooting unless I had some help. We hired a second editor, Andrew London, and I gave him the cab scene. When he was done with that, I gave him another.

Shooting continued the same way, each scene getting longer than originally written. One day I went down to the set and asked the script supervisor how it was going.

"Not well," she replied, "the master runs fourteen minutes."

"But the camera only holds eleven minutes of film!" I said.

"We did a pickup."

As time went on, I gave my longtime assistant Peck Prior a scene to cut, then another. Then I gave another assistant, Adam Bernardi, a scene, so there were four of us cutting.

I got a chance to use the gag that Herbert hadn't liked in *Secret of My Success*. At the airport, Steve Martin gets into a fight with a taxi dispatcher, and Candy comes to the rescue. "Are you all right?" he asks. "I never saw anyone picked up by his testicles before. You're lucky I came along, or you'd be lifting up your *schnuts* to tie your shoelaces!"

When Steve answers him, I pitched his voice up to a falsetto, the gag that Herbert had rejected in *The Secret of My Success*. John loved it.

———

One night at home, the Santa Ana winds were blowing and the heat kept me from sleeping. I went outside and lay down in my hammock. The wind felt like a blow-dryer, the palm leaves rattling overhead. I don't know why, but I started thinking about how to fit the title of the film on the screen. It was a very long title, and it was a puzzle how to fit it into the rectangle of the 1.85 aspect ratio. It suddenly occurred to me to have each letter fill the frame, top to bottom, and not even try to get the whole title onto the screen at once. The camera would then pan across the words, getting faster and faster until the letters strobed. I suggested it to John the next day, and we tried it. The strobing didn't interfere with the legibility of the words, and Wylie Stateman put in the sound of the respective engines.

———

Every day, an avalanche of dailies would descend on us. We struggled mightily to keep up. The production was over schedule, and the cast and crew were working overtime each day to finish before the strike deadline,

June 30. A scene in which all the passengers on a bus start to sing the *Flintstones* theme song took two days to shoot. Finally, on the last day of June, the shooting was complete. The production had lasted eighty-five days.

With the help of my team, we were ready to screen the picture right after the Fourth of July, one week after completion. The picture ran twenty-four reels, or three hours and forty-five minutes. It was longer than the first cut of *Ferris*, my previous record, by an hour. We started watching it one morning in one of the screening rooms on the lot. After twelve reels, we stopped and had sandwiches brought in, and then resumed.

When we got to the end, John turned to me and said, "It's too long."

No kidding, I thought.

He then promptly went on vacation with his family. The studio was frantic, but I couldn't proceed until he got back. When we did start, two weeks later, we went through the reels on the Kem. He had clearly been thinking about what to do. "Lose that, and that, and that."

We swept through the picture, dropping entire scenes right and left. When we finished going through the whole film, we had cut out an hour and fifteen minutes, a third of the running time.

"Do you know we just cut out twenty-eight days of shooting?" I asked.

John just shrugged. This was his method.

We kept cutting, losing scenes with Neal's wife and in particular a subplot involving money, a credit card mix-up, and who was paying for what. It was too complicated, and anyway, who cares, we thought. We got it down to two hours and got ready for our first preview. It was the end of August, and we were booked into thousands of theaters in early November.

The screening was held on the Paramount lot, in what was then the main theater. I was confident. This was a really funny movie with two great comics and a wealth of great jokes, both verbal and visual. We had polished the cut down to what I thought was a good length, and I was ready for the same kind of reaction I had witnessed with *Ferris* and *Success*.

But the preview was a disaster. After about twenty minutes, a couple of people walked out. Then a few more a few minutes later. I had never seen this before, and my stomach sank. More people left, and then a whole row got up and left. I was shocked. By the end, twenty people had walked out of what I thought was a really funny movie. I was blindsided as never

before, and to tell the truth, I have never recovered. To this day, I never go into a preview without feelings of trepidation.

We reviewed the audience's response cards and discovered that the picture felt long to the audience, so we scheduled another preview for later that week. This is one of the problems of a long first cut. You cut and cut and cut, and you think you're done. But you're not.

We worked like crazy and screened again. The results were better, but only a little. We recut, remixed, and screened the picture twice a week for the rest of September, nine previews in all. It wasn't until the fourth one that we discovered what was making people walk out. Because we had cut out the scenes about money, the audience perceived Del as using Neal and taking him for a ride. They hated him for it. Then they started hating Neal for staying with this guy who was just exploiting him.

When we realized this, we put back a small beat in a scene in which Del offers to repay Neal for a train ticket:

> DEL: "Just give me your address, I'll send it to you."
> NEAL (never wanting to hear from Del again): "No, that's OK."

Just putting those two lines back turned the audience's perception of the two characters completely around. They now felt OK about Del and, by extension, about Neal staying with him. I was amazed to see how critical seemingly unimportant nuances can be.

Our problems still weren't solved, however. Most people still felt the picture was too long. So, we kept cutting and screening. John had shot several different gags at the end of the picture, after the duo reach Neal's home, and we tried them all. We screened the picture so many times that one of the cards from the audience read, "I liked the other ending better."

The biggest problem of all was the penultimate scene. The two men part company on the elevated platform of a commuter train in Chicago. They say their goodbyes, and Neal gets on the train. These were the dailies I watched with John on my first day on the picture: Neal alone on the train. Neal then gets off the train out in the suburbs and walks into the little station, tripping over Del's trunk once again, a gag that ran throughout the picture. Del had talked a truck driver into giving him a lift out to Neal's suburban station and ambushed him. Del is sitting there,

forlorn, and a dialogue scene ensues during which Del pours his heart out to Neal, explaining that he is actually homeless, that his wife Marie had died years earlier, and that he had no place to go on the holiday. At this point Neal invites him home with him.

The scene was meant to be touching, but people laughed uncomfortably, and then laughed some more. We had to fix the problem. It took all of our nine previews, but we finally came up with an ingenious solution.

Since we were getting a bad laugh when Del throws himself in front of Neal and begs for pity, we threw out the scene. Instead of Del spilling it all to Neal, we had Neal figure it out on his own. This had the added benefit of enhancing Neal's character. Using that one take of the close-up of Steve on the train from that first day I watched dailies, we intercut flashbacks in which Del alluded obliquely to his being alone, dropping hints of his homelessness. All those seemingly unmotivated expressions that played on Steve's face in the dailies became the hook on which we hung our solution, expressive of Neal's empathy and sensitivity.

Also, since we didn't want Del to be throwing himself in front of Neal, we recut it as if Neal had gone back to the elevated station in the city and fetched Del on his own. Since we had only one take of the train leaving the station, we ran the film backward to make it appear to be arriving instead of leaving. At the last preview, we tried it out and it worked perfectly. We had licked the problem.

During this period, we were all under intense pressure. The final mix had to happen in October in order for us to make the release date, and the sound editors needed time to conform their work to the final cut whenever we arrived at it. In our discussions, I took rather strong positions, and I guess I crossed a line with John.

One day, I got a visit from Bill Brown, the associate producer on the show. He had a sheaf of notes in his hand.

"What's this?" I asked.

"These are notes from John."

I looked them over. "Are you kidding me? Where's John? I've never worked from written notes in my life."

Whenever I had been working on a final cut before, the director was by my side, and I was able to discuss with him whatever I considered to be problematic. With written notes, I was literally turned into a "pair

of hands," the derisive term Brian De Palma used for editors who had nothing to contribute.

My protestations were ignored. I didn't see John again until the final mix, during which he promptly threw out the entire score by his composer Ira Newborn. He started digging through his record collection and, using the mixing stage as a giant Moviola, began experimenting, playing song after song against scenes of the movie. Needless to say, this is not an efficient way to operate.

Ira and I had fallen victim to a repeated pattern I observed in John. He would meet someone and develop a crush on him or her, believing that the person could do no wrong. He courted people in these initial stages and made them feel important, well respected, and personally liked. Then, for reasons known only to him, he would turn on them and just completely shut them out of his life.

I met James Spader at Sundance a few years later, and he told me a similar story. After appearing in *Pretty in Pink*, he had become friends with John. He would go over to his house, eat dinner with the family, stay up all night with him listening to records, relax with him in his hot tub. Then one day, he couldn't get him on the phone and had no idea why. He'd never spoken to him again.

This sudden turn in John's affections was hurtful, but it helped me a little to know that this was a repeated pattern in John's life. I consoled myself with the advice I give people who have been bruised in the business: "Don't take it personally; they don't consider you a person."

———

Planes, Trains & Automobiles opened in time for Thanksgiving. It did not win the weekend, however. We were beaten out by a remake of a French film, *Three Men and a Baby*. I was very disappointed at the time, because I didn't think that movie was very good. Nevertheless, the audience chose it over us. So it goes. But as I've said, some pictures have long lives.

In 2012 I was invited to a twenty-fifth anniversary screening at the New Beverly Cinema in Hollywood, which featured a Q&A. The theater put my name on their marquee, which is the only time in my life that ever happened to me. I watched the picture with fresh eyes, and it was

a pleasure to see it with a live audience. So much of comedy is a shared experience, which is why they put laugh tracks on TV sitcoms. After all the emotional sturm and drang and the mad scrambling we did to get the picture right, it was very rewarding to see it play so well. It is a very funny movie.

PTA has become a cult favorite!

19

Steel Magnolias

I HAD BEEN BOUNCING BACK and forth between John Hughes and Herbert Ross for five years. Once again, Herbert sent me a script to read, the title of which I forget. Unfortunately, I hated it. I had learned an important lesson on *Blow Out*. It wasn't enough that I liked working with Herbert. I also had to like the script; otherwise, the negativity I felt about the material could affect my relationship with him, and I didn't want to risk that. I had already turned Herbert down on *Dancers*, though, and I wondered how he would react.

I told him I couldn't do the picture because I hated the script. I also told him that to do the picture justice, he needed an editor who was as enthusiastic about the project as he was, and I honestly could not represent myself as that person.

To my surprise, Herbert took it very well. "I understand hating something; it happens to me all the time," he told me. "I respect that."

So, I passed. Eventually the project fell apart, so my take on it was validated. Herbert turned to a new project for Tri-Star Pictures, *Steel Magnolias*, based on the play by Robert Harling, a dramedy about six small-town southern women and how they cope with the death of one of them. I was sent to see it in New York. It was very funny and poignant and had a spectacular moment near the end in which you find yourself crying in one instant and laughing in the next. It was a real coup de théâtre. I loved it and was glad to work again with Herbert on something we both agreed on.

The producer of the picture was Ray Stark. Ray was an important figure in Hollywood, a powerful mover and shaker. After I was hired, I got a phone call at home from him, no secretary or receptionist, just Ray on the line. "Hi, Paul, this is Ray Stark."

"Hi, Ray."

"I just want you to know this is the seventh picture I've done with Herbert, and the others have all been hits. Do you understand what I am saying?"

I detected an undertone of menace in his voice. "Yes, Ray, I understand." I was warned. If the picture failed, it was my fault.

Herbert had a complicated relationship with Ray. He was almost like a son to a disapproving father. I think Herbert was envious of, and intimidated by, the money that Ray had made. Although he had acquired nowhere near the wealth that Ray had, Herbert and Nora had lived very well. Their home was large and in the international style, very modern and opulently furnished. It was on one of the loveliest streets in Santa Monica, La Mesa Drive. The street is hidden away off San Vicente Boulevard and is lined with Moreton Bay fig trees from Australia, distinguished by their eye-popping aboveground root systems. The house was like a museum curated by someone with very eclectic taste; it had a Rauschenberg on the wall near the dining area. Nora was always selling things at auction and buying new ones.

Nora and Herbert had both come from the world of dance. He told me he had been swept away the first time he saw a ballet, seeing all these people devoting themselves to creating something beautiful, and he wanted to be part of that. Their home reflected their desire to surround themselves with beautiful objects. But it wasn't entirely beside the point that money could be made trading them.

———————

Sally Field had already been cast, as had most of the other female roles, including Shirley MacLaine, Olympia Dukakis, Dolly Parton, and Daryl Hannah. Olympia and Daryl both had small roles in De Palma pictures I had cut, Olympia appearing as a bakery worker in *Sisters* and Daryl as a timid schoolmate of Amy Irving's in *The Fury*. All these women were terrific performers, but Sally Field as M'Lynn really knocked me out. When they

shot the funeral scene, the one that leaves you crying and laughing at the same time, Sally's performance was so affecting that I watched the dailies in tears. Even her off-camera voice when they were shooting the other women's reaction shots made me weep. It is as powerful a performance as any I've cut.

Herbert was searching for someone to play the critical key role of Shelby, M'Lynn's daughter. He invited me to sit in on the casting, which was a first for me. All the most promising young actresses in Hollywood came to his office to read for the part. I was amazed to see the various spins different actors could put on the same lines of dialogue.

Justine Bateman, one of the leads on *Family Ties*, came in to read. She had prepared by wearing two different outfits, one over the other, and did a quick change right in front of our eyes. I remember thinking she was definitely a possibility. Laura Dern came in and blew everyone away with her performance, but she looked so different from Sally that there was no way they could be mother and daughter.

Finally, Julia Roberts came in. She had been acting for only a couple of years and had drawn some notice for her performance in *Mystic Pizza*. Herbert was absolutely stunned after she left. "Did you see that?" he asked, in amazement.

Frankly, what he had seen wasn't obvious to me, which is why he was a terrific actors' director and I am not. He saw her star quality right away and she got the part, although during the shooting he was really hard on her—so much so that Dolly Parton called her business partner to ask him to get Herbert to leave the poor girl alone. But her performance in the film earned her an Oscar nomination for Best Supporting Actress and a Golden Globe.

Herbert could be ruthless in pursuit of the right performance. He once told me a story about *The Owl and the Pussycat*. He was shooting a scene in Central Park in which Barbra Streisand was supposed to cry, and Streisand couldn't summon the tears in her close-up. He was losing the light, so he lowered the camera and made Streisand kneel on the ground to play the scene. The pebbles digging into her knees did the trick and she cried.

Watching dailies with him on *Protocol* once, I noticed Richard Romanus, a rather wooden actor, jerk upright. Herbert laughed.

"What was that?" I asked.

"I stomped on his foot. I was just trying anything to get some kind of reaction out of him."

I was invited to come to Sundance. Every year, prominent people in the industry gathered for a week at Robert Redford's resort in the mountains of Utah to advise young aspiring filmmakers on their projects. I felt honored to be invited, and as I had some free time before *Steel Magnolias*, I accepted. The projects were all shot on video, so I was simply there to advise while a young editor provided the hands-on.

After a day or so up there, I got a phone call from a producer I'd never met, Joe Roth. He had produced a western titled *Young Guns* and wanted my help. My friend Wylie Stateman was doing the sound for it and had spoken to me about it a couple of times, saying it could use my input. I guess he had spoken to Joe about me. Joe asked if he could send me a videotape of the cut.

I watched it and called him back. "Without even seeing the dailies, I can tell you that I can make this better," I said, adding, "It would be an embarrassment to all concerned for the picture to go out in this condition."

"Do me a favor," he said. "Please tell that to the director, but don't use those words."

When I got back to L.A., I met Chris Cain, the director of *Young Guns*. There were now only two weeks left before the film's final mix, so time was extremely short. He asked me what I planned to do. I told him, "Look, we don't have time for a lot of discussion. There are ten reels, and only ten days left. That gives me one day per reel, so I'm just going to make my changes and you can decide whether you want to use them or not. You have a copy of your current cut, so you have nothing to lose. Just give me access to any scenes you have cut out of the picture, the lifts."

I started by screening the lifts, and there, in the very first one, was the answer. The scene was the backstory that explained all the characters' motives. "Why did you cut this out?" I asked Chris.

"It's all exposition, it's boring," he replied.

"Maybe to you, but it's not boring to the audience. They need to know all this in order to make sense of the action."

Fixing the major problem with the film turned out to be easy. I put in the two weeks, smoothing the bumps and clarifying the inconsistencies,

and prepared to move on to *Steel Magnolias*, which was just about to start shooting. *Young Guns* opened well, and its subsequent performance was strong enough to spawn a sequel a couple of years later.

———————

Steel Magnolias was shot on location in Natchitoches, Louisiana. It was July, and I heard that the locals sometimes went to Florida in the summer to escape the heat. Fortunately, I was not required to go, per Herbert's custom of leaving me back in L.A. The company was shooting six days a week, to shorten their stay there, but I was to work no more than five days, to save on overtime. Herbert called to give me some extraordinary news. He had met a woman and fallen in love. He and Princess Lee Radziwill, Jackie Kennedy Onassis's sister, planned to marry after the end of the shoot.

"We are planning a honeymoon in Europe, so don't finish the cut too quickly!" he told me.

I did a quick mental calculation. *They're shooting six days a week for ten weeks. Sixty days. If I work five days a week, that comes out to twelve weeks.* On top of which I needed the usual week after shooting to complete the cut. "I can show you the picture three weeks after you finish," I said.

"I said *not too quickly!*" he repeated.

"How about six weeks?" I ventured.

"Perfect."

———————

About a week into shooting, word came that Ray Stark had fired Jim Glennon, the DP on the film, and John Alonzo was replacing him. Alonzo was a much bigger name. He had shot *Chinatown* and *Scarface*.

Ray's reason for the change was simple, and it taught me an important principle. He couldn't see the actors' eyes on the screen. The eyes are critical tools for acting, and if the DP doesn't light so you can see what's going on in them, you are in trouble.

When Alonzo came in, the lighting became less artful, with shadows on walls next to actors, but at least you could see their eyes. Later, when

we were doing color corrections, Herbert was admiring a close-up of Julia when I reminded him that it was one of Glennon's shots. But Ray was happier with Alonzo.

———————

The key scene in the picture was the funeral scene. It included the moment that had worked so well onstage and was the scene on which the success of the film rested. The dailies were extraordinary. Sally is at the cemetery, grieving at her daughter's grave while surrounded by her friends as she rages at the unfairness of the loss.

Earlier that year, I had lost a dear college friend. I was still grieving for her, and the dailies were almost too much to bear. I couldn't deal with cutting the scene, so after watching them, I put the dailies aside and busied myself with something else. They sat untouched on the shelf for weeks, as if they were radioactive.

Finally, I had cut everything else and I had no choice. I had to open myself up and empathize as intensely as I could. I had to decide if this take was more heartrending, or this one; which one made me cry harder? I powered my way through and finished it and couldn't even play it back, it was so painful to watch. I just cut it into the body of the film as it was. When Herbert saw the cut, he too was still grieving, over Nora, and he didn't want to wade into it either. So, to this day, the final cut of that scene is exactly the way I cut it the first time.

———————

I finished the cut three weeks after the end of principal photography, as I had figured I would. Ray Stark called me. "When are you going to have the cut ready?" he growled.

"Well, it's taking a little while," I lied lamely, to give Herbert the time he wanted.

Ray kept calling. "Why is this taking so long?" he asked.

I didn't really have a good answer. I just took the heat like a good soldier and stalled.

Herbert had hired David Shire to write the score for the film. David had been really unhappy with me when I used John Williams's great cue from *E.T.* in the temp of *The Blue Yonder*. With that in mind, and three weeks to kill, I thought I would begin working on the temp track. I called Herbert and suggested that I include David in the process. This way I could avoid painting him into a corner the way I had on the earlier film. Herbert agreed it was a fine idea, and I made a date with David for him to come in and spot music for the film with me. We began, sitting at the Kem.

"I thought we could use music here," I said.

"I don't think so."

OK. He was the composer. I went on. "Well, how about here?"

"No. It doesn't need it," he said.

We continued on this way. Finally, I got to the scene where Julia is married and is leaving home for the first time. Sally is filled with mixed emotions, her face reflecting both fear and hope for the future. "Surely we need to play this?" I tried.

"Why? What would you play?" he asked.

This was truly strange. It seemed as though any composer would leap at the chance to write for these moments. It was like an actor wanting fewer scenes. I couldn't understand it. We talked about it.

"Look, I wrote a score for *'Night, Mother*," he said. "That was a stage play. This is a stage play. I had one cue in the whole picture. This is not *Star Wars*."

I thought he was deeply misguided. *'Night, Mother* was deeply depressing and not a model I wanted to emulate, not to mention it made about two cents. This was a different case altogether. But we slogged on. We finally got to the one scene in the movie that definitely should *not* have music. It was Julia's death scene, where the family shuts off the ventilator and lets her die.

"Here is where I should write something."

In my opinion, putting music on that incredibly dramatic scene would undercut the pain and weaken it, turning it into a Hallmark moment.

When we finished the spotting, I called Herbert in Europe again. He was at the Ritz in Paris. "Paul," he asked, "can I ring you back? I'm having a massage."

When we spoke, I explained my dilemma. "David and I have very different ideas about how to track the picture," I said, "and I'm afraid that if I do it his way, it won't show off my work to best advantage."

"Then do it the way you think it should be done," Herbert replied. "Just show it to David before you show it to me."

The music editors working on the temp track found one cue I was particularly happy with. It was borrowed from the movie *The Escape Artist*, whose score was by my old friend Georges Delerue. The cue we borrowed had a tinkling celeste motif, and we used it in the goodbye scene, when Julia is leaving home. The scene takes place in the very bedroom she has lived in all her life. Her mother pins a corsage on her lapel, and the sad but sweet music was suggestive of a music box or a toy you might find in a nursery. *Perfect*, I thought.

We finished the temp score and did a rough mix. I called David and invited him to come see the picture. We watched it together, and when the lights came on at the end, he turned to me. "Well, I see what you are doing," he said, "and I suppose that is one way to go, but there is one cue in particular that I really hate. The corsage cue, with that music box sound."

A day later, Herbert was back in town after his six-week honeymoon, and I screened the cut for him. He cried in the funeral scene, and at the end he complimented me generously.

"I loved your choices for the music," he said, "particularly the music for the corsage scene. It was just perfect."

"Funny, that's the one cue that David really hated," I replied.

"What! Get him on the phone right now! I want him to write music just like that!"

I prevailed on him not to make that phone call just then, but he was determined to get a score that was just like the one we had constructed.

Of course, Ray Stark wanted to see the cut, and we showed it to him a week or two later, after some adjustments for Herbert. Even with his six-week honeymoon, Herbert showed his cut to Ray before his director's ten-week cut was up. Ray arranged a screening for his longtime employee, the legendary Margaret Booth. Margaret had been Irving Thalberg's editor and had headed the editing department at MGM when that position was truly powerful. Ray trusted her judgment and got her input on all his

pictures. Herbert liked her because in an earlier dispute she had supported his cut of the musical numbers in *Funny Girl*, which he had choreographed and directed. He was reluctant to tell me about the screening, because he thought my feelings would be hurt, but I was truly interested to hear what she had to say. Margaret was nearly ninety years old at the time, and her career had spanned the entire history of the film business. She had cut negative on *Birth of a Nation* at the age of fifteen! She died in 2002 at the age of 104.

After the screening, she was coolly complimentary. "The transitions are good, but you could take out some time in the middles," she said to me. Then, "Why did you cut to Sally while Julia says the line, 'I would rather have thirty minutes of wonderful than a lifetime of nothing special'?"

"For rhythm," I answered.

"You don't need it," she said.

I reported this to Herbert. We went back and looked at it again, decided she was right, and changed it. Herbert and I then talked about her other comment and decided to leave the "middles" alone.

In the next few weeks, Herbert and David Shire traveled to New York and would meet from time to time so that David could play him ideas for cues. Herbert called one day. "I am sending you a tape of David's latest work. I think we have made a breakthrough."

I listened to the cue when it arrived. To my ear, it seemed cold and overly intellectual. I told Herbert what I thought. I think he agreed, but he was determined to make it work with David. They came back to L.A. and kept working together, but the music didn't change much. Finally, Herbert arranged for Dan Carlin to set up a video deck and an upright piano in his office for David to play his music for us, live, to picture.

The four of us assembled and spent all of one morning in an agonizingly awkward situation. David would play something on the piano, and Herbert would turn to me and say, "Well?"

"It's good," I felt I had to say. "Although when it gets to a certain point, there was a dissonance I thought was wrong for the moment," I hazarded.

"Play it again, let me hear it," he commanded.

The next time through, David changed it so it wasn't dissonant. After several hours, we broke for lunch. Herbert got into my car.

"What do you think?" he asked.

"I think this process is painful. Do you really like working this way?"

"No! I hate this."

"I thought because of your work as a choreographer, you might like this."

"No, it's awful. What do you think we should do?" he asked.

"Well, it's not up to me," I said.

"No, I'm asking you what you would do if you were in charge."

"Well, personally, I don't think you will ever get what we need from David. You loved that corsage cue. Why don't we see if Georges Delerue is available?" I said.

"Find out. Let me know."

I called Georges, and fortunately he was available and interested. The next thing I knew, David was out and Georges was in. He came to watch the movie. "I know just what to do," he said.

And he did.

I don't know if David was just wrong for the film or if he was going through something personal at the time that prevented him from doing his best work. He is a fine composer with many wonderful credits, so it was unfortunate the way it worked out. But Georges's sensibility was perfect for the picture. He reprised the music box sound in the corsage scene. He wrote nothing for the shutting off of the ventilator, which we played entirely with sound effects. It is devastating.

He wrote a beautiful, melancholy cue for Sally's drive from the hospital directly after Julia's death to see her grandchild. When Herbert heard the cue, however, he said to Georges, "That music is beautiful, but when the child appears at the end of the scene, you have to give the audience a break, you have to lighten up a little."

So Georges rewrote it, doing exactly what Herbert asked, and the result was even more heartbreaking. At the cemetery, with Sally standing by her daughter's grave, Georges composed a violin and cello duet, reflecting the mother-daughter relationship. It was so moving that after the first take in the recording studio, the entire orchestra broke into applause.

I got an idea for a deep cut. I felt that the entire last reel was unnecessary. After the cemetery scene, Sally is pushing her grandchild on a swing and says to Daryl Hannah, "Life goes on."

It's a platitude, but perfectly expressed the point. Nothing more needed to be said. But from that point, there were another ten minutes illustrating how life went on. It just wasn't needed. I enlisted Georges's help. I made a freeze-frame of the baby on the swing and gave him the counts, and he recorded an alternate cue that went straight into the end title music. I mixed it in and showed it to Herbert.

"You're right," he said, "but I can't do that."

"Why not?"

"Because it was my idea for the additional pages at the end. The play actually ended right where you cut. But I argued with Ray for the extra money to shoot the final reel, and I can't go to him now and say we didn't need it after all."

So the final reel stayed in, even though Herbert, Georges, and I all agreed that the other ending was better.

We began the mix in the spring of 1988. I had worked the previous summer and covered for Herbert while he took his six-week honeymoon. I had worked through the Christmas break so Herbert and Lee could go to the Caribbean on vacation. Now Easter was coming up. I knew I was going to be working that summer and this was my only opportunity to have a vacation with the family. We booked a trip to Washington, DC, over spring break to show Gina, eleven, and Eric, eight, their nation's capital.

Herbert was not happy. He had booked his own spring holiday a week earlier and asked me to change my plans to coincide with his. I explained this was not possible because of the kids' schools. He insisted, but I refused.

So selfish, I thought. Here I had extended myself and covered for him all year and he wanted me to pass up a week with my family?

We took our vacation as planned. When I got back, I found out that Herbert had asked the mixers to come in the week I was away, but they also had all taken off with their own families. I don't think he ever really forgave me. On that sour note, we finished the picture.

Steel Magnolias opened in the fall of 1988. Ray had arranged a gala screening of the film at an enormous theater in Century City, the Plitt. It was a benefit for his favorite charity, the Juvenile Diabetes Research Foundation. He had invited all of Hollywood to attend. The heads of all the families were there, as we jokingly called the studio chiefs, as well as the film's six female stars. Herbert had taken a tranquilizer to get through it and was noticeably at ease. It was to be the worst screening of my entire career.

As the first reel began to play, I saw that the sound was badly out of sync. The first reel is filled with comedy, and now none of the jokes were landing. None of the laughs we had gotten in previews were to be heard. A knot formed in my stomach as I watched helplessly. Once the screening had begun, there was nothing to be done but sit through it. I was in agony.

At the end of the first reel, things got better but still were not right. But I have found that once you start questioning sync, nothing looks right. I watched the rest of that evening's screening in a fog. Fortunately, the audience seemed receptive and Herbert, zoned out on Valium, was unperturbed. I, on the other hand, was a wreck.

The next morning at dawn, I called Donna Bassett, our negative cutter, and told her what I had seen. I wanted to check to see if the optical negative was properly aligned with the picture negative. I went to her office and checked it myself. It was correct. Donna was unlikely to have made a mistake like that. I had to go to work at Fox, so later that morning Donna checked the print from the night before and phoned me.

It was one of a small number of "show prints," prints made off the original negative to assure the best picture quality. There is a noticeable drop-off in quality in prints made from the dupe negatives that produce the thousands of prints that are screened in theaters. Because they were made when I was no longer on the payroll, a postproduction supervisor had checked and approved the show prints.

Donna called to say that the print from the night before had been printed four frames out of sync. This was egregious, but the supervisor hadn't noticed it. I have twice rejected prints for being one perf out.

There was an all-media screening scheduled for that evening at the Academy. Donna ordered a new print of reel 1 that the lab was rushing through so it would be ready in time. I then made a mistake that would

cost me for years to come. I called Ray Stark to tell him about the problem I had discovered and what we had done to solve it. "I can't vouch for the rest of the prints, however," I said. That was the mistake.

A few minutes later, I got a phone call from Jimmy Honoré, the head of postproduction at Sony and Tri-Star. I had never met nor spoken to him before. He was furious. He let me have it, saying, with some heat, "Hey, if you have a problem with something, you call me, not Ray Stark, you understand?"

"He is the producer of the picture," I replied. "I had to tell him, didn't I?"

With a few more choice, angry words, Honoré slammed down the phone. In all the years since then, I have never been approached about a single project at Sony. Nor have I ever met Honoré.

Ironically, when the lab reprinted reel 1 that day, they neglected to place the changeover cues on the end of the reel. At the all-media screening, without the cues, the picture suddenly went black, then white, and then shut down. After a brief pause the image came up again, except it was the leader at the head of reel 2, counting down 7, 6, 5, and so on. The only way it could have been worse is if I had been there to see it. But I was working on my next project, so I was spared.

Despite these TFUs, *Steel Magnolias* was a hit and became an audience favorite. It was remade twice for TV, the second time with an all-black cast in 2012.

I never worked with Herbert again after that. We saw each other from time to time. He introduced me to his wife Lee at lunch one day in Beverly Hills. She listened attentively when I spoke and made me feel that everything I said was the most fascinating thing she had ever heard. I guess that's what you learn in Swiss finishing schools. Later they moved to New York and I saw Herbert less and less.

I learned a lot from him, not only about filmmaking but also about how to deal with tricky political situations that come up from time to time in the business. One trick I learned from him is particularly useful when I find myself wanting to duck an uncomfortable question. Instead

of saying "I can't talk about that" or "You should know better than to ask me that," Herbert in analogous situations would say, "This is a conversation you should be having with . . ."

I visited Herbert on the set of *My Blue Heaven*, where I also dropped in on Steve Martin in his trailer. He and Rick Moranis were playing cards and invited me to sit in with them. I lost twenty dollars in each of two hands I played and excused myself; too rich for my blood. Herbert hired a couple of New York editors to cut the picture, Bob Reitano and Steve Rotter, both friends of mine. They cut his next picture, *True Colors*, as well. Herbert always made it a point to tell me how *generous* Rotter was with his time. He directed two more pictures, and he would always invite me to a screening and ask my opinion about them. On my recommendation, he hired Michael Miller, my acolyte from my earliest days, to cut his final film, *Boys on the Side*.

Herbert described his glamorous life in New York to me, with dinner parties at Jackie Onassis's home featuring live performances by Metropolitan Opera stars or chamber music performed by prominent musicians. Eventually he and Lee divorced in an ugly, public way, the story appearing in Liz Smith's gossip column, and I felt bad for him. The last time I saw him was in a TV news report covering JFK Jr.'s funeral.

Herbert fell ill in New York and died there in 2001. His death came as a surprise to me. He hadn't wanted anyone to know he was ill, so his closest confidants, respecting his wishes, abided by that. Then he complained that no one was coming to visit him in the hospital. I wish I had known and gone to see him. He was a major figure in my career and had treated me with great respect. When you worked for him, you always "traveled first cabin"; whatever you needed, he got you. He always tried to elevate anything he worked on to the level of art, even if it was "just" a comedy. He was generous, giving me autonomy in my work and points in his films, and two of them, *Footloose* and *The Secret of my Success*, both went into profits. At his interment in Westwood, Goldie Hawn was in attendance, as were Steve Martin, Nick Meyer, and about a dozen other people. His ashes are buried next to those of the great love of his life, Nora.

20

I Become a Studio Bigwig

ONE DAY I WAS IN THE *Steel Magnolias* cutting room alone. A visitor suddenly appeared at the door. It was Joe Roth, the producer of *Young Guns*. We had spoken only on the phone the previous summer and had never actually met. Joe was of average height with light brown hair, and had the relaxed demeanor of a former athlete. He introduced himself and said, "Thanks for your help on *Young Guns*."

"My pleasure."

"I'm going to direct a movie in a couple of months, and I'd like you to edit it," he said.

"That's very nice," I replied, "but I don't want to edit anymore. I want to direct."

I had been thinking of trying my hand at directing for a while. I was in my forties and thought, *If I am going to do this, I'd better do it now.* I had been in Hollywood for five years, with a string of successful films, and had learned a lot while working for Herbert.

"Sorry, that job is taken on this picture."

I saw a possibility, however. "You're a producer. Would you be willing to produce a picture I would direct, if I cut this one for you?" I asked.

"Sure, if we can find a project we agree on."

I realized he had left himself an out, but it was also an in for me, so I agreed. His picture was titled *Coupe de Ville*. It was written by Mike Binder and starred Patrick Dempsey, Arye Gross, and Danny Stern as three

brothers who don't get along. They are asked by their father, played by Alan Arkin, to drive a Cadillac cross-country as a gift for their mother's birthday.

Joe had told me that I didn't have to come on location, which was fine with me. I asked him where he wanted to cut, and he said it was up to me. I found a place on the West Side, since that's where we both lived. I called Joe, asking him if he wanted to see it. He said he didn't care, which struck me as odd, but it made my life easier, so I wasn't concerned.

Near the end of the shooting, an article appeared in the trades that Joe would be leaving his production company to become the new head of production at 20th Century Fox! He called me in the cutting room. "Mr. Roth!" I exclaimed, with mock obsequiousness.

"Come off it," he said. "Be prepared to move onto the lot when we finish shooting."

It suddenly made sense why he hadn't cared where I set up shop. He knew he wouldn't be there when we began work on his cut. I was very excited, although I wondered how our understanding about my future would be affected.

It was the fall of 1989 when I moved onto the lot at Fox and set up in a small building directly opposite the scoring stage. Joe was busy running the studio. As a consequence, he was forced to leave the finishing of the picture to me. It turned out to be a lot of fun.

Coupe de Ville was to be released by Universal, but now Joe was the head of Fox, a competitor. He called Tom Pollock, his counterpart at Universal, and offered to buy the rights to the picture for Fox. Initially Pollock agreed, but over the weekend he changed his mind. Some speculated that he thought having the head of a rival studio direct a potentially successful picture wouldn't be in Universal's interest, but I really don't know about that. In any event, Pollock backed out. When I screened the first cut for Joe, I got a big laugh by playing the famous Fox fanfare over Universal's logo at the head of the film.

James Newton Howard was the composer, and he supplied me with synth demos of the cues he planned to record. It's a great way to work, because there are no surprises "on the day." This has become common practice, but it was a first for me. There were also to be a lot of songs from the period of the film, which coincided with my growing up, so I had a field day putting in many of my favorites.

Joel Sill was tasked with getting the rights and best-quality copies of the songs. A genial man with an easy smile and a fellow member of our generation, he was well versed in the business of putting music in films, having been head of the music departments at Paramount and at Warner Bros. In 2019 he was presented with the Guild of Music Supervisors Legacy Award, their highest honor. I threw him a curve with one of my selections, a song called "Transfusion" that I remembered from when I was about eleven. It had sound effects of car engines, screeching tires, and horrible-sounding accidents to go along with the music. It was performed by Nervous Norvus. Joel hunted far and wide to find out who had the rights but never found the answer. We used it anyway and were prepared to pay for it if we were ever challenged.

The cutting went smoothly. During shooting, Joe Roth had problems dealing with one of the actors, Joe Bologna, and wanted to cut him out as much as possible, but I thought his scenes were strong and talked him out of it. Meanwhile, I started looking around for a script to direct.

When it got down to having to lock the cut, Joe came in to sign off on the final tweaks. "I feel like I only half-directed this movie," he said.

It was sort of true. I had directed all the actors in the looping, which I enjoyed. I got to hear some great John Cassavetes stories from Alan Arkin and had a series of furious Ping-Pong games with Danny Stern.

When the picture was released, it got a positive review from the *New York Times*, the first picture I ever worked on that did. But Universal, still loath to hand Joe Roth a success, made only fifty prints. It failed to make any money, of course, which taught me a new lesson about Hollywood: the bottom line isn't always the bottom line.

We had reached the end of the schedule without agreeing on a directing project for me. I needed to earn money, so Joe proposed that I come to work for the studio in the capacity of an in-house movie doctor, or fireman, or relief pitcher—choose your metaphor. I would be assigned to help out on pictures that appeared to be in trouble, while we continued our search for a suitable project for me to direct.

The exec directly under Joe was Roger Birnbaum. He had started as a limo driver and worked his way up through hustle and smarts. He and I shared the same birthday, although he is five years younger. Roger was energetic, enthusiastic, and a born salesman, sure to go far. Tom Jacobson, the producer on *Ferris*, was also part of the executive team.

It was an interesting time for me. I sort of got my nose above the line for the first time and wasn't just a grunt in the trenches. The building where I had cut *Coupe de Ville* became my office, and I started going to screenings of dailies of the films Fox had in production at the time. The screenings were held in the basement of the administration building, in Screening Room Z, which I suspect was named after former 20th Century Fox boss Darryl Zanuck.

At one screening, I was taken aback when, in the middle of the second take on the reel, Joe asked, "What else is on this reel?"

"Just coverage, Joe," a junior executive answered.

Just coverage? I thought that was why we were watching dailies, to see what the coverage was! But they didn't care about that. They were easily bored and would switch over to the next reel just to get an idea of what the scene looked like.

The pictures in production included a Tim Burton film titled *Edward Scissorhands*. The dailies were among the strangest I had ever seen. I had serious doubts as to whether they could pull it off. When I saw the finished film, it struck me what a miracle composer Danny Elfman had accomplished. His music transformed these weird images into a fairy tale and made believable the events on the screen.

They were also shooting a John Hughes production being directed by Chris Columbus, *Home Alone*. Fox had picked up the project in turnaround when Warner Bros. decided that the budget had grown too high. This miscalculation proved to be among the worst in the history of the business. When the deal with John was made, Joe decided that this was the answer to our dilemma. Hughes knew and liked me, or so Joe believed. I wasn't so sure, but maybe he had checked with John; I don't know. In any event, John was planning to write and produce pictures for Fox for others to direct, and Joe saw it as a natural opportunity for me. I was fine with that.

In the meantime, I consulted on a couple of mediocre pictures, but despite my best efforts, they stayed pretty bad.

Then Joe came up with a more felicitous task for me. He had picked up a low-budget British comedy written and directed by Jonathan Lynn. "He's the Jim Brooks of British TV," Joe told me, in typical Hollywood shorthand. It meant he was an extremely successful and well-known writer in the UK because of his hit satirical series *Yes, Minister*. I had never seen the show, but Jonathan gave me copies of the book versions of the series and its sequel, *Yes, Prime Minister*. They are in the form of diaries that brilliantly skewer the British government and are hilariously funny.

The movie Fox had picked up was called *Nuns on the Run*, about two small-time gangsters, played by Eric Idle and Robbie Coltrane, hiding out from bigger, meaner gangsters as well as the police by posing as nuns in a nuns' teacher-training school. The tagline was "The Story of an Immaculate Deception."

Joe thought it could benefit from a little tightening and asked me to take a look at it. I agreed with Joe but had another reaction as well. To me, the picture looked like an old film that was being rereleased. There was nothing about it that said to me it was contemporary. It was shot largely on location in England, and the historic buildings gave no clue as to the period. I thought the music was contributing to this impression as well, and I proposed to replace it with something a bit more up-to-date.

Jonathan was extremely nervous about my doing anything to his film. I assured him that we had made a copy of his cut and that nothing I did was irreversible. There was nothing to be lost and possibly much to be gained. He finally consented, warily. The assistant editor working on the picture was Chris Peppe, a Brit himself. He knew of my work on *Ferris*, and I happened to mention to him that I thought we needed new music for the film. Chris knew I had used Yello's "Oh Yeah" in *The Secret of My Success* as well, and asked if I had heard "The Race," the single off their latest album. I hadn't, and it turned out to be a great suggestion, exactly what I thought the picture needed. I had a music editor track the new music into the picture and screened it for Jonathan.

The song is explosive, with racing engine sounds, a kick-ass tempo, and a dazzling drum part. I hadn't known it, but Jonathan had been a drummer himself as a young man and had a kit at his home. He absolutely loved it. He also loved the cut, which I had tightened up a bit. What I did included cutting away sooner at the end of lines for a punchier feel. Jonathan had

also been an actor and interpreted this through his experience on the stage: "It makes sense. It's like wanting to see the actor pick up his cues."

At that point, I had earned some credibility with Jonathan, and he and I started to get to know each other. I met his wife Rita, a highly respected psychoanalyst, and I learned that Jonathan came from an illustrious family. His cousin was the neurologist and bestselling author Oliver Sacks, and his Uncle Aubrey, as he called him, was the scholar and diplomat Abba Eban, once foreign affairs minister of Israel as well as ambassador to the US and the UN. Jonathan himself had been trained in law and was skilled at debating, which made me up my game.

Jonathan proved indeed to be a master of comedy. That is, he had developed very strong beliefs about how to get laughs—how the reaction is often where the laugh is, except of course when someone falls down. That never fails. Even better, though, is when the reaction itself is someone falling down. He taught me the importance of a principle he called "first time funny." This is because comedy depends heavily on surprise. During the course of editing a film, because of repetition, jokes that initially produced genuine laughs from us eventually fall flat. We were to constantly remind ourselves what our first reaction had been and not lose faith in material we no longer found funny.

Joe dispatched us to London to oversee the remix of the film. We had another assignment as well. *Miss Saigon* had just opened in the West End to great notices, and Joe asked us to go see it and give our opinion as to whether there was a movie to be made from it. We did, and we both agreed that it was not very good. Jonathan claimed he had amused himself while watching it by rewriting the lyrics in his head during the performance.

Our remix was being done at Twickenham, a storied landmark in British filmmaking. I found the place surprisingly shabby. The commissary was up a flight of stairs, right next to an elevated railroad line. When a train roared by, the entire floor shook violently, as if in an earthquake. It amused the locals when visiting California residents like me experienced a moment of panic. By the end of our time there, I was unhappy with the way the music sounded, so when we got back to California I took the tracks to Dave Campbell, who had been our music mixer on *Footloose*. In one day, he made all the tracks sound great.

Nuns on the Run opened to great reviews, but the initial release was limited. Fox planned to go wide in its third weekend, but it ran into a buzzsaw called *Teenage Mutant Ninja Turtles*. *Nuns* got swamped, and ultimately didn't do as well as we had all hoped, but at least one wonderful thing came out of it. Jonathan and I have been friends ever since.

———————

When *Home Alone* came out, it was a phenomenal hit, way beyond what anyone predicted. It made $286 million in the US alone. I had a theory about why it did so well. It was 1990. The country was gearing up for the first Gulf War, and there were stories on the national news every evening of women in the reserves being called up and having to leave their children behind as they went off to war. *Home Alone* tapped right into that general anxiety in a comedic and reassuring way.

When Joe realized how big a hit he had on his hands, he decided that a sequel had to be the first priority, not only because of the commercial potential but also and primarily because the film's young star, Macaulay Culkin, was growing visibly older every day. Hughes was tasked with writing the sequel as fast as humanly possible. Another of John's scripts, *The Nanny*, had been announced as a film I would direct. But it was not ready and was temporarily shelved. Yet another of John's scripts, *Dutch*, was ready, and they decided to make that next. Tom Jacobson gave me the news that an Australian director named Peter Faiman, a protégé of Fox owner Rupert Murdoch, got the nod over me. He had directed *Crocodile Dundee*, which had earned over $300 million worldwide in 1986.

I got a phone call from John. He asked me if I would cut *Dutch*.

"I don't really trust this guy," he said, referring to Faiman, "and I would feel much better if I knew you were on the picture."

I had been a bit frustrated with the job of fireman. It felt to me like semiretirement, and I was only in my early forties. In addition, I wanted to work on good material, but good pictures didn't need my help. By definition, my job was to try to turn terrible movies into bad ones. It was no fun. So I thought about cutting *Dutch* and decided to accept.

I went to meet Peter, a small man with a Steve Carell–like profile and seemingly inexhaustible energy. The meeting lasted four hours, with Peter

chain-smoking and doing 90 percent of the talking, and I was hired. I was happy to be back with John again, even if not as a director yet.

The picture started shooting, and the dailies rolled in. There were a huge number of takes, and the staging and direction were fairly pedestrian. Ed O'Neill, a tremendously funny actor as Al Bundy on *Married with Children*, starred as Dutch. Faiman had conceived of Dutch as a fish out of water, a working-class man among the very rich—strikingly similar to the character of Crocodile Dundee, an Aussie in New York. He directed Ed away from playing for laughs, and the dailies weren't particularly funny. But they appeared to be endless. I hired an editor friend from New York, Rick Shaine, to come in and help deal with the volume of film we were getting. My assistant Adam Bernardi was also cutting scenes.

I was very happy not to be on location, as they were shooting in snow and extremely cold weather. A story came back from the set. It appeared that Peter, even after many hours of shooting, liked to unwind at the end of the day by talking, and the producers were both worn out and didn't have time to stay up late listening to him. So, they hired a guy named Jamie specifically to stay up and listen to Peter. After shooting ended and Peter started coming to the editing room, this Jamie came along and seemed to have taken control of the film. Every time he was asked for a decision about the cut, Peter would turn to Jamie and ask him what he thought. Once while I was recutting a scene, Peter was searching through the outtakes on my search machine. "Paul! Paul! Look at this!" he said suddenly. I looked. I couldn't see what he was so enthused about. "What am I supposed to be seeing?" I asked. "This cut! What do you think of it?" I looked again, incredulous. "That's not a cut! I replied. "That's the head trim spliced to the tail trim of a piece I used in the film!"

Peter came up with some truly wacky ideas, so I decided to turn Rick into a lightning rod. Every time Peter wanted to try something that seemed pointless and doomed to failure, I would ask Rick to work with him. I was very grateful to Rick for this and told him so. I tagged him the "editor of lost causes," not for any fault of his own, but because the ideas were so absurd. As I tried to pare the movie down, Peter argued over every cut I

tried to make. Nothing could be cut because every scene, every line, had a reason that would justify it, and he was prepared to defend at great length each and every one of his choices. We previewed the film, although it was too long. The results were not good. Peter seemed at a loss.

"I know exactly what to do," I told him.

"Go for it," he said.

I did my cut and showed it to him. He asked me to meet him later in the cutting room. At the appointed hour, the line producer showed up with a briefcase, from which he pulled a sheaf of papers.

"Where's Peter?" I asked.

"He'll be here in a bit. He asked me to give you these," handing me the pages. They were editing notes, changes he wanted me to make. I still hated working from written notes, and when Peter arrived at that moment he could see I was angry. When he asked what the problem was, I let him know in no uncertain terms how I felt about the notes. He grabbed them brusquely from my hands and threw them into the wastebasket. The other people in the room started to back away, like bystanders in a western saloon when there is about to be a gunfight. The briefcase the producer was holding in his lap started to slide slowly up his chest until his face was half hidden behind it. But we talked it out, cleared the air, and resumed work.

———————

Hughes was in Chicago, and it was decided that the next preview would be there. My assistant, Adam Bernardi, flew on ahead by commercial airliner with the print, while I flew in the Fox company jet with a gaggle of executives. The screening went fairly well, and the discussion afterward generated a bunch of ideas from John as well as others. Joe Roth was enthused. "If Adam can get the print onto our plane tonight, you can start on the changes in the morning."

Adam was certainly up for a ride on the company jet. I waited for him at the theater while the assistant editors broke down the print. It took a while before he appeared with the Goldbergs, the hexagonal steel cans that movie prints are shipped in. We jumped into a waiting limo and sped off to the airport, where the jet was waiting for us. As we got aboard, I got

a needle from Joe. "Come on, Hirsch! What's taking so long? We've got a long flight ahead of us."

We got on board, settled in, and took off. The group chatted for about a half hour, with everyone in a good mood, when a pause came in the conversation.

Joe said, "What do we do now?"

"How about a little poker?" I said, not realizing that I had just reached a turning point in my life.

And in a blink, the steward had produced a carousel of poker chips and two decks of cards. He set up a table, and we began to play.

The stakes were nickel, dime, quarter, with a maximum bet of a dollar in the last round of betting. We played for a couple of hours, dealer's choice, and as usual, the games got more and more complicated. The deal came around to me, and I proposed a game I had recently learned. It was a high-low game, and it involved a lot of betting.

The betting spiraled up until there were about ten dollars in the pot, the biggest pot of the evening. When it came time to declare, Joe turned over his cards. He had a sixty-five low, but my hand was better. I turned over my cards, and Joe went crazy.

At first I thought he was kidding, but it soon became clear he was not. He was in a rage. He'd been a former college soccer star and was, as is to be expected, an extremely competitive individual.

"What kind of game is that?" he shouted. "We're playing a friendly game, and all of a sudden you call that? What the hell is that? It's not bad enough we had to wait for you before we took off?" And so on. It was such an outburst that no one spoke, and he went on and on.

That was the end of the game, of course. A pall descended over the group. We were about an hour from landing, and we spent the rest of the flight in silence. When we got off, I asked Tom Jacobson, "Is Joe really angry at me?"

"Oh, don't worry about it," he said. "I'm sure he'll forget all about it in the morning."

But things were still tense for a while. I didn't hear from Joe for a week. Another week went by. The work went on, and there were conversations with many of the others about the changes, but nothing from Joe. Finally, another preview was scheduled in San Diego. As I was about to

set out to drive down there, I got a call from Joe's secretary, saying that I was to ride down with Joe and Roger in their limo. I felt like I was back in Joe's good graces, and much relieved. The three of us chatted on the way down, but the atmosphere between us was still awkward.

We got to the theater a little early, so Joe and I chatted outside. I finally felt that Joe had relaxed, and I was able to talk to him comfortably for the first time since the incident.

At that very moment the head of the National Research Group came ambling up to us. "Hi, fellas, anyone got a deck of cards?" he asked with a grin.

I wanted to kill him.

By the end of *Dutch*, my contract to serve as a fireman for Fox had expired. The picture was a flop, which affects everyone associated with it. I found myself running short of cash. After being informed by Tom Jacobson, a mensch (my definition of a mensch in Hollywood is someone who stabs you in the chest), that I wasn't going to be directing a John Hughes project for Fox, I appealed to Joe Roth and Roger Birnbaum for help. I needed work.

The studio had produced a picture that wasn't working and had fallen into an acrimonious relationship with the director. I was asked to help them make it better. I began work with the team, and it quickly became very clear that the director didn't want me there, nor did his editor, with whom I could easily sympathize. But I needed the job, so I stayed on. The whole situation couldn't have been more uncomfortable.

At this point, I got a call from my new agent, Marty Bauer, who also represented Brian De Palma. "Brian called. He wants to know if you can come help out on the picture he is doing."

Brian had suffered a severe career blow with his previous picture, *The Bonfire of the Vanities*. Its failure at the box office provoked a rage in the press that was way out of proportion. You would have thought he had committed infanticide. This new picture he was cutting was his comeback from that disaster. It was a relatively low-budget film called *Raising Cain*.

I was thrilled. I hadn't worked with Brian in ten years. To work with my old mentor again, cutting, and not playing all these political games,

was like a life preserver tossed to me in a heavy sea. "Tell him I'd love to," I said.

I went in and told Fox I was leaving to go help Brian. Joe Roth was gracious about it. He understood that Brian and I shared a special relationship and that Brian wanted me. Roger Birnbaum, however, was furious. In fact, he was so angry that he refused to pay me for my final two weeks. This was particularly petty, since I needed the money badly and had performed the work. But you don't get anywhere suing studios, so I just let it go. I eventually got most, but not all, of what they owed me. Years later, Roger hired me to help out on a picture he produced. He was thrilled with my work. "You are the wind beneath my wings," he told me. I never heard from him again. At the time, however, I was just glad to get away from Fox. Promises hadn't been kept, and although I had really wanted to direct, by now the fever had broken. I had learned a few things about being a director and about myself.

To have a career as a director is like running for office for the rest of your life. You are forced to deal with a great many difficult personalities, and you are usually selling rather than buying. Being on set is chaotic and you are always racing the clock. It's like laying track in front of an approaching locomotive. The pressure can be crippling. By contrast, editing is relatively sheltered. You only have to deal with one or two potentially difficult personalities. Maybe the truth was I just didn't want badly enough to direct.

––––––––––

Brian had set up his editing room in Woodside, near Palo Alto, in the home he shared with his then wife Gale Ann Hurd, who had produced the picture. On the plane to San Francisco, I settled back to read the script of *Raising Cain* for the first time. You would think that I would have learned by then to read the script before accepting the job. But I had been so eager to reunite with Brian that I had accepted the gig script unread. To my dismay, I couldn't follow the story. I started over a couple of times, but it still eluded me. As the plane descended, I asked myself, *What have I gotten myself into?*

Brian decided to let the original editor go. Though he was experienced and talented, he and Brian just never got on the same wavelength. Brian and I ran the picture together, and my confusion deepened. We looked

at the picture reel by reel, and I just couldn't follow the story. Brian then explained it to me, and I was still confused.

"If my own editor can't follow the story, I must really be in trouble!" Brian said.

The story involved a character with multiple personalities and was told in nonlinear fashion, with flashbacks and dream sequences. As you watched, there would be a sudden cut to someone waking up, and you realized that the shot of the character waking up was a part of the dream, so the dream was still not over! Finally, we got to the end of reel 14, which had a big set piece with a million setups and a lot of parallel action, which needed recutting. Brian just looked at me and said, "Fix it!"

So, I took out my pad and wrote down "Reel 14—fix."

It was December of 1991, and we were working in a converted pool house, with a fire going in the hearth until the smoke got too heavy. I sat at the Kem recutting the picture, doing my best to clarify the confusing continuity. Brian sat behind me, glancing up from his reading from time to time to consult on the changes I was making, signaling his approval or raising an objection. My assistant, Melissa Bretherton, stood next to me on the other side, handing me the pieces of film. She is overly self-effacing but has a very good eye.

Occasionally, while I was working I would hear a discreet "Ahem!" from behind me. I would turn around and see her shaking her head ever so slightly. I'd look back at my cut and realize I had made an awkward cut. "No?"

She would shake her head again. Melissa worked for me for ten years, and I count her as one of the best. She is now cutting, a talented editor in Judd Apatow's stable.

To amuse himself while I was cutting and splicing, Brian was reading aloud from *Final Exit*, a recent how-to book for people wishing to commit suicide. Brian jokingly pretended he was researching how to kill himself. He would go on about the hazards of shooting yourself, laughing about the mess it makes and the chance you could miss and leave yourself even worse off. All this was a sort of macabre obbligato accompanying my work on the film.

We never did satisfactorily solve all the aesthetic problems of *Raising Cain*. We attempted to make the story more comprehensible by

straightening out the timeline a bit, which I think helped, but the basic sensibility of the picture was too extreme for many people. They found the theme of stealing children to use as subjects of psychological experiments too unsettling. But every picture, no matter how unpopular, has its champions. Quentin Tarantino admired it and claimed it was a strong influence on him when he wrote *Pulp Fiction*.

Years later, while we were working on *Mission: Impossible*, Brian told me he had woken up one morning and realized he had figured out how to recut *Cain* and make it work the way he had intended.

"But then I forgot," he said.

21

Falling Down

JOEL SCHUMACHER HAD APPROACHED ME years earlier about cutting his picture *The Lost Boys*. As soon as I read the script and realized it was a vampire movie, I didn't want to do it. I have always thought vampire movies were among the stupidest of all film genres, and I hoped never to have to work on one. Fortunately, I had been offered something else and was waiting to conclude negotiations for that project before calling Joel back. He called me instead and put me on the spot. I stammered something or other, which is an effect Joel loves to produce in people. He was annoyed with me, but that was that and I didn't do the picture.

Now, while I was working with Brian on *Raising Cain*, Joel was prepping a picture titled *Falling Down*. My agent gave me a copy of the script to read, and I really wanted to do the film. I let Joel know through my agent that I was very interested, and Joel called me. Mindful of my previous mishandling of *The Lost Boys*, I told Joel immediately and unambiguously how much I loved it and wanted to do it. He said, "Fine," and that was that. I was hired.

Falling Down is about an unemployed aerospace engineer who had worked in a defense plant and whose license plate read "D-FENS." This is also the character's name as it appears in the script. The picture begins at the moment when life suddenly becomes too much for him. He sits immobile on a hot day stuck in a traffic jam on the freeway, and a fly lands on his neck. This sends him into a frenzy of unsuccessfully trying to kill it. The noise, the traffic, the people in the cars around him all magnify his

frustration until his mind snaps. He just up and walks away, leaving his car blocking traffic, a wildly transgressive act we may have fantasized about but would never do. He then proceeds to cross L.A. on foot, from downtown to the beach where his ex-wife lives, provoking a series of increasingly violent conflicts with a cross-section of the city's inhabitants.

On one level, the picture functions as a cop story, a film designed only to entertain, but on another, it is also a portrait of L.A. society and the tensions in the metropolis. When a Korean grocer refuses to give him change for the pay phone and then charges him too much for a soda, D-Fens trashes the store using the grocer's own sawed-off baseball bat. In the process, he spouts some facile racist and ignorant opinions. "Do you have any idea how much money my country has given your country?" he asks.

"How much?"

D-Fens is nonplussed. "I don't know, but it's . . . it's gotta be a lot," he stammers. "You can bet on that."

The things that annoy him are familiar to us all, but his response to the various irritations is way out of proportion. The picture takes the position that there is no place for violence in our society as a response to everyday urban frustrations.

The studio had sent the script to Michael Douglas, offering him the role of the retiring cop who pursues D-Fens. But Michael said he was more interested in playing D-Fens. Joel agreed and hired the great but volatile Robert Duvall to play the cop. Duvall had a reputation of having a short temper, so Joel told me how he had approached Duvall before shooting. "Whatever you need to do to prepare for your performance as an artist is absolutely fine with me," he told him.

Joel had a theory that Duvall, after losing his temper in front of the crew, would feel embarrassed and didn't want that to become a distraction. So he in effect gave Duvall permission to misbehave. And therefore he never did. Smart.

The first two things Joel told me turned out to be absolutely 180 degrees from the truth. He told me, "I never travel with an entourage, I detest entourages." The second was, "You can say absolutely anything to me."

In fact, I don't think I ever saw him alone. He had an assistant named Guy Ferland who followed him everywhere. Joel is over six feet tall, half Scandinavian. His mother was a model and very beautiful. Guy is barely five foot six, but he and Joel dressed exactly alike. The uniform was khaki shorts, a black leather motorcycle jacket, worn open over a white T-shirt and beads, and tall lace-up construction boots. Seeing them together was comical, like Dr. Evil and Mini-Me in *Austin Powers*.

———

It was 1992. About three weeks into principal photography, the verdict on the cops in the Rodney King beating came in. They were found not guilty, and this outrageous result triggered the infamous L.A. riots. Because the picture was shot almost entirely in the streets, the shooting had to be suspended for a day or two until it was considered safe to resume production. Some people encouraged Joel to include some shots of burned-out stores as background in the picture. To his credit, Joel refused. "I would never want to exploit someone's misfortune in that way," he explained.

———

Falling Down was singular in my experience, in terms of the amount of film Joel shot each day. It was absolutely minimal. Usually on a feature film, a director would print anywhere from four to five thousand feet (forty-five minutes to an hour) upward. John Hughes would print three hours of dailies some days on *Planes, Trains & Automobiles*! It was a rare day on *Falling Down* when we got more than thirty minutes of film.

The other unusual thing about the production was that the crew would wrap every day while it was still light out. Motion picture crews often shoot fourteen or sixteen hours a day. Since the action in *Falling Down* takes place all in one day, there were no night scenes. Many days we would get a phone call requesting that we screen dailies earlier than planned. We would finish work by six o'clock every day, which is almost unheard-of in the industry. Joel was like a blindfolded Zen archer who would hit the bull's-eye day after day. It was a pleasure cutting his work, as it is with any director who knows what he's going after.

Joel is gay. Makes no bones about it and is also rather mischievous. He loves to say things that will shock straight people. He was constantly leaving me, and others, speechless.

He once said to me at dailies, in front of about twenty members of the crew, "I had a dream about you last night, Paul. I woke up with an erection." Not knowing how else to respond, I simply said, "Thank you."

At the mix one day, Joel was on the phone. The sound editor was a sideburned, gold-chain-wearing, white-haired gentleman of the old Hollywood school. He interrupted Joel and asked him to listen to some Foley and tell him if he thought it was too loud. Joel said (in a room filled with about a dozen mixers, sound editors, and assistants), "Look, I didn't get into show business to listen to footsteps. I got into it for the sunglasses and the blow jobs."

When I told Joel I was celebrating my eighteenth anniversary, he said, "God, that's amazing. The longest relationship I ever had lasted about two years. Of course, that's the equivalent of twenty in straight years."

Once Joel shared with me how he cast his movies. "I only hire actors that I would want to fuck," he said. This was an exaggeration, of course, because there were actors of all ages in his films, and I never once believed that he had any interest in sleeping with women.

There was a scene in our movie to be shot on Venice Beach, and Joel invited me to do a cameo. I was to play an ad agency executive attending the shoot of a car commercial. There was a car suspended from a crane, while a bodybuilder from Muscle Beach posed in front of it as if holding up the car. The bodybuilder was having oil applied by the makeup artist before the first take. Joel said to me, "Oh man, did you see that guy? I would love to fuck him every which way." He sounded like a construction worker on his lunch hour ogling girls passing by in the street.

In today's world, with sexual harassment training mandated by human resources departments at every studio, his comments probably wouldn't fly. In those days, you learned to just roll with the punches. To us, the comments were just Joel being Joel.

Eventually I learned that the second thing Joel told me was also not true—namely, that I could say anything at all to him. He was extremely suspicious of my motives when I called his attention to some problem or other. "What is it now, Paul? How have I failed the picture today?"

My job is to catch all the mistakes and make everyone look good, from the focus puller to the hairdresser to the director. If I catch an error and there's no way to fix it in the cutting, I call it to the attention of the director, who can decide how he wants to approach fixing it. For instance, watching dailies one day on Brian's *Mission: Impossible*, I noticed a sign on a door that read AUTHORISED PERSONNEL ONLY. The door was supposed to be at CIA headquarters in Langley, Virginia, and the British crew had used the British spelling of *authorized*. I pointed it out to Brian, and they reshot the scene the next day.

Joel didn't want to hear about any mistakes. Rather than trust that the comments I made were in the spirit of trying to make the best possible movie, he would take every comment as an attack, a criticism of him. "Why does everything have to be so heavy with you?" he would ask.

One day I noticed that a close-up of Robert Duvall was out of focus. I told Joel. He said, "All right, Paul. You run the dailies again at lunchtime, and I will have the camera crew come watch them with you, and you can point out to them what you see."

So, at noon, cameraman Andrzej Bartkowiak and his crew were forced to come to the screening room to eat their lunches off their laps in the dark because the *editor* had seen something out of focus. When the shot came up, Andrzej challenged me. "Where? What's wrong?" he asked.

"It's soft, look at it," I told him.

He turned to me and said dismissively, in his Polish accent, "That's not out of focus, that's just a little buzz! A little buzz!"

Joel's mind works really fast, and sometimes when he asked me a question I would need to think for a moment. If I took too long to answer, it would excite Joel's paranoia. "What is it, Paul? What's wrong now?"

"I'm just thinking, Joel," I would say.

At times, I would get an idea and would suggest it to Joel. I might have thought of perhaps two or three ways in which the proposed change

would help. More than once, Joel would agree before I had finished stating my case, and if I went on to say, "And not only that, it helps because—" he would cut me off sharply, saying, "I *SAID* yes!"

I learned not to sell past the sale.

After a while, if something had gone wrong on the film that Joel needed to know about, there would be a discussion about who would be the one to break the news to him. Nobody wanted the job. Not that they were afraid of being fired, but Joel had a way of haranguing you that was really unpleasant. No one wanted to be the target of his razor-sharp wit and acid tongue. He had a black belt in verbal combat.

On the very last day of principal photography, Joel filmed a key scene in the picture. (Spoiler alert!) Michael Douglas has murdered an army surplus store owner. D-Fens has killed for the first time in the movie and has definitely flipped out. He makes a weird, ominous, threatening phone call to his ex-wife. Joel staged it in a single, slow camera move, tracking through the dim, smoke-filled light across the bric-a-brac in the back room of the store and gradually pushing in until we are in a tight close-up of Michael at the end. The shot lasts a couple of minutes. Joel shot and printed four takes, which was a lot for him, and every one of them was out of focus.

Joel wasn't at dailies that day, however. Aaron Spelling had asked him to shoot six episodes of a new series called *2000 Malibu Road*, and Joel was scouting locations out at the beach.

"Well," I said to Andrzej, who was there, "what do you think? It looks like it's out of focus to me."

"Yes," he said, "we blew it that time."

I called the line producer and told him about the problem. Joel was to screen the dailies later. I thought no more about it.

The next time I saw Joel was when I presented my cut to him. The lights came on. I waited to hear his reaction. Nothing. Something like "Well done!" would have been appreciated.

There was a long silence. Finally, Joel spoke. "Was that shot of Michael out of focus?" he asked.

I knew of course which shot he meant. "Yes, Joel, it is," I replied. Another pause.

"Why didn't you tell me it was out of focus?"

I was confused. "I thought you would be able to see for yourself that it was."

"I never saw these dailies," he said.

"I didn't know that, Joel." Not a word yet about the cut.

"I only saw these dailies on tape," he said.

Whose fault is that? I wondered. He had been busy shooting what he called a "glam-trash" soap opera for TV and hadn't taken the time to screen the last day's shooting of our movie on a big screen in a proper screening room.

"You should have told me," he continued.

"I told the line producer, and Andrzej knew too," I replied, tiring a bit of the way this was going.

"Do you mean to tell me," he asked in deliberately exaggerated tones, "that the editor, the cinematographer, and the line producer all knew this shot was out of focus, and not one of you told me?"

I was tired of this game. "OK, Joel, fine. You want to blame me? I'll take the responsibility for it. It's my fault the shot is out of focus." This was absurd, of course. Focus is the camera department's responsibility. "Is that what you want to hear?" I asked.

Joel was a great enthusiast of a game called NIGYYSOB, an acronym for "Now I've got you, you son of a bitch!" Also known as "Gotcha!" He wasn't about to let this go. "Why did no one tell me?" he persisted.

"Well, Joel, you're not going to like what I'm about to say, but the truth is, you make life so hard for people when they point out a problem to you that no one wants to be the bearer of bad news."

Long pause. "I reject that," he said. "I don't believe that I am such a frightening person that people working around me are so afraid of me that they can't carry out their professional responsibilities."

"It's not that they're afraid, Joel, it's more like, well, life is too short."

Really long pause. "Well, if that's the case, I will have to do something about it."

The shot remains out of focus.

———————

The unexpected consequence of casting Michael Douglas as D-Fens became clear in the first preview. There is a scene early on in which a gang of Latino youths tries to mug him, and he drives them off with the sawed-off baseball bat stolen from his earlier encounter with the Asian grocer. They then retaliate by trying to shoot him in a drive-by attack, only to lose control of their car and wreck it. D-Fens calmly walks up to one of the youths injured in the accident and, using one of the gang's own guns, shoots the shooter in the leg from close range, and walks off with a gym bag filled with weapons, clearly the act of a man who has lost it and is not in control of his rage.

The studio was very uncomfortable with this. Their star, Michael Douglas, was doing something too controversial for them, even though it was totally in character. They scheduled a second preview and had us cut out the gratuitous shooting; he simply took the guns and walked away.

I was upset by the cut. Although the audience could sometimes agree with D-Fens about the annoyances of modern urban life, he also was espousing numerous racist and jingoistic opinions. I felt that to try to make him and his behavior more normal would result in making his transgressive positions more acceptable. I felt it was important to let the audience know that we as filmmakers did not share his attitudes, especially toward minorities. We had to portray him as someone who could cold-bloodedly shoot a helpless person.

When a picture is previewed, many aspects of the audience's response are measured and quantified. How many people thought the picture was too slow, how many didn't like the ending, and so forth. When they analyzed the data in this case, there was practically no difference in the overall audience response between the two versions. The numbers remained about the same. Approximately the same percentages of men and women, under and over twenty-five, liked the picture.

I burrowed into the report and came up with an interesting statistic. The only significant change in all the various things they measured was that the audience at the second screening felt in far greater numbers that the ending was predictable. (Another spoiler alert!) The movie ends in a confrontation between D-Fens and the cop played by Robert Duvall. Like in a classic western showdown, the two square off and draw their

weapons. D-Fens wins the draw, but he is armed only with a child's water pistol and is shot and dies. By changing the earlier scene, removing that insane act of violence, the audience had grown to believe that D-Fens would never kill Duvall at the end, and when he reached for his gun no one was really worried that he would pull out a real weapon and use it. By having the shooting in the first version, we had laid the groundwork for D-Fens acting murderously, and the audience believed he might in fact actually kill Duvall.

I brought this statistic to Joel's attention, and he pointed it out to the studio, giving me appropriate credit for noticing it. Since the overall numbers were unaffected, the execs consented and the scene was restored. I felt the picture got better, in addition to being "less predictable."

This is a classic example of how a problem at the end of the movie can be addressed not by changing the ending but by changing something earlier, which then becomes the basis for the ending's success. *Context is everything.*

I am proud of *Falling Down*. D-Fens strikes me as a prescient portrait of the sort of disaffected middle-class American worker who, decades later, changed the course of our politics by voting for Trump. I believe it to be Joel's most interesting picture.

22

The Trouble with *Trouble*

My agent, Marty Bauer, called to tell me that Disney was planning a picture for the fall starring Julia Roberts. Julia had stopped working for a couple of years, and people were excited about her return to the screen. By now, Joe Roth had left 20th Century Fox and started a production company with Roger Birnbaum called Caravan Pictures. It was their project at Disney, and they were determined to have the picture out for the July Fourth weekend the following year. The picture was to be directed by Charles Shyer and produced by his partner Nancy Meyers. My good friend Richie Marks had cut their previous picture, *Father of the Bride*, and being unavailable, he recommended me, as he often did. He was a really good friend that way.

I Love Trouble was a romantic comedy about rival newspaper reporters who fall in love while competing over a big story. Though I had reservations about the script, I agreed to meet the Shmeyers. (He was Shyer, she was Meyers, and everybody called them the Shmeyers, but not to their faces.) They turned out to be extremely likable. Charles and Nancy had written *Private Benjamin*, had disliked the way it was directed (go figure—it was a huge hit), and had leveraged that success into a directing career for Charles, with Nancy serving as his producer. They specialized in updating classic Hollywood comic genres.

Nancy was extremely witty. Charles seemed to be very concerned about being liked. He had a full head of hair, which he constantly pouffed

absentmindedly. Nancy shared with me that his hair was one of the things about him that she loved. Everyone thought Charles and Nancy were married, as they had two kids, but they had never officially tied the knot. Shortly after they did, after many years together unmarried, they got divorced.

We chatted. "One thing you should know about us is that we're very collaborative," they told me.

It sounded good to me, although that wasn't quite true, as it turned out. What they meant was they were very collaborative with each other. But they liked me, I was game, they hired me, and in October 1993, I went off to Madison, Wisconsin, to begin work on *I Love Trouble*. I hadn't had more than a weekend off since leaving Fox in late 1991.

———————

Charles asked me one day how the dailies were.

"Great!" I said.

"Just great?" Great clearly wasn't good enough.

"They were fantastic!" I said.

This went on every day for a while. I started running out of superlatives. Finally, I thought I'd make a joke out of it. I answered, "Charles, these are the greatest dailies I have ever seen in all my years as an editor!"

He seemed delighted. "Really?"

———————

Charles and Nancy were worried about a scene that was shot early on. Back at Disney from location, they asked me to put the scene together, bring it to the screening room, and run it for them.

The scene lasted maybe three minutes. Before they had finished viewing it even once, they asked the projectionist to turn it off. This was a first for me. Most of my directors have liked my first cut, but even when they didn't, they at least watched it through once. Unlike Herbert Ross, who never stopped an actor in midtake, the Shmeyers had no such compunctions. As the house lights came on, Nancy said, "Charles, maybe you could work with Paul this weekend on this scene." Then, turning to me, she said, "I just couldn't bear watching it on the big screen. Work with Charles, it'll be fine."

And that was just the beginning. From then on, they would ask me for tapes of everything I cut. They would then type up pages of notes, numbered, and send these to me to be executed while I was cutting the dailies that were coming in each day. It started to be a bit much.

"Look, I think I can give you a first cut a week after the end of shooting, but I don't know if I can do a second or third cut of every scene and still keep up."

They decided I needed help. In December 1993, I hired Adam Bernardi, my former apprentice who had coedited *Dutch* with me, and we kept on cutting.

By the middle of February, Charles decided that we needed more help. "Look, booba"—they were the only people I ever heard pronounce it that way—"I like Adam, but we need an A-list editor." Charles had, in fact, drawn up a list.

I looked it over, and there were indeed a lot of A-list editors, people who could easily captain the team. However, I was the captain on this team, and I wanted team players. I spotted Billy Weber's name. Billy was the editor of *Beverly Hills Cop*, among many other films, and he was known to be really fast. I knew he would be great. I also knew he wanted to direct and figured, correctly, that he might want this kind of work just to earn some money while developing projects for himself.

He agreed to come in for a meeting. I met him in the cutting room downstairs before he went up to the Shmeyers' office to be interviewed. He is engagingly loose and relaxed, with a long ponytail in those days and an easy smile. I was looking forward to having him join us. The interview lasted barely five minutes. Billy came back into my room scowling.

"I can't do it. I'm sorry. I won't do it. I've known people like them before, and life is too short. I'm sorry." And he walked out. I wondered what had happened.

Charles came downstairs. "I guess the interview didn't go that well," he said, which was quite an understatement. I found out later they had asked Billy if he thought he could cut comedy—as if *Beverly Hills Cop* wasn't proof enough. I went back to Charles's list. I saw Walter Murch's name. I called him up.

"What do you say, Walter?" I asked, explaining the situation.

"Excellent!" he said. Typical Walter.

He had a project in England coming up in July, and this would fill in neatly for him. I was thrilled.

I went to see Charles on the set. They were behind schedule and over budget, but Joe Roth was determined to have the picture ready for the July Fourth weekend. After every take on the set, Charles and Nancy were huddled around the monitor in their little "video village" from which they would observe the shooting, some distance away from the action itself. This has become standard practice now, but old-school directors, especially Herbert, would insist on being close to the actors so they could see their eyes. (Ingmar Bergman, however, was reputed to close his eyes and only listen to the performances. "If it sounds right, it will look right.")

Nancy and Charles watched their little black-and-white screen and conferred in loud whispers. "What do you think?"

"I think it was great."

"Me too."

"I can't think how it could be better."

"Neither can I!"

"OK, great!" he shouted. "One more just like that!"

Charles would print take after take after take. Twenty was not unusual for him. Obviously, Charles was the comparison shopper type of director.

I got to Charles in his trailer at last. "What is it, booba?" he asked.

"How about . . . Walter Murch?" I asked excitedly. I waited for a reaction.

"Who is he? What's he done?"

"Well, let's see . . . *Julia*? *Apocalypse Now*, picture and sound editing, *The Conversation*?" A pause.

"What's he done lately? And those weren't hits. Has he had any hits?"

"Let's see. How about *Ghost*? It made $300 million!"

Charles thought for a moment. "Why does he work so infrequently?"

I lost my patience. "Charles, if Walter Murch isn't good enough to work on your movie, nobody is!"

Charles agreed to meet him. They loved him, as I knew they would. But the madness was just beginning.

So now there were three of us cutting. I asked Walter to address himself to the big climactic scene, composed of hundreds of setups, which was taking days and days to shoot. It had been building up for a while, and I was mired in endless recuts.

"Excellent!" he replied. Walter had a wonderfully positive attitude. It was a big load off my mind.

———————

Julia Roberts was not happy. She and Nancy didn't hit it off, nor did she and her costar, Nick Nolte, nor did she and Charles, for that matter. The big romantic moment of the movie, set in a luxury hotel suite, required Julia to kiss Nick. However, she couldn't stand him. He was given to gross-out humor, and it drove her up the wall. By this time in the shoot, there had been some ugly scenes between them in the trailers, with shouting easily overheard. I heard he stopped bathing just to annoy her.

Julia laid down the law to Charles. She would only agree to kiss Nick once. Charles was distraught. He had never shot only one take of anything. In addition, Julia had to get drunk to play the scene, polishing off a bottle of wine in order to tolerate kissing her costar in a romantic comedy! "Make sure the camera is in focus," she announced. "I'm only doing one take!"

This lack of chemistry may have contributed to the film's ultimate demise at the box office.

In any event, Julia had run out of patience with Charles's method, shooting endless takes of scene after scene. It was March 1994, and we were now seriously behind schedule, with time running out and the end only dimly in sight. She went to Joe Roth and extracted from him an "out date," after which she would be considered to have fulfilled her contract and could leave. This put Charles in a serious bind. He was forced to shoot all her remaining scenes in only her direction. This meant going back to each of these scenes later and using a double for her, seen only from behind or in extremely wide shots. This was a real complication in figuring out the staging. In any event, this was the situation forced on Charles, who would moan and complain and clutch his head in desperation. "How can I think?"

The shooting went on. One day Adam got sick, and we were down to two editors. Charles freaked. "We've got to get someone in right away!"

"Who?" I asked.

Charles suggested Richie Marks, which was fine with me. It was Richie who got me into this mess, and the Shmeyers had complete confidence in him.

"Great!" I said.

But Richie couldn't (or wouldn't?) do it. "I can come in in May, but no sooner," he replied. It was the end of March.

"What about Lynzee Klingman?" Charles suggested.

Lynzee was a good friend and had helped me out on *Protocol*. Moreover, she had also worked with Charles and Nancy before, editing *Baby Boom*. I called Lynzee and explained the situation. "Want to work for a month until Richie comes on?" I asked.

She agreed. So she came in and started cutting the next day. Adam, meanwhile, had recovered (he was out for only a day), so now there were four of us cutting, and the crew of assistants had grown proportionately.

This meant that there were now four sets of tapes for Nancy and Charles to view and critique. The second unit was still shooting a few stunts, as well as quite a few inserts—close-ups of hands thumbing through filing cabinets, looking through a Rolodex, a key going into a lock, and so forth.

The cutting rooms were across the street from the soundstages where this shooting was going on, so a cable was strung to our room, carrying a video feed from the camera. The second unit director would set up the shot on the set, call Charles on a walkie-talkie in the editing room, and they would discuss the action and the framing so that Charles didn't have to actually be there while the shooting went on. This freed him up to work with us editors. It was getting chaotic.

May 1 rolled around, and Richie Marks started work. It was like General MacArthur landing in the Philippines. The first day, he called a meeting of all personnel involved in postproduction on the film. He chaired the meeting with a clipboard in his hand, quizzing each sound,

looping, and music editor closely about the schedule and their plans for meeting the various deadlines, referring to a calendar in his lap. Normally I would have resented someone coming in this way and taking over, but by this point I was beyond exhausted. When Nancy asked me a question I couldn't answer, I would simply say, "Disk full."

I had been working for about thirty months straight with no more than a weekend off by then, and we weren't getting weekends off anymore. So when Richie started work, I was more than grateful for him to take over. I believe in delegating work and not micromanaging how people do their jobs. This was no more possible for Richie than to stop breathing. He was into every detail of every assistant's work and scheduled everything so that the picture would be delivered on time. This was just what we needed at that point. His scheduling was magnificent, but the Shmeyers's method would get to him too, eventually.

In the script there was a scene on a plane in which Julia is trying to avoid Nick while on her way to scoop him on the big story. She sits down next to a "Man with Goatee" who is reading a newspaper. His face is hidden and she is worried that it's Nick. Then the man puts the paper down. It's not Nick, so she breathes a sigh of relief. The Shmeyers had been casting people from their office in small parts in the movie. I thought, *Why not me? I have a goatee.*

They agreed. I thought it would be fun. It wasn't. When I saw the dailies, I wanted to die. I am not an actor. I prevailed on Richie to cut the scene so I wouldn't have to. He did a great job, sparing me from complete humiliation.

We screened the picture for the studio. Joe Roth and my old pal Roger Birnbaum were there from Caravan Pictures, the producers of the film. Michael Eisner and Jeff Katzenberg, now the top dogs at Disney also attended. We ran the picture in Katzenberg's personal plush red velvet screening room on the top floor of the Team Disney building. Everyone there was well aware of Julia's unhappiness on the picture, of her terrible relationship with Nolte, of how far over budget we were, and of how much overtime we were facing to get the picture done in time.

But after it was over, everyone congratulated Charles and Nancy. "Great, just great!" they said. "You've got to start thinking about a sequel," someone offered.

I spoke up. "If you do a sequel, I've got a suggestion for a title," I said. "*More Trouble . . . Than It's Worth.*"

With Richie's arrival Lynzee had left, after an able stint, and the cutting was left to me, Adam, Walter, and Richie. The second unit was still shooting inserts, the actors were busy looping their lines, and Academy Award–winning composer Elmer Bernstein began recording the score at the CBS studios across the street, all at the same time. Charles and Nancy were riding a whirlwind.

The morning of Elmer's first day of recording, they invited Richie and me to join them over on the stage to listen to the playback of the first cue. Charles questioned the instrumentation of a particular moment, second-guessing the great man as he was wont to do. We couldn't stay, because all these other things were going on that required our attention. After some brief conversation with Elmer, and without staying to hear the result of Charles's suggestion, we left to go back to cutting, shooting, and looping.

Word came to us from the music executive at Disney: Elmer was very put out by our visit to the stage and didn't want us to come back. He threatened to walk off the picture if Charles and Nancy returned! And that went for Richie and me as well. That was OK with me. We had our hands full anyway. We were close to the end of May by this time and needed the score ASAP so we could begin the final mix.

Because of the volume of work and the brevity of the schedule, the predubbing of effects was already well underway on a couple of stages at once. To make our release date, we would have to be finished by mid-June, as the laboratory needed at least ten days to produce, mount, and ship the three thousand or so prints needed for a wide release. Final mixing usually took two to three weeks, so we had planned to start right after the Memorial Day holiday.

That weekend, we gathered in the Shmeyers's office to watch a tape of the film with Elmer's music roughly mixed in. It was a disaster. The score

he had written was brass heavy and not appropriate for a comedy. If the picture was to work at all, it was going to need a new score, and Elmer was not the man to do it. Composer David Newman was called in the next day. He had eight days to come up with fifty-six minutes of original music. An impossible task, so he assigned a number of the action cues to other composers and to arrangers who had worked for him in the past. The recording studios were all booked, so the first session was set for the following Thursday evening. The final soundtrack, music, dialogue, and effects had to be delivered the Friday after that.

The first session was proceeding OK when Charles and Nancy started asking David for changes. It was a miracle, it seemed to me, that he had showed up prepared to record anything at all, but they were undeterred.

"Booba, that cue isn't light enough. Do you think you could come up with something else?" And so forth. We recorded for three hours that night, another three the next night, and a full day, six hours—plus a bit of overtime—both Saturday and Sunday. At the end of Sunday's session, we had thirty of the fifty-six minutes recorded.

Normally, music is recorded, mixed down, and laid down on tracks to be mixed with the other elements. In this case, there wasn't time. The cues were recorded right onto hard drives, and the drives rushed over to the dubbing stage where we were mixing the picture. The studio, Warner Hollywood, had four dubbing stages on its lot. We were booked in all four.

Walter, who has won a Career Achievement Award from the Cinema Audio Society, was essential to getting the job done. The mixers were working around the clock, which, unhappily for them, is not all that uncommon. Bernard Herrmann once said to me, "Mixers are people who committed terrible crimes in their former lives."

It was now Monday morning. We needed to be finished with everything by that Friday, and there were still twenty-six minutes of music to be recorded. Another session was booked for Monday night. A small army of copyists had been assembled in a small soundproof room just off the recording stage. About twenty poor souls were madly copying the individual parts for each of the different instruments from the composer's score. Still Charles and Nancy were asking for changes. I wondered how much more they could inflate this balloon before it burst. David was astounding. He started dictating changes from the podium.

"Clarinets, in measure 36, change the E-flat to an F; first violins, lay out until bar 38," and so on. He was literally rewriting on his feet.

The following night, Tuesday, we had another session. This would give us only two days to mix in all the rest of the music, since Friday was to be devoted to print mastering, a necessary technical step that required a finished soundtrack. The lab would print over the weekend, and a fleet of planes had been chartered for Monday, standing by to deliver the prints all over the country. At the end of Tuesday's session, we still weren't done.

Another session was booked for Wednesday morning, and David Newman spent yet another sleepless night rewriting his music, and some of the others', for the Shmeyers. At last the score was complete, and we could focus on getting it mixed into the film. We were working eighteen-hour days. Richie Marks had taken it upon himself to make sure the schedule was met, and he was going crazy. When Charles had to make a decision about something and would hesitate, Richie was all over him, but the Shmeyers seemed oblivious to the chaos they were creating around them. Richie was tearing his hair out.

Finally, it was the last day of mixing. Charles and Nancy decided they wanted to show their gratitude to the crew. Chasen's, the venerable Hollywood establishment that had fed the industry's elite during the Golden Age, was going out of business, so a final takeout dinner was ordered from there. Tables were set up just outside the main dubbing stage. Chasen's was famous for its chili, as well as for its banana cream pie, so that's what was on the menu that night. The crew had broken for dinner around seven or eight in the evening and had gone back to work trying to finish the job. Around one or two in the morning, it was done, and we all could go home. On the way out, a few of the mixers and some of the machine room operators, who are essential to the process, helped themselves to seconds of the pie, which was delicious.

Unfortunately for them, it is unsafe to eat anything made with cream that has been left standing for some hours at room temperature. About half a dozen of them became agonizingly sick to their stomachs during the night. Just when we needed everyone for the last day of print mastering, several of them called in sick and had to be replaced by mixers who didn't know the show. One devoted mixer dragged himself in, but his stomach

wouldn't cooperate and he ran in a frenzy to the men's room to throw up. According to witnesses, he almost made it.

I Love Trouble opened to no business. The budget, which had started out at $45 million, wound up around $65 million. Nancy had asked me how well I thought the picture would do. I wrote $150 million on a slip of paper and sealed it in an envelope. The first weekend, it took in barely $4 million. When I bumped into her twenty-five years later, she teasingly reminded me of my mistake, as if my prediction of success was somehow responsible for the picture's failure. I'm sure she was kidding. I pointed out that I was merely off by a couple of pictures. A few years later, her second picture as a director, *What Women Want*, grossed $183 million in the US and Canada.

Joe Roth's dream of a Julia Roberts hit picture on July Fourth weekend turned out to be a big bust. However, in the way that Charles and Nancy have often been lucky in their careers, the failure went largely unnoticed. It was one of the craziest work experiences I have ever had. And it was the last picture I ever cut on film. From then on, I worked only on the new computerized editing systems, Lightworks and Avid. They would have made life a lot easier for us, although working for Charles would always have been trying.

There have been a number of pictures with "Trouble" in the title. Not one has ever turned a profit.

23

Mission: Impossible

It was mid-1994 by the time I finally got my vacation, a fabulous trip to Bora Bora. When I got back, I called Marty Bauer and discovered to my surprise that he was no longer my agent! He had palmed me off to a more junior agent named John Lesher. Since then, Lesher has become an Academy Award–winning producer. At the time, though, he was a young agent under Marty, who was one of the principals at United Talent Agency and could hardly be expected to represent someone as lowly as a film editor. It has been said that the true art form in Hollywood is not making pictures; it's making the deal. I believe, however, that the true art form in Hollywood is humiliating people.

Swallowing my pride, I called Lesher. Brian had nicknamed him "the Undertaker" because of his somber demeanor and his penchant for dark suits. "I need a job, John," I said.

"I am not in the business of finding work for editors," he replied coolly.

WTF? "Then why are you my agent?"

"I have no idea," he said. At least he was telling the truth.

———

After a brief stint helping out on other projects, I got a call from Brian De Palma. It was early 1995. Brian had grown unhappy with the course

of his career at that point, left Marty Bauer, and signed with CAA when superagent Mike Ovitz was still at the height of his power there. Ovitz had put him on Paramount's feature version of its old TV series *Mission: Impossible*, which would star and be produced by Tom Cruise. Brian had promptly hired Jerry Greenberg, but when the release date was announced as December 1995, Brian asked me to come on as second editor, anticipating a crunch. Work had been slow, and I accepted. Later the release date was moved to spring 1996, which obviated the need for two editors, but of course we didn't know that at the time.

Jerry and I flew to London, where the picture was to be shot, to meet with the vendor who would be supplying and maintaining the editing machines on the show. They were Lightworks, a computer-based system that featured a joystick controller familiar to any of us who ever worked on flatbed machines. Jerry, however, was strictly a Moviola editor. We hired a local assistant who seemed bright and had worked with Lightworks before. The cutting room was at historic Pinewood Studios, about an hour outside Central London, where many famous films have been shot, including the James Bond series.

Brian had always regarded the cutting room as forbidden to all cast members as well as to producers. Now his star was also the producer. "How are you going to handle Cruise when he wants to come to the cutting room?" I asked.

"I'm not going to let him," he replied. "He can screen the picture all he wants, and give me his notes, but he is not coming into the cutting room." And he never did.

Shooting had begun on location in Prague. I went for the first day of photography, bored as I always am on sets after about half an hour. Back at Pinewood, Jerry and I were installed in what the local crew referred to as the "Legend Block," because the Ridley Scott picture had used it ten years earlier.

There were three big set pieces in the film: the first one set in an embassy in Prague, the second a break-in at CIA headquarters, and the third a chase between a helicopter and the high-speed Eurostar Chunnel

train. Because Jerry had been hired before me, it was natural that he would cut the first set piece, a mission that goes terribly wrong. I worked on some smaller scenes also shot in Prague.

Because computer drives in those days were extremely limited in their capacity, no one drive could hold all the material, so my assistants were constantly switching my system from one drive, about the size of a small suitcase, to another. Otherwise, adjusting to cutting with computers was easy for me. I would say to my assistant, "I want to select a piece of this shot to cut in. How do I do that?" And he would show me. I picked up the system in about a week.

The monitor was divided into two displays, one representing the dailies and another showing the cut I was creating. Underneath was the timeline, an image of an imaginary piece of film, and I would make imaginary splices in it, which were graphically represented. There was one band representing picture and another representing track—or, as they call them in England, action and sound. It was all pretty logical to me, and I grasped it intuitively. When you are assembling a first cut, you generally use just a few commands again and again. It didn't take long to learn the few moves I needed to make. Essentially, editing is not technical. Just as writing is not about the pen or the typewriter, neither is editing about the tools we use.

Jerry told me he was used to working by looking at the image, not at the film, so he didn't pay much attention to the timeline. I couldn't understand how he could do that. But he is a great editor, and I figured he had found a method that worked for him. At the time, Jerry was dating a woman he had met in New York. He was flying back to the States on weekends to see her, leaving early Friday afternoons and returning late Monday mornings. When Brian got wind of this, he was not happy. Jerry had edited five films for Brian, the last being *The Untouchables* eight years earlier. They had a history, and presumably there were issues from earlier times, because one morning Jerry came in and announced to me that Brian had fired him. I was shocked.

Brian came to see me. "You have to take over the embassy scene," he told me. "Take a look at the cut." Brian shook his head, as if in amazement at what Jerry had presented to him.

I went into Jerry's room and watched the cut. It was very exciting, but suddenly a whole series of shots repeated, and then again, with slight

variations. By watching only the images and not the timeline, Jerry had lost his place in the cut and had repeated sections. It looked bad, although there were terrific bits. It was the overall cut that just needed a lot of sorting out and cleaning up. To tell the truth, I had very mixed feelings about Brian firing Jerry. No one likes to see a friend get fired. But I do prefer working alone. It's just simpler. It's not about the credit. Jerry could have had a credit on the film, but he refused.

I went on as before, except now I didn't have to wait around for material, which was the case when there were two of us. I cut the rest of the picture, including the remaining two big sequences, the CIA break-in and the crazy helicopter/Chunnel train chase. The CIA sequence became an iconic scene, with Cruise hanging spiderlike above a secure room to download a secret file.

John Knoll from ILM came over to supervise the filming of the background plates for the train. It was the first time we had met. He and his brother, both brilliant, had created Photoshop, a culture-changing invention if ever there was one. In fact, the app has altered all perception, since it is no longer possible to believe one's eyes when looking at a photograph or video. There is no longer any such thing as "photographic evidence."

Now that the tools from Photoshop have been applied to moving images, the whole way of making movies has changed. It is now routine for even non-VFX films to employ hundreds of digital shots. Locations with bothersome backgrounds that would have been rejected can be used, with unwanted objects in the frame simply "painted" out. Even using locations at all is often rejected in favor of matting in backgrounds. Effects that had previously been achieved with makeup can now be done in post. Wrinkles and blemishes can be erased, faces lifted, bodies enhanced or slimmed. You simply cannot take at face value what you see anymore.

In the Chunnel chase, all the images of the chopper were created digitally, as were the interior of the tunnel and much of the train. The only actual photographic images were of the actors. To film Cruise on the exterior of the train, they built a large box the size of a railway car and draped it in blue so they could isolate and extract his image from the background. An enormous jet fan was rigged to blow at him to create the illusion that he was on a very fast-moving train. The wind was so powerful it made his cheeks ripple.

Each of the setups in the sequence had been storyboarded using pre-viz shots, or previsualizations. These pre-viz shots are early representations of special effects to be achieved later. They were once simply moving storyboards, but over the years became more and more sophisticated animations of the action. As the shots came in, I would replace the animated shot in the pre-viz sequence with the actual photographic image. I would then turn over only the specific frames we were planning to use so that the VFX people at ILM could begin working their magic. The shots were extremely complicated to set up, as many of them also involved stunts.

To save time, I started using the black-and-white tapes of the video feed from the camera. At lunchtime, I would get a copy of what had been shot that morning. The material would be digitized and fed into the Lightworks. I would then cut the shots into the sequence before the film had even been delivered to the lab. Brian would come by at the end of the day, and we would do the same with the afternoon's footage. Sometimes we would discover a more efficient way to cut the scene than in the animated sequence that was our guide. By working this way, we were able to eliminate some of the setups that Brian had planned to shoot. This saved the company a lot of money in reduced production time.

When shooting wrapped, we moved our operation to Skywalker Ranch in Marin County to be near ILM, able to quickly answer any questions they had and also to keep an eye on them. Brian and I moved into neighboring apartments on the ranch. We would watch Monday Night Football together. I commuted back to L.A. on the weekends to see Jane and Eric, who was still in high school. Our daughter Gina had left for college at Brown in September. I had flown back to L.A. from London during production to attend her high school graduation.

Tom Bellfort was hired to be the sound supervisor on the picture, on my strong recommendation. We hadn't worked together in seven years, since *Steel Magnolias*, and it was nice to have my childhood friend around. He had come over to London for a while and had traveled to the continent to make some recordings of train sounds. When the discussion turned to composers, Brian was unsure of whom he wanted to hire. I had worked with Alan Silvestri on *Dutch* and found him to be extremely talented as well as very warm and accommodating. I had a feeling that he and Brian would hit it off. Alan flew himself up from Carmel to the ranch in his own plane.

He and Brian talked, and everything went perfectly. Brian agreed to hire him, and Alan flew back home to begin work on the score. Eight weeks went by.

———————

True to his word, Brian never let Tom Cruise come to the editing room. Cruise did look at a preliminary cut of the film, projected in a screening room, and made a sort of offhand comment that we still had all the entrances and exits in. He wasn't unhappy or harsh; he just offered an observation. But it had a profound effect on my thinking about the cutting. It is better to come into a shot while there is some action in progress rather than wait for the characters to enter. It helps "keep the ball in the air." In editing, we have to be concerned with not losing the audience's attention. Beginning every scene with the director's planned camera move or reveal requires a certain "lift" on the part of the viewer, and repeated beginnings, scene after scene, eventually take their toll. Better, as Cruise had pointed out, to get right to it. You would think I would have known this by now. "Cut to the chase" is among the most clichéd expressions relating to editing. But hearing it expressed in terms of entrances and exits cast it into a new light for me, and has influenced my approach ever since.

———————

The first day of recording the music was exciting, as always. This day, however, was special, because the famous theme of the *Mission: Impossible* TV series, originally composed by Lalo Schifrin, was the star, more so than any other element. The orchestra performing the theme was being videotaped for the press kit. After the hoopla of laying down a good take of the main title, Alan began recording the first cue for the Prague sequence. After just a few notes, Brian turned to Cruise, who was sitting next to him, and said derisively, "It sounds like the 'Song of the Volga Boatmen.'"

I knew then that we were in trouble. Tom picked up on Brian's unhappiness and seemed to share it. Once a negative comment like that is made, it can poison everything.

As hard as it is to believe, not once since Brian and Alan first met had they spoken again. Brian never called up and said, "Hey, Alan, I was

wondering if you could play me some of what you are writing, just to make sure we are on the same page." And not once had Alan called Brian to say, "Hey, Brian, I'd like you to hear some of what I have in mind for the film, just in case you want to make any changes."

So here we were on the day, and Brian was unhappy. He huddled with Cruise and the head of music from the studio. The next thing I knew, the rest of the recording session was canceled and Alan was being replaced. We had used a track from *Dead Presidents* for temping the CIA scene, and as is often the case, the temp led to hiring the composer. It had happened on *Sisters* and again on *Steel Magnolias*, and now it happened again. Danny Elfman, a brilliant composer, had written that track and was available. All of a sudden, Danny was in.

Once the deal was in place, Brian asked me to go with him to Elfman's house in Topanga Canyon. We waited while Danny was finishing up a phone call in another part of the house. The room was decorated with strange, creepy objects, of which I remember two. One was a foot-high human skeleton in a jar. The other was a cat lying on the sofa, seemingly asleep, but when I stroked it, I realized that it was dead and stuffed.

In his studio, Danny had a large monitor in front of a keyboard, and he and Brian settled in to look at a scene together. We didn't stay long, and the next day Brian told me that Elfman had asked him not to have me accompany him to the house anymore. Brian went back and worked with him every day for weeks. He confided to me that he had never worked so hard with a composer in his life.

I couldn't resist pointing out, "If you had worked like this with Alan, he would have written you a great score."

We went back to Skywalker to finish the final mix. It was decided that we would set the levels for the effects and dialogue using the temp music as a guide. However, this turned out to be pointless, since the work had to be done all over again when we got Elfman's music. By that time, the studio at

the Ranch was no longer available, so we remixed in L.A., at Todd-AO. We were back in the same large room I had been in when we mixed *Coupe de Ville*. A strange problem had emerged on that earlier film when we mixed the TV version: many of the sound effects were out of sync.

The same thing happened on *Mission: Impossible*, but by the time I realized it, the theatrical version had already shipped. I got a copy of the sound effects stem, the portion of the mix that isolates the effects, and put it up on a Kem. I made careful notes of each effect that was out of sync and how much it had to be moved for the sync to be correct. After my experience with *Footloose*, I had learned that the theatrical version of a film is not the historical record. In years to come, anyone wanting to see an old film was going to see the videotape transfer or the DVD version, not a print on celluloid. As much care, if not more, must be given to the home version of the picture. I went back in and we made each adjustment as I had noted. At least this picture would be in sync, for all time.

Paramount previewed the film. The audience burst into loud applause at the first few notes of the iconic theme, and their response was so enthusiastic the studio wanted to frame the cards. No one, however, asked this crucial question: "Was there anything in the film you found confusing?"

"OK, Cruise," Brian would tease, "we know you can get an audience the first weekend, but what about the second weekend?"

Brian and Tom would laugh about it, but that joke turned out not to be so funny, because after the biggest opening weekend in history, the box office for *Mission: Impossible* dropped a stunning 61 percent the second weekend. The critics were particularly harsh on the film. They couldn't follow the plot. My theory is that *Twister*, one of the dumbest movies ever made and, like ours, a Paramount release, came out three weeks earlier and lulled the reviewers into complacency. At *Mission: Impossible* screenings, they probably thought, *Oh, another dumb Hollywood blockbuster.* By the time they realized they needed to pay attention, it was too late.

It also didn't help that some of them couldn't understand Cruise when he whispered a crucial line: "This whole operation was a mole hunt?" This was a key to following the plot. Had we but known, we could have had

him loop the line and it might have helped. But a lot of people were able to follow the plot anyway. The picture made $400 million worldwide and initiated a franchise that is still going on today. I guess we didn't do too badly.

––––––––––––

The foreign market has grown immensely during my years in the business. It used to make about half of what a picture grossed in North America. Now the ratio is reversed, and most of a picture's gross comes from overseas. This is one of the reasons Hollywood makes big action movies. They play well in foreign markets.

Shortly after the picture opened, I got a call from Paul Haggar. "Can you go to Barcelona to cover the Spanish dub?" he asked. "Mr. Cruise has asked for you to cover the foreigns."

"When is it?"

"Day after tomorrow."

"What! I don't think I can even get there in time. When would I have to leave?" I asked.

"A car would come get you this afternoon."

I thought for two seconds. "OK, I'll do it!"

Jane was out shopping with a friend that day. I tried to reach her, to no avail. I packed and was ready to leave when she finally showed up, just before the limo. "You might have gotten a trip to Barcelona if only I had been able to reach you," I said, and kissed her goodbye.

I arrived in Barcelona fifteen hours later, but twenty-four hours by the clock. I was wide awake all night. At 9:00 AM, I reported to work. It was midnight by my internal clock. I told the crew I was looking forward to a nice siesta after lunch.

"Siesta? No, no siesta anymore. That's over."

I was very disappointed to hear that.

The Spanish actors had already recorded their lines, and my sole task was to supervise mixing the Spanish dialogue with the music and effects tracks we had supplied. There is a vast industry all over the world that is devoted to recording foreign versions of American films. The people employed at this work do it week in, week out, and are expert at their jobs. The translators who created the scripts in the local language had done

remarkably well in choosing words that would fit best into the mouths of the actors on the screen.

As we worked our way through, however, we came to a scene in which Jon Voight complains, "Those damn Gideons!" I thought I heard the word *cretinos*.

"Wait a minute, back up please. What is that word?" I asked.

"*Cretinos*." I had heard right.

"Why *cretinos*?"

"The script reads, 'Those damn idiots.'"

"No, not idiots, Gideons," I corrected.

Blank looks all around. "What are Gideons?"

I explained that they are people who place Bibles in hotel rooms.

"Well, nobody in Spain has ever heard of this. No one will understand."

I thought about it. *Idiots* works just as well, I realized. So we went with *idiots*. It turned out that the person at Paramount transcribing the final version of the film had misunderstood the line, and the same mistake was therefore repeated in every one of the foreign versions.

Paul Haggar called, checking in with me to see if all was going well. He explained he wanted me to cover the German, Italian, and French versions as well, but it wouldn't be until a few weeks later. I asked him if I was going to get my rate as editor for doing this.

"No, Paulie. This job is 'foreign dub supervisor,' and it only pays [half of what I was making]."

I was outraged and was going to hold out for the full amount of my editor's rate until I spoke to Jane. "Are you crazy?" she said. "They are going to pay you to go to Europe and you are going to refuse?"

I saw her point. In the end, I got them to agree to give me a ticket for Jane as well. So we flew first class to Berlin, Rome, and Paris, and stayed for a month in first-class hotels with all ground transportation paid for on top of a salary and per diem for our meals. When I spoke with the person at the studio who was scheduling the mixes, I asked her if she could work in a week off for me between Rome and Paris. She did,

and during that week we were able to travel, albeit at our own expense, to Florence, Venice, and Lake Como. Since all other expenses had been paid, we treated ourselves to staying at the finest hotels, including the Gritti Palace in Venice and the Grand Hotel Villa Serbelloni in Bellagio, right on the lake, a truly magnificent experience.

It was the best paid vacation we ever had, thanks to Mr. Cruise.

24

Mighty Joe Young

I WAS NO LONGER A young, up-and-coming editor. At this point in my life, in my fifties, my kids were going off to college and editing was how I made my living. I had to hope work would come my way. You can't really go after it. You just have to be patient and hope for the best. But as Herbert Ross used to say, "It's all about hits and flops."

Coming off a hit, I got a call from Mark Gordon, another former member of the class that helped Brian De Palma make *Home Movies*. He was producing a picture called *Hard Rain*. It turned out to be a flop, but while working on it he and I became friends. He is still one of my biggest supporters.

In 1997 I got a call from Jonathan Lynn, but not about a job. He was inviting me to a screening of his latest picture, *Trial and Error*. After *Nuns on the Run*, Jonathan had scored big with the hilarious *My Cousin Vinny*, in which he made use of his legal training. After three more films that were not as successful at the box office, including what I consider to be the best film about American politics, *The Distinguished Gentleman*, Jonathan was returning once more to the world of jurisprudence. In his cast was a young woman who knocked me out with her beauty and poise, Charlize Theron. She had made only two films at that point, neither of which had

been released, and it had been a gamble for Jonathan to cast her, but it was clear to me she was destined to be a star.

Around the same time, I got a call from an old friend, Tom Jacobson. After the ill-fated *I Love Trouble*, Joe Roth had left Caravan and taken the job of chairman at Disney. Tom was producing a new film for Disney, a remake of *Mighty Joe Young*, and they were thinking of casting Charlize as the lead. Tom had heard that I had seen Jonathan's picture and wanted to know what I thought of Charlize.

"Do it." I said. "Sign her up immediately."

Now I don't flatter myself that I was the reason they hired her, but I did recognize her beauty and ability. Tom then asked if I was available, and I was. He invited me to come meet the director, Ron Underwood. Ron had a couple of hits to his name at that point: *Tremors*, a horror picture about giant earthworms, and *City Slickers*, a Billy Crystal vehicle that Billy himself produced that had done good business. Ron and I had a pleasant conversation, and I was hired.

Mighty Joe Young is basically a Lassie movie, with a giant ape in place of the dog. It was pitched at a youthful audience. We shot in what used to be Howard Hughes's airplane factory near the Ballona Wetlands, south of Marina del Rey. The building we were in was the hangar where Hughes had built the famous Spruce Goose, the largest airplane ever built, over five stories tall with a wingspan longer than a football field. Because of wartime restrictions on metal, it was constructed entirely out of wood. The enormous seaplane flew only once. The hangar also housed hundreds of offices upstairs that were filled to capacity during the war. Now they were vacant, and I would occasionally walk down long, sunlit corridors past empty offices, feeling the ghosts of the previous occupants. It was not hard to imagine those offices once buzzing with activity, carrying out the war effort with the energy of thousands of people working round the clock.

My daughter Gina had just finished her sophomore year at Brown University and came to work on the picture as an apprentice for the summer. At this point in the transition to the digital era in filmmaking, the camera and the projector lagged behind. This meant that although the editing

was all digital, the camera still had film in it, and film was needed again to project the workprint. All the steps in between had been digitized, but not those. To project the picture, my assistants would assemble a physical workprint reflecting my cut. When I made alterations in the cut, the assistants would make the matching changes, creating trims that had to be cut back into the rolls they had come from. So Gina got some experience handling film, reconstituting Kem rolls, and generally helping out. It was a treat for me to have her around until the fall, when she went back to school.

———————

Ron proved to be a workmanlike director. He was sufficiently experienced to cover himself, but he showed no flair for imaginative filmmaking. He was pleasant, with a disarming big grin and an easy laugh. He had a habit, which eventually wore terribly thin, of faux-stammering whenever he wanted to say anything that he thought might be interpreted in any way as criticism. But he seemed to like my work, which went a long way toward my liking him. In conversation, though, he used only two superlatives: *incredible* and *unbelievable*. This always made me wonder, when talking about acting or visual effects, *Shouldn't acting that is very good be called* **credible**? *Shouldn't effects be* **believable**?

Opposite Charlize was Bill Paxton, the nice-guy actor who later played the polygamist family man on HBO's series *Big Love* and, in a tragic turn of events, died at sixty-one in early 2017. But the real male star of the picture was Mighty Joe Young, a fifteen-foot-tall gorilla. We used three tricks to depict Joe's size. The first was using life-size puppets, one prone, one up on all fours, and one sitting. The second trick involved blue screen shots and forced perspective. We photographed an actor in a gorilla suit and matted him into real backgrounds, magnifying him in the process to make it appear he was bigger than he actually was. And the third, for shots that were impossible to achieve with those two techniques, was a fully digital Joe, created in the computer using the latest in animation technology.

We ran into some big problems with this third technique. Hoyt Yeatman was the visual effects supervisor on the film. He was a boyish, garrulous man with great knowledge of, and boundless enthusiasm for, his field

of expertise, but he sometimes just didn't know when to stop talking. The executives at the studio had great faith in him, though, and had funded an in-house VFX facility modeled on ILM for him called the Secret Lab. It would produce our digital shots.

After many months of work, Hoyt presented us some shots as final. They were terrible. The gorilla fur was unrealistic, and the character moved unnaturally.

"Well, this is the best we can do," he announced.

This was unacceptable. This was going to make or break our film. If the forty or so shots of Joe done digitally looked phony, the whole thing would fall apart. ILM was finally called in. Even they, who were the best at this, had to acknowledge we were breaking new ground with Joe. The dinosaurs in *Jurassic Park* were simple by comparison, their smooth skins offering little challenge in terms of credibility. We adopted an oxymoronic mantra, "Fur is hard."

The studio decided to preview the film. At that point, most of the digital shots were in extremely early stages, and Joe was represented in many of the forty shots by a shiny, light-blue animated gorilla. It was laughable. He looked like a Mylar balloon. So the studio made up a large still photo of one of these frames and, before the screening, held it up in front of the audience. Predictably, everyone laughed.

"This is what Joe is going to look like in some of the shots," they were told. "And this"—another large still of Joe, fully rendered, was displayed— "is what he will look like when the movie is finished." *Oohs* and *aahs*. The hope was that we had inoculated the audience, and sure enough, there were no untoward laughs during the showing. In fact, one of the cards read, "The special effects were amazing!"

Bob Badami, one of Hollywood's top music editors, came in to help with the temp music. He knocked me out with one of his choices, one that would never have occurred to me. When Joe sets out to rescue a small boy trapped on top of a burning Ferris wheel, instead of playing tension as Joe climbs to the top, Bob played triumph, victory, success. The effect was to make Joe seem wonderfully heroic.

James Horner was hired to write the score. In an unfortunate bit of timing for the studio, he had just won two Oscars for James Cameron's *Titanic*, including one for Best Song, and he made extraordinary demands that they felt obliged to approve. Horner spent a week recording percussion prerecords on a stage large enough to accommodate a full orchestra. He had them build a platform constructed of wood, with steps up to it. He then brought in thick poles, like telephone poles, in eight-foot lengths that the players would stand on end and then lift and drop onto the platform on cue, creating deep thudding sounds. I thought that much the same effect could have been achieved by hitting a bass drum. He then recorded with an enormous orchestra for a second week, doing numerous takes of each cue, including the end title music. This usually consists of cues from the body of the film edited together by the music editor. Horner spent half a day on that cue alone. The score cost Disney $3 million.

Music editor Joey Rand, who possesses a unique sense of humor, came to the recording sessions dressed in a gorilla suit, with an inflatable palm tree by his desk. When I heard one of the cues, I asked Joey, "Does Jamie know he ought to change at least one of the notes from his previous themes?" Horner didn't care. He loved a kind of breathy flute and used it in all his films—Irish movies, African movies, whatever he was working on. He was a gifted composer, no doubt about that. He was nominated for eighty-three awards and won fifty-two.

———

I thought the picture had turned out pretty well, but it didn't perform as well at the box office as the studio had hoped. *Titanic* was swallowing up all the business, week after week, as if all the other releases were small boats capsizing in its wake. I had occasion to meet James Cameron around that time, at the American Cinema Editors' Eddie Awards dinner. Someone with whom I had worked briefly at Fox introduced me to him. The great man was surrounded by a small band of acolytes.

"Sorry," he said, after learning my name.

"Excuse me?"

"I'm sorry," he repeated.

"I don't understand," I replied.

"Today *Titanic* passed *Star Wars* as the highest-grossing picture, so I was just saying 'sorry.'"

The bastard, he wasn't sorry in the least, he was baiting me. "Well, on the other hand," I countered, "what are you going to do for a sequel?"

There were audible gasps from the retinue around him. I had dared to challenge the king of the world!

He reacted huffily. "I don't have to make a sequel!"

To give him his due, the man has made some of the most innovative films in our time, and he is clearly a superlative talent. The *Terminator* films alone would have ensured his fame forever. *Avatar* was absolutely spectacular. And now he is planning sequels. I wonder if I gave him the idea . . .

Nah.

25

Mission to Mars

IN EARLY 1999 I WAS HAPPY to get another call from Brian De Palma. After *Mighty Joe Young*, I had picked up some additional editing work, but nothing substantial. Brian was out in L.A. and needed me. With the help of an assistant editor, he was cutting together some silent pre-viz sequences for his next picture, *Mission to Mars*. I came in and tightened them up, added some temp voices and music, and suddenly the sequences came to life.

"You're a genius!"

I was hired. Back with Brian. It felt good, like coming home.

———————

It was a Disney production and Tom Jacobson was the producer. Gary Sinise, Tim Robbins, Don Cheadle, Connie Nielsen, and Jerry O'Connell led the cast. I rejoined Brian up in Vancouver at the start of principal photography in June. I wondered if the weather in that damp part of the world would hold up enough for us to shoot Mars exteriors, but I needn't have concerned myself. The weather all summer was sunny and clear.

Vancouver is set amid some spectacularly beautiful scenery, and on weekends Jane and I would drive out to Horseshoe Bay and rent a motorboat for the day. We would bring a picnic lunch and tool around Howe Sound, visiting the seals lolling on Pam Rocks and cruising around the islands there.

The production was mostly interiors, though, and we were working in a repurposed steel mill, the Bridge, so called because that was where the steel bridges around the city had been made. As manufacturing in North America started to decline, Canada had discovered new sources of revenue in moviemaking, attracting Hollywood producers with money-saving tax inducements. Soundstages are cheap to build, and production was leaving Southern California for other, more welcoming business environments.

There was a lot of concern at Disney that another studio was planning to release a rival Mars film. This has happened a number of times, when a subject catches the interest of a couple of different filmmakers simultaneously. The second picture released never fares as well as the first. Disney was determined that ours be the first one out. In fact, on a visit to the set, when I mentioned that we could do a better job if we had more time, one of the studio's creative executives told me it was more important to get the picture finished in time than it was to make the picture better!

Under pressure of the schedule, Brian thought of offering up the legendary John Ford solution. When he was told he had to finish shooting in fewer days, Ford simply ripped out the last twenty pages of the script in front of the startled executive. Instead, Brian started shooting scenes all in one, covering pages of dialogue in a single take.

Joe Roth reacted wryly. "I could finish quickly too, if I didn't shoot any coverage," he said.

The actors in many of the scenes wore space suits. The suits were functional, with glass covering their faces and temperature-controlled air pumped in. Small throat mikes recorded not only the actors' dialogue but also the sound of the air coming into the suits. The sound of the hiss varied from actor to actor, so all their performances had to be rerecorded. Since the schedule was so short and the actors were available on their off days, I was given the assignment of directing all this dialogue replacement.

We recorded it in a mixing stage in North Vancouver. The actors were not in a booth, as they usually are, but in the same room as me and the recording engineer. Tim Robbins was particularly unhappy. Looping is a skill that is distinct from acting per se. Some very good actors

struggle with looping and Tim was one, although, to quote a line from a Joel Schumacher movie, "*Can't* lives on *won't* street." Tim claimed to be worried about his performance, but I have found that often, if you stay at it, you can get excellent results. Sometimes you have to record lines word by word, or even by the syllable. In the end, it is usually imperceptible to the audience. With Tim, I used my standard line: "You're the only person here who can do it."

You try to be encouraging without lowering your standards. Actors are all different, though, and sometimes an approach that works with one will backfire with another. Connie Nielsen had a full meltdown, disappearing from her session after a break and crying when she came back. Tim eventually got through it, grumbling all the way.

Don Cheadle, on the other hand, was very good at it and had no trouble with sync. He said he was no perfectionist and that he just wanted to get through it all as quickly as possible. There was a pool table on the stage, and I had been shooting a few balls around while waiting for Don to show up. He picked up a cue and we started playing eight ball between recording his lines. He would rush back to the mike from pocketing a ball.

He did test me though. "What did you think of that take?" he asked me.

"It was good," I said, trying to be encouraging.

"No it wasn't, it was crap."

It seemed he did care, much more than he let on at first. It's a tricky thing. You tell actors they are doing well so they won't constantly feel like failures, but when you ask for another take, they sometimes challenge you. "What was wrong with that last one?" as Shirley MacLaine asked me on *Steel Magnolias*.

In the end, it turned out fine. We replaced every single line spoken in the space suits and consequently had full control of the background hiss, so we could protect the intelligibility of every syllable. At the mix, Brian asked if what he was listening to was production or loops. Not even he could hear any diminution in the performances.

———

On the last day of production, Brian and I screened dailies together. He was scheduled to fly out the next morning, early. The scene was one of the set

pieces that we had worked on in pre-viz form. We were looking at a close-up of Tim Robbins for the moment in the film in which he gives his life to save the other members of the crew. He is adrift in his space suit, running out of air, his tether having broken, and he played it frightened and panicky for the most part. I thought it was the wrong approach. I saw moments in some of the takes where he was more composed, so I pointed them out to Brian.

"I think we should use this take, don't you? Where he is less panicked? I think it makes him look a little more heroic," I said.

Brian agreed.

When I came in the next day, I learned that Brian had postponed his departure and had hurriedly scheduled a reshoot with Tim. When the dailies came in, Tim had played the scene completely differently: calm, confident, and cool, a true movie hero.

———————

Back in New York for postproduction, we moved into the Brill Building, where we had edited *Obsession* twenty-five years earlier. The cutting room was again in the southeast corner of the building, looking out onto Times Square. It was late 1999, and the impending Y2K New Year made the customary buildup of energy before the Christmas holidays even more intense. The crowds in the street filled the sidewalks. The lights from the billboards and the noise of the traffic were so powerful that I had to keep the shades drawn to shield myself from the energy. At times, as I left work through the side door on Forty-Ninth Street to avoid the crowds at the main entrance, the tide of people was so overwhelming I'd be unable to turn the corner onto Broadway.

My daughter Gina had graduated from Brown and was now living in New York. She was pursuing an acting career, so she needed to earn some money. We hired her on the picture as an apprentice again. The New York crew liked her enough to ask her to join them when they moved on to their next project. But Gina chose a different path at that point and decided to concentrate on her true passion, acting.

———————

While I was putting together the first cut on location, I had started building a temp music track. Now that we were back in New York, for the first time we had a real music editor on the crew. His name was Nick Meyers, and we had known each other from childhood. His father was Sidney Meyers, the first film editor I had ever known. Nick had been one of the older kids in Provincetown, where I spent five summers between the ages of eight and twelve. He was a talented pianist and had written and directed an opera but had to earn his living as a music editor.

I loved Nick, who had an Ichabod Crane physiognomy, with a crown of frizzy hair and a large aquiline nose and possessed a gloomy outlook on life. Even though he was happily married to another music editor and the father of three children, he would sigh deeply from time to time. His sad face always made me want to cheer him up, which was easy to do, and he had an infectious cackling laugh. Nick was enthusiastic about my choices of music for the cut, but he managed to make the temp much better.

When I called him in his cutting room, a couple of floors above mine, he would always answer the phone by saying, "Hello, Music."

So, I started responding, "Music, this is Picture."

"Hello, Picture!" he would say.

Sadly, Nick contracted an especially fast-moving case of Lou Gehrig's disease a few years later and died at a relatively young age. I miss him to this day.

While we were working on refining the cut, we were also forging ahead on the VFX. The scenes of weightlessness in space were the relatively easy part of the job. What was hard was designing a Martian female for the end of the picture. She was to appear as a holographic image. Brian had to work closely with the VFX people, who were in California. They communicated by videoconference, which was relatively primitive at the time. The picture feed was unable to carry sound as well, so we kept open a speakerphone connection to discuss the shots.

Hoyt Yeatman, whom I had just worked with on *Mighty Joe Young*, was on the crew, since it was a Disney project and they were still very high on him at the studio. Brian has no patience for computer nerds, and the

relationship with Hoyt was not one made in heaven. The speakerphone connection proved to be an additional problem, since when someone spoke, it would automatically mute the listener's end. It was impossible to ever interrupt anyone. They simply couldn't hear you.

Hoyt would go off on long technobabble explanations that Brian couldn't care less about. But since Hoyt could speak continuously without stopping to take a breath (or so it seemed), Brian was unable to stop him. At one point, Brian was so frustrated trying to get a word in that he picked up the handset and started hammering the phone with it.

The VFX work was so extensive and the schedule so short that the work was parceled out to different houses, with Hoyt handling the less difficult work. ILM was handling the hardest challenges and created a memorable, dazzling shot showing how evolution had occurred on Mars. Brian was constantly consulted, approving the Mars woman detail by detail, but the result was turning out to look phony. It also didn't help things that the final scene in the movie was written hurriedly during production, and it wasn't particularly successful.

To write the score, Brian decided on the immortal Ennio Morricone, with whom he had worked so well in the past. We had used a tension cue of his in the temp, at Brian's request, but it seemed wrong to me. It was from *The Untouchables*, but even so, it had a kind of horror-movie-like quality, which was not exactly the right tone for a scene of physical peril. As much as I admired Morricone's work in any number of memorable films he had written, he seemed wrong for the sci-fi genre, and in person I found him to be rather cold.

Around this time, we previewed the picture, and it did not go terribly well. Tom Jacobson arranged to come into the cutting room to sit with Brian and me and give us his notes. Of course, Brian wasn't having any of that, so he simply walked out. Tom got the idea, gave up, and left also. This was a battle he would not win.

We went on finishing the picture. We had hired Lon Bender to be the sound supervisor. Lon had been Wylie Stateman's partner when they started Soundelux after I used them on *Footloose*. They were among the best in the business. In addition to cutting the sound, Lon was also on the board, mixing the picture.

One day Brian and I were out having lunch at the Palm when Brian suddenly asked me, "Shouldn't you be at the mix?"

"No, Lon's there, he's covering it, it'll be fine."

"Oh, I see. Lon is *your* Paul Hirsch."

One day while we were recording the score, Brian suddenly decided we needed to make a change in one of the cues. It was for the scene we had reshot, in which Tim Robbins sacrifices himself to save the lives of the crew. In our temp score, we had played tension during the scene, and then when it becomes clear that Tim was doomed to die, played the tragedy of the moment. Brian, who had endorsed this choice for months, abruptly reversed himself and asked Morricone to rewrite the cue and play tragedy from the beginning of the scene, when Tim initiates the risky maneuver that will ultimately cost him his life. "You can't play tension anymore," he said. "We've been playing it too long. Anyway, it's clear that he is going to die."

"But isn't that playing the end of the scene at the beginning?" I asked.

I've learned that this is a common mistake by acting students, who often play the wrong emotion at the start of the scene because they know how it is going to end. When I had been at Fox working for Joe Roth and thinking that I should learn more about acting if I was going to be a director, I had taken an acting class with a well-known acting teacher. He once asked the class, "Does anyone know a shortcut for making fruit salad? No? That's because there isn't one. You have to cut each piece of fruit." In other words, you have to take all the steps to get to the finish; you can't just rush to where you want to wind up.

Brian disagreed with me. "You know right away that he's a dead man," he said.

I persisted, because I thought this was a serious mistake, and ultimately Brian got angry with me. I had always been able to be candid with him before, and he usually accepted my opinions, but this time he just shut me down. I had gone too far, apparently, and Brian stuck me in the deep freeze and never let me out. We stopped having lunch together, and when we got to the end of the last day of the mix, after the final playback, with everything completed, every sound effect, every music cue,

every loop, every visual effect perfected, after all that work and all those lunches over decades and across continents, all Brian said, without looking at me, was "Ship it."

And he walked out.

———————

It was to be the last time I worked in New York for many years, and also the last time I worked with Brian. We had worked on eleven pictures together over thirty years, sharing innumerable lunches and many laughs. He had been my mentor as a young editor, and now he had nothing to say to me. I tell people that my relationship with him was like a film running in reverse: we started out almost as brothers, became friends, then colleagues, then acquaintances, and then near-strangers for eighteen years. Happily, he and I are once again in touch. Perhaps we will work together again, which I would love.

26

Pluto Nash

RON UNDERWOOD, THE AMIABLE DIRECTOR of *Mighty Joe Young*, was about to start an Eddie Murphy comedy titled *The Adventures of Pluto Nash*. He had sent me a script while I was working with Brian. In it, Eddie is a nightclub owner on the moon who falls afoul of some gangsters. I thought, *OK, Eddie Murphy on the moon, I get it. That could be funny.*

And the script was. Funny, that is. I agreed to do it, since the schedule dovetailed neatly into mine and it's always nice to be asked back by a director, especially on big-budget movies. I was looking forward to doing a comedy again.

The picture was shooting in Montreal, a wonderful city to spend some time in. I was there from early spring into early summer, and I fully enjoyed the parks and the restaurants. I rented an apartment in what had once been a Catholic church in what is called the McGill Ghetto, near the university and not far from Mount Royal. The living room had stained-glass windows in it from its previous incarnation.

When I arrived, I was given a new copy of the script, with revisions. I read it with increasing unhappiness. What had been a funny script no longer was. I spoke to Ron about it. "What happened to the funny version you sent me before?"

"Eddie didn't want it written funny," he said. "He wanted it written straight and he would play it funny."

I was skeptical, and with good reason. When you start letting the star dictate what the script should be, you are, in De Palma's words, "letting the inmates run the asylum."

The first day of shooting confirmed my fears. Pluto's introduction was to be at his nightclub on the moon. An enormous set costing millions of dollars, it was a whole lunar colony on a soundstage, with streets and buildings replete with neon signs, a garish fantasy of a Las Vegas in the sky. The club is jumping, with lots of dancers and patrons at the bar, when suddenly a glass window from an interior office shatters and Pluto comes flying through, thrown by a big ape of a gangster. That was how it was written.

Eddie had asked for a simple change. He wanted to be the one doing the throwing. This completely reversed the intention of the scene. When Pluto was introduced being roughed up, the audience's natural sympathies would flow to his character. Everyone likes an underdog. There are many Davids in the world. Nobody names their kid Goliath. In my view, this change was a mistake, and a harbinger of more problems ahead.

When the dailies started coming in, I was increasingly concerned. The scenes just weren't funny. I asked Ron about it. "I thought you said he was going to play the material funny."

"I know, but he won't do it. If I tell him a take wasn't funny, he asks me what I want him to do. If I make a suggestion, he'll say he doesn't want to do that, that he has already done it in another movie, and he doesn't want to repeat himself."

"Well, we have a problem, because this stuff we're getting just isn't funny or good."

Everyone knew it. It was discussed at dailies, with the producers. We all knew there was a problem with Eddie, but no one had the nerve to confront him. Someone in authority should have said, "If you're not going to play this funny, or use the funny version of the script, we're going to shut this down."

But no one did, so we just kept shooting and hoping for the best. I considered Ron's response to the situation and interpreted his pliability as strength, like a reed bending in the wind but not breaking. But in fact, he was operating out of weakness. It's not always easy to distinguish between being weak and being strong.

The problems on the film came to the fore when we finally previewed. The results were not good. There was a long chase sequence near the beginning of the picture involving a minor character. I argued that we didn't need the scene, and we could save a good five minutes by taking it out. Ron was willing to look at it that way, although the producer, Marty Bregman, was opposed to the idea—why, I'll never know. They had scheduled a pair of previews for the following week, two days apart. It seemed to me a perfect situation for comparing the two versions. There was no time to make any changes based on the first screening since they were so close together, and there seemed to be no point in screening the same version twice. So, I prevailed on Ron to make the cut I had suggested and screen that version on Saturday.

At the Thursday screening, about an hour in, I noticed people getting up and wandering out into the lobby to buy more popcorn or whatever. The picture scored poorly. On Saturday, though, the audience didn't get up and walk around as they had before. The scores were still terrible, but clearly better. I felt vindicated. Bregman, however, hadn't been informed we were going to do this comparison test, and he was outraged.

That Monday, Ron went to a meeting with the producer and the executive in charge of the project at Castle Rock to talk about the results of the two screenings. I was not invited. I spent the morning in the cutting room, waiting for Ron to call.

Finally, around noon, he called from his car. "Meet me in the parking lot downstairs in five minutes," he said, "and we'll go have lunch."

I walked downstairs. Ron had just driven in and was sitting behind the wheel, the engine running. He looked glum. He rolled his window down. "Good meeting?" I asked.

He looked down, and just shook his head slowly.

"What, did they beat you up?"

Still no answer, just a slow shake of the head.

"Did they fire you?"

Another shake of the head, still looking down.

"Then what, did they fire me?"

He looked up at me sadly and nodded. It was the first time I had ever been fired, and no one had the guts to tell me. I had to fire myself.

I learned an important lesson: you can't care more about a picture than the director does.

———————

They brought in a new editor. He cut for about a month, putting back a lot of stuff I had cut out. When they screened his cut, they were unimpressed. After all this time, and spending $100 million, the picture just wasn't funny. It wasn't going to be solved through editing alone, and they had finally come face to face with this. You can shuffle two pair as many times as you like, but it's never going to be a full house unless you draw a new card.

They brought in a writer who rewrote both the beginning and the end of the picture. They rebuilt the nightclub set at a cost of another million dollars. Then it turned out Eddie wasn't available for another six months, so they sat around and waited for him. They continued to work on the picture for another year after I left.

Pluto Nash turned out to be the biggest flop of all time up to that point. It made $2 million the first weekend and maxed out around $4 million. I like to joke that they should simply have bit the bullet and released my version.

They might have taken in twice as much.

27

Lean Times

BEING FIRED AFFECTED ME MATERIALLY. In the five years after *Pluto Nash*, I earned half as much as I did in the five years before it. The whole fiasco also affected my way of thinking: I started to worry about taking the wrong script. If they were going to blame me for a bad outcome, I was going to have to be very careful about what I agreed to work on.

Paul Haggar at Paramount sent me a script by Stephen Gaghan. He had just won an Oscar for writing *Traffic* and was going to direct his first film. There was talk of an impending strike around this time, and I knew that if I didn't work on this one, I would probably be out of work for a long time. But when I read it, I felt it didn't work, and so I turned it down.

I got a phone call from a postproduction executive friend at 20th Century Fox. He wanted my help on a picture of theirs that wasn't working, *Dr. Dolittle 2*. The star of the film was ... Eddie Murphy. I turned it down.

Haggar called again. "Are you working?"

"What's the picture?" I asked.

"Do you want the job or not?"

"What's the picture?" I repeated.

He hung up on me. Typical Paul.

I waited a day and called him back. "We already hired someone else," he said.

I found out it was a picture with Angelina Jolie. It might have been a good job. She was a big star, and the bigger the star, the more prestige attaches to the project.

Shortly thereafter, Fox sent me a script to read, *Daredevil*, a Marvel Comics property about a blind superhero. I got to page 4 and put it down. It was stupid and boring. I tried again, but I could never get past page 4. I turned it down.

At a Christmas party that year at producer Mark Gordon's house, I bumped into Jessica Harper of *Phantom of the Paradise* fame. I had been chatting with her about Brian and the old days when she introduced me to her husband Tom Rothman, the chairman at Fox. I had no idea they were married. Rothman knew that I had declined *Daredevil* and asked why. I told him, "I've decided that I only want to work on pictures that I would like to see myself."

"Those are very hard to find, my friend," he said. "Even for us to make."

I was stunned. It seemed to be quite a damning admission from the head of a major studio.

I needed work, and a friend came through. Jonathan Lynn was going to direct a film titled *The Fighting Temptations* and asked me to cut it. It was a comedy with lots of gospel music, starring a young singer named Beyoncé Knowles opposite Cuba Gooding Jr., who had won an Oscar for his performance in *Jerry Maguire*.

My agent called to tell me that the studio was playing hardball and refused to pay my rate, offering me only 75 percent of what I had been making. I found out later that Jonathan had asked them why they wouldn't agree to my rate and they told him, "Well, *Pluto Nash*," as if it were self-explanatory.

I accepted the lower offer, realizing that I had to if I wanted to work. I was grateful to Jonathan, because if not for him, I don't know where I might have found a job at that point.

I started cutting the musical numbers as they came in, and I noticed that everything was out of sync, so I started making adjustments internally, sliding individual takes to get them into sync. After two or three weeks of this, I suddenly realized that the takes weren't out of sync as I had thought. It was the brand-new flat-screen monitor that was. After doing some investigating, I learned that the new monitor was slow in loading all the data, and I had to delay the sound coming through my speakers accordingly, about a frame and a half. The new technology was creating problems I had never before encountered.

The music was wonderful, and I had a great time cutting to the various songs. Cuba Gooding's energy was amazing, and Beyoncé's on-screen presence was sizzling when she sang. The supporting cast delivered some great gospel singing and some wonderfully funny moments, and featured Melba Moore, who hadn't been seen in ages. In one scene, set in an advertising agency, Jonathan surprised me by naming it "Fairchild & Hirsch," with a big sign featuring my name in the movie's conference room.

In the end, the picture didn't do very well. I was surprised, but it seems Cuba Gooding had become box office poison somewhere along the way, and Beyoncé hadn't yet become the megastar she is now. Some thought that because there were so many single moms in the black community, the main plot point—that Beyoncé's character would be rejected by the church for having a child out of wedlock—wasn't believable. Others thought the problem was that the picture was seen as too "churchy" for the general black audience, while not "churchy" enough for the gospel audience. Still others offered the opinion that it would have benefited from having a black director. Jonathan felt the studio marketed the film poorly, treating it as an African American comedy instead of as a musical, which might have increased its crossover appeal. In any event, I had a good time cutting it and will always remain grateful to Jonathan for giving me a job when I most needed one.

Paul Schrader had told me you don't come to Hollywood to make friends, and to a large degree that is true. But I consider Jonathan a friend.

28

Ray

ONCE AGAIN, I NEEDED A JOB. A friend of mine used to say that the only time you could ever rest was when you were working. Jobs were just a respite from having to look for work. Fortunately, a call came in. Bill Brown, who had been John Hughes's assistant, was now a production executive involved in shooting a picture based on the life of Ray Charles, directed by Taylor Hackford. It was titled *Unchain My Heart*, after one of Ray's songs. Bill asked if I was free.

"Not free, but I am available," I joked.

I loved both Ray Charles and cutting to music. I wanted badly to do the film.

I flew down to New Orleans to meet Taylor on a Friday night. I checked into Le Pavillon Hotel, an ornate historic establishment built in 1907 and known for serving peanut butter and jelly sandwiches at night in the lobby. The next day I went to meet with Taylor. As it was the weekend, he wasn't shooting, and we met at his apartment, which he was renting from Francis Coppola. It was in an eighteenth-century building near the French Quarter and had a lot of atmosphere, with high ceilings, but no air conditioning. Taylor and Curt Sobel, his music editor, were meeting to choose a traditional hymn that would be sung in a funeral scene in the film. Curt was shirtless, due to the heat.

When they had finished, Taylor turned his attention to me. We chatted outside on the balcony overlooking the street. He explained the situation. They had been shooting for seven weeks, and sadly, the editor Taylor had hired on the picture had to leave the film due to the death of his father.

We went over to the cutting room and looked at some dailies on the Avid there. Sensitized to the issue of sync by my recent experience on *The Fighting Temptations*, I noticed that the monitor here was out of sync in just the same way. I pointed this out to Taylor, who was stunned. I think that earned me some points right there. I found out later that Curt had given me a very strong recommendation, which surely helped, for which I am very grateful.

Taylor and I went out to lunch in the French Quarter and shared a first course of fried chicken livers and onions, which were absolutely delicious. We talked about what needed to be done. I asked him if he wanted me to use the existing cut, but the editor had been so distracted by his father's illness that Taylor told me not to even look at it. "I want you to start over again from scratch."

There were still another six weeks of shooting left. "I would usually be able to show you a cut one week after the end of shooting," I told him. "But in this case, since I am starting seven weeks into production, I can do it eight weeks after the end."

"There's no way I am going to stay out of the cutting room for two months," he exclaimed. "I'll give you four weeks. If you have to hire someone else to help you, we can do that."

I agreed. I had no choice. I set up my cutting room at Lantana in West L.A.

Jimmy White, himself a former drug user, had written the script with an insider's knowledge of both the horrors of heroin addiction and the difficulties of being born black in America. Phil Anschutz, a billionaire from Colorado, had financed the film; he was a patron of a number of religious and conservative causes who was dedicated to turning out films with a moral message. A devoted Christian, he had insisted that the film contain no obscenities, a seemingly tall order in making a film about jazz musicians and their lives and loves. Taylor referred to the clause in his contract as the "shit" clause. Therefore, neither that word, nor any stronger than it, was heard in the film. Interestingly, no one ever noticed.

Bill Brown and I talked about whom to bring on to help get the first cut together. We both thought of the same person: Peck Prior. Peck had been my assistant twenty years earlier. I had given him a battlefield promotion on *Planes, Trains & Automobiles*, and he had been cutting pictures, mostly comedies, for years since then. But I knew he could do it and there would be no ego problems. Plus, I loved him and was glad to have him around.

We started cutting. The first thing that struck me was the extraordinary quality of Ray's voice. We were using original recordings of the man himself, and I was reminded how soulful his voice was. Jamie Foxx was playing the adult Ray, and he was doing a fantastic job. Playing a known figure is always a challenge, but his impersonation was precise, mimicking Ray's idiosyncratic gestures and pigeon-toed walk, and his voice was uncannily like the real Ray's. And he did it all without an actor's major tool: his eyes. He wore makeup with prosthetics that covered his eyeballs and prevented him from seeing. In many of the scenes, he wore sunglasses as well and had to convey all his emotions using only his voice and his body language. It was a bravura performance that won him an Oscar.

I spoke to Taylor by phone only once or twice. I told him that I loved what he had shot, and I understood from the choices he had made how the scenes were to go together. And like Herbert Ross, he gave me the freedom to pick the material myself.

I worked out a routine with Peck. I started by giving him a scene I didn't care about doing myself, and he did great, so after that I gave him pretty much whatever scene was up next. When Peck finished his cut of a scene, he would then pass it over to me. I found I had to make a few changes for it to better reflect my sensibility, but even so, it was an enormous help. I could do in a half hour what might have taken me all day.

Taylor had devoted a lot of effort to choosing which of Ray's songs to use and when. He used the emotion of the music to help dramatize and illustrate the story. And he designed the music to work in innovative ways. The song "Every Day" continued over several different scenes. The location would shift, and the script would read, "Music continues." The first part of

the song starts with a piano solo as Ray is left behind by his bandmates one evening, continues into a multilayered montage, then a performance at a club on the road, and then onto the bus that takes them from one small club to the next on the "Chitlin' Circuit." There were several sequences like that, with the music linking scenes that took place over a much greater period of time than the length of the song. But I found that the music served to cut loose the ties to reality and allowed a freer way to present the scenes.

I had never been a big fan of multiple exposures, images superimposed over each other in postproduction; I always found the results sort of messy. But I was working on a new version of Avid that had a package of VFX I had no experience with. I started trying things. *I wonder what this button does?* I would think, and try it out. I discovered the luma key, which could combine images based on the intensity of the exposure. The effect was especially useful with a series of shots of neon signs that the talented second unit director Ray Prado had shot. I was able to place these over other shots without muddying them.

I used pushes, which replace one image with another by sliding one shot out as the second one slides in. I had used these on occasion before, but I made some really slow ones, to great effect. I discovered that I could accurately control irises, so I could pinpoint which part of the image would be the last to disappear or, conversely, which part would be the first to come on. I discovered "dip to color," which gave me a way to introduce the flashbacks.

I was having a great time playing in a virtual sandbox, experimenting with all the new toys the Avid provided. Before that, working on film, when I did some of these special wipes it always involved some guesswork, followed by a delay of days waiting for a version from the optical houses. In addition, there was a drop-off in quality with opticals. On this film, we were going to be making a digital internegative, or DI, and everything would be the same generation, or same quality. This has become the norm, but it was still early days in 2004. We were using a lot of period footage from film archives to show Harlem in the 1940s, for instance, and the DI helped to blend the new and old footage.

Peck and I worked together for the four weeks I had been granted. On the very day I had committed to three months earlier, I showed the picture to Taylor, at a running time of about three hours. He came to see it with his wife Helen Mirren and two of the producers. I couldn't have hoped for a better reaction. Taylor loved the cut, even though it was long.

The movie operated on two different time tracks. One followed Ray linearly as he grew up and rose from the proverbial rags to riches. The other consisted of flashbacks to Ray's traumatic childhood, during which he suffered the sudden accidental death of his younger brother, the catastrophe of going blind, and a separation from his beloved mother. I had cut a montage at the beginning of the film to the song "Hard Times." It included images from Ray's childhood in rural poverty, in particular highly impressionistic shots of "the bottle tree," a tree outside their small village hung with empty bottles, a superstitious holdover from the community's African roots.

The locations for these scenes were the slave quarters of a preserved plantation. It seemed to be perfect for "Hard Times." But Taylor informed me that he wanted to have a main title sequence featuring Ray's signature hit "What'd I Say?" and thought "Hard Times" was too much of a downer. He wanted to start the picture off with a bang. The main title sequence hadn't yet been shot, so what I had cut served as a placeholder until it was. Taylor was so pleased with the cut and that I had delivered on time that he gave me the rest of the day off and watched the cut a second time that afternoon. With the delivery of that first cut, Peck left the picture. He had done a great job, and I could never have met the deadline without him.

Taylor and I started work on cutting the picture down the next day. Taylor is a great guy, a natural-born leader—he had been student body president at USC—and very gregarious. He had a cell phone with a wild spiraling ring tone that he kept turned up loud, and he never ignored an incoming call. He would show up in the mornings with a plastic bag of dry cereal and nibble out of it as we worked. He was also a genial and unfailingly courteous collaborator. When he asked for a change, he invariably included "please" in his request and always thanked me once I had made the change. Taylor was clear about his opinions but also seemed generally interested in my take on things. He asked me what I thought we needed to do.

"Well, apart from the length, which has to come down," I told him, "I think that the flashback material is really powerful, and it's a shame that it goes away in the first third of the movie."

He agreed. "Let's see if we can move some of it later in the film."

We looked at a continuity of the scenes and identified several places later in the story that might provide opportunities for framing the flashbacks. As we started moving the scenes, I had another idea. "What if we save the death of Ray's brother for later? We could introduce a tension by showing the funeral, so we know he died, but not how."

The scene in question showed Ray and his brother horsing around outside their little shack. The young boy slips and drowns in an outdoor bathtub when he can't get himself up. Ray is frozen at seeing this and forever after blames himself. His mother is beside herself in grief and cries, "Why didn't you call me?" Ray has no answer. Shortly after this, still a child, he begins to go blind. I thought that if we waited to reveal the death of his younger brother until much later, we could create a mystery that would carry through the picture. Ray Prado had shot a number of images of the tub that we could use to create hints of the event. Taylor liked the idea, and we recut the flashbacks with this concept in mind. We tried it out on two or three of Taylor's associates, but the idea didn't fly. They were confused, not intrigued, and it seemed to do more harm than good.

But we did not go all the way back to square one. We kept the idea of extending the flashbacks much later in the film. It was a useful exercise, and I was grateful that Taylor had given us both the freedom to fail. Experimenting with the editing can bring great dividends as long as you don't care about failure along the way.

When we got the picture down to 2:35, Taylor decided it was time to try it in front of a preview audience. There is nothing like putting it out there for an audience of people who don't care if the picture succeeds or fails. I thought it was still too long and that would be the only thing we'd learn. The producers were worried about previewing in the L.A. area. They were sure that a review would appear on the Internet the next day. So we flew to Kansas City. The preview went great, but the next day, wouldn't you know, there was a review on Ain't It Cool News, a website devoted to previewing upcoming films. Traveling to Kansas City had been totally unnecessary.

Fortunately, the reaction to the film had been overwhelmingly positive, although a significant portion of the audience thought it was too long, as I had thought. Taylor and I kept cutting. My position is that no matter how good a meal is, eventually you get full. So, with my nagging, we got the picture down to 2:25, which was a struggle for Taylor. But it was worth it. The producers arranged a deal with Universal to distribute the picture, and the studio, which had just undergone a change in management, decided to hold a preview of its own. Apparently, the new Universal execs had doubted the scores we had gotten in Kansas City, thought the picture was still too long, and were going to use the cards to cudgel us into cutting further.

But the scores at their own preview were even higher. When the focus group was queried, they were asked if any part of the movie felt too long. On the contrary, the only criticisms were that the movie left things out. They wanted to know more about Ray, not less.

Instead of telling us how to recut the picture, the studio execs now wanted to know how soon they could have the finished film, with no changes at all. It seems we got the second-highest score in the studio's history, 97 percent; only *Schindler's List* had scored higher. The only thing Universal wanted to change was the title. I thought *Unchain My Heart* was perfect, but it will be known forever as *Ray*.

Of course, the studio couldn't resist trying to improve it, so we started fiddling with the end. We had concluded with a montage of stills of the real Ray, and since the audience had asked for more, someone came up with the bright idea of having a montage of the real Ray singing "America the Beautiful." He had sung it at the Super Bowl, at the National Mall in DC on July 4, on a Christmas special, at the All-Star Game, and at other venues as well.

I protested to Taylor. I thought it was a terrible idea. "America the Beautiful" was not what the movie was about. If anything, it was about the poverty and racism still endured daily by millions of our fellow citizens. It might have turned out well in the end for Ray, who made millions, but it smacked of a kind of jingoistic propaganda and was a bad way to end the film, in my opinion. But like a good soldier, I dutifully cut the montage to the best of my ability.

We previewed again with the exact same cut, plus the "America the Beautiful" montage at the end. The cards were overwhelming. Where there

had been few negative reactions before, a large proportion of the audience said they hated the ending. For some, it was a political objection, like mine. For others, it was simply "cheesy," the all-purpose put-down. So instead we went with a particularly soulful performance of "Georgia" to carry us into the titles at the end.

The picture was locked, and all that was left to be done was to turn out the final DI. Once it was done, Universal started screening the picture, selectively. I got a phone call from David Brenner, the Oscar-winning editor who had been my apprentice years earlier. He called to say he had seen the picture and loved it, but it looked to him like the first reel was out of sync. I checked. He was right. With only a day or two left, before the deadline for making the prints, we corrected the one-frame mistake by having a negative cutter physically cut one frame out of the printing negative. Mindful of the fiasco on *Steel Magnolias*, and hypersensitized, I rejected one of the show prints from the lab because it was printed one perf out of sync.

At the premiere, for some reason I became convinced that reel 5 was out of sync, although no one noticed. Watching it was agony for me. I was seated behind director Michael Apted, who had greeted me before the film began. At the end I ran out so fast that, as he later told me, he had turned around to congratulate me and I was already gone. Years earlier, during one of the Writers Guild strikes, one of the writers' demands was that they wanted language in their contract stating they had to be invited to the premiere. I wanted my contract to say that I was excused from having to attend.

Ray was a landmark project for me. I was nominated for both an Eddie, the American Cinema Editors' award that had eluded me on *Star Wars*, and a second Academy Award. Taylor too was nominated for a second Oscar. He had won with a short film many years earlier. He and Helen came to cheer me on at the Eddie Awards dinner, where I won the award for Best Edited Feature Film, Comedy or Musical.

Winning an Eddie meant a lot to me, since it is conferred by my peers. At the Academy Awards, I managed to hustle up two extra tickets and my children were able to attend, sitting in the upper reaches of the

last balcony. Unfortunately, neither Taylor nor I won that night. Clint Eastwood won Best Director for *Million Dollar Baby*. The Oscar for editing went to Thelma Schoonmaker once again, for Scorsese's *The Aviator*. Rounding out the experience, on our way home, the limo had to stop, its motor overheated. At midnight, tired and let down, we sat there as the driver poured bottle upon bottle of Evian into the radiator.

Ray remains a special memory nevertheless. Taylor and I, nominated for our work together, formed a bond that lasts to this day.

29

A Fallow Stretch

You would think that being nominated would bring me a lot of offers, but you would be wrong. In the wake of *Ray*, my agent got me no meetings at all. It was 2005 and I was turning sixty, a worrying development. I wondered if I would ever get back to cutting hit after hit as I had earlier, or if I was "retired by popular demand." Any work was welcome at that point, and fortunately, people from my past came to the rescue. Paul Haggar called with another picture in trouble. It was a fairly polished feature-film version of the classic sitcom *The Honeymooners*. The film had reimagined the characters as African Americans.

The idea might have worked if not for the colossal miscalculation that the producers had made by trying to make the characters "likable." No more "To the moon, Alice!" Threatening bodily harm to your spouse was not politically correct. No more acid wisecracks by Alice, just sweetness and light. They had thrown away what made the show a classic. I turned it down.

Meanwhile, Taylor Hackford had lined up a pilot for a TV series called *E-Ring*, set in the Pentagon. I didn't want to do TV, but I had no other offers and Taylor was directing, so I agreed. Compared to the world of features, everything was terribly rushed—too little money, too many bosses, and too little time. I swore I would never do a pilot again, and I never have.

Months had passed since the Oscars, and I was living the aimless life of the unemployed. One morning, as I went shopping for groceries at a Ralphs in my neighborhood, I saw a familiar face crossing the parking lot in front of me. I turned off the car engine and jumped out. It was Paul Schiff, one of the producers on *Coupe de Ville*. He and I had attended the same public school in New York.

"Homie!" I exclaimed. "What are you up to these days?"

"I'm producing a movie, actually."

"Oh yeah? Do you need an editor?" I was half-joking.

"As a matter of fact, we do," he said.

I was surprised to hear this, but pleased. When I was younger, I felt embarrassed to admit to people that I was looking for work. But I had come to lose any sense of shame about being unemployed. I just like to put it out there when I am looking for work. It never hurts to ask. "So, what's the movie?"

It was called *Romcom*, and it was a spoof picture, a first feature by two writers named Aaron Seltzer and Jason Friedberg. The script was broad and hilarious, one gag after another. I had never worked on a spoof movie before. OK, it was not the kind of project that I had hoped to get after *Ray*, but it was the only thing around for me at that time and it certainly was fun.

When we previewed the picture, the laughs were explosive. It was exhilarating sitting in the audience. Retitled *Date Movie*, it cost under $20 million and made almost that much in the first weekend. The published figure was eventually $50 million. The studio was happy and offered Aaron and Jason another picture right away. They wanted me for the job, but I wasn't comfortable doing another spoof. It had been fun and I had grown fond of "the boys," but I wanted something else. I recommended Peck Prior to them, and it turned out to be a perfect marriage. Peck has cut five pictures for them, all spoofs.

An offer then came from Regency, the people who had made *Date Movie*. The picture was called *Deck the Halls*, a Christmas comedy. The material was sitcom-like, and there were three huge laughs in the picture. It all went rather painlessly. We finished the picture in five months, from start to finish, and once again I was looking.

I signed with a new agency, Innovative Artists. They found me a job on a picture Robert Redford had directed for MGM titled *Lions for Lambs*.

The principal editor was Joe Hutshing, who had been my assistant twenty years earlier on *The Blue Yonder*. MGM was being run by Tom Cruise through his longtime business partner Paula Wagner, who had produced *Mission: Impossible*. She greeted me warmly and arranged for me to fly up for the day to meet Redford, for his approval. He lived in Napa Valley, and they had rented a house to use as a postproduction office.

I flew up to Santa Rosa and, after a brief meeting with Redford, I was hired. It is hard not to be a little starstruck when meeting him, but soon working for him became normal. He was just Bob. "Hi, Bob." "Good morning, Bob." But occasionally I would go upstairs for something or other and I would see him out on the deck, on the phone, running his free hand through his hair, and I would think, *Wow! That's Robert Redford!*

Ultimately, the picture didn't work. I was there for seven weeks, but I can't say my cutting made a big difference to the film.

Toward the end, my new agents told me about a picture called *Righteous Kill*, starring Bob De Niro and Al Pacino, to be directed by Jon Avnet. What a cast! I knew Redford had worked with Avnet, and I asked him if he would put in a word for me.

Graciously, he did.

I met with Avnet in his Culver City office. My agents told me going in that the rate was low and not negotiable, but if I agreed, the job was mine. Around the same time, I got a call on another picture. It's always amazing to me how rarely I am offered *a* job. I get offered two jobs, and then I have to try to land the one I prefer. This second picture was to be directed by Kathryn Bigelow and was titled *The Hurt Locker*. It was also low budget, with an unknown in the lead. But I was a big admirer of Kathryn's *Point Break*. I went to meet her and her writer, Mark Boal, at her large house near Mulholland Drive overlooking the San Fernando Valley. We chatted pleasantly for a while. Then Kathryn said, "So, how would you like to go to Jordan?"

And I, like an idiot, said, "In July?" I had violated one of my cardinal rules when interviewing for a job: *Never give anyone any excuse not to hire you.*

I told her I would like to think about it. I slept on it and decided that, despite my misgivings about being away from Jane, it would be an adventure. I told my agents to let Kathryn know I would love to go to

Jordan. They called me back and told me she had already hired someone else. One day later! I was disappointed, but the idea of editing Pacino and De Niro was very attractive to me. I told my agents to close the deal on *Righteous Kill*, which they did.

Shortly thereafter, Kathryn Bigelow's people called again. "Is Paul still available?" they wanted to know.

Had I known then what I know now, I would have jumped at the chance. *The Hurt Locker* was a terrific picture and wound up winning its editor an Oscar, while *Righteous Kill* turned out badly. But I didn't know that yet, so I told them it was too late.

The script of *Righteous Kill* had excited me. I thought it had real potential, and I was looking forward to cutting Al Pacino for the first time. On the set in Connecticut, I had a nice reunion with De Niro. I sat in his trailer for about half an hour and we reminisced together. It had been thirty-seven years since we last worked with each other. He kept saying how lucky he had been, and I told him I felt the same way about myself.

"Do you remember what you once said to me?" Bobby asked. "We were standing on Broadway, near the Riverside and Riviera Theatres." These were twin theaters on the same short block between Ninety-Sixth and Ninety-Seventh Streets, on the west side of Broadway, that usually showed double features of second-run films. "You pointed up at the marquee, and said, 'Bob, someday your name is going to be up there in lights!'"

I remembered well, having often told that same story myself. I was surprised, though, that he remembered it too.

I won't go into detail about my experience on the film. Suffice it to say, Avnet and I were not in sync. Fortunately, I had negotiated a hard out after twenty-six weeks, at which point I left. An editor named Peter Berger took over. Peter was experienced, courteous, and considerate, calling me every so often to tell me the changes they were making were really minor and he was very respectful of my work. When I finally saw the finished film, I hardly recognized it.

Meanwhile, Taylor Hackford had been prepping another picture titled *Love Ranch*. It starred his wife Helen Mirren and Joe Pesci, who hadn't done a film in years. I was thrilled at the prospect of being back on a feature with Taylor, who since *E-Ring* had busied himself as president of the Directors Guild. I was looking forward to seeing Helen's performance,

and she fully lived up to my hopes. My daughter Gina, who had worked with me on *Righteous Kill*, was once again an assistant on the picture. I assigned her the task of organizing the footage for a complicated boxing match that Taylor had filmed over many days. I could never have gotten through it efficiently without the prep work she did on it.

The first cut was around three hours. Taylor and I started cutting the picture down. But suddenly, how to accomplish that turned out to be the least of our worries. It was September of 2008, and while we were working the economy blew up. Immediately, we stopped being paid.

I asked the postproduction supervisor on the film if we were being laid off. "No, they want to keep you on."

"But they're not paying us," I said.

I kept coming in for a while, but it seemed pointless, since we weren't doing any work. The union requires producers to give us a week's notice before laying us off, but the notice never came. After a while, I stopped going in. Months went by, and the economy was spiraling downward. But still, we were technically on payroll despite not being paid. The weeks of salary we were owed by the company just kept piling up.

Then, in the spring of 2009 I got a call from Gil Adler, whom I knew from *Home Movies* back in the 1970s. Gil was a producer on a little horror picture shooting in New Orleans titled *Dead of Night*, based on an Italian horror comic book called *Dylan Dog*. He offered me the job. It was not at all the kind of project I had any interest in, but I needed to earn some money. My situation reminded me of something my friend Nick Meyer had said of his own career at that time: he felt like "a polar bear jumping from one melting ice floe to another."

In an odd but fortuitous coincidence, Gil had made a deal with the same people from whom *Love Ranch* was renting rooms and equipment. This led to an extraordinary situation, unique in my career. They set me up in the exact same room. I had an Avid on one side of the room for one picture, and a second one on the other side for the other picture. And sure enough, while I was working on *Dead of Night*, *Love Ranch* was revived.

I didn't know how I was going to do two pictures at once, but the two directors worked out an arrangement by which they shared me, taking days off so I could work on the other picture. I felt like a child in a joint custody arrangement. Working two pictures that way, the paltry salaries

I had been forced into on each one added up to what I normally made. In the end, neither picture performed well at the box office.

These were among the darker days of my career. I had once been cutting big-budget movies, with big stars. Since *Pluto Nash*, all the jobs I had were lower-budget projects, which pay less. In addition, the results were mediocre at best—with the exception of *Ray*. It reminded me of the biblical story of Joseph and the seven years of famine.

But then I got a call from Mark Gordon. He was producing a picture called *Source Code*. I read the script, by Ben Ripley, and loved it. It was the best script I had read in a long time. I felt my fortunes turn.

Speaking of scripts, I haven't said much about the writers of the films I've cut. It's not that I don't appreciate their contributions. I do. Without writers, no one else who works in movies would have a job. It's mostly due to the fact that when I join a project, I come in very late, and all the arguments over the script among the writer, director, star, studio, and producer have already been resolved. I have made suggestions at that point, but by the time I join the party it's politically awkward and too late to make any significant changes. When I'm working on a picture, I try not to get overfamiliar with the script, so that I can respond spontaneously to the dailies. My medium is not the written word but the filmed images and sound. The editing is, of course, the final rewrite of the script, to the degree that the changes we want to make are possible.

Both editors and writers have historically felt ignored and undervalued by the film community and the press. In my opinion, the writers have a much stronger case, based on what they bring to the table—though frankly there's not much point in comparing degrees of underappreciation.

It took them a while to get *Source Code* going, and the director left the project. I was asked to meet the new man who was taking over.

Which is how I met Duncan Jones.

30

Back to the Big Time

I'VE WRITTEN ABOUT HOW GETTING past "old" and achieving "venerable" status can get you work as a film doctor. There is a second way to prolong your career—as the old hand to be paired with promising but inexperienced young directors whom producers are taking a chance on. This was most likely why Mark Gordon hired me to work with Duncan Jones on *Source Code*.

Duncan's father is David Bowie, so I wasn't sure what to expect. I guessed someone brought up in what I imagined to be highly privileged and unusual circumstances might be difficult, but the opposite was true. He turned out to be down-to-earth: friendly, polite, unassuming, likable, and easy to talk to. His business partner, a younger man named Stuart Fenegan, who had been one of the producers on Duncan's only picture to date, *Moon*, joined him in the meeting with me. We chatted about this and that, with some lovely compliments from them about *Star Wars*, when they asked me how long I had been cutting digitally.

"Well, the first picture I cut on a Lightworks was *Mission: Impossible*, but I really wish I had cut the previous one on a computer. That was a crazy project, with miles of film, and it would have been a lot easier if we had done it digitally," I said.

"Which one was that?" Duncan asked.

And for the life of me, I couldn't remember the title. It was *I Love Trouble*. (Maybe that explains it.) I stammered. "Hang on, it'll come to me," I said. But I just couldn't summon the title to mind.

It was becoming awkward when Stuart bailed me out with a joke. "I wish I had made so many movies that I couldn't remember the name of one of them," he said, and we all laughed.

The picture was filmed in Montreal. I had hired Gina as my second assistant and wanted her with me in Canada. For budgetary reasons I could bring only one assistant along, so I had to hire a local first assistant until we went back to the US.

Hawk Koch, the executive producer, had arranged to house the cast and crew in a building in Old Montreal. Gina and I were given an apartment to share. Hawk was the son of legendary producer Howard Koch, a man beloved by all who knew him, and he'd changed his name from Howard Koch Jr. late in life. Hawk had worked for years as a first assistant director and had many fabulous stories to share.

By coincidence, we were set up in the same complex outside the city where *Pluto Nash* had been shot. The cutting room was right next to the extras holding pen and the spot where they served lunch. Downstairs on the soundstage was the train interior where much of the action was set. Green screens were visible out the train's windows and would later be replaced by film plates representing the passing scenery.

The premise of *Source Code* could be described simply as *Groundhog Day* done as a thriller. The hero, played by Jake Gyllenhaal, is a soldier who wakes up on a commuter train bound for Chicago, with no idea where he is or what he is doing there. A lovely young woman across from him, played by Michelle Monaghan, is speaking to him as if she knows him, but she is using a name unknown to him because, as he soon discovers, he is inside another man's body. Eight minutes later, a bomb on the train explodes, and Jake wakes up disoriented in a new location, a mysterious, strange cockpit. A woman in an army uniform, played by Vera Farmiga, is addressing him over closed-circuit television. She instructs him that he is on a mission and that he is to find the bomber on the train and stop him. She sends him back

to the train, and he relives the eight minutes again, ending with the bomb exploding again. All the events on the train are repeated, except his new and different responses alter them slightly. He is sent back repeatedly until he is able to identify and foil the bomber.

To communicate to the audience that we are reliving the same eight-minute period on the train, certain events are repeated. A ring tone on a cell phone sounds, a cup of coffee is spilled, a passenger makes a joke, and so forth. Michelle repeats the same lines, although Jake changes his responses as he begins to sort out what is going on. As soon as the audience grasps the concept, we have to be careful not to bore them through too much repetition. And yet, some repetition is necessary. Drawing the line between too much and too little was the challenge.

The solution was to go faster each time. The gag required less time in each succeeding iteration. At a certain point, it became a montage.

Because the picture was shot in Montreal, a second unit was engaged to shoot some exteriors of Chicago to be used as the plates for visual effects shots. This involved hiring a helicopter for a day to shoot aerial shots of the train. Shooting the train footage took the second unit only half a day, so they went and shot downtown as well, even though there was nothing in the script that called for it. It had been a bright, clear day, and the city looked spectacular on film.

Around this time, I saw Roman Polanski's *The Ghost Writer*. The score was composed by Alexandre Desplat, who hadn't yet reached the height of his fame. It reminded me of Bernard Herrmann's work in its boldness and nervous energy. By coincidence, the local assistant I hired had worked on Polanski's film. I told him how much I liked the music in the film, which wasn't yet available to the public.

"I might be able to get you a copy," he told me.

"Please do!" I replied.

The main title, when I heard it again, seemed better suited to our film than the one it was written for. It had tension and drama and was suggestive of a train. I used it to cut together a main title sequence of aerial shots of the train and of Chicago. I have loved title sequences ever since working with Bernard Herrmann.

The sequence was a success with everyone, and it stuck. I brought on music editor Mike Bauer to cut the rest of the temp track, and he did

a brilliant job, although Duncan was initially uncertain about the tone. The editing of the film proceeded fairly normally, although Duncan, who had a free hand during the making of his first film, *Moon*, felt a bit pushed around. He was unused to working with a strong producer and had not gotten along very well with the DP. He reacted by withdrawing, saying (and I'm paraphrasing), "This is not really my film. I get it. I'm paying my dues in Hollywood, but I don't really feel as though this is mine."

I told him that the director is always given either the credit or the blame for a film, and like it or not, this was *his* film. As Jonathan Lynn has described the job, "The director goes into the first test screening as the captain of the ship, but if it goes badly he comes out the culprit."

The end of the picture was one of the last elements to jell. There was an epilogue that dramatized the paradoxical nature of time-travel films. It took the form of a letter that was read in voice-over. I found it clever and liked it, but it had a sour tone that audiences had trouble with. The message had an antiwar quality reminiscent of the end of *Johnny Got His Gun*, in which the mutilated hero asks to be put on display to discourage young men from going to war. The audience, though, was not receptive to that. At the end of one of the previews, there were discussions about cutting the epilogue entirely. So Duncan rewrote the voice-over so that Jake's character embraces the idea of going on future missions. It made him seem more heroic and turned out to be more pleasing to the audience as well. Some people might justifiably feel that we had subverted the point that Ben Ripley had started out to make. But these films are big investments with millions of dollars at stake, and as they say, we are engaged in "show business, not show art."

Around this time, I was approached about cutting the next *Mission: Impossible*, the fourth in the series Brian DePalma had initiated. It was subtitled *Ghost Protocol* and was being produced by J.J. Abrams and directed by Brad Bird, the animation genius behind *The Incredibles* and *Ratatouille*,

as well as *The Simpsons* earlier in his career. Brad was to be directing his first live-action film.

I had to go to Bad Robot, J.J.'s company, to read the script. The security around the project was so intense that they wouldn't give me a copy. I had to read it on the premises, and adding to the inconvenience, the paper it was printed on was a deep, eye-straining blood red. The idea is to prevent its duplication, but it's pointless. Anyone wanting to copy the script could just scan the pages in color.

I went to meet Brad at Paramount accompanied by Ben Rosenblatt, who handled post for Bad Robot. Ben was a jolly young man who clearly knew his stuff.

Brad was in his early fifties but had a boyish quality about him and looked younger than his years. With strawberry-blond hair and crinkly blue eyes, he looked like a grown-up Huck Finn or Dennis the Menace. I spent a half hour with him while he talked to me mostly about himself. This was fine, except I left there wondering if he had learned anything at all about me, the interviewee.

I then went to Bad Robot, where I met J.J. and his longtime pal and producer Bryan Burk, a.k.a. Burky. After some teasing about *Pluto Nash* from Burky and some very nice compliments from J.J., I was hired. After eleven years, I was back in the big leagues, on an important picture with an ample budget.

The only problem was that there would be a brief conflict with *Source Code*. I explained to Duncan and Mark Gordon that I had to go to Prague for a week at the start of shooting on *Ghost Protocol*, but after that I would be working five minutes away from the *Source Code* cutting room. I promised to make myself available to consult should the need arise, and they generously agreed. We had locked picture, so the overlap was doable.

Late one afternoon, I got a call from Duncan. He told me he had received some demos from his composer and asked if I would come over and listen to them. I went over on my way home that evening.

Demos from composers have become increasingly elaborate and sophisticated. They often sound just like a full orchestra. But these sounded as if they were played on a twelve-inch Casio, and one of the main themes consisted of just two notes alternating over and over like a French ambulance

siren. I told Duncan I thought they were extremely worrying. There were only four weeks left until the final mix.

"What should I do?" he asked.

"Here are your choices," I said. "You can sit with him every day and get him to write a better score." (Like De Palma did with Elfman.)

"I can't do that."

"Or you can tell him to write the temp track"—by which I meant essentially copy it, changing it just enough not to be plagiarizing it.

"I can't do that either."

"Or you can replace him and tell the new composer to write the temp."

"I think that might be what we have to do."

"Has Mark Gordon heard this?" I asked.

"Not yet."

So, we called Mark, whose office was nearby. He came, he listened, he agreed.

"Who can we get to do the job who won't be insulted by being asked to copy the temp?"

I had just the man in mind. James Newton Howard was the composer Taylor originally wanted for *Love Ranch*, but he couldn't do it and recommended a young composer in his stable. His name was Chris P. Bacon. He had been forced to work with an extremely low budget, using only a few instruments, and I had been impressed with how he had designed the score. His themes were developed and varied according to the dramatic context in which they played. He was young, relatively unknown, and would not feel insulted by being asked to imitate a temp track.

Most composers resent temp tracks. In a perfect world, they would be presented with a blank canvas on which to paint their composition, inspired only by their own sensibility. The problem is that films need a soundtrack before the composer gets involved, so it is up to the director, the editor, and the music editor to construct a temp track. The composer, hired later, then has to listen to and adopt, or adapt, the choices that were made regarding the score before he or she ever saw the film. Every so often I address a class taught by Dan Carlin for young composers at USC. I play them the temp cues we used in *Star Wars* and then play John Williams's cues for the same scenes. Sometimes he was very closely influenced by the choices we made. Sometimes not. The class is a real eye-opener for young composers.

Chris showed up at the cutting room the next day wearing a hospital bracelet on one wrist. We asked him about it and he told us his wife had just given birth to their second child. He agreed to start immediately, however, and we all complimented his wife for being such a trouper. Fortunately, Mike Bauer had cut together a wonderful temp track, and it provided a solid guide for Chris to follow. He did a great job of capturing the intention of the temp while endowing the score with a unity that can only be achieved when the final music is written.

With that fire extinguished, I turned my attention to *Ghost Protocol*. I was away in Vancouver when *Source Code* was released. It was like thirty-five years earlier, when *Carrie* came out while I was in Marin: I missed the hullabaloo and the excitement of both.

Source Code fared well at the box office, although not as well as I expected. It made over $150 million worldwide and has a solid critical reputation.

Duncan has even started accepting compliments for it.

It was only after I had been hired on *Ghost Protocol* that I learned how it happened. Ben Rosenblatt had been proposing one action editor after another to Brad, who rejected them all. "I hate the way they cut action," he complained. "You can never tell what's going on in their movies. I want this to be cut more like the first *Mission: Impossible*."

Ben replied, luckily for me, "I think that guy is still around."

I agree with Brad's sentiment about the way action scenes have come to be cut, almost like montages. The scenes seem to be trailers for the scenes rather than the actual scenes themselves. What I have always loved about movies is their ability to transport me to a different time and place. When action scenes are cut like trailers, you lose that sense of actually being in another world. It's all just a spectacle without involvement.

I watched Brad's picture *The Incredibles* again, noticing how well the action sequences were "cut." I was going to have to be at the top of my game. Once again, I hired Gina to be one of my assistants.

For the first week of shooting I was sent to Prague, which was standing in for Moscow in the movie, although there had already been some second unit shooting in Red Square itself. The first day, I was taken to a screening room where we were to view some tests shot the day before. Many of the crew were there, all waiting for Cruise to appear. When he did, ushered in by his security team, he gave me a big hello. I was surprised. I didn't think Tom would even remember me. On the first *Mission: Impossible* we had hardly spoken. "Great to see you, buddy!" he enthused. Tom is the most intense person you have ever met. If you inquire as to how he is, he replies, "Making a movie!" with a grin on his face, as if that explains it all.

"Great to see you too, although unlike you, I've changed in the last fifteen years," I replied.

It was true. He didn't look a day older, although he had been in his early thirties then and was now in his late forties. I had been fifty and was now sixty-five. On the first *Mission: Impossible*, after Brian had fired three veterans from his crew, he told me, "When you reach sixty in this business, you're through. Something happens to you and you just don't have it any more."

I was determined to prove him wrong. In this job, we are always being tested. When you are starting out, you have to prove you've "got it." Later on, you have to prove you've *still* "got it."

Usually I hate going on location and hanging around the set those first few days. However, we were shooting inside Prague Castle, its gate flanked by two statues of fighting giants, one clubbing his foe, the other stabbing his. Inside, I got the chance to explore and photograph some extraordinary spaces, including a ballroom candlelit by rococo ormolu sconces and crystal chandeliers. I imagined the room 150 years earlier at the height of the Austro-Hungarian Empire, filled with women in ball gowns and men in formal dress and glittering uniforms, each one thrilled to be there, waltzing dizzily to a live orchestra and drinking champagne. Now it was bare, with a film crew invading its ghostly beauty.

Cruise had gym equipment set up in a room nearby. He exercises religiously. He makes his living with his appearance, and he is extraordinarily disciplined about his body. He eats only a strictly prepared diet, brought to him on a rigid schedule in plastic containers. Paradoxically, he loves to treat people to cakes, cookies, burgers, and all sorts of irresistible fattening foods he would never touch himself.

––––––––––

Once the work there was completed, the company moved to Dubai for a month of location work, and I returned to L.A. I settled into my room at Bad Robot. J.J. employed a gourmet chef who served lunch every day, and the kitchen was in the middle of the ground floor, open to all. To avoid attracting unwanted attention, the company's sign on the building outside read NATIONAL TYPEWRITER CO. Secrecy surrounding the film required that you enter a PIN code on a keypad to move through various doors in the building.

Bad Robot and I differed over who was to be my first assistant. I wanted to hire Mark Tuminello, who had assisted me on my previous two pictures, but they objected. I'm unsure why they didn't want him, but I compromised. They let me keep Mark on the team and I hired Evan Schiff to be the first. He was young, computer savvy, and extremely fast. He did a fine job, but I never lost confidence in Mark.

When the Dubai shooting ended, the company moved to Vancouver. Now I was supposed to relocate there to be with them. On big VFX pictures like this, sequences involving effects have to be locked as soon as possible to give the digital graphic artists enough time to do their work. So off I went to Vancouver. Most of the crew stayed in L.A. while Evan accompanied me to British Columbia. Jane agreed to come too. It's difficult for her: when she accompanies me on location, as she did for many years, she is forced to make a life for herself, largely by herself. I have a job and a purpose. She does not. I have work colleagues and a social life related to work. She is alone. So at a certain point she stopped coming, which meant we were separated for weeks or months at a time. My weekends became very lonely, and I didn't want to do that anymore. I told her I was prepared to turn down *Ghost Protocol* unless she came along. But, loving wife that she is, she agreed to come for the later part of the shooting and the director's cut.

On this picture, the dailies were distributed in an unprecedented way. The days when everyone gathered in a screening room at the end of the day and watched the rushes together were long gone. Now the rushes were transferred to iPads and then handed out by our PA, our postproduction assistant. He had a stack of the tablets, and every day he would collect the previous day's from the recipients and give them the freshly loaded ones.

As a director, Brad was a little remote, so the second unit director and people from the art department would come to me with questions I was able to answer. Occasionally, they would ask to see a cut scene. I never show anyone cut material without the director's OK, but when I checked with him, Brad never minded. I then started getting requests for cut scenes to be placed on people's iPads. This was heresy.

In all my years in editing, no one ever had access to my cut before the director had a chance to work with me on it. But Brad OK'd it. It was disconcerting to go to the floor and see the first AD looking through cut sequences on his iPad—not that I was embarrassed about it. I was just unused to it. This was my first iPad movie. I thought, *This is the way it's going to be from now on.* As it turned out, it was my last. On the next picture, the technology had evolved yet again, and people were able to stream the rushes from a secure website.

Eventually the producers leaned on Brad to come work with me on locking some of the more complicated effects sequences. He and I started to relate as we committed to takes and frame counts. If those are changed later, there are costs involved. Working this way creates a certain amount of waste, since you can't really make final decisions until you have the whole picture in front of you and can, with the benefit of context, see where the problems lie. There are always shots that get lengthened or even abandoned. It just can't be helped. But ILM had laid out a delivery schedule we had to adhere to.

We finished shooting and moved to Skywalker Ranch for the director's cut. I had stayed in one of the apartments there when I was working on *Mission to Mars*. The ranch is seven miles up a winding two-lane

road from the freeway, and I didn't want to have to face that drive every morning and, worse, every evening. So Jane and I decided to stay in one of the apartments.

It was a decision I came to regret, mostly due to the ranch's isolation. I like to joke that first prize in a contest is a week at the ranch; second prize is *two* weeks at the ranch.

Our home in L.A. has a view of the ocean, and I didn't realize how much I had become used to seeing the horizon every day. The ranch, as beautiful as it is, is in a small valley with hilltops all around. It was like living at the bottom of a bowl for eleven weeks, which induced a feeling of claustrophobia. We relieved this on weekends by going for some magnificent walks in surrounding Marin County.

The cutting room too was magnificent. It was Pure George Lucas Northern California Rustic Opulent Chic. The lushly carpeted rooms were large, with tall windows open to the greenery. There was a screening room downstairs that linked with ILM in San Francisco, so they could play the VFX shots for us remotely. Suspended in the middle of the ceiling was a chandelier made of deer antlers. The room was state of the art, but to our amazement it had never been used before.

When I started working with Brad, I was in for a shock. First of all, he didn't want to screen the rough cut. We would start to watch a reel, and he would immediately want to stop and go back. He stumbled over small things, and we would have to address them then and there.

But the capper was the way he wanted to view the action scenes. "Do me a favor, play it for me one frame at a time," he said.

"Excuse me?"

"A frame at a time, like this," and he tapped his finger rhythmically: *tap, tap, tap, tap.*

"You're kidding, right?"

"No, I'm an animator. I can't tell what I'm looking at unless I see it a frame at a time."

"Well, I can't tell what I'm looking at unless I see it at speed."

So of course I humored him, and we would watch the film that way. We did a lot of what editors call "frame-fucking": adjusting cuts by a frame here, a frame there. It's true that a single frame can in many circumstances make a noticeable difference, but there are many times when one frame is

totally inconsequential. But part of the editor's job is to give the director what he wants. And so we went through the cut a frame at a time.

It turned out to be more interesting than I thought it would be. Brad would sometimes drop a frame from an action. He would do it so that the omission was imperceptible but the result was palpable. If a punch or a kick looked a little floaty, or slow, removing a frame either from the windup or in the middle of the action could make the action seem sharper and more decisive. I remembered seeing Bruce Lee in *Enter the Dragon* and marveling at how fast his hands were. Hah. He had the editor's help! I have since adopted this little trick, to great success.

Brad had another rule he insisted on. He always wanted to cut in the middle of an action rather than at the end of it. I sometimes prefer to cut at the end of an action, when the image is momentarily still. For instance, if someone swings a hammer down, I might cut when the hammer has come to a stop, even for one frame.

The stillness of the image on the last frame of a cut is accentuated by the biological phenomenon known as persistence of vision, especially when you are cutting from a strong image to a weaker one—say, from a close-up to a wide shot. So we see the image, briefly, even after it's gone.

In my version, therefore, the action was occasionally punctuated by brief still images. It is a technique I have used throughout my entire career. But Brad always wanted me to extend the shot a frame or two so that the hammer would start its next movement upward before cutting away.

I was describing this to Walter Murch, who lived nearby. "He says he wants to make everything smooth, but I like it crunchy sometimes," I said.

"Yes, keep it crunchy," replied Walter.

But crunchy was not what Brad wanted. And as I said, giving the director what he wants is part of the editor's job. The other imperative is to do what is best for the picture, and the two do not always jibe. Protocol requires doing the first over the second. This is small potatoes, all in all, and audiences probably wouldn't care one way or the other. But I did care, and no one likes to be told what to do. I have worked with directors who trusted me and understood that my ideas and suggestions were always intended to improve the picture. Others, for some reason, have distrusted my intentions—at least they acted as if they did.

On this subject, I would quote David Mamet on editing, in a statement read aloud at the Academy Awards in 2002. I don't agree with all of it, but the essence is true: Editors care about the film above everything else:

> The humbling truth is that a film is made in the editing room. The most magnificent performances and the best intentions mean nothing if they don't cut. The film goes by at twenty-four frames per second, and however lovely it is, however thoughtful it is, however deeply felt, all the audience cares about is what happens next. The director, the actor, the designer, the writer can and do become sidetracked, confused, indeed even inspired into serving two masters—the story and themselves. The editor serves only the story. As such, they are the best friend of the audience, and time and again, the salvation of the filmmaker.

If only all directors took this to heart.

We went on working on the cut. There are occasions when it is necessary to watch entire scenes at a time, sometimes full reels, in order to feel the rhythms and tempos. Metaphorically, it's like working on a mural. Sometimes you have to step back to see the whole thing. Brad never could. When we started out to watch a whole scene, he would need to stop at once if he had a problem with even the smallest detail. It was frustrating, but everyone has his own way of working. The last reel was heavily intercut and needed to be evaluated in toto, because we needed to see if the pacing of the intercuts was working, but every time we tried, he would want to stop frequently. His years as an animator were manifest in his work process.

On top of that, the opening of the picture turned out to be a problem. We tried doing it the way it was written, but we realized that it didn't work. Originally there had been a battle on a frozen lake with snowmobiles, intercut with some scenes on a train and at a train station. But the studio cut the snowmobile scene in order to save money. So we had the train action, but not what it was meant to be intercut with. After attempting some other approaches that also didn't work, the solution we

devised was to take some of that action at the train station and come in in the middle of it.

At the start of the film, with no explanation, a man bursts from a doorway onto a rooftop; two men follow, shooting at him; he leaps off the edge of the building, throws down a small object, and pivots in midair, firing back at his pursuers, killing them, then lands on what turns out to have been a compressed airbag that has inflated just in time; another would-be assassin appears around the corner and our man shoots him; he gets up and dusts himself off, checks to see that a sheaf of documents in his shoulder bag is safe, then starts to walk away, when a beautiful blonde woman appears, walking calmly toward him; his smartphone starts to ring; he looks down and sees that a facial recognition program has identified the woman as a known assassin, and before he can react, she guns him down, takes the bag, and makes her escape.

This is the best kind of opening for a thriller. As Lee Child, author of the *Jack Reacher* series and the master of page-turners, once explained, "It's very simple. You create questions in the reader's mind. Then, they just keep reading to find out the answers to those questions."

You would think that everyone in the movie business would know this. In any event, the second and crucial part of making the opening work is finding the right moment in the film to provide the answers to all these questions. The second scene in the picture has Cruise breaking out of an Eastern European prison with the help of the IMF (Impossible Mission Force) team. Later on, he is catching up with what he missed while in prison. We took the unused material from the train station that was meant for the opening of the picture and made it into a flashback in this scene, during which we put all the mysterious events at the start of the film into context.

Whether or not something "works" is a slippery concept. Like most people, I rely on my instinct. If it works for me, I expect it will work for a larger audience. This has been a reliable method for me, but sometimes there is disagreement among the filmmakers, which is why studios like to preview. It's like arguing about what's funny. The best definition I have ever heard comes from Carl Reiner, who says, "If a lot of people laugh at it, it's funny."

The best way to reach consensus on whether you have achieved your desired effect is to have an audience react the way you had hoped.

There were a few pickup shots necessary to make this change at the start of the picture work, and the last of these were to be filmed on location in a Vancouver train station. The producers organized a wrap party to be held there once we were done, and asked us to prepare a gag reel from the entire shoot to show during the party. By this time, Gina had been working on the reel for months. Gag reels always consist of actors screwing up their lines. How they react is usually the funny bit. On *Ghost Protocol*, Jeremy Renner and Simon Pegg would curse if they blew a line. They both got into the habit of saying "C**t!" which is quite common in the UK but almost never spoken in mixed company in the US. Gina had cut together a montage of each and every time they said it. It was hysterically funny.

But our executive producer freaked out. "You can't show that!" he shrieked. "We have all sorts of dignitaries from the government of British Columbia coming!"

Sadly, we had to show a much tamer version.

When we had cut in the new material, we kept working toward the day when we would have to show the cut to the producers, J.J. and the others. To me, it is essential to watch the whole cut to see if there are any problems. But I couldn't get Brad to do it.

Finally I said, "Well, I'm going to watch the picture all the way through. You can watch it with me or not, it's up to you."

He reluctantly agreed, and I felt hopeful that we were making progress. But when we did sit down to watch it, he took notes and spent half of the time with his head down, writing. I thought back to Herbert Ross's injunction that you only get one opportunity to see a picture for the first time. He would encourage people *not* to take notes the first time, since to do so you would have to take your eyes off the screen. George Lucas liked to watch the rough cut twice, once to get an overall impression and then again to take notes. Well, you can show a director a cut of his movie, but you can't make him watch it. Brad missed half the picture.

We moved back to Bad Robot. I was glad to be sleeping at home in my own bed again. Brad then decided to take his annual summer holiday with his family, and in the interim, producer Bryan Burk came into the cutting room to work with me on the cut. We reassured Brad that his cut would be preserved and that any changes Burky and I made in his absence would be subject to his approval.

I really enjoyed working with Burky. He was always upbeat, and whatever suggestion he made was always put out there in the best possible way. He made me laugh but also had some very good ideas. Brad had neglected to devise a dramatic entrance into the film for Jeremy Renner's character. So Burky and I scoured through the dailies and came up with what is in the film now. Still maybe not the greatest, but better.

How characters are introduced into films is one of the aspects of watching a picture that gives me great joy. I love it when directors can come up with a memorable piece of business. In some cases, like with Henry Fonda, Charles Bronson, and Jason Robards in *Once Upon a Time in the West*, the introduction speaks volumes about the character and defines him or her in the audience's mind from the start. In *Sunset Boulevard*, William Holden's voice over the image of his drowned corpse floating facedown in a swimming pool reveals as much about the tone of the story as it does about the character. In other films the character's introduction is simply memorable, like the cat leading us to Orson Welles as Harry Lime in *The Third Man*.

Before we got to the final cut, both Tom and J.J. Abrams came in to work with me and make some last-minute minor changes. Occasionally in discussions with the director, there is a choice that doesn't seem to matter very much. George Lucas used to say, "It's six of one, a half dozen of the other." That had always seemed cumbersome to me, too many syllables. I had a phrase that I used when I didn't feel strongly about something one way or the other. I had learned it from my stepfather. "How do you feel about that change?" Brad would ask.

"Ipsy-pipsy," I would say, and make a waggling gesture with my hand. I used it with J.J. once. He laughed. A few minutes later, a PA came into the room carrying a baseball cap with IPSY PIPSY embroidered over the

brim. J.J. had bought a cap labeling machine and texted someone in the next office to make it and bring it in.

We previewed in Phoenix. The previews, wherever they are, always seem to be in a multiplex in a shopping mall. We fly for hours to get to a theater that is virtually identical to ones all over Southern California. But studios feel they get a more representative sampling of "real" audiences that way. After it was over and the cards had been collected, the studio executives gathered in a room next to the projection booth.

After a quick tally of the cards, the research people came in and passed out brief summaries of the ratings the audience had given the film. The executives broke out into applause, with enthusiastic cheering. I had never seen anything like it.

"Just so you know," I told Brad, leaning over to his ear so I could be heard over the whooping and clapping, "this *never* happens. Just remember this."

We went back to Marin County and Skywalker Ranch to do the final mix. Gary Rydstrom was the rerecording mixer, along with Andy Nelson. Gary was also the sound designer and supervising sound editor on the film, along with Richard Hymns. Brilliant at his job, Gary had worked with us on the original *Mission*. He has seven Oscars to his name. Richard Hymns has three, and Andy Nelson has two. This was fast company. Gary had recorded brand-new punches for the film, no resorting to old library sounds.

We were just about finished with the soundtrack when Ben Rosenblatt called me. "TC is in Pittsburgh," he told me. "He's shooting *Jack Reacher* there, and he wants to screen the picture. He would like you to go and watch it with him."

"You're kidding, right?"

"No. Tom wants you there when he sees it in case he has any notes. And we have a few ADR lines he needs to record, so you can be there for that as well."

So I flew to Pittsburgh on my sixty-sixth birthday. I went straight from the plane to a multiplex somewhere. We watched *Ghost Protocol* in an otherwise empty theater late that evening. Cruise had been shooting on *Jack Reacher* for about twenty hours at that point. I wasn't sure what his reaction would be. Happily, he was satisfied. We went off to a local studio to pick up the last lines we needed from him. He is indefatigable. During the session, the ADR editor let it slip that it was my birthday. When I got back to the mix the next day, Tom had sent me a large chocolate cake and two bottles of very expensive wine. In addition, Brad had bought me a very fancy Jedi light saber. The cherry on top was something no one had ever done for me before. Ben arranged for me to have a private screening of the picture in New York, and I could invite anyone I wanted. Usually I have to try to get my friends and family back east invited to one of the publicity screenings the studio holds. This was my very first personal screening.

Ghost Protocol turned out to be the highest-grossing film of Tom Cruise's career to date. It made almost $700 million worldwide.

A few days before Christmas, a messenger came to our door carrying a beautifully wrapped box. "From Tom Cruise," the young man announced.

I went to open it right away, but Jane stopped me. "No. We have to put this under the tree. We'll open it Christmas morning with the rest of the gifts," she said.

So under the tree it went. On Christmas morning we unwrapped the box, and to our horror, discovered a large white coconut cake crawling with ants. "They might have said something about it being perishable," I muttered.

Jane loves coconut cake and was undeterred. She brushed off the ants, cut herself a slice of the cake, and ate it. It turned out that Tom has a list of regular recipients of these cakes, and we had been placed on the list.

We always refrigerate it now.

31

The Elder Statesman

By 2011 I REALIZED THAT my career had moved into a new phase. I had now achieved elder statesman status, and my jobs were now as either "film doctor" or "old hand." On *Source Code* and *Ghost Protocol*, I was hired to support relatively inexperienced directors. Duncan had shown great promise in his only film to date, while Brad had proven how gifted he is but had never before directed a live-action, big-budget feature.

I was now getting more work from studios and producers than I was from directors. The directors had to approve me, of course, but it was a subtle shift. My loyalties were not quite as clearly defined as when I was working for De Palma or Lucas. After the success of *Ghost Protocol*, Paramount approached me about one of its pictures that was in trouble. It was called *World War Z*, as in *zombies*. I don't care for zombies, were-wolves, and vampires. Not only that, it was also a two-hour-and-twenty-three-minute mess, and its third act was completely bewildering. So I was reluctant to take it over.

I met with the production executives and some of the producers and gave them my thoughts. I told them that the third act was hopeless. They actually already knew this. They are not stupid people, but often group-think takes hold, leading to errors in judgment.

Doctor jobs can be tricky politically, because someone other than the director, either the producer or the studio, is hiring me, and it often creates two camps. In any event, no matter who hires me, I am always trying

to make the best picture out of the materials at hand. But I still try to be accommodating to directors' sensibilities. In this case, however, Brad Pitt was the star and producer, so the director had to take a step back.

I still harbored hopes of getting on another picture from the start and was looking to get away from *World War Z* at the first opportunity. I asked the execs if they would consider hiring two doctors instead of just one.

"Who do you have in mind?" they asked.

"Billy Weber," I replied.

Billy is one of the great editors of my generation, and his career is similar to mine in that he has worked with many different directors. And although he is well known in the film community, the mainstream press renown that attaches to an editor who works exclusively with an A-list director has eluded him. This is true despite the fact that he has edited some timeless classics, like *Beverly Hills Cop*, *48 Hours*, *Top Gun*, *Midnight Run*, *Days of Heaven*, and countless more. I had known him for a long time but not well, and we had almost worked together on *I Love Trouble*.

The execs at Paramount knew and liked Billy, so they hired him to work with me to see if we could bring the patient back to health. They also agreed that we would be left to recut the picture as we saw fit and would not, for the moment, be taking notes from the director or anyone else. We also stipulated that we did not want our names on the film. This was because we could have more influence if we didn't appear to be trying to garner credit for ourselves. Also, I thought the picture was so bad that I didn't want to be associated with it. I explained to Billy that one of the reasons I had brought him on was that I wanted to be able to get away if the opportunity presented itself, and he was fine with that. He would take over if I left.

After a couple of weeks the execs were dying to see what we were doing, so we played our cut of the first reel for them. They were absolutely blown away. Reassured, they left us alone. We kept cutting scenes we thought useless or terrible, and by the time we were done the whole movie ran seventy-two minutes! And this after an expenditure of, reportedly, $170 million!

This couldn't be. It was decided that the studio would have to bite the bullet and admit that the third act would have to be reconceived,

rewritten, and reshot for it to have a chance. They decided to bring in Damon Lindelof, whom I had gotten to know at Bad Robot. Damon later cursed me for not warning him what a mess the picture was. But he must have done something right, because after reshoots of an additional forty minutes, with which I was not involved, the picture opened a year later to good reviews and to my astonishment was Paramount's biggest hit that year.

By then I had left the project and moved on. My agents had called about another doctor job, this one at 20th Century Fox. It was Ang Lee's *The Life of Pi*. This was very exciting. Instead of some stupid, infantile schlock about zombies, this was an ambitious interpretation, by an A-list director, of a book I had read and admired. I thought the film was a masterpiece, although it felt a trifle slow, so I took out about ten minutes. Though Ang was gentlemanly and treated me with respect, he rejected my cut. In the end, I wound up working only a couple of weeks on the picture, and none of my work is actually on the screen. But I did make a small contribution with two suggestions that Ang ultimately agreed with: that one scene be cut and another that he had cut be reinstated (the "Tiger Vision" sequence). I was happy to be involved in any way, and I thought the result was wonderful.

Another doctor offer came in. Warner Bros. was looking for help on Australian director Baz Luhrmann's remake of *The Great Gatsby*. I watched Baz's cut, which the producers and the studio were unhappy with. It was very chaotic, filled with the razzle-dazzle that is his trademark, and too long. But the drama was solid, and it seemed the problems were really about clarity and length. The pace was very dynamic, so that was not a concern.

Slow and *long* are two very different animals. A picture can be either or both; ideally it will be neither. In some cases, the pace of events may drag. The audience is asked to wait for each next beat to occur, but at the same time the running time may be fine, not overlong. Other pictures may have a quick and engaging pace but go on and on seemingly endlessly. Baz never has a problem with pace; his movies tend to be cut

very quickly, dazzlingly so. But I thought the picture was too long and needed some clarifying.

Before meeting with Baz, I asked the head of postproduction at Warner Bros. who had final cut on the picture. It's important to understand the political landscape in these situations.

"The studio does," he replied, "but if Baz were adamant about something, I don't think we would force him to make a change he didn't want."

To me, this meant Baz had final cut.

I went to meet Baz early one morning at the famous Chateau Marmont on the Sunset Strip, where I had stayed almost forty years earlier when George Lucas hired me on *Star Wars*. We met in the lobby over a cup of tea. Baz is a very engaging person, charming, well educated, with a refined eye for the decorative aspects of filmmaking and a great enthusiasm for camera movement and dynamic cutting. He was clearly immersed in the project. I'm not sure what they had told him about me, but he seemed very willing to have my help. "I would love to have you help Matty [his editor and countryman Matt Villa] with the ending—"

I interrupted him. "That wasn't what I had in mind," I said.

He looked surprised. "What do you mean? What did you have in mind?"

"I would like to make a pass on the picture without benefit of notes from anyone, just reacting to the cut based on my own intuition, and present that to you."

He thought for a moment. "Who would see this?"

"Just you. I would be working for you," I replied.

"Great!" he said. "I am going to call them and tell them that *you* said that no one would see your cut but me."

He did and was told that was fine, as I expected.

When I showed him my cut, he was very polite and poised. I had taken out about twelve minutes, bringing it down to about 2:05. "I think you are right about the length of scenes," he said, "but I miss some of the details you took out."

He, Matty, and I then talked at some length about the various changes I had made and why. The conversation reached a pause. I wasn't sure what to expect at that point. I thought that, like Ang Lee, he might say, "Thank you very much for your contribution, goodbye and good luck."

"Do you see a continuing role for me in this, going forward?" I asked.

They both looked shocked. "Why, of course!" Baz exclaimed, to my surprise and pleasure.

And so I began working as part of the team. Matt was the lead editor, so it was agreed that when Baz OK'd something I had cut, I would pass it over to Matt and he would cut it into the body of the picture. Matt was a lovely guy who would greet me each morning with a cheery, "Hello, dear Paul!" His wife was in L.A. with him, along with their young child, but Baz kept Matt working around the clock. Jane reached out to Matt's wife and spent some time with her, knowing how difficult it can be to be alone on location with a small child while your husband works long hours.

The experience of working on *The Great Gatsby* was a wild ride. I had a terrific time working with the Aussies, Matt, Baz, and Baz's wife Catherine Martin, or C.M., who was a producer on the picture. They were so friendly and welcoming that it was a joy to be there. Baz turned out to be a bit mad, in a nontoxic way, for me at least. He did put his countrymen through their paces, working long hours and late into the night. He is an artist and is driven by a restless, insatiable search for something he would be hard put to define. He was always seeking to improve the film in any way possible. Over the course of eight or ten weeks, Baz asked me to recut various scenes. When he looked at my work he never expressed any displeasure. On the contrary, he loved everything I showed him. But he would always say something like, "That's great! That gives me an idea. Why don't you do a version where we try . . . ?" Or, "Terrific! Now let's do one with a different ending."

He was never unhappy, but he never accepted anything. Somehow, the way he did it, I never felt rejected. But you could never pin him down. He always wanted one more alternate version, and I felt like it was a never-ending game between a man and his dog, where he would throw a stick and the dog would happily fetch it and bring it back, only to have him throw the stick again. In this version, I was the dog. My tail was wagging the whole time.

We had a preview a few weeks after I started, and the producers and the studio were happy. Some of the changes I had made had stuck, and it was generally felt we had made progress. Baz's team all went back to Australia to mix the soundtrack, and we parted ways. When I saw the final film, I realized that Baz had kept making changes right up until the last

second. There were still scenes that were just as I had cut them, but much of the picture had been reworked. I was still very happy with the film, which overall I thought was highly entertaining and faithful to the book.

The critics were not terribly friendly. It still amazes me to this day that they can find fault with a high-minded adaptation of a great novel that may fall short in one respect or another but give much friendlier reviews to films that aim much lower and hit their target. Why *World War Z* got better reviews, I will never understand. It's about zombies!

Some months went by. I had a meeting with an Icelandic director and his producer. The producer was like a fanboy. He knew all my credits and asked me questions about *Star Wars* and *Ferris*. But the job went to someone else. This reminded me of a conversation I'd had with the legendary Ralph Winters when I first moved to L.A. He had won Oscars for editing *King Solomon's Mines* and *Ben-Hur*. Yet he told me he couldn't get jobs anymore.

"With all your credits?" I asked.

"Yes, they call me in and love to hear all the war stories, but then they offer the job to someone else."

I couldn't believe it. He had cut the galley scene and the chariot race in *Ben-Hur*! But now it seemed this might be happening to me. Fortunately, Duncan Jones asked me to edit his next film, *Warcraft*.

We are now in the Era of the Franchise. Studios are desperate to produce pictures they can base a series of films on. Movie stars seem not to have as much drawing power at the box office as they used to, so the best way to market a picture is to have it presold, as part of an existing series. That way, the audience knows what to expect. This was the thinking on two big-budget films I cut that were intended to launch franchises, *Warcraft* and *The Mummy*. On both films, I was to be the old hand who would support and backstop the young director. Duncan, on *Warcraft*, had only two smaller films under his belt. *The Mummy*'s director had a lot of experience as a TV writer and producer but had directed only one small feature. Both films were expensive, VFX-laden fantasy films. Neither one fared very well, although neither ended in total catastrophe.

Interestingly, both films, produced by different studios, suffered from the same problem. The producers and executives forgot rule number one of creating a franchise: make the first picture so much fun for the audience that they will want to see another. Two successful examples are *Star Wars* and *Raiders of the Lost Ark*. But with *Warcraft* and *The Mummy*, the studios loaded down the scripts with all sorts of exposition relating to the films that would follow that the audience couldn't care less about. The producers of *Warcraft* even added "The Beginning" to the title. *The beginning of what?* I wondered.

Both pictures previewed badly. On *Warcraft*, audiences were confused, and the producers thought the solution was to have more exposition at the start of the film. So we added a crawl to explain things. Then the audience couldn't process all the information and got even more confused. So the producers kept adding more information, playing looped lines offscreen or on the backs of characters' heads. They were approaching storytelling as if they were writing a contract. "How can they be confused? We put in a line that explains that." *We covered that in clause 3, subparagraph b.*

But it doesn't mean that bit of information is going to land. You want to raise engaging questions at the start of a film. You don't want an explanation of the rules. On *The Mummy*, the same thing was tried, slathering on more and more information. Both pictures were reshot extensively, to no avail. Both pictures brought in "fresh eyes" at the very end, pointlessly, and without achieving better results. Both wound up test screening alternate versions in a vain attempt to snatch success from the jaws of failure.

They were both unhappy experiences for me, except for one redeeming aspect. On *Warcraft*, my daughter Gina got a chance to do some cutting and was awarded a credit for "Additional Editing." On *The Mummy*, she was hired as a full editor from the start, with a main title credit. At her urging I hired a crew that was 50 percent women. Not only did they perform diligently and professionally, but they also altered the atmosphere in the cutting room for the better. It was a good call.

During the years that Gina was working her way up in editing in L.A., my son Eric was following a parallel path in sound mixing in New York. After starting at the bottom of the totem pole at Sound One in 2003, he gradually worked his way up and is now one of the top mixers in the city, regularly mixing features and TV series.

Postscript

WE HAVE REACHED A CRITICAL MOMENT in the history of Hollywood films. There are fewer traditional studios today than ever before. Theater attendance in the twenty-first century is down as a result of the "disruptive" (read "destructive") effects of the digital revolution. The breathless reporting of "who won the weekend" has morphed into the social networking of sites like Rotten Tomatoes, which reduce films to numerical ratings and can consign pictures to failure before even one showing. New "content providers" relying on streaming technology are forcing older studios out of business and redesiging the business model. Many pictures today are not even released theatrically, so there is no box office number from which to infer how well they are received. While their parents or grandparents loved going out to movie theaters, today's young audiences have many forms of alternative media competing for their attention. I've read that watching others play video games online is very popular. It would be a shame if cat videos were sufficient to satisfy the audience's need for entertainment.

The digital revolution has affected filmmaking in other ways too. It is common practice to build only parts of sets now. This saves money and time during production, but it means relying on VFX to provide set extensions. Even films that don't seem to have VFX in them may have hundreds of them. This means hours and hours spent in postproduction, designing and refining what used to be baked into the dailies.

Less care is taken with lighting on set. Subtleties of light and shadow are achieved when taking the dailies into the DI suite. There, directors and cinematographers can add shadows or highlights they hadn't taken the time to do on the set, which was the way it used to be done. The new technology enables directors to focus unnecessarily on details in unproductive ways, if they happen to be obsessive-compulsives.

It's not just the movie business that is being forced to transform. Business models in news, television, publishing, music, transportation, hotels, and retail are all under attack. We are in the midst of the Fourth Industrial Revolution, with its astounding advances in robotics and AI. The civilization we grew up in is being destroyed at a never-before-seen pace and being replaced by we know not what. And many of us are not happy about what we are witnessing. Much of modern life is spent negotiating with computers rather than using them, following routines designed by software engineers. Enter your user ID, now your password, password must contain etc., etc. Robots are asking you to prove you are not a robot. We are becoming like rats in Skinner boxes, pressing buttons for pellets of food.

For immigrants from the twentieth century like me, these are discomfiting times. I believe the heightened rate of change has helped generate political ripple effects all over the world.

Technology has also spread filmmaking to the general public. High school kids learn how to edit, sometimes posting their own versions of feature films on YouTube. In November 2016, during a Q&A session I conducted at Cinema Action in Paris, an audience member asked me if I had heard that someone on the Internet had recut *Raising Cain* and that Brian had been quoted as saying that he preferred it to the existing cut. What did I have to say about it?

"He should have gotten that guy to cut the movie," I replied.

Some of the work of these amateurs is extraordinary, demonstrating to me that talent doesn't need to be (or can't be) taught. Computers are empowering individuals in all manner of human endeavor. This isn't necessarily a threat. Pencils have been around a long time, but it doesn't mean anyone can write a novel or a play. For editors, however, these advances in technology do seem to have had a negative effect. There appears to be less respect for editors in general and for the contributions

we can make. Before the computer age, cutting celluloid required skill as well as taste. Editing film dailies was like painting in fresco; you had to be fast and sure. You had an intimate, direct physical relationship with a tangible medium, and there was a premium attached to getting it, if not right, at least close, the first time around. We danced to the film, and the machines we cut on were our partners.

I have led a charmed life. The conventional wisdom is that Hollywood is filled with backbiting and generally reptilian behavior. That does exist, but I have benefited from the kindness of a great number of people, and I found in writing this book that I keep repeating how grateful I was at different points in my life. In my fifty years of editing films, I have worked with many different directors, some more talented than others. Many of them admired my work, liked my ideas, welcomed my suggestions, and generally treated me as a collaborator. The respect they accorded me made me feel I had a proprietary stake in the project.

Making a good movie is hard. No one ever sets out to make a bad picture, and there are many pitfalls. But I have observed that good directors believe in stimulating their casts and crews' imaginations and eliciting from them their very best contributions that enhance the totality of the work. They have respect for the experience and expertise of artists and professionals, and with this philosophy they obtain the best results.

My happiest times at work have been when I was given free rein. George Lucas welcomed my ideas. Herbert Ross said to me, "Use whatever you want. If I don't see something in the cut, I'll ask for it." Brian De Palma said, "You're the editor, you figure it out." On *Ray*, Taylor Hackford turned me loose and left me alone for four weeks while I finished the cut.

They all gave me the freedom to fail and let me try things, improvise, take chances, and arrive at solutions that were surprising even to myself. I want to thank all the directors who believed in me and granted me this freedom.

I recently read a quote from Paul McCartney. He said, "I'd rather have a band than a Rolls-Royce." Being the editor on a movie is like

being in a band. We are certainly not the lead vocalist, nor perhaps even the brooding, mysterious solo guitarist. We are more like the bass player or the drummer. Our contribution is taken for granted, but we can make a huge difference. I've played in some terrific bands in my life, and it has been a blast. For that, I am truly grateful.

Acknowledgments

DEDICATED TO JANE, who is my everything.

And to my beloved Gina and Eric, Katherine, Joe, and Ivy.

Special thanks to longtime friend Nick Meyer, who gave my book its first read and made so many wonderful suggestions, and introduced me to legendary agent Charlotte Sheedy. Thanks also to Charlotte for seeing potential in the overlong manuscript I sent her and for introducing me to the outstanding Jenefer Shute, who, as my editor, helped enormously to shape the eventual book and proved to be a most exceptional collaborator. Her help was invaluable, and her enthusiasm for the book is deeply appreciated. Thanks as well to Kevin O'Connor, the super literary agent, for being my Sherpa guiding me to this point, and for his excellent suggestions. To James Hughes and Dick Pearce, who helped me by giving notes on an early draft, and to Devon Freeny, whose diligence, sharp eye, and attention to detail impressed me no end. A grateful nod to my brother Chuck, who helped me at the beginning of my career, and my brother Ric, who assisted me briefly in the cutting room before passing his bar exam, as well as to his mother Gen, who cooked countless delicious meals for me.

A big shoutout to my dear childhood friends Ron Roose and Tom Bellfort. Who could have imagined that we would all wind up working in the movie business? And in fond remembrance of Marc Kusnetz, Alan

Jacobs, Richie Marks, Lenny Bocour, Peter Bocour, my parents Joe and Ruth, and the many others I loved who, sadly, are no longer with us.

Thanks also to my picture department collaborators: Glenn Allen, Gordon Antell, C. J. Appel, Guy Barresi, Alan Baumgarten, Adam Bernardi, Todd Boekelheide, Deborah Boldt, Teresa Book, Étienne Boussac, Susan Braddon, David Brenner, Melissa Bretherton, Dax Brooks, Travon Brumfield, Todd Busch, Thomas Calderon, Carolyn Calvert, Dan Candib, Catherine Chase, Tony Ciccone, Tim Colletti, Simon Cozens, Candace Cruzd, Tom Dailey, Petra Demas, Lisa Dennis, Patrick J. Don Vito, David Dresher, Duwayne Dunham, Michael Duthie, Barbara Ellis, Jeff Etcher, Jim Flynn, Jerrie Fowler, John Fox, Adam Frank, Robert Grahamjones, Bruce Green, Ulysses Guidotti, John Haggar, David Handman, Caroline Hardon, Gina Hirsch, Ric Hirsch, Rick Howe, Joe Hutshing, Maria Iano, Amar Ingreji, Mike Jackson, Michael Kirchberger, Colin Michael Kitchens, Bettina Kugel, Lisa Levine, Andrew London, Pam Malouf, Christopher Marino, Michael Matzdorff, George McCarthy, Emma McCleave, Nick Moore, Jim Prior, Thy Quach, Bart Rachmil, Mark Rathaus, Jody Rogers, Gina Roose, Khadijah Salahuddin, Shae Salmon, Philip Sanderson, Marcelo Sansevieri, Emmy Scharlatt, Greg Scherick, Jonathan Schwartz, Justin Shaw, Joe Shugart, Sandy Solowitz, Robbie Stambler, Steve Starkey, Tim Sternberg, Debra Tennant, Jonathan Thornhill, Paul Tomlinson, Mark Tuminello, Salvatore Valone, Jeff Watts, and Adam Wolfe.

Thanks to the sound editors and music editors and mixers who made my work look better: Gary Alexander, Christopher Assells, Michael Babcock, Bob Badami, Mike Bauer, Alison Beckett, Lon Bender, John Benson, Gary C. Bourgeois, Ben Burtt, Dave Campbell, Joanna Capuccilli, Dan Carlin, Chris Carpenter, Kevin E. Carpenter, Harry Cohen, Patrick Cyccone Jr., Lisa Dennis, Teresa Eckton, Robert Fernandez, Marc Fishman, Frank Fitzpatrick, Tom Fleischman, Joe Gilbert, Stan Gilbert, Harriet Glickstein, Ken Hall, Per Hallberg, Doug Hemphill, Michael Hilkene, Eric Hoehn, Petur Hliddal, Richard Hymns, Adam Jenkins, Chris Jenkins, Doc Kane, Ken Karman, Michael Keller, Larry Kemp, Bonnie Koehler, George Korngold, Laurel Ladevich, Greg Landaker, Karen Baker Landers, Dan Laurie, Bob Litt, Don MacDougall, Anna MacKenzie, Steve Maslow, Paul Massey, Nick Meyers, Scott Millan, Frank A. Montaño, Glenn T. Morgan, Shawn Murphy, Andy Nelson, Kevin O'Connell, Thomas J. O'Connell, Greg

Orloff, David Parker, Craig Pettigrew, Mike Prestwood Smith, Joey Rand, John Reitz, Dan M. Rich, Gary Rizzo, John Roesch, Gregg Rudloff, Greg P. Russell, Michael Ryan, Gary Rydstrom, Dan Sable, Chris Scarabosio, Curt Schulkey, Leslie Shatz, Sam Shaw, Curt Sobel, Wylie Stateman, Mark P. Stoeckinger, Rich Stone, Gary Summers, Orest Sushko, Elliot Tyson, Robert Ulrich, Bill Varney, Dick Vorisek, Ken Wannberg, Kim Waugh, Hugo Weng, and Gwendolyn Yates Whittle.

And my thanks as well to Heather Griffith, Debbie Haeusler, and Craig Mizrahi, my agents three; to Fred Chandler, Stephanie Ito, Ted Gagliano, Marc Solomon, and Howard Fabrik.

Lastly, my apologies to anyone I have inadvertently omitted from these pages. To edit is to be part of a team, and I have always had wonderful teammates. Thank you all.

Index